AFRICAN MASKS

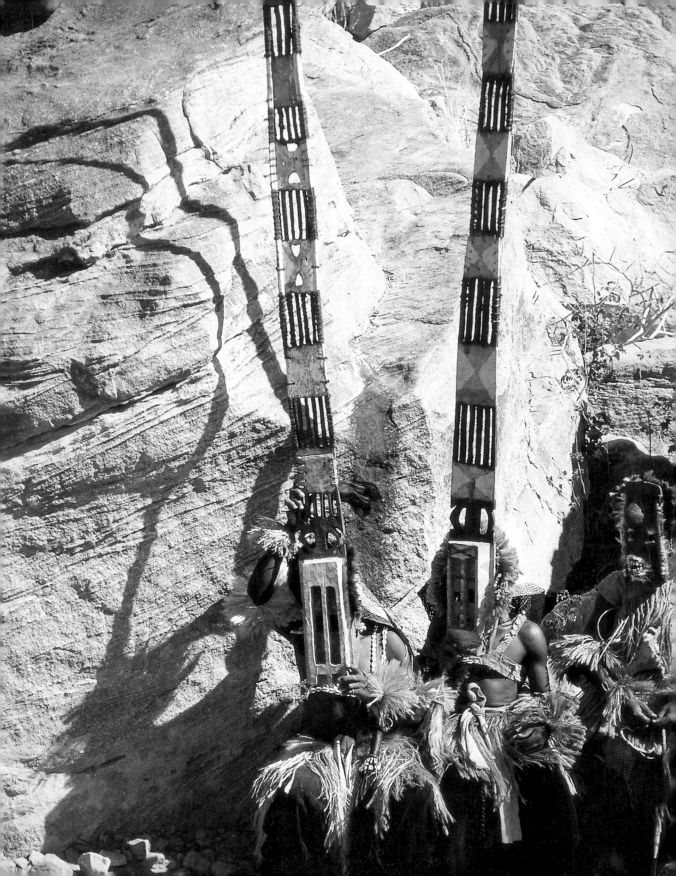

AFRICAN MASKS

THE BARBIER-MUELLER COLLECTION

By
Iris Hahner, Maria Kecskési,
and László Vajda

PRESTEL
Munich · Berlin · London · New York

Front cover: Face mask of the Mahongwe
or Ngare, Republic of Congo (photo by
Pierre-Alain Ferrazzini); cf. plate 73
Back cover: Plank mask (Nwantantay);
cf. plate 8
Frontispiece: Mask (Sirige) in Tireli, Mali,
1997 (photo by Monique Barbier-Mueller)

Library of Congress Control Number:
2006939117

British Library Cataloguing-in-Publication
Data: a catalogue record for this book is
available from the British Library Deutsche
Bibliothek holds a record of this publication
in the Deutsche Nationalbibliografie;
detailed bibliographical data can be found
under: http://dnb.ddb.de

© 2007 Prestel Verlag
Munich · Berlin · London · New York
(First published in hardback in 1997;
reprinted in paperback in 2004)

Commentaries to the masks in the catalogue
section are from the Musée Barbier-Mueller,
Geneva, with the exception of the following
catalogue commentaries, which were written
by Iris Hahner: 3, 7, 10, 11, 67, 70, 98, 202,
247, 248

Drawings to plates 3, 14, 69–73, 76, 89, 90,
99 by Jaime C. Bruma. Drawings on pp. 15,
16, 22–23 by Michaela Drescher

Photographic Acknowledgements: p. 287

Prestel Verlag
Königinstrasse 9
80539 Munich
Tel. (089) 38 17 09-0
Fax (089) 38 17 09-35

Prestel Publishing Ltd.
4 Bloomsbury Place
London WC1A 2QA
Tel. (020) 73 23-50 04
Fax (020) 76 36-80 04

Prestel Publishing
900 Broadway, Suite 603
New York, NY 10003
Tel. (212) 995-27 20
Fax (212) 995-27 33

www.prestel.com

Translated from the German by
John W. Gabriel, Worpswede
Copy-edited by Carol Thompson

Production by Sebastian Runow
Design and original layout by
WIGEL, Munich
Originations by Reproline
Genceller, Munich
Printing and binding by
Druckerei Uhl, Radolfzell

Printed on acid-free paper

ISBN 978-3-7913-3807-1

CONTENTS

ACKNOWLEDGEMENTS

It is not without emotion that I take up my pen to write a brief introduction to this volume. Eighteen years ago, when we were collaborating with the late William Fagg on a less ambitious book about African masks, I did not believe I would ever have another opportunity to concern myself with this art, although many portions of our collection still awaited publication. The project suggested by our friend Christoph Vitali, Director of the Haus der Kunst in Munich, sounded tempting to my wife and myself for two reasons. First, the book written by William Fagg had been published only in French; and second, we had acquired further significant masks since 1979. Also, contemporary research has at its disposal much new information about the function and meaning of many works which had not been sufficiently investigated previously.

African Masks presents a selection of 248 pieces on whose function and symbolism light has been shed by reference to new sources, many of them yet unpublished. Iris Hahner, who has provided notes to the 100 plates, was assisted in her investigations by Laurence Mattet, Secretary General of the Musée Barbier-Mueller. Maria Kecskési and László Vajda have written a general but penetrating introduction. To all three authors I wish to express my special gratitude. Even the layperson is bound to realize, on turning the pages of this publication, that it is not just another lavishly illustrated book on art. It offers an opportunity to enter the universe of the creators of African masks. An attitude of respect towards the sacred sculptures that embody the values of a society is the key to understanding them. These masks represent much more than objects capable of giving aesthetic pleasure.

My thanks go to Pierre-Alain Ferrazzini, our full-time photographer, as well as to the staff of Prestel-Verlag for the patient care they devoted to this project. Not least, I am indebted to the directors and curators of the other museums and institutions who contributed to its success: Thomas Kellein of the Kunsthalle, Bielefeld; Messrs. Alain George and Kik Schneider of the Banque Générale du Luxembourg; Messrs. Dirk Thys van de Audenaerde and Gustaaf Verswijver of the Musée Royal de l'Afrique Centrale in Tervuren; and finally, M. Russel Porter and Mme. Monica Dunham of the Fondation Bismarck in Paris.

Yves Piaget, Honorary Consul of the République de Côte d'Ivoire in Geneva, has shown unflagging interest in our publications over the years. It is both a great honor and an encouragement that His Excellency, the President of the République de Côte d'Ivoire, Henri Konan Bédié, has generously assumed patronage of the exhibition and the catalogue.

Jean Paul Barbier

PREFACE

Let us not delude ourselves: African art is a concept that goes back only a few decades. Although Europeans began collecting objects after the expeditions of discovery and research through sub-Saharan Africa, for many years interest focused solely on their ethnographic significance. It was the artists of emergent European modernism, above all André Derain, Maurice de Vlaminck, Pablo Picasso, Georges Braque, and the Cubists, followed by the Expressionists and Surrealists, who recognized the aesthetic qualities of the sacred sculptures and masks, and even of the furniture and textiles used in daily life. They were fascinated by the formal dynamism and expressive power of African objects, which corresponded to their own search for simplified forms and directness and immediacy of expression. Thus it came about that artists active in the first three decades of the twentieth century were the first to collect African art. Educated elites scoffed at this activity with as much incomprehension as they did at the artists' own creative work.

Among the first businessmen to concentrate on African art was Josef Müller of Switzerland (1887 – 1977). His interest was by no means coincidental. As early as 1908, when he had just turned twenty, Müller began to acquire paintings by Gustave Courbet and Pierre-Auguste Renoir, the Post-Impressionists and Vincent van Gogh, Paul Cézanne and Henri Matisse, followed by Cubist works by Pablo Picasso and Georges Braque, paintings by Vassily Kandinsky, Fernand Léger, Joan Miró, Georges Rouault, and many more. Over the next twenty-five years there emerged one of the greatest private collections of early twentieth-century European art in the world.

After making his first study-trip through Africa in 1923, Müller began acquiring African sculptures. By the mid 1930s the prices of European art had risen so sharply and the collector's funds become so limited that he began to concentrate on "Negro art," as he referred to it, and developed a collection of African and other non-Western art just as magnificent as his European collection. "A Medley of Beautiful Things from Africa, America, and the South Seas" was the title of an exhibition Müller organized at the museum of his hometown of Solothurn, and it was an exhibition of pioneering character.

Building on this foundation and inspired by his father-in-law's example, Jean Paul Barbier began in the 1950s a collecting activity that has continued and burgeoned to this day. Major works from his collection, in the meantime one of the most significant private collections of non-European art anywhere, are regularly presented to the public in ever-new selections at the Musée Barbier-Mueller, Geneva, founded by him in 1977. The present publication is devoted to masterworks of the art of African mask-making, which, though only one emphasis of the collection, is one in which the entire range and richness of form, the vitality, and the mystery of African art surpasses all other genres.

Christoph Vitali

MAP
OF ETHNIC GROUPS

1	Diola	35	Guro	69	Teke-Tsaayi
2	Bidjogo	36	Mau	70	Pomo
3	Baga	37	Wobè	71	Kwele
4	Nalu	38	Nyabwa	72	Mahongwe
5	Landuman	39	Bete	73	Ngare
6	Malinke	40	Wè	74	Yaka
7	Temne	41	Fante	75	Suku
8	Mende	42	Fon	76	Kwese
9	Gola	43	Yoruba	77	Pende
10	Bassa	44	Owo	78	Chokwe
11	Grebo	45	Edo	79	Kuba
12	Dan	46	Benin	80	Bena Biombo
13	Toma (Loma)	47	Bini	81	Luluwa
14	Bamana	48	Urhobo	82	Salampasu
15	Dogon	49	Ijo	83	Lwalwa (Lwalu)
16	Bwa	50	Ogoni	84	Lwena
17	Marka / Dafing	51	Ibibio	85	Mbunda
18	Mossi	52	Anang	86	Songye
19	Nunuma	53	Ejagham	87	Tempa Songye
20	Winiama	54	Igbo	88	Hemba
21	Nuna	55	Idoma	89	Kumu (Komo)
22	Sisala	56	Boki	90	Ziba
23	Bobo	57	Kutep	91	Lega (Rega)
24	Bolon	58	Yukuben	92	Bembe
25	Tusyan	59	Mambila	93	Tabwa
26	Senufo	60	Western Grasslands	94	Sukuma
27	Dyula	61	Bangwa	95	Iraqw
28	Kulango	62	Duala	96	Luguru
29	Hwela	63	Fang	97	Chewa
30	Bondoukou region	64	Galoa	98	Marawi (Niafa, Zimba etc.)
31	Nafana	65	Vuvi	99	Lomwe
32	Ligbi	66	Punu / Lumbo	100	Andonde
33	Baule	67	Tsangui	101	Makonde
34	Yaure	68	Vili		

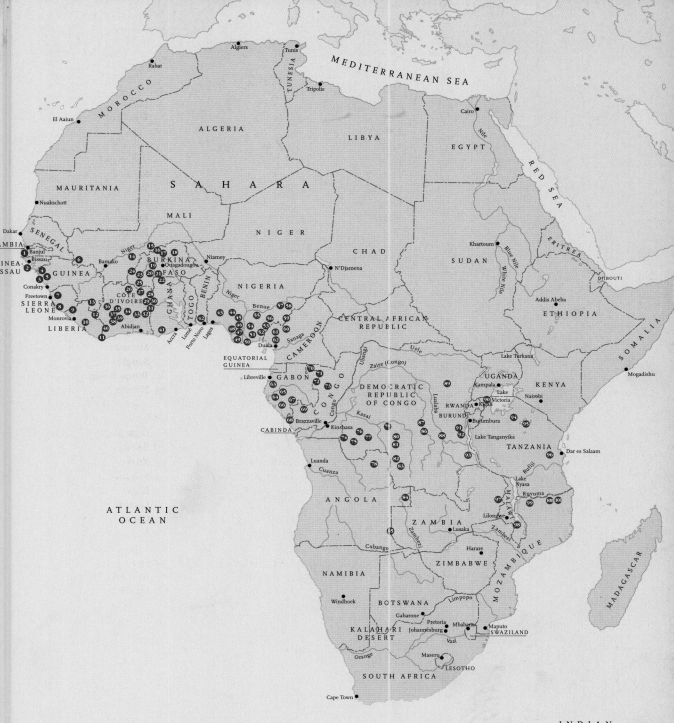

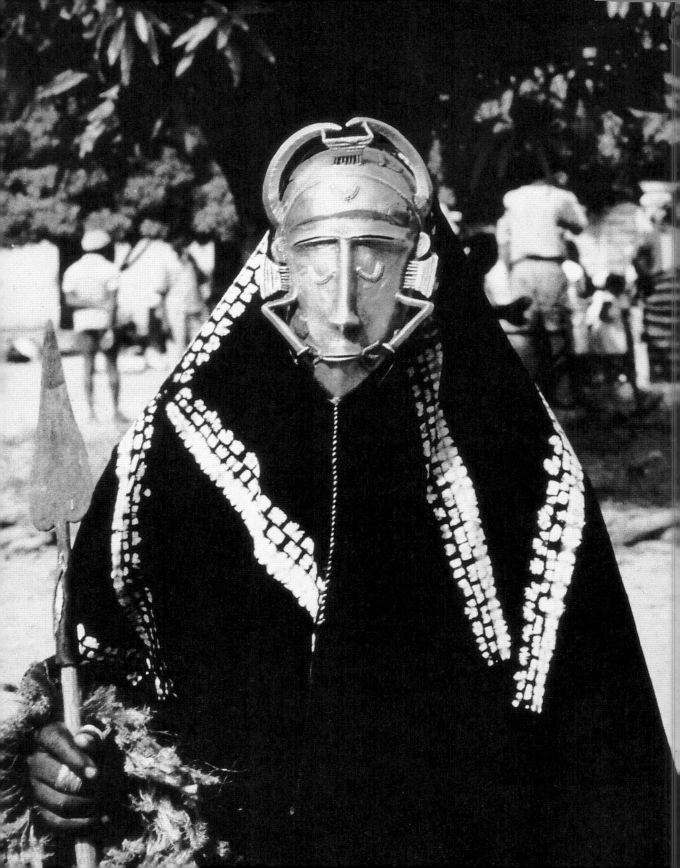

"I AM NOT MYSELF"

by Maria Kecskési
and László Vajda

In 1891 Richard Andree, eminent pioneer of comparative ethnographic investigation, made one of the first attempts to sift and order the information contained in early travel reports about the masks of African peoples. The material available to him at the time was very scanty. Thus, the picture Andree projected was quite incomplete, to say the least. But what discomfits the contemporary reader even more is the total lack of understanding on the part of the nineteenth-century travelers quoted by Andree regarding the aesthetic quality and significance of African masks. Some observers, for instance, described them as "horrible, ugly, devil's grimaces," whose purpose was supposedly to ward off enemies and evil spirits.

Face mask of the Do society, Dyula, Ivory Coast.

The final years of the nineteenth century and the first of the twentieth, however, saw a radical change in European views of African art. The initiative came from two quarters: from the fledgling science of ethnology, and from the field of visual art. The ethnologists realized that Africans (like the indigenous peoples of the South Pacific, Australia, America, and the Arctic) possessed an art that deserved to be taken seriously, and that conveyed culturally specific significance. Ernst Grosse[1] did not hesitate to emphasize the validity of this insight, which many now take for granted, and to apply it to European art: "Every work of art is basically just a fragment," Grosse wrote. "The artist's depiction, to become complete, requires the viewer's imagination. Only in this way is the whole engendered which the artist set out to create."

Twenty-year-old Leo Frobenius, in his 1893 monograph on African masks, set forth what he knew — or assumed — about the rich cultural background of masquerading. Almost concurrently Europe was undergoing an artistic and cultural revolution. Avant-garde painters and sculptors seeking to break the fetters of tradition discovered the works of African art that slumbered in many an ethnographical museum. Previously considered little more than curiosities, these objects were seen to embody a

2

Mask faces. Tassili n'Ajjer, Station de Sefar, Algeria.

1

Human figures with animal masks. Rock art at Melikane, Maluti Mountains, Lesotho. Drawing by J. F. Thackeray after J. Orpen and P. Vinnicombe.

unique approach to the subject-matter depicted which completely diverged from European norms, and which possessed an expressiveness often achieved by means of concision and formal reduction.[2] The "grimacing devils" attracted increasing interest and admiration. This was reflected, among other things, in the thousands of African objects, including masks, which entered European and American museums and private collections in the course of the twentieth century. Among the latter, the Barbier-Mueller collection of Geneva, whose treasures are presented in this volume, is among the most significant.[3]

The majority of these collections defined the topic of African art very liberally. In addition to covering the textbook genres of fine art, they extended to works that even today are still sometimes classified under the unsatisfactory rubrics of "arts and crafts" or "applied arts." The present project is thematically limited to a single aspect of sculpture: the art of masks. In terms

of quantity, variety, and poignancy, African masks are matched nowhere else in the world — except perhaps in Melanesia.

The road from demoniacal curios to highly valued works of art was studded with misunderstandings. Many of these have since been largely redressed. Aesthetic systems at first incomprehensible to Western eyes gradually began to be better understood. The composition and proportions of African sculptures began to be seen as a carefully considered distillation of forms. Regions with similar traditions and stylistic groupings began to be distinguished. The existence of esteemed masters who created identifiable bodies of work and who passed techniques and forms down to their pupils began to disrupt the assumption of naive spontaneity. However, this insight itself has led to another misconception: that the making of masks is not generally a creative artistic activity but merely an unimaginative copying of conventional models. This is just as mistaken as the

opposing school of thought, which tends one-sidedly to emphasize the autonomy of artistic personalities. Yet as exhaustive case-studies and comparative investigations have shown, mask forms, as so many other genres, are characterized by a dialectical interplay of tradition and innovation — that suspenseful relationship between old and new which in fact is one key to an understanding of the history of art in general.

Very little evidence, in contrast, has been advanced to support most

3

Initiation mask from Gambia. Engraving in François Froger's report on his travels in western Africa (1695–97), detail.

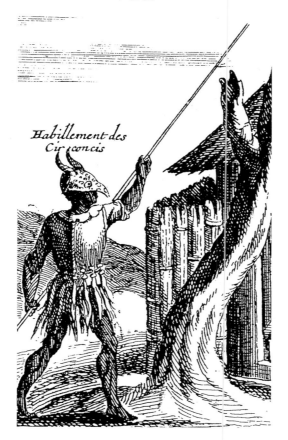

Habillement des Circoncis

speculations about the age and the early forms of mask-making and masquerading in Africa. The opinion that the forms (as opposed to the objects) known to us are "very ancient," is quite untenable. Though rock paintings, vaguely described as prehistoric, discovered in various regions of the continent show figures which might be hybrid creatures or masked humans (figs. 1, 2), their dating is in most cases highly insecure. But regardless whether these images are a few hundred or a few thousand years old, their supposed representations of masks provide no solid basis on which to determine the age of the known nineteenth and twentieth-century forms. An insufficient similarity apart, they give no indication of a continuity between old and new. Also, the earliest written documents stem from a much later period.

In the fourteenth century, for instance, the great Arabian traveler Ibn Battuta reported having seen singers and jugglers masked as birds.[4] François Forger's description of his travels in western Africa (1695–97) contained an illustration representing a man from Gambia — presumably a participant in a youth initiation rite — wearing a horned mask (fig. 3) similar to those used by the Diola group in today's Senegal (plate 20).[5] Such documents, if frequently imprecise, are valuable, though it is by no means certain that earlier reports are relevant for more recent periods. Masks and the performances of maskers belong in many countries and among many ethnic groups of Africa to the most vital and variable cultural practices. Cases are known in which, for whatever reason, these activities were abandoned and forgotten, and other cases of ethnic groups that had no masking tradition but have recently developed one or adopted one from other groups. Among many groups, several different types of mask exist concurrently, and each of them has its own, unique history.

Where field researchers have succeeded in reconstructing the development of certain recent mask types with the aid of information provided by group elders, an abrupt "change-of-fashion" has also been observed. Take, for instance, one of the best-known of all African art forms, the graceful Chi Wara masks of the Bamana, headdresses with a striking, abstract antelope design (plate 3). Amazingly, these configurations emerged only just over a century ago. Originally the mask consisted of a cap made of wickerwork, with two small antelope horns and a facepiece of leather or fabric.[6]

Despite the volumes of research published on African art, one still hears the occasional, inconclusive discussion about whether or not masks (and other works of African art) should be viewed within their social and cultural context.[7] Many a connoisseur and collector is satisfied with the aesthetic pleasure to be derived from such objects — l'art pour l'art. This attitude would be entirely legitimate were it not that many who hold it have raised it to an absolute. At least in one key respect their view has carried the day. Many masks now in museums and private collections have been, as it were, mutilated, only the aesthetically appealing face or head portion having been saved. Missing are the costume made of raffia, textiles, animal hides or pelts, feathers or leaves, as well as the masker's paraphernalia (staff, stilts, dagger, whip, fly whisk, bull-roarer, rattle, etc.), despite the fact that all of these often play a salient role in mask dances.[8]

Instead of art for art's sake, our presentation is based on the ethnological view that each individual mask — like perhaps any other work of art — represents part of a larger cultural ethos. It should be viewed not as an isolated thing but as a component of a social, intellectual, and, not lastly, an artistic whole. We should recall that the objects that sometimes seem to lie so lifelessly in their museum display cases were conceived for an entirely different setting and atmosphere. The masks were worn by men in exuberant dances, or stridden slowly and with dignity. Accompanied by music and song, gestures and rhythms were determined by the type and purpose of the masquerade. Some masks were intended to shock or horrify, others to astonish or to make audiences laugh. Even the most mystifying of masks, as we now know, had a meaning or a message to convey (cf. fig. 4). A thorough knowledge of the role played by masks in the life of African peoples past and present need not diminish our appreciation of them as works of art. On the contrary: to ignore their non-aesthetic aspects would diminish our appreciation of and sensitivity towards the broad range of effects and nuances of meaning of African masks.

4

Procession of *kanaga* masqueraders. Dogon, Mali.

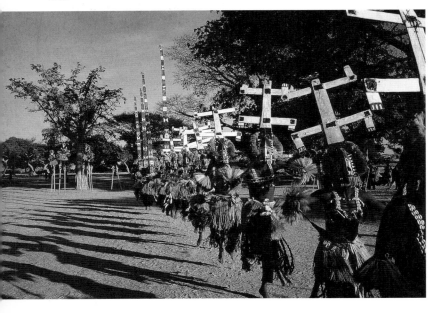

BASIC FORMS, TYPES, AND STYLISTIC GROUPINGS

In order to bring some sort of order into the variety of African masks, it is perhaps helpful to classify them in terms of a number of basic types. At this point only their physical characteristics will be taken as distinguishing traits. Based on the form of the main part of the mask, six types may be distinguished:

1. Face masks (fig. 5a), which occur almost everywhere in Africa where masks are used.
2. Helmet masks (fig. 5b), which are carved out of a section of tree trunk and hollowed to fit over the wearer's entire head. This type, too, is widely disseminated. In some regions — as with the Mende in Sierra Leone and the Suku in the Democratic Republic of Congo — it appears to be the sole form of mask.
3. Helmet crests (fig. 5c). This type differs from the helmet mask in that it does not cover the wearer's entire head, but is worn like a cap, leaving the face free. Helmet crests are a type commonly used by the Kwifon association in the Grasslands of Cameroon and by the Gelede association of the Yoruba, in southern Nigeria.
4. Cap crests or forehead masks (fig. 5d). Like the face mask, this type consists only of a half-face. But it is worn horizontally, stabilized on the wearer's head by a circular ridge. In the case of anthropomorphic varieties (such as those of the Cameroon Grasslands), the wearer bends forward and lowers his head to direct the mask's gaze towards the spectators (cf. plate 59). In the case of zoomorphic forehead and helmet crests, this stooping posture is unnecessary (cf. plates 60, 63). Both this and the previously mentioned form leave the wearer's face free; to complete the masquerade, his face is concealed with a piece of cloth, a translucent veil, or some similar material.
5. Headdress masks (fig. 5e). These consist of representations of human or animal heads or figures, rising above a small base that rests on top of the wearer's head. Examples are found in the art of various ethnic groups in the area of the Cross River in Nigeria (cat. 154), and among the Bamana in Mali (plate 2).
6. Shoulder masks (fig. 6d). These are large, very heavy busts designed to rest on the wearer's shoulders, with a small opening or peepholes to see through.

5
Typology of masks — basic forms
Face mask: Dan, Liberia
Helmet mask: Bassa, Liberia
Helmet crest: Diola, Senegal
Cap crest or forehead mask: Guro, Ivory Coast
Headdress mask: Bamana, Mali

6

Typology of masks — special forms

Vertical plank mask: Bobo/Bwa, Burkina Faso

Plank mask: Tusyan, Burkina Faso

Horizontal plank mask: Bobo/Bwa, Burkina Faso

Shoulder mask: Baga, Guinea

Multi-wearer mask: Senufo, Ivory Coast

7

Nasolo multi-wearer mask, Poro society, Senufo,
Ivory Coast, 1969.

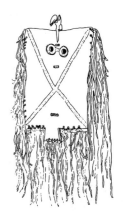
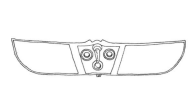
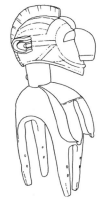
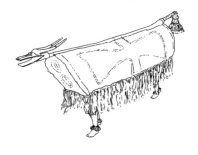

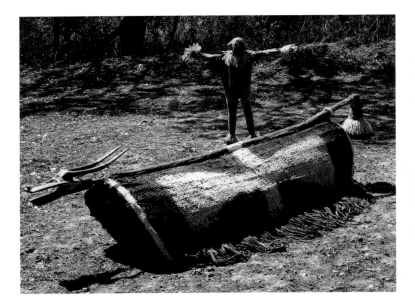

In the literature, the characteristic mask form of the Waja (Nigeria) and the Baga (Guinea) is often described as a shoulder mask. This may involve a misunderstanding, because the hollow of these masks is not large enough to receive the dancer's upper body. They probably represent a special variety of headdress mask.

A number of special forms were developed by modifying details of and making additions to the basic types mentioned. Examples are the vertically or laterally extended plank masks (figs. 6a, b, c), which exist in numerous local variants. These include the types described by Annemarie Schweeger-Hefel[9] as stele and sword masks, in use among the Kurumba/Nyonyosi in Burkina Faso. Other special variants

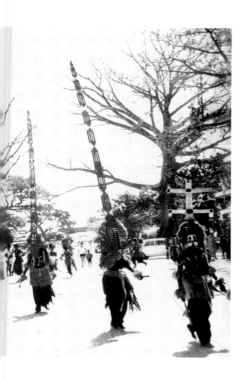

are characterized by proliferation, such as the multi-story mask (fig. 8) or that with long lateral extensions (fig. 9). Still others are gigantic in size and made of composite materials (fig. 10), or are designed to be worn by several persons at once (figs. 7, 6e).

Occasionally masks are simply painted designs. Among the Ubi (Ivory Coast), the colorful patterns applied to the face of young women in preparation for a ritual dance (fig. 11) probably represent an imitation of certain face masks common in the region.[10]

For the sake of completeness, mention should be made of the quite frequent use of mask forms as ornament on vessels, house walls, doors, door-posts, the bows or sterns of boats, shields, knives, drums, chairs, head-rests, staffs, bracelets, necklaces, and rings (figs. 12–16). Miniature masks, or maskettes, of wood, bone, ivory, or metal, worn as necklace pendants, as brooches, on a belt or at the elbow (figs. 14–16), also serve as amulets or as signs of successfully completed initiation (cf. plate 44). Their forms and characteristic details are similar to those of the other masks of the region in question.

As far as the mode of wearing is concerned, face masks are tied with

8

Performance of multi-story *sirige* masks in the village of Ireli. Dogon, Mali, 1976–77.

9

Mask with lateral appendages, wooden stick frameworks covered with bark cloth. Katoko, Angola, before 1923.

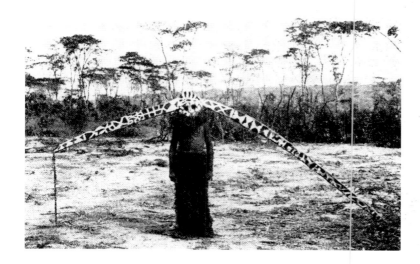

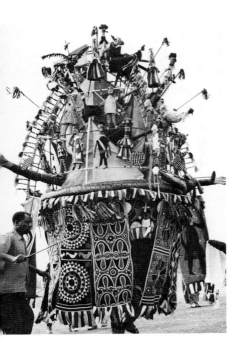

10
Dancer in giant composite *ijele* mask. Igbo, Nigeria, c. 1975.

11
"Living masks": dancers with face painting. Ubi, Ivory Coast.

12
Boat prow adorned with steer mask. Bidjogo, Guinea-Bissau, 1931.

bands either directly to the head or are held in place by a scarf or a raffia wig. All have holes drilled in the edge for the purpose of securing them. Some masks are fitted on the back, or inside, with a horizontal stick which the wearer grips between his teeth. The members of the Bwami association among the Lega (northeastern region of the Democratic Republic of Congo) employ their face masks in unusual ways. Expressive of a complex symbolism, the masks are worn not only on the face but at the temples, on the back of the head, on the upper arm, and on the knee — even held in the hand, laid on the ground, or suspended on special frameworks (cf. plates 94, 95).[11] Among the highland Bangwa of Cameroon, the members of the night association (Troh) carry their helmet masks (plate 64) on their shoulders rather than wearing them,

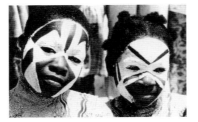

perhaps due to the dangerous forces associated with them, against which not even association members are immune.[12] The shoulder masks of the Limba in Sierra Leone, which are made of copper plates and worn during the funeral of a chief, are worn in a similar manner.[13] The multiple-wearer mask which is an especially striking element of the procession of initiates among the Senufo (Ivory Coast), has only one head, though the creature's body, fashioned of mats and wooden slats, is generally carried by two people (fig. 7). A similar construction is found in many of the animal masks used in memorial services by the Chipeta in Malawi[14] and by the Chewa in Zambia.[15]

The themes and motifs employed alone or in combination in African masks range from more or less clearly recognizable human features or busts (male, female, but only very rarely hermaphroditic) to the heads of animals (antelope, steer, elephant, leopard, monkey, crocodile, fish, bird, etc.). There are also combinations of the two, including horned humans and hybrid creatures with human and animal features or with traits typical of various animal species (cf. plate 25). Within all of these thematic groupings, especially

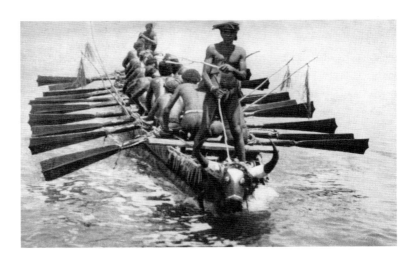

characteristic traits can appear: the heart-shaped face (cf. plate 71), the double, or so-called Janus face (cf. plates 12, 64), multiple heads (cf. plate 41), multiple-figure compositions, such as birds or human heads surmounting the mask (cf. plates 6, 39), human figures on an animal's head (cf. plate 9), or a leather covering (cf. cat. 154).

The morphological characteristics listed above do not suffice, by themselves, to permit a definition of styles, or rather, stylistic groupings. These emerge from a comparison of individual objects which evince similarities close enough to justify speaking of a relative continuity of form or combination of forms. With the necessary caution, historical reality may be ascribed to these groupings, for the complexes of features they share in common reflect formal traditions — conventions, in other words, which were followed by generations of artists in a particular region and which to some extent were even binding.

One key to stylistic definition is the position a sculpture occupies within a range extending from figurative at the one extreme toward abstract at the other. Though completely abstract masks are rare (cf. plate 56, cat. 90), in some cases the tendency toward abstraction is very marked, as in the masks of the Dogon (plate 7) and the Igbo (cat. 161). A close scrutiny of seemingly unimportant details can also be typologically revealing. The contour of a mask, the proportions of the features, the use of convex or concave surfaces, the shape of the eyes and eyebrows (cf. fig. 17), nose and nostrils, mouth and corners of the mouth, of ears, teeth, hairdo, scarification patterns, and finally painting — all are useful aids to stylistic classification.[16]

The sum of similarities can define a stylistic grouping. But before going on, we should note that the term "style," borrowed from European art

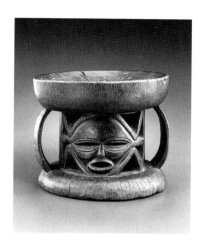

13
Headrest with mask decor. Lwena-Mbundo, Angola.

14
Mask worn at elbow, Gabon. Drawing by Pater Grébert, 1917–19.

15
Finger ring with buffalo head. Senufo, Ivory Coast.

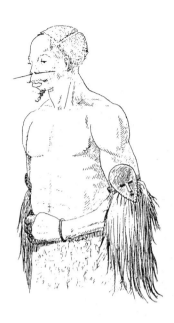

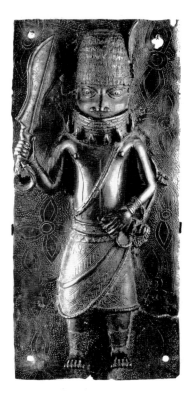

16

Bronze relief of a sword bearer with belt decoration in the form of a mask. Benin, Nigeria, 16th/17th century. National Museum of African Art, Washington, D.C.

history, has different connotations in the context of African art. When we speak of stylistic groupings, we are dealing almost without exception with works of the nineteenth and twentieth centuries, which means that stylistic determinations have little chronological depth. Thus terms such as "Dan style," "Chokwe style," or "Kuba style," even though they may be accurate, imply no chronological determination.

As regards the naming of stylistic groupings by ethnic group, common in mask collections, this goes back to ingrained European notions of the communal character of African art, and of the "tribe" as something akin to a primordial group. If these notions were correct, every ethnic group would possess a culture (including art) distinct from that of every other, and its members would adhere to a common artistic style. In reality, tribalism belongs to the phenomena of the colonial era: ethnic sensibilities in Africa are variable, and ethnic identities often shift and blur.[17] Several different styles may flourish within one and the same "tribe" (as with the Dogon, Bamana, Senufo, Bobo, Dan, Baule, Yoruba, Igbo, Fang, Chokwe, and many more), and the dissemination area of individual stylistic groupings is determined not by ethnicity but by economic and political ties, shared institutions (kingship, men's associations, rituals), religious movements — in other words, by communities of exchange.[18]

THE ARTISTS

The African masks of the past, and some of those of the present day, are still described as works of anonymous artists. Yet even as early as the end of the last century Frobenius thought it necessary to record the name of the carver of a Yoruba mask he purchased. In 1927 Franz Boas demanded that

future ethnological art research take into account the "action and attitude of the artist." In the 1930s Hans Himmelheber began to interview individual artists in Liberia and the Ivory Coast, to observe them at work, and to discuss their creative role.[19] The past few decades have produced a considerable series of reports whose authors describe the personality, working methods, and social status of individual artists in various African societies.[20]

The present discussion will be limited to woodcarvers, for the great majority of masks in Western collections were made by these artists. Woodcarvers are without exception men; even the masks of the Sande women's association in Sierra Leone are the work of male artists. Many of them come of families of woodcarvers, though they were under no obligation to continue the family tradition. The situation is different in those areas of the western Sudan where, as among the Senufo, an attenuated caste system still exists. The separate crafts still occupy certain strata here, and the son of a woodcarver is, at least theoretically, obliged and entitled to adopt his father's vocation.[21] Finally there are examples of boys who voluntarily decide to train as woodcarvers, without being influenced by family or caste tradition. The story of precocious talent early recognized, so common in European artists' biographies, seems rare in the life histories of African artists, and if referred to at all, it is only vaguely. As reasons for adopting an artistic vocation, most tend to mention a supplementary income (in addition to farming), or social prestige.

The apprentice's training is conducted by his father, if the father is a woodcarver. But even then the young man might absolve an apprenticeship of several years in the workshop of an experienced master, who, against remuneration, teaches him craft methods and how to make the products which are most in demand. The training is

informal, the apprentice himself deciding when he has learned and practiced enough. At this point he pays his mentor and establishes his own shop. In the small kingdoms of the Cameroon Grasslands the young carver presents a piece he has done to the king. If it is accepted, he is permitted to work independently from then on.[22]

The further career of the traditional carver depends mainly on the number and extent of the commissions he receives. Though his shop will usually contain several objects done for their own sake, as samples of his skill, generally the woodcarver works by order. If his business proves successful, he may start carving on a full-time basis. The paths of those who concentrate on utilitarian items (drums, stools, mortars, spoons, hoe handles, etc.) and those who are entrusted with more demanding tasks soon diverge. The latter group is only small in number — with the exception of artists employed by one of a few royal courts. The client is usually the representative of a clan, an association, or a royal court, or, in recent times, of a music and dance group. When ordering a mask the client will give only a very general description of its type and function, leaving the details up to the artist, who knows the traditional configurations and their iconographical features. However — and on this important point all observers agree — the artist does not simply copy an existing model. Even if he is given the task of replacing an old, termite-ridden mask by a new one, the result will not be a replica; nor does the client expect precise adherence to the motif, let alone a faithful copy.[23]

The carver's individual modifications may be minor, and made for reasons of no great importance. Perhaps he is simply tired of repeating the procedures learned from his teacher; perhaps he is looking for better ways to solve some part of the carving problem. Yet there are also reports of

innovations which go beyond small divergencies from tradition. The resulting works (which are just as rare as in earlier European art history) possess the quality of true artistic originality. These have the chance of becoming new prototypes, which in turn will form the basis for series of similar works each of which again differs from the model only in terms of slight modifications in detail.

How this comes about is just as inexplicable as artistic creativity itself. In numbers of interviews, artists have emphasized the effort of thinking involved, evidently reflecting a concern with something that had not yet been realized which spurred them to creative expression. They have at first only a vague idea of what form might satisfy this longing. The process continues with an attempt to lend material shape to the mental image, with all the skill at the artist's disposal. We generally describe this creative process by terms such as inspiration and intuition — concepts no more concrete nor rational than the explanation frequently given by African artists that their novel work actually came "from the spirits," who revealed themselves to the artist in a dream or a vision in the bush, and obliged him to carve the mask in question.

Can we conclude that the gifted African artist considers himself merely the tool of supernatural forces which guide his hand? The question brings us back to the obsolete doctrine of the collective character of African art and its lack of creative personalities. Whether this conforms with the way the artists see themselves and their activity is doubtful. Though field researchers' records contain no statements from which, say, the existence of an African version of the genius theory could be deduced, artistic ambition and a pride in the created object are definitely not unknown among talented African sculptors. Sculptors often look upon

17

Eye forms

Round eyes: Dan, Ivory Coast/Liberia

Rectangular eyes: Dogon, Mali

Slit eyes: Kwele, Gabon

Rhombic eyes: Baule, Ivory Coast

Asymmetrical eyes (illness mask): Dan, Liberia

Double eyes: Vuvi, Gabon

Triple eyes: Kwele, Gabon

Double eyes in mirror position: Teke-Tsaayi,
Republic of Congo

Double eyes of different sizes: Bembe,
Democratic Republic of Congo

Multiple eyes: Ubi, Ivory Coast

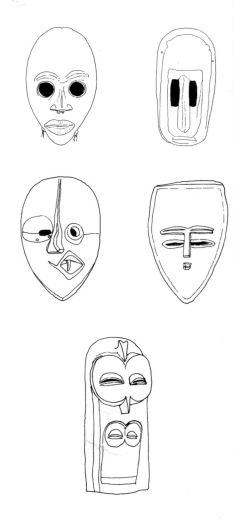

themselves "merely" as good artists, whose business success may have been due in part to assistance from certain spirits. If they seek renown as accomplished sculptors, it is not for the sake of renown itself but for the prosperity and social respect it entails.[24] Yet though skilled sculptors often do enjoy considerable social respect, not even the most gifted of them are placed on a pedestal. A statement made by a Bangwa king in 1899, to the effect that he made a certain masterful sculpture, is occasionally quoted to illustrated that this profession is highly valued. Actually, this involved a misunderstanding. Since an artist "belongs" to his king, his works are likewise described in courtly language as being the king's.[25]

Since many masks serve ritual purposes and are considered magically powerful objects, it is not surprising that the work of the mask carver is accompanied by religious ritual. He works outside the village, usually at a place considered sacred, and he must observe certain rules of ritual cleanliness (fasting, isolation from women, sexual abstinence until the work is finished, an avoidance of anything associated with death and dead bodies, etc.). As far as we know, these measures serve not to protect the artist from any threatening powers ascribed to the object but to ensure the success of his technically difficult task, including, for example, the prevention of cracks from forming in the half-finished piece. These rules do not differ substantially from those valid for other enterprises, such as hunting or house building. It is characteristic of the mask carver, however, that he never participates in the ritual wearing of masks in dances or performances. When, as among the Dogon, dancers make their own masks,[26] a distinction is made between their work and the products of professional carvers.

WORKING PROCEDURES

Wood is not the sole material used in masks, but it is the most common one. Numerous varieties of wood of different hardness and density are employed. Certain types of wood appear to be preferred in some regions or by some carvers' shops, and not only because of their local availability. There are symbolic links between certain masks and certain trees, although little research has been devoted to this topic.

African masks are carved for the most part from a single piece of wood

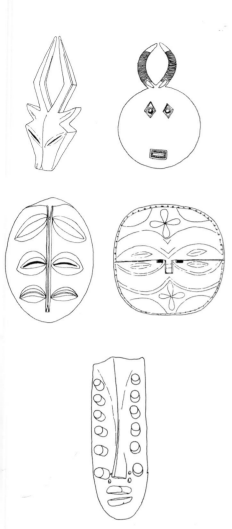

(monoxylic). The exceptions include types of mask fitted with a movable lower jaw (cf. plate 50), and the antelope figures in the headpieces of the Bamana in Mali, which are built up from several pieces of wood (cf. plate 2).

Once a tree has been chosen and felled, the trunk is usually left to dry for some time (except among the Dan, who work mostly with fresh wood). Then the trunk is cut into chunks whose size conforms to that of the mask to be made, which the carver has envisaged from the beginning. The tools used by the traditional woodcarver are quite simple: an adze with a relatively long handle, a knife, and possibly a gouge. Working with these tools requires great skill and much practice.[27] After the basic shape and main features of the mask are established by means of precise blows of the adze, finer shaping of the surface is done with a knife. Then either a knife or gouge is used to produce notches, such as those seen in the hairdos of many masks. Holes are bored through the edges using a kind of awl, or burned through with a hot iron. Finally the surface is smoothed with the aid of the rough leaves of certain plants, used like sandpaper. The finished carving is then rubbed with the sap of certain plants or with oil, which darken with time; in more recent masks these have been replaced by stains. In many areas there are special houses in which masks, mounted on frameworks, are suspended in the smoke of continually burning fires of green wood, which gives them a blackish-brown surface. Or masks may be colored, polychromy being characteristic of certain types of masks in areas such as southern Nigeria and the southwestern region of the Democratic Rebublic of Congo. For coloring, artists of the past employed organic and mineral pigments exclusively, which required a thorough knowledge of raw materials, especially of plants. However, such pigments began to be replaced decades

ago by imported commercial oil-based paints.

Besides wood, other materials are used to fabricate masks as well. Among the Chokwe in Angola there exist, in addition to wooden face masks, others with a substructure of plaitwork over which the face is modeled in a malleable resin mixture.[28] The leopard mask of the Shilluk group on the White Nile consists of a slightly convex calabash disk to which cow dung is applied to produce a design resembling the animal's head.[29] A similar construction is found in the Yoruba masks of Nigeria, although here the substructure is covered with clay (cf. cat. 138). A special form of head mask from the Cameroon Grasslands — actually a hood of cotton and wool fabric — is embroidered with glass beads to give a semblance of eyes, nose, and mouth.[30]

Several ethnic groups in western Africa, the Temne (Sierra Leone), the Dyula, Dan, and Senufo (Ivory Coast), the Abron (Ghana), and the Bini (Nigeria), are known to have produced masks in cast or hammered brass or bronze. Some of these are face masks (cf. plates 16, 27); others serve as pendants (cf. plates 34, 44). A high aesthetic level was achieved in the ivory masks of the ancient Kingdom of Benin. No wider than a human hand, these were designed as breast or belt ornaments. The glass-beaded leather masks of the Iraqw, of Tanzania, are compelling in their simplicity (cf. cat. 254).

Whatever material is used in a mask, it is almost invariably combined with others. The list of materials extends from sheet metal, such as copper or aluminum,[31] to fur, leather, hair and teeth both human and animal, the horns of wild or domestic animals, feathers, seashells (including cowries), glass beads, porcelain shards, fruit seeds, and many more (even upholstery tacks and shirt buttons). The costumes that complete the mask and cover the masker's body can be made of sheaves

of palm-leaf strips, woven plant fibers, leaves, local cotton fabrics, pelts or leather, but only seldom of bark cloth or imported European textile remainders.

RITUAL MASKS AND THE IDEAS ASSOCIATED WITH THEM

Though portrait masks exist, artists' statements about these traditions have rarely been recorded. In the case described by Eberhard Fischer[32] regarding Dan portraits, representation of individual features is hardly detectable. The mask described in this study is dominated by what Jan P.L. Vandenhoute (1948) called idealizing stylistic features, characteristic of other works by the same carver. In the case of many other masks possibly intended as portraits, individual idiosyncrasies likewise tend to be limited to ornamental scarification and coiffure.[33]

The great majority of African masks are associated not with certain living persons but, directly or indirectly, with supernatural beings or spirits. The performance of masked figures is generally thought to represent the visit of spirits from the beyond among men in the here and now. These supernatural presences may be roughly categorized as follows:

1. Spirits of the ancestors of a kinship group (family, lineage, clan);
2. Figures from the mythical tradition of a larger "we group": gods, royal or priestly ancestors, renowned warriors or hunters, cultural heroes;
3. Spirits of nature: spirits of wildlife and the bush; lords of the animal kingdom or of individual species; earth, tree, river, mountain, rain, and storm spirits, as well as spirits that cause fertility or illness;
4. Spirits of possession.

The borderlines between these categories are anything but sharply drawn, for they converge in countless ways. For instance, in many cultures the role of the founder of a dynasty corresponds to that of a cultural hero, while ancestral spirits are frequently associated with trees, mountains, etc. Earth spirits may be linked with fertility and motherhood (the earth being the progenitress of food plants), or on the other hand, they may signify the underworld and ancestral realm. The spirits of possession bear affinities with all of the other types listed above.

Why a certain supernatural presence should be associated with one mask instead of another — in other words, the relationship of idea to form — is seldom traceable. According to many reports, the conceptions of both spirits and masks are often inspired by dreams or visions. The artist to whom the supernatural presence reveals itself[34] captures its image and the community accepts or rejects its representation in this form. The amorphous nature of a spirit often owes its concretion to the making of a mask.

Within any stylistic group, suggestions of what might be called an iconography of spirit-categories can be discerned. Among the Igbo (Nigeria), the "beautiful" white-faced masks (cf. cat. 153) with features often considered to be female, are said to represent the peaceful, friendly spirits, whereas the black or dark red, frequently horned, "ugly" masks are associated with angry, aggressive beings.[35] In general, however, the external form and structure of a mask provides no clear indication of the type of presence it is intended to visualize. When the masker is cloaked in foliage, he might, but need not, represent a forest spirit. Crocodile masks do not necessarily refer to river spirits. A relatively clear link between ghosts of the dead and ancestors is seen in sculptures that represent the human skull.[36] Yet there are ancestral masks which are not even anthropomorphic, for an association of ancestors with zoomorphic or hybrid forms is also common.

Similarity between subject and masked representation is usually not strong, especially in the case of animal masks. No one who has ever seen a leopard or an elephant would consider a masker disguised as a leopard or elephant spirit a perfect animal impersonator (cf. plate 55). Yet zoologically correct mimicry is not the aim of African masquerade. The masked costume and its performance is generally limited to a few characteristic traits. Symbolic evocation of the animal is fleshed out in the viewer's imagination. Tradition ascribes certain external traits to the spirit so embodied. That is, masquerade is concerned not with animals but with the manifestation of spirits, which in a particular case may be given animal features (fig. 18).

As this implies, a performer's assumption of a mask and disguise can signify spiritual transformation. This was very likely the original and principal meaning of many ritual masquerades. Observers have told of the vital (or once vital) belief that the assumption of a ritual disguise — mask, body painting, costume, paraphernalia — actually brought about a transfiguration which involved not only the outward appearance of the masker but his very body and soul. The masker — in his own eyes or in those of the spectators — temporarily ceased being himself.[37] In the context of the rite he was not merely a man in a costume who was personally known to most of the spectators in daily life; he was actually and truly the supernatural presence whose attributes he bore.

In order to understand the numinous quality of the situation which lends this irrational event psychological reality, we must try to look beyond masks as objects to imagine the scene in which they appeared — the rhythmical, now exuberant, now solemn and dignified movements of the dance; the acoustic accompaniment by drums, rattles, noisemakers, bull-roarers, whistles, bells, etc.;[38] the hoarse, hissing, roaring voices of the spirits; the words of an unintelligible spirit language pouring forth from the mouths of possessed dancers.[39] The spectators at such rites experience the transformation of the maskers, actually feel themselves in the presence of spirits. This experience is both feared and desired, because the spirits are in essence ambivalent. On the one hand they are aggressive and destructive: they torture, kill, eat people alive, send diseases,

18

Masquerader in zoomorphic helmet crest. Fante, Ghana.

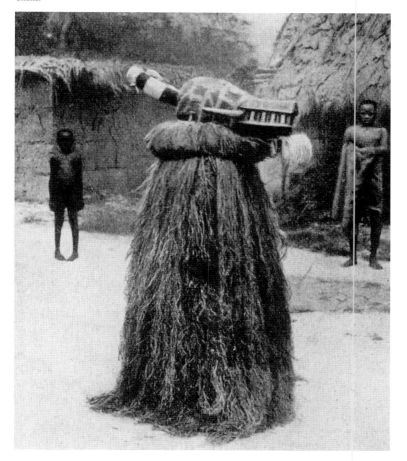

devastate crops, ruin the luck of hunter or fisherman, delay the labors of pregnant women. On the other hand, the spirits can help humans in times of crisis, accompany them through the vicissitudes of their lives, insure social amity and just leadership, bring prosperity and health. But whether malicious or beneficial, the spirit's power is absolute.

This power, according to many accounts, inheres solely in the supernatural beings; the masks are said to be ineffectual and without meaning outside the ritual. Yet there is no lack of accounts which, while emphasizing the hegemony of the spirits, suggest that masks themselves might possess a supernatural power, and perhaps even a sort of personality. This is the reason for the abundance of religious regulations relating directly to masks. They are to be kept in the house of the elder, or in a special building or shelter at a consecrated place (e.g., a sacred grove, fig. 20). The masks are not to be shown or even touched except on certain occasions, and they must be regularly cared for (i.e., by sacrificial offerings). According to a report from the Dan (Liberia), a gnashing of teeth can sometimes be heard from a mask lying in a corner.[40] Among the Kurumba/Nyonyosi (Burkina-Faso), "deceased" masks, that is, ones made useless by the influence of weather or termites, are even given a funeral and buried.[41] In the Grasslands of Cameroon, non-initiates who touch certain masks despite the prohibition are said to contract skin rashes or even die; when an animal sacrifice is made to a mask, the animal is said to die on contact with it. In this region various masks are considered so dangerous that their appearance in public must be accompanied by priests, who continually sprinkle them with liquid from a magic calabash in order to "cool them down," because otherwise they might unleash terrible damage.

Spirit masks appear in the context of various rites. Many of these are celebrations which directly or indirectly mark a change in status of individuals or small groups. These rites of passage or transition are held at critical times of life: birth, maturity, marriage, entry into a higher rank in the hierarchy, death (burial). The course of the rite often displays a characteristic division. In the initial phase of transition, the idea of separation from a previous status dominates (rites of separation). After an intermediate phase in which the participant or participants are neither what they were nor what they will be (threshold rites), follows an acceptance into the new status, accompanied by the proper initiation or enrollment rites.

All rites of passage include numerous symbolic actions. For example, the transition from one social status to another is often expressed in terms of a change of place, which is the source of the multifarious door, gateway and bridge symbolism in the rites of separation and initiation. Symbolic representations of death and rebirth are also frequent, most strikingly so in the rituals accompanying the initiation of adolescent boys: the novices must first "die" (i.e., be separated from the community) before, awakened to new life, they can be accepted into it as mature, marriageable members (i.e., be enrolled in the community). In many ethnic groups this process and its dramatic representation are combined with the idea of a monster that devours the initiate and then coughs him up (rebirth, i.e., entry into adult status). Sometimes there is a blend of various symbols, as when the gateway is combined with the voracious monster, whose mouth becomes a door to the future.

The inexhaustible store of symbolic means of expression and embodiment available to African cultures includes

that of dramatic mimicry — the performances of masked and costumed persons who represent certain spirits in human or animal form. But again, in the context of ritual, these are not considered actors or performers but are thought actually to embody the beings they represent (fig. 19).

That rites of metamorphosis also play a role in this context is not surprising since the change of status, say, from childhood to adulthood is frequently looked upon as an abrupt physical transformation of the adolescent boy or girl themselves. Before initiation they are considered incapable of procreation or conception; after initiation — and in a sense, thanks to it — they are sexually mature.[43] It might be expected that those who are to experience the metamorphosis, the initiates, would appear in the ritual in disguise. This is indeed the case, at least to an extent, in certain girls' initiations. In the case of the boys, it is generally not only the novices who wear costumes but those who conduct and guide the ceremony: ritual experts, initiation mentors, sponsors. Interestingly, the activities of these participants relate not only to the separation from childhood or the entry into adult status, but, and particularly, to the middle phase of transition (threshold rites). In male initiations this threshold phase can last for weeks or months, and the candidates spend this period outside their familiar milieu, in a camp in the wild. Observers have aptly termed this "bush school," because the period of isolation from family and village is not least a time of learning (cf. fig. 21).

The small group of novices receives systematic instruction on the part of the accompanying experienced adults concerning what it means, according to sacred tradition, to be a human being and to belong to the ethnic group. This includes the entire mythic tradition dealing with the origin

and structure of the universe, the creation of man, animals and plants, the origin of peoples and institutions. Knowledge pertaining to gods, spirits, and other supernatural powers and how to communicate with them (sacrificial customs, festival calendars, ritual dances, songs and incantations, holy symbols) is also transmitted. The teachings also extend to rules and prohibitions of social life (i.e., regarding sexuality, matrimony, personal hygiene, food taboos) and to many other areas, including, in some cases, the learning of a secret language. This is truly an enormous curriculum, and its successful teaching requires special methods. The conditions are established by the character of the "bush school" itself. It is a true wilderness camp, where the

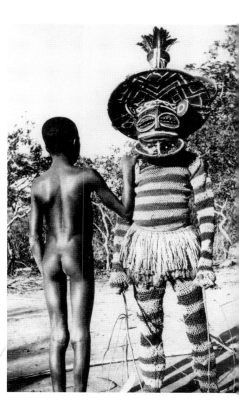

19

Initiate with masked mentor at the beginning (or end) of a puberty cycle. Chokwe, Angola.

20

Plan of a sacred grove (*sinzanga*) of the Senufo, in Pinion, Ivory Coast. The most dangerous mask is kept within the grove, and the more innocuous masks on its edge or outside it.

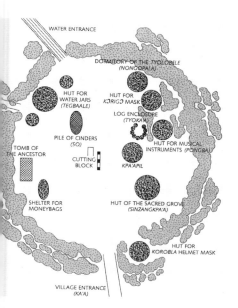

WATER ENTRANCE

DORMITORY OF THE TYOLOBELE
(NONOOPALA)

HUT FOR
WATER JARS
(TEGBAALE)

HUT FOR
KORIGƆ MASK

LOG ENCLOSURE
(TYOKA'A)

PILE OF CINDERS
(SO)

TOMB OF
THE ANCESTOR

CUTTING
BLOCK

KPA'APIL

HUT FOR MUSICAL
INSTRUMENTS (PƆNGBA)

SHELTER FOR
MONEYBAGS

HUT OF THE SACRED GROVE
(SINZANGKPA'A)

HUT FOR
KOROBLA HELMET MASK

VILLAGE ENTRANCE
(KA'A)

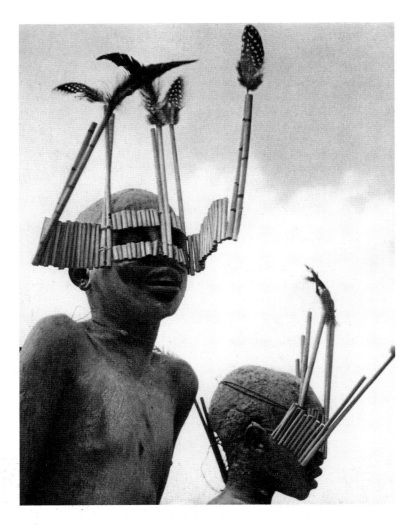

21
Masked initiates. Gogo (?), Tanzania, before
1960.

have to pass through a dark tunnel in which terrors lurk, including, for some, death between the fangs of a fabled leopard; their mothers are led to believe that no boy will return alive.[44] According to numerous reports, the psychological pressure on the initiates in "bush camps" is almost unbearable, and at times they react by falling into possessed states. Participants in the initiation ceremonies of the Tenda (Guinea) explained that they had gone crazy, because "everything they had seen in the bush had confused their heads."[45]

At this "school" the performances of masked teachers and sponsors take on an educational, didactic meaning: "The initiated instructors appear in the costumes of those primordial beings who were the first to suffer the fate of the living. The godhead, which has realized itself in this form of being, is itself present, and the magnificence of the apparel, together with the demonaical omniscience of the progenitors, make the passing on of doctrine an affective experience that contains more for the pupils than any sober statement of the utterable."[46] The masquerades conducted during initiation rites convey traditional knowledge about man and the universe such that it is not merely learned by the novices, but profoundly experienced.

SOCIO-POLITICAL ORGANIZATIONS

boys ritually experience a precultural, as it were primeval state of existence (nakedness, no fire or cooked food, hunting with simple weapons), and where they occasionally are subjected to physical pain (circumcision, filing of teeth, tattooing, whipping, etc.). On top of this comes a feeling of apprehension about future unknowns. Among the Bushong (main group of the Kuba in the Democratic Republic of Congo), teachers announce that the initiates will

A considerable proportion of the masks originating in western and central Africa was made for one or another of the numerous "secret societies," or socio-political organizations, active there. These organizations are so diverse and so complex in nature that no general description fits them all. Theoretically, they extend across the borderlines between clans, villages, and even ethnic groups, though in practice there exist all varieties of hybrid forms with orig-

inating groups. One person may belong to several associations, and several associations may exist in parallel. Usually they are purely masculine societies, in which misogynist tendencies are not infrequent; yet the exclusion of women is not strictly practiced everywhere. The powerful Bwami society of the Lega (eastern region of the Democratic Republic of Congo) has female members, and special women's societies exist among the Mende (Sierra Leone) and the Duala (Cameroon). Membership in an organization is voluntary, and acceptance into it depends on the fulfillment of certain conditions — primarily on the payment of considerable sums (fig. 22). In many societies, however, membership and status are hereditary, and in some regions, nearly every man belongs to the society active there. The structure of the societies is hierarchical: Each new member receives the lowest rank on the scale, and must show considerable accomplishments in order to reach a more prestigious and influential higher rank. In many cases the succession of

ranks is more or less identical with the system of age levels or social strata. The societies are meant to function as quasi-democratic controls on the political authorities, though in practice they are often dependent on a chief or king.

The adjective "secret" refers not to membership in an organization but to the jealously guarded knowledge of certain religious procedures and to the ownership of certain ritual objects (including numbers of masks), which are thought to contain supernatural powers. All of these things must remain inaccessible to non-adepts, a ban which in many societies is furthered by the use of a secret language known only to members. Any infringement of the code of secrecy is draconically punished, even, under certain circumstances, by death. In practice, however, the esoteric discipline of these societies is more relaxed than in theory. Still, the belief in their religiously based power is so great (and is so skillfully kept alive) that the organizations are ultimately capable of fulfilling their goals.

22

Members of the Kuosi association with elephant masks. Bandjoum, Cameroon, 1930.

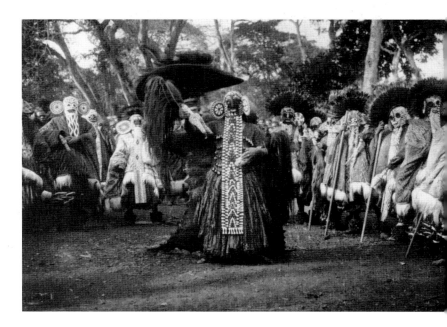

Their activities are ramified. Being primarily religious in nature, the societies' organizations have their own rituals. Stages in members' careers — acceptance into the society, advancement to higher ranks, funeral and memorial celebrations — are accompanied by rites of passage. Public appearances of such organization's masked groups are among the most spectacular features of general celebrations (initiation, seasonal festivities, inauguration of a new chief, funeral ceremonies; fig. 23). The supernatural power ascribed to these associations is drawn upon on many other occasions as well, usually in furtherance of the common good. The maskers, considered embodiments of the spirits, perform dances which relate to the fertility of the crops, the end of a scourge, the warding off of destructive forces, or the protection of the country from enemy attack. Another of the societies' self-imposed tasks is to maintain and, if necessary, restore the social order established by supernatural beings in times immemorial. They exercise police and judicial authority, for example determining, with the aid of oracles, whether someone has used malevolent means to threaten the life or property of another person. Personal rivalries and other tensions that disturb the peace of the village or the region, and that might prove detrimental to the order desired by the spirits, are therefore kept strictly under the organization's control. A great deal of attention is devoted to marital problems, in particular to unfaithful or nagging wives, evidently with an eye to maintaining the traditional, rigorously defined roles of husband and wife within the family. The Scottish explorer Mungo Park, who traveled through the Niger region in 1795–97, graphically described the appearance, among the Mandingo, of an emissary of a secret society feared by all unvirtuous women. This was the forest spirit "Mumbo Jumbo." With masked face and brandishing a stick, Mumbo Jumbo first ran back and forth in the woods, emitting bloodcurdling screams. Then, at nightfall, he entered the village and ordered the women to gather at the dancing place; not one dared to stay away. During the singing and dancing the masker performed grossly comical antics. At the approach of midnight, he suddenly fell upon the "culprit," tied her nude to a stake, and whipped her. Then he vanished into the bush again.[47]

Men's organizations not only concern themselves with domestic affairs, but are frequently determining forces in questions of legislation and political leadership: many nineteenth-century observers characterized them

23

Masquerade performance on the occasion of a funeral. Senufo, in Korhogo, Ivory Coast.

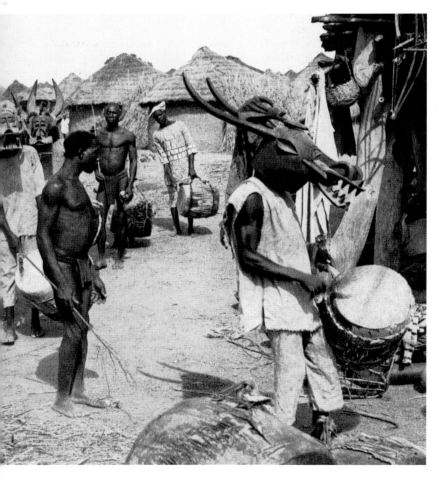

as states within the state (cf. fig. 22). Kings, chiefs, and dignitaries wisely avoid conflict with secret societies, unless they themselves are members.

Membership in political associations, particularly at a high rank, not only confers respect and power in society, it brings accessibility to supernatural forces and benevolent spirits that proffer riches and success. The great influence of the organizations easily leads to an abuse of power, for some have been known to degenerate into ruthless, parasitical terrorist groups. When this happens, the populace lives in continual fear, not only of supernatural powers but of the very concrete threat of violence at the hands of anonymous masked men. Their ritual performances now serve, apart from plunderings, merely to foment anxiety among non-members. It is rumored that the members of certain male societies transform themselves into leopards and other beasts of prey and kill their victims by night. Many field researchers are convinced that these and similar tales of atrocities are not entirely unfounded.

Organizations possess sacred appurtenances and insignia which are kept secret and protected by strict prohibitions. Often the religious implements include certain containers and vessels, oracular objects, weapons, whips, and sticks, and also noisemaking instruments (bull-roarers, drums, double bells) whose sound is considered by non-initiates to be the voice of the spirits. The most striking objects in ritual performances, secret and public, are the masks. Their number is usually considerable, because each mask is intended in principle to represent a certain spirit. The range of masks is further increased by the fact that each type is often reserved for a single degree of rank (the supernaturally "weaker" category for the lowest rank, the supernaturally "strongest" for the highest), and by the possible hierarchy of mask

"families." In some areas the number of ritual mask types — apart from those made for the trade — probably extends into the hundreds. For all their immense variety, one feature occurs very frequently. This is the tendency of costume masks which are associated with natural spirits to be taller than most humans. Often these are shoulder masks, whose height is further increased by means of vertical superstructures or by the use of stilts. Nowadays the latter are mainly used by itinerant acrobats for entertainment purposes, but their original ritual function is well documented. The dissemination of stilts in Africa corresponds to that of masquerading and secret societies.[48]

PROFANE AND SECULARIZED MASKS

There are animal costumes which help hunters approach their prey unnoticed, until it is within range of an arrow shot. This hunting method is documented in several rock paintings in South Africa (cf. fig. 26). Here a San (Bushman) carries on his shoulders a sort of framework of woven grass into which ostrich feathers are inserted. In his hand is a stick topped with a carved ostrich head (sometimes a real ostrich head and neck are used, making the camouflage even better). The hunter imitates the movements the bird makes when feeding or preening, letting the real or carved wooden head emerge above the high grass. The disguise is so realistic that the ostrich flock senses no danger.[49] Comparable hunting methods are known in other parts of Africa as well. The Fulbe of northern Nigeria use hornbill masks (fig. 24),[50] and numbers of rock drawings in Namibia show hunters clad in antelope head masks (fig. 25).

In these cases, the disguise has a practical use, and its wearing is functionally determined. In contrast to

the symbolic suggestions of ritual masks, the animal costumes used by hunters are accordingly as naturalistic as possible. It is conceivable, though not proven, that they also have a supernatural function. By imitating his prey the hunter becomes one with it, enabling him to impose his will on the creature he stalks.

However, most African masks serve no immediately practical purpose of this type, but are determined by religious ritual. There is abundant evidence that masquerades are elements of the most sacred institutions in many African cultures. But is every spectator at these performances equally gripped by the numinous character of the ceremony? Do all experience the metamorphosis of the maskers and the presence of the spirits with equal intensity? This was probably never the case. After all, differences in attitude, imagination, and suggestibility, on the part of individuals or small groups, even within the same community, are inevitable and no more than human.

A mask some look upon with religious awe will be considered by others merely a sign of an association or a status symbol; for still others it may have no more than entertainment value. As a result of the comprehensive cultural transformation that has taken place in Africa over the past hundred years, increasing numbers of ethnic groups have abandoned traditional rites or begun to practice them without deep commitment. Nevertheless, masquerading has not — or not yet, or not entirely — disappeared, despite the fact that its unadulterated character has apparently fallen prey to modernization.

Yet it is a matter of record that profane masks and masquerades serving purposes of entertainment already existed before this transformation began. Nineteenth-century travel reports make frequent mention of such secular spectacles. Also abundantly documented are masked performances of professional comedians, dancers, and singers concerned only, or primarily, with the donations they expected from

Hunter wearing hornbill mask. Nupe, Nigeria.

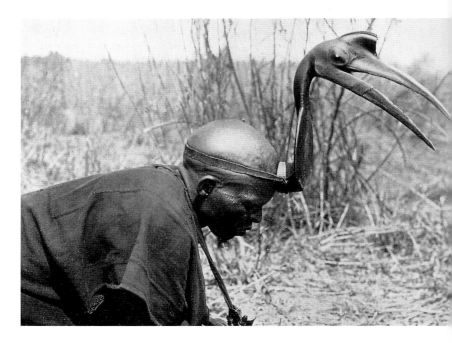

their audience. However, these sources require a thorough analysis. Apart from the fact that such performances may have represented religious activities which were only later secularized,[51] their European witnesses may well have seen only the public, exoteric aspect of the spectacle without learning anything of its esoteric, ritual content. There is also occasional evidence of an observer having been unable to understand the deeper meaning of scenes which struck him as comical.

Among the Senufo (Ivory Coast) the masked actor known as *yarajo* is often called a clown or buffoon, and indeed he fits the part, mingling with the spectators — including women and children — and asking them all sorts of absurd questions. Actually the *yarajo* is one of the most important figures of the Poro association, and his ridiculous queries are stock sayings to which members of the society among the audience respond with equally stock, apparently absurd replies. In this way the *yarajo* determines who is entitled to take part in the secret portions of the ritual.[52]

Generally speaking, it is doubtful whether the blanket terms "religious" and "secular" do justice to the actual meaning of many masquerades. Max Buchner, an early and sensitive observer, was apparently aware of the ambivalence of such performances. In 1880 he reported on a belief of the Minungu (a group in northern Angola related to the Chokwe) in terrifying spirits of the bush, who were evidently to be banned by similarly terrifying maskers. "Almost every day," wrote Buchner, "...one or two of these merry-andrews came into our camp, to dance for my men to the rhythms of a drum, and their cry of 'mukish!' electrified the whole company every time. When they began to run, everybody scattered before them with gleeful shrieks, and the enjoyment they gave surely lay partly in the thrill of getting a fright. My bearers

25
Hunter wearing antelope mask aiming at a buck. Rock art in the Eland Cave, Cathedral Peak, South Africa.

26
Scene from an ostrich hunt, with hunter masked as an ostrich (far right). Rock art, Witte Mountains, Herschel District. Drawing by G.W. Stow, 1843/53.

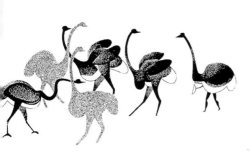

invariably met them with extraordinary generosity and lavished tobacco, meat, and beads upon them, perhaps in order to gain the favors of the terrifying beings that awoke their superstitious feelings."[53]

Are masks and masqueraders still capable of evoking such ambivalent, deep feelings among contemporary Africans, in view of technological development, increasing literacy, a money economy, and urbanization? There can be no clear, generally applicable answer to this question. All one can say is that a not inconsiderable proportion of mask types and masquerading customs has survived cultural and economic transformation to this point, and that, moreover, new masks (fig. 27) and masquerade ceremonies have

emerged.[54] There are even examples of the integration of Western industrial products in African mask dances (fig. 28). Not even the spread of Islam with its ban on imagery, which was radically destructive in the area of activity of the Poro association,[55] has led to a complete suppression of masquerading. In the northern area of Ghana and in Nupe (northern Nigeria), ritual masks — now declared to be without religious connotation — are still in use among the Moslem populace.[56] The idea of the warding off of evil, widespread throughout Africa, flourishes even in some Moslem regions. In the region of the Bondoukou (Ivory Coast), for instance, the fire-breathing Gbain mask used against destructive forces enjoys great popularity among Moslems, who have even passed it on to non-Moslem groups.[57]

There are any number of ethnic groups in Africa whose adherence to tradition has ensured the maintenance of what has been passed down to them, including masks and the attitudes associated with them. The efforts of fanatical modernizers to stamp out the masquerading traditions as a sign of backwardness are a thing of the past. Educated Africans have long since recognized the value of this tradition. Yet changing social and intellectual circumstances cannot help but produce changes in the forms and functions of masks. Anyone who posits a religious function as the defining condition of "authentic" masquerading, will tend to speak, all too glibly, of a degeneration process. We must remember that even the masquerading of the past had aspects apart from the sacred, as evinced by the role played by maskers' societies in the maintenance of public order, in organizing firefighting, in political affairs, and so forth. So when sacred functions recede into the background (which is by no means always the case), this does not imply

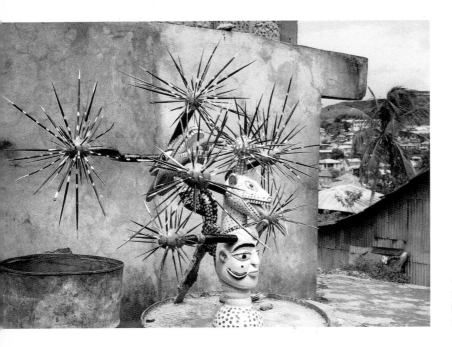

27

Ode-lay mask, made in 1979 by John Goba, Freetown, Sierra Leone. The form was inspired by the typical headdress masks of the Ejagham, Nigeria. Collection of Hans and Betty Schaal.

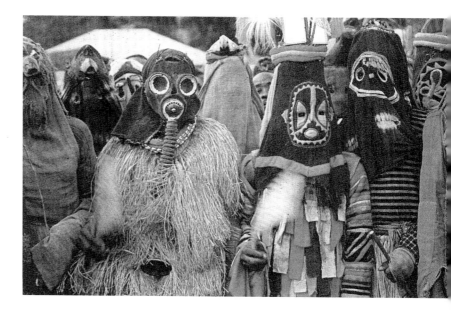

28
Masked "grasshopper" or "locust" dancers. Awka region, Igbo, Nigeria, mid-1960s.

29
Mask by Romuald Hazoumé, 1995. Various materials. Dany Keller Galerie, Munich.

that the masquerade has become devoid of meaning. It merely indicates that other functions of a social, political, or aesthetic nature have taken prominence.

Present-day Africa continues to have great numbers of gifted artists. Their accomplishments are remarkably diverse, covering a range that extends from traditional dance groups through politically and socially committed art to the incorporation of the visual art forms of Europe and America.[58] Within this vital creative scene, masks, too, still have a place, especially in the art of dance and the dramatic and performing arts. The modern masks used in these contexts may not always be more than spectacular props, but they very often are. What contemporary African artists envisage is by no means "un-African," in view of the dramatic and theatrical tendencies already apparent in traditional masquerading. To this extent the use of masks as a modern means of expression represents an acceptance and continuation of these traditions. The closeness of the link is more confirmed than denied by ironic, and

self-ironic, attempts at alienation.[59] The revolution now underway in the arts — in terms both of content and of form, including that of masks (cf. fig. 29) — remains a genuinely African revolution.

Will Africa succeed in creatively integrating its rich artistic and cultural heritage in the arts of the coming century?

The title of the present essay was inspired by Herbert M. Cole's book, *I Am Not Myself: The Art of African Masquerade*, University of California, Museum of Cultural History, Los Angeles, 1985

1 Grosse 1894, p. 26.
2 Concerning the course and details of this process, see Gerbrand 1957; Goldwater 1969; Rubin (ed.) 1984, p. 198 ff.
3 Sager 1992.
4 Defrémery/Sanguinetti 1853–1858, IV, p. 413.
5 Mark 1992, p. 4 f; Hirschberg (ed.) 1962, p. 213.
6 Imperato 1981, p. 21.
7 Cf. Schmalenbach 1988, p. 21.
8 Förster 1988 b, p. 15 f. Examples of the significance of the supplementary parts of the costume are given in Frobenius 1898, p. 172 ff.; Koloß 1980, p. 32.
9 Schweeger-Hefel 1980, p. 25 ff.
10 Barbier 1993, vol. I, p. 219.
11 Biebuyck 1978, p. 210 f.; Biebuyck 1985–1986, vol. II, p. 132 f.
12 Brain/Pollock 1971, p. 131 ff.
13 Hart 1988.
14 Kubik 1987, p. 25 f.
15 Yoshida 1993, pp. 39, 41.
16 A good example of detailed morphological analysis is Verger-Fèvre 1985, an investigation that includes the varieties of wood of which individual masks are carved.
17 Vansina 1945, p. 29 ff.; Bravmann 1973, p. 9 ff.
18 Though W. Bascom (1969, p. 102 ff.) retained the link between larger stylistic groups — or at least their sources — with individual ethnic groups, he attempted to resolve the evident inconsistencies this involved by introducing various stylistic subgroups ("local substitutes," "multiple subtribal styles," "individual styles," "regional styles," "blurred tribal styles"). The usefulness of these rather doctrinaire categories has yet to be demonstrated.
19 Frobenius 1898, p. 24; cf. Bascom, in Biebuyck 1989, p. 103; Boas 1955, p. 155; Himmelheber 1935; Himmelheber 1960.
20 From the extensive literature on this topic, mention should be made of several articles in Biebuyck 1969; d'Azevedo 1973; Fischer 1963; Fischer/Himmelheber 1976; Fischer/Homberger 1985, chap. V, p. 34 ff.; and Gerbrand 1975, chap. III.
21 Krieg/Lohse 1981, p. 23 ff.
22 Koloß 1980, p. 23 ff.
23 Paula Ben-Amos (1980, p. 57) reports a case she experienced near the city of Benin. She ordered a rattle stick from several woodcarvers, explaining that it was to resemble a piece used in the Ekpo cult as closely as possible. But the result did not meet her expectations at all. When she complained, the carvers were completely confused. What the ethnographer did "lay outside the system."
24 Fischer/Homberger 1985, p. 47.

25 Lintig 1994, p. 149.
26 Griaule 1938, p. 408 f.
27 Detailed visual and written documentation is found in Fischer/Himmelheber 1976, pp. 21–30; Fischer/Homberger 1985, pp. 65–73; Cole/Aniakor 1984, pp. 114–116; Richards 1974, p. 50; Willett 1978, pp. 28–33.
28 Herold 1967, p. 11; Bastin 1982, pp. 81–85.
29 Krieger 1900, no. 10 ff.; Holy 1967, pp. 10, 169.
30 Krieger/Kutscher 1960, fig. 46.
31 Hart 1987.
32 Fischer 1970, p. 31.
33 Mack 1994, pp. 33, 36, 47.
34 Cf., for example, Fischer/Homberger 1985, p. 75.
35 Cole/Aniakor 1984, p. 113 f.
36 Frobenius (1898, p. 180 ff.), then still under the influence of the notion of a one-track linear development, attempted to trace masquerading in general back to the skull cult. Though he and others later abandoned this generalizing view, the role of the cultically revered skull as the model of certain mask types — especially those with movable lower jaw (cat. 150 f.) — remains noteworthy. Interestingly, the Lega (eastern region of the Democratic Republic of Congo) refer to certain masks and maskettes which bear no external resemblance to skulls as the skulls of ancestors, and treat them accordingly (Biebuyck 1971, p. 212; Biebuyck 1985–1986, vol. II, pp. 126, 130).
37 Cole 1985.
38 The acoustic and dance elements of ritual ceremonies have been rarely documented in detail. Superb exceptions are the precise descriptions of the rhythms and dance "figures" associated with the masquerades of the Dogon (Mali) given by Griaule (1938, pp. 716–739), and with those of the Yoruba (Nigeria) provided by the Drewals (1983, p. 138 ff.). Himmelheber (1935, p. 41) records a saying of the singers of the Guro (Ivory Coast): "If you don't dance, the spirit whose face you wear will kill you."
39 In some areas, as among the Senufo (Krieg/Lohse 1981, p. 104) and among the Tikar of the Cameroon Grasslands (Koloß 1980, p. 42), the dancer's voice is distorted by a whistle held in the mouth or by a U-shaped tube sealed with spider's web and fixed in front of the mouth.
40 Himmelheber 1964, p. 77 f.; Fischer 1978, p. 18.
41 Schweeger-Hefel 1980, p. 164 f.
42 Koloß 1980, p. 35.
43 Many features of the initiation tradition point to an archaic doctrine concerning the original dual-faced nature of man. According to the Banama (Mali), in childhood the body contains a powerful energy (*wanzo*) located in the prepuce of boys and the clitoris of girls. This force is said to counteract fertility and order of any kind, explaining why children are incapable of procreation and are asocial. Only circumcision, believe the Banama, frees boys of the feminine element and girls of the masculine, permitting them to become members of society. It is thought that

during circumcision, part of the *wanzo* energy flows with the blood into the earth, but the rest is passed on to the masks (!), increasing their power (Dieterlin 1951, p. 64 ff.; cf. also Baumann 1955, pp. 193–205). Among the Yaka and their neighbors (southwest region of the Democratic Republic of Congo), the *nkada* mask presiding over initiation must have male and female facial features, jewelry, and a headband; the color symbolism is also intended to signify sexual duality (Bourgeois, discussed in Cole 1985, p. 79 ff.).
44 Vansina 1955.
45 Delacour 1947. The initiation of girls usually takes place when they have their first menstruation and, like that of boys, it involves circumcision in some ethnic groups. The ceremony is generally a family affair, the girls remaining in the village instead of being sent to bush camps with rites of rebirth and masquerade performances (an exception are the Makonde in southern Tanzania and northern Mozambique). The instruction they receive from older women primarily concerns their sex lives.
46 Jensen 1950, p. 32.
47 Park 1807, p. 46; supplemented by Frobenius 1898, p. 150 f.
48 Lindblom 1927, pp. 11 ff., 24 f.; Lindblom 1928, p. 8 ff.; Jensen 1960, p. 75 ff.
49 Straube 1955, p. 129 f.
50 Balandier/Maquet 1974, p. 629.
51 Himmelheber 1935, pp. 42, 48.
52 Förster 1988 a, p. 47.
53 Quoted from Frobenius 1898, pp. 36, 65; on the concept of mukishi, cf. Biebuyck 1985–1986, vol. I, p. 212.
54 We refer here not to the masks of low quality produced in large numbers expressly for the commercial market but to new types which have a place in the life of the community. In many areas there are recently established, very popular dance groups which have developed their own forms of mask, such as the *ode-lay* masks in Freetown, Sierra Leone (Nunley 1981, p. 32 ff.).
55 Krieg/Lohse 1981, p. 60.
56 Vansina 1984, pp. 129, 163.
57 Bravmann 1973, p. 19.
58 Vogel 1991.
59 As the artist Romuald Hazoumé of the Republic of Benin once commented, "People expect Africans to make masks, so I make masks" (Feuilleton, Süddeutsche Zeitung [Munich], 16 April 1996).

PLATES

with notes by Iris Hahner

Headdress mask (Chi Wara)

Bamana, Mali, Segou-Koutiala region

Wood, dark brown and blackish-brown patina,
metal nails
Height 78 cm (30 ¾ in.)
Inv. 1004-36
Formerly collection of Josef Mueller; acquired
from the collection of Antony Moris before 1939;
collected before 1931
Cat. 5

The religious and social life of the Bamana, who live in the area of southwestern Mali, was once determined by six initiation societies (Jow, sing. Jo). Nearly every Bamana male had to pass through these societies in succession, until, upon reaching the highest rank, he had acquired a comprehensive knowledge of ancestral traditions. Each stage of initiation was accompanied by the use of certain mask types, most of them based on animal forms (zoomorphic).

Among the best known of these is the antelope headdress of the fifth society, Chi Wara, whose members performed ritual dances intended to ensure the fertility of the fields. The masqueraders always ap-

peared in male-female pairs, symbolizing the sun and the earth and their significance for human life. At the same time, the representation of the male roan antelope (*Hippotragus equinus*) which the Bamana call *dega*, invoked the mythical primeval era when this animal gave the first grain to human beings and taught them how to till the soil. In spite of fundamental social changes, the Bamana in many rural regions have retained the tradition of Chi Wara masquerades, performed at the beginning and end of the agricultural cycle.

The gender of this superbly carved antelope is obvious from the outsized sexual organ, as from the stylized mane and sweeping, spiral horns. The head and two of the three arcs that represent neck and mane are decorated with incised lines and bands of small triangles. The mane consists of four squarish, notched elements. Although in many Chi Wara headdresses the animal's body is strongly reduced in scale and almost geometric in form, this figure has a naturalistically curving body and relatively differentiated legs. According to Ezio Bassani, the sculpture is the work of the "Master of Antelopes," to whom numerous other pieces have been attributed. He is thought to have been active from the final years of the nineteenth century to the 1930s, in a workshop which Bassani has localized in the region between Segou and Koutiala.

Bibliography: Bassani, 1982; Brett-Smith, 1988, p. 72; Fagg, 1980; Goldwater, 1960; Haley, 1985; Imperato, 1970; Imperato, 1981; McLuhan, 1974; Zahan, 1974; Zahan, 1980

Male-female pair of Chi Wara masqueraders at a hoeing contest. Near Koutiala, before 1912.

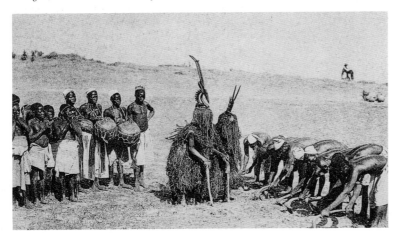

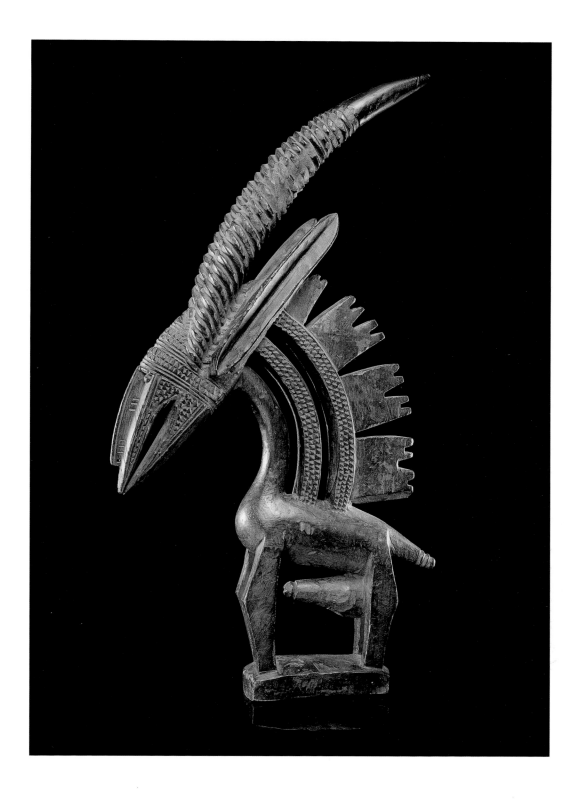

Headdress mask (Chi Wara)

Bamana, Mali, Beledougou region

Wood, upholstery tacks, sheet metal strip,
red glass bead, plant fibers, basketwork
Height 55 cm (21 ⅝ in.)
Inv. 1004-100
Formerly collection of Josef Mueller; acquired
from the collection of Emil Storrer about 1950
Cat. 4

In terms of style, Chi Wara headdress masks can be classified in three groups, each of which is associated with a certain Bamana region. The "vertical" type (cf. plate 1) occurs primarily in the eastern Bamana region, between the towns of Sikasso in the south and Segou in the north. A second type, characterized by strong abstraction, is found in the southwestern Ouassoulou region (cf. plate 3). The third style, called "horizontal"

due to the position of the antelope's horns, is typical of the area around Bamako and northwestern Mali. This sculpture belongs to the third category. It is still affixed to the woven cap used to fasten it onto the wearer's head. The head and body of the figure were carved of separate pieces of wood and fitted together at the neck with a strip of metal, a characteristic feature of "horizontal style" headdresses.

Both head and body are ornamented with low-relief zigzag patterns and rows of engraved circles and small triangles. The animal has certain hybrid traits. Though its long, curved horns are those of a roan antelope (*Hippotragus equinus*), its head, body, legs and tail, as well as the tongue seen in its slightly open mouth, recall an aardvark (*Orycteropus afer*). This animal is a quick and skilled tunneler, which is why it is so admired by Bamana farmers. A reference to farming is also seen in the standing female figure, affixed by two nails and a cord to the antelope's horns. The larger a Bamana man's harvest is, the more in demand as a husband he will be, and the more wives he can support. Also, the Bamana look upon plowing and sowing as a process akin to the sexual act. Sexuality and agricultural activity are closely related in their minds, since both ensure human survival.

Bibliography: Brett-Smith, 1988, p. 71; Fagg, 1980; Goldwater, 1960; Haley, 1985; Imperato, 1970; Imperato, 1981; McLuhan, 1974; Zahan, 1980

Masquerader wearing a Chi Wara headdress mask in the "horizontal style."

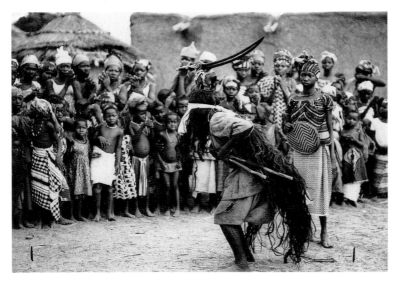

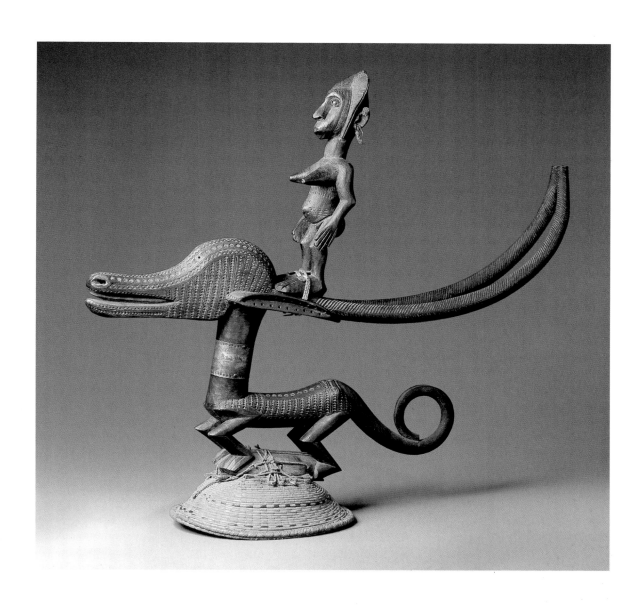

Headdress mask (Chi Wara)

Bamana, Mali, Ouassoulou region

Wood, remnants of ocher painting, red and
white glass beads, plant fibers
Height 40.5 cm (16 in.)
Inv. 1004-187
Formerly collection of Armand Trampitsch
Cat. 2

This headdress represents the comparatively
more abstract type of Chi Wara mask, which
is found primarily in the Ouassoulou region
of the southwestern Bamana area. It shows
a typical combination of three different spe-
cies of animal — the aardvark (*Orycteropus
afer*), the pangolin (*Manis tricuspis*), and the
roan antelope (*Hippotragus equinus*).

The base of such headdresses is in-
variably formed by a representation of the
aardvark (*timba*). Here it is clearly recogniz-
able from the simplified but still relatively
naturalistic elongated head, pointed ears,
arched body, and bent legs. The structure
on the aardvark's back, circumscribed by
a nearly closed oval, represents a pangolin
(*n'koso kasa*) in the rolled-up position it
assumes in defense and to protect its young.
This stylized figure is surmounted by two
vertical elements and by the horns and long,
pointed ears of an antelope (*dega*). According
to Zahan, all three animals are symbolically
linked in the Bamana farming community
with tilling the soil, including its sexual
connotations. The aardvark and pangolin,
especially, are associated with the growth of
sorghum, the Bamanas' most important
grain crop. The aardvark's ability to dig
itself rapidly into the ground and create a
network of subterranean tunnels and
chambers recalls the men's skill at working
the fields, as well as the deep root system
formed by the germinating sorghum seeds.
The pangolin, in contrast, which lives
mostly on the ground and in trees, recalls
the windblown stalks of millet, which are
stabilized by air-roots anchored in the
ground.

Bibliography: Goldwater, 1960; Haley, 1985;
McLuhan, 1974; Roberts, 1995; Zahan, 1980

Compositional scheme of the "abstract style" Chi
Wara mask. From top to bottom: horns of the
roan antelope (*Hippotragus equinus*), pangolin
(*Manis tricuspis*), aardvark (*Orycteropus afer*).

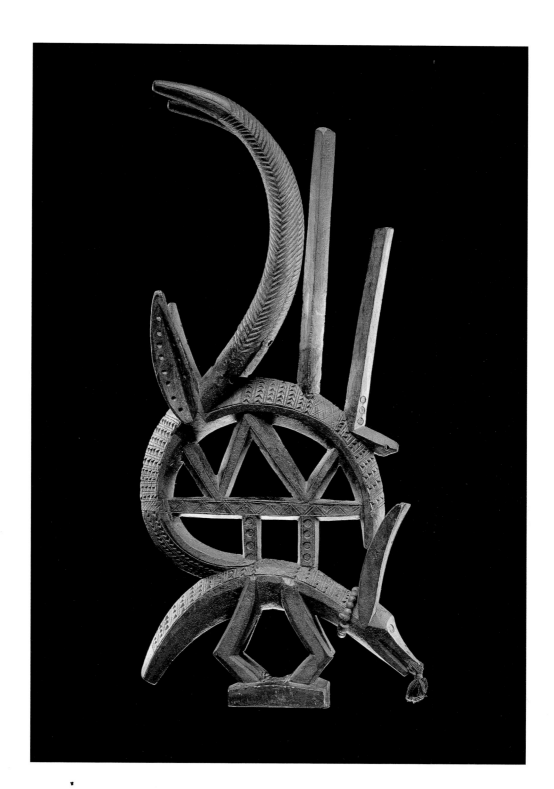

Face mask (Korè Dugaw)

Bamana, Mali

Wood, colored dark brown, animal skin
Height 37 cm (14 ½ in.)
Inv. 1004-11
Formerly collection of Josef Mueller;
acquired before 1942
Cat. 8

Of the six Bamana initiation societies (Jow), Korè represented the highest level. Its members achieved a degree of spiritual knowledge that enabled them to experience a mystic union with divine power and enter a perpetual cycle of reincarnation. In order to reach this highest plateau, the adepts of the Korè society had to submit themselves to protracted and painful initiation rites which included their symbolic death and resurrection. Each neophyte was assigned to one of eight Korè classes, each of which had a different emblem and dealt with a certain aspect of religious experience.

This zoomorphic face mask with its erect, pointed ears shows a geometric configuration typical of this type of Korè mask. The elongated, curved, angular face ends in a rectangular mouth opening, and is dominated by a protruding, straight nose and a hemispherical forehead (in this case almost hidden by the fur wig).

The mask represents a type used by the Korè Dugaw group, the class of "vultures" or "horses." Wearing such masks and a net costume from which dangled bits of calabash shell, pieces of iron, fruit husks, and other objects, members of this group would descend upon the village riding hobby-horses. Their antics broke every taboo — they parodied sexual behavior, smashed implements, and devoured everything they could lay hands on, even excrement. This unrestrained behavior not only proved the physical and mental prowess of the Korè Dugaw; it attested to a state of superhuman transport in which social conventions paled to insignificance.

Bibliography: Brett-Smith, n.d.; Goldwater, 1960; Zahan, 1974

Korè Dugaw masquerader with hobby-horse and sword. His net costume is decorated with various objects, including fragments of calabash gourds.

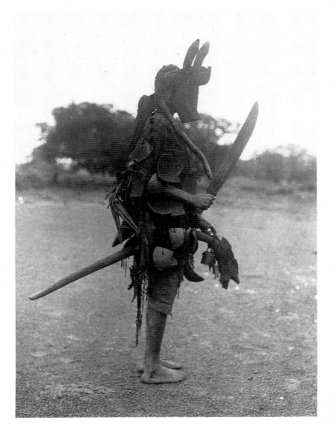

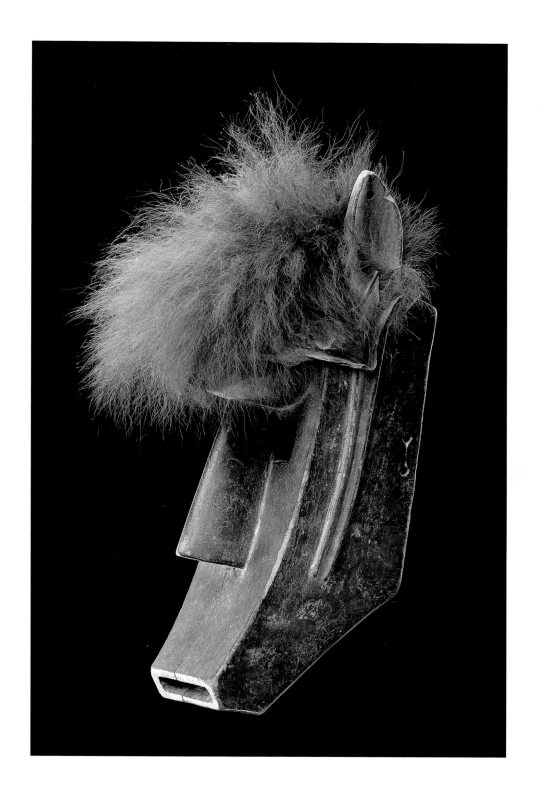

Helmet crest (Komo)

Bamana, Mali

Wood, encrusted patina, iron nails,
remnants of feathers
Length 110 cm (43 ¼ in.)
Inv. 1004-172
Cat. 9

The most prestigious of Bamana initiation societies was Komo, whose members were grouped by age. Almost every young man entered Komo after having passed through the first society, Ndomo, and been circumcised. The Komo oversaw all key events in life, from birth to circumcision, marriage to burial, and played an important role in the ancestor cult and in agrarian rites. In addition, the leader of each local Komo (*komotigi*), who always belonged to the clan of blacksmiths, acted as a diviner and supreme judge. The term Komo was applied not only to the society but to its members, living and dead, to its sacred objects including altars, and to its masks and masqueraders, who appeared in various public ceremonies in the course of the year. The masquerader was considered an embodiment of the primal blacksmith, who taught humans this craft.

Komo masks, worn horizontally on top of the head, combine traits of various animals. These are alluded to not only in the carved mask itself but in the feathers, bristles, bones and horns attached to it. As a rule, the basic wooden configuration consists of a hemispherical head with a long, open mouth recalling a crocodile's snout. The various supplementary materials, as well as a thick coating of black mud from a sacred lake or river, have a symbolic meaning and serve to increase the power of the mask.

The mud covering and typical attributes are missing from this striking example, with its extremely long, pointed ears and four open triangles along the snout. Only tiny remnants of feathers on the head give an idea of the mask's original surface accumulation.

Bibliography: Goldwater, 1960; Haley, 1985; Jespers, n.d. [1995]; McNaughton, 1988; N'Diaye, 1994; Zahan, 1974; Zahan, 1980

Group of Komo masqueraders, who accompanied all important events in Bamana life: birth, circumcision, marriage, and funeral.

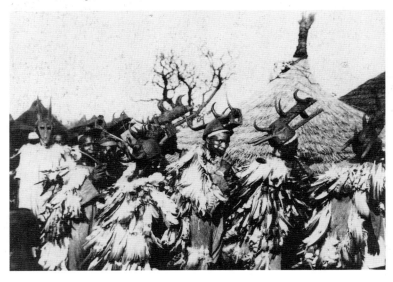

Face mask (Walu)

Dogon, Mali

Wood, remnants of white paint, plant fibers
Height 63 cm (24 ¾ in.)
Inv. 1004-8
Formerly collection of Josef Mueller; acquired
from the Emil Storrer collection about 1952
Cat. 15

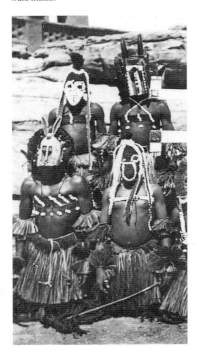

Various masks of the Dogon, including two
Walu masks.

The Dogon continue an ancient masquerading tradition which commemorates the origin of death. According to their myths, death came into the world as a result of primeval man's transgressions against the divine order. Every five years, *dama* memorial ceremonies are held to accompany the dead into the ancestral realm and restore order to the universe. The performance of masqueraders — sometimes as many as 400 — at these ceremonies is considered absolutely necessary.

This mask, with its traces of white paint, is geometric in style. The arrow-straight nose is flanked by large eyeholes in a rectangular, recessed face, which ends below the tubular mouth in a slightly projecting, square chin. The edges of the face are decorated with raised triangles, and a graceful arc extends from the bridge of the nose to the feet of a slender female figure standing straight above. This figure represents Yasa, twin sister and wife of one of the *nommo* culture heroes who brought rainwater from the sky to the earth in a jug. Legend has it that this water formed the first lake, which enabled life to develop on earth.

What appear to be ears are actually upright horns, indicating that the mask depicts a mythical antelope known as Walu. Walu is said to have been directed by the god of creation, Amma, to protect the sun from the fox Yurugu, who coveted it because he hoped to find his twin sister, Yasigi, there. To avenge his foiled attempt, the fox dug holes in the ground, in which the antelope stumbled and fell, gravely injuring himself. Though he was cared for by one of the eight progenitors of mankind created by Amma, the antelope died. The dance of the Walu masqueraders reflects this mythical story.

Bibliography: Dieterlen, 1988; Dieterlen, 1989; Ezra, 1988; Fagg, 1980; Feldmeier, 1992; Förster, 1988b; Griaule, 1938; Laude, 1973

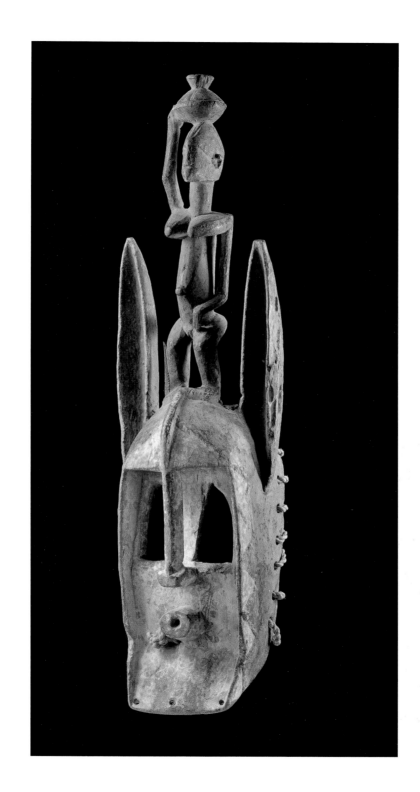

Face mask (*Kanaga*)

Dogon, Mali

Wood, painted in white, black, red, and blue,
leather and fur cords, raffia net
Height 115 cm (45 ¼ in.)
Inv. 1004-35
Formerly collection of Josef Mueller;
acquired before 1952
Cat. 16

Over seventy anthropomorphic and zoo-morphic mask types, made of plant fiber or wood, have been recorded among the Dogon. Made by members of the Awa society, they appear during *dama* memorials for the dead and the *baga-bundo* rites performed by small numbers of masqueraders before the burial of a male Dogon.

The *kanaga* mask is danced in the Dogon village Tireli. Mali, 1997.

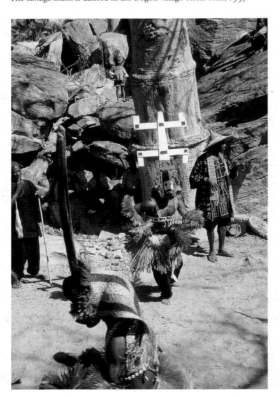

One of the most widespread types is the *kanaga*, which represents a bird known as *kommolo tebu*. Its origin is traced back to a mythical hunter who, having killed one of these birds, fabricated the first *kanaga* mask in its likeness.

A characteristic feature of this type is the form of a dual cross with short bars ex-tending upwards or downwards from the ends of the crossbars. The top end of the vertical central plank is sometimes adorned with an abstract shape, tufts of red fiber, an animal figure, or, as in this case, with hu-man figures. Since such figures were often damaged or destroyed during repeated use of the mask, fully preserved examples are rarely found in Western collections.

The color scheme of the superstruc-ture — black squares, triangles, and strokes over a white ground — evokes the black and white feathers of the *kommolo tebu* bird. Also carefully painted is the helmet portion, into which a rectangular face with large eyeholes has been carved, leaving the thin, vertical ridge of the nose standing.

Kanaga masqueraders, who generally appear in large groups, present very exciting dances which in the meantime have be-come a popular tourist attraction. Back in the 1930s, Marcel Griaule recorded the steps of these dances, which are accompanied by seven different rhythms. One dance is re-served for *kanaga* masqueraders only. Ac-cording to Germaine Dieterlen, the dancers' movements evoke the gestures made by Amma, god of creation, as he was creating the universe.

Bibliography: Dieterlen, 1989; Fagg, 1980; Förster, 1988b; Griaule, 1938; Imperato, 1971; Laude, 1973

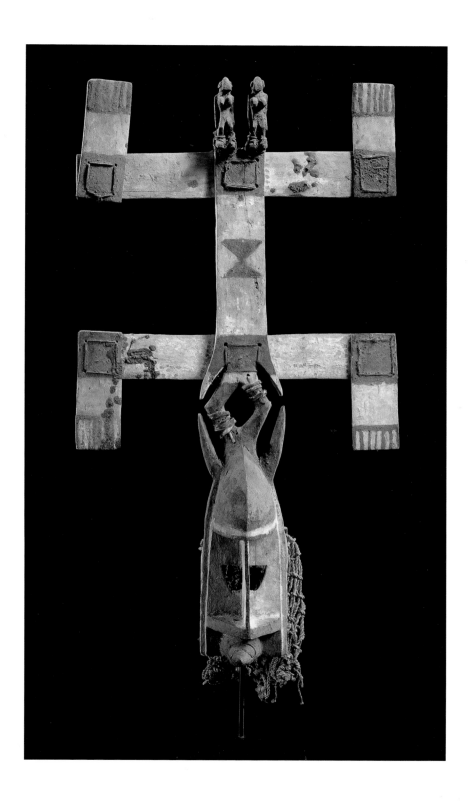

Plank mask (*Nwantantay*)

Bwa (Bobo Ule), Burkina Faso

Wood, painted in black, white, and red
Height 203 cm (79 ⅞ in.)
Inv. 1005-10
Formerly collection of Josef Mueller; acquired
from the Emil Storrer collection in 1953
Cat. 25

The Bwa, formerly known as the Bobo Ule ("Red Bobo"), have a rich masking tradition. The northern Bwa, who live either side of the border between Mali and Burkina Faso, primarily use masks made of leaves, feathers, and plant fibers, worn in the context of the Do association. The southern Bwa, whose settlements lie along the upper reaches of the Black Volta in western Burkina Faso, also have various types of wooden masks, which they adopted from the neighboring Gurunsi peoples (Nuna, Nunuma, Winiama,

and others) and from the original Bobo, or Bobo Fing ("Black Bobo"). Representing spirits of nature which influence human life, the maskers appear on market days, during initiations, funerals, harvest rites, and on other festive occasions.

The *nwantantay* plank mask, embodying a water spirit, is marked by a high degree of abstraction. Yet the Bwa associate some of the compositional elements with certain birds that play a role in the spirit world. The eyes set off by concentric circles, for instance, are intended to recall an owl, and the hooked shape extending from its forehead alludes to the hornbill (*Bucorvus abyssinicus*). As Christopher Roy's investigations have shown, the geometric ornamentation on the plank has symbolic connotations, too. The rows of small triangles stand for the hoofprints of the *koba* antelope, for the masculine number of three, or for the bull-roarers used to invoke the spirit of Do. The black squares of the checkerboard pattern symbolize the old, darkened goatskins sat upon by the elders, and, by analogy, their great wisdom. The white squares, in turn, represent the new, light-colored goatkins sat upon by young, unexperienced initiates.

Bibliography: Kamer, 1973; Roy, 1988, p. 78; Roy, 1991; Roy, 1992; Skougstad, 1978; Zwernemann, 1978

Two *nwantantay* maskers, who represent water spirits and appear in public on festive occasions and market days.

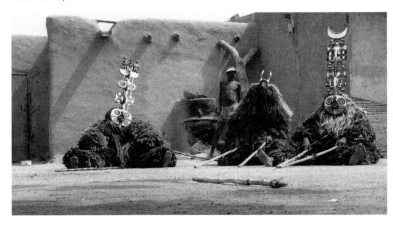

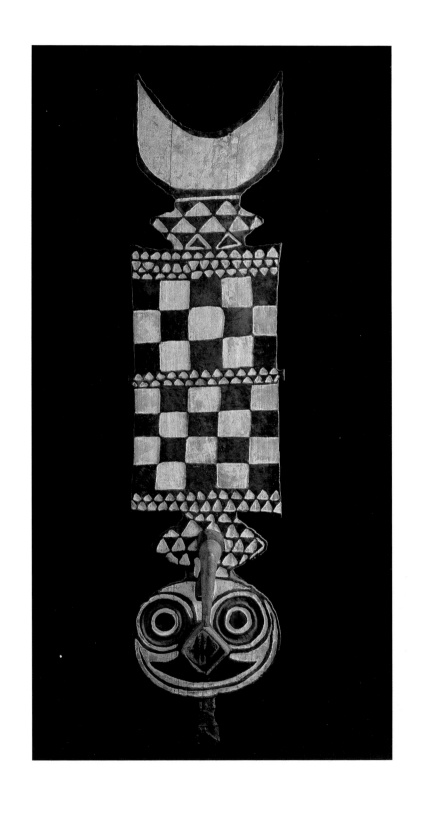

Face mask

Winiama, Burkina Faso

Wood, painted in white, black, and red
Height 57.5 cm (22 ⅝ in.)
Inv. 1005-51
Cat. 32

The Nuna, Lela, Nunuma, and Winiama, who live in the region between the Red and Black Volta, are called Gurunsi by the neighboring Mossi people. This name has become established in the scholarly literature despite the fact that the ethnic groups themselves consider it pejorative.

Audience watching the performance of a dancer during the funeral of an elderly woman. Ouroubono, 1995.

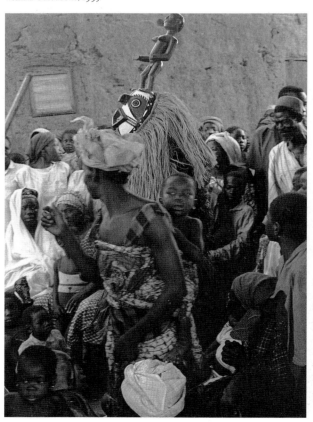

These groups have attracted particular attention for their zoomorphic masks, strikingly decorated with geometric patterns and painted black, white and red, which have influenced the mask styles of other groups such as the southern Bwa (cf. plate 8) or the Mossi (cf. plate 10).

This mask has a high, hooked nose and eyes set in raised concentric rings, emphasized by two bands of parallel lines. It might well have been produced by the Winiama. Their masks are frequently characterized by a diamond-shaped mouth with deeply ridged lips and bared teeth. Moreover, they are usually so strongly stylized that it is difficult to identify them with any particular animal. A remarkable feature in this mask is the unusually low, planklike superstructure bearing a pair of female figures. According to Christopher Roy, this motif of a couple, whether of the same gender or male and female, refers to the spirits of nature embodied in every mask, which ensure the welfare and fertility of the population in general, and of the mask owner and his family in particular. To this end, mask dancers perform on numerous ritual occasions, as well as appearing at the annual ceremonies to commemorate the dead and honor their spirits.

Knowledge of the masquerading tradition and the meaning of the geometric patterns on masks is a strictly male prerogative. Adolescent boys are introduced to this arcane knowledge during their two weeks of initiation, which at the same time serve to convey social and moral values.

Bibliography: Kamer, 1973; Roy, 1987; Skougstad, 1978; Zwernemann, 1978

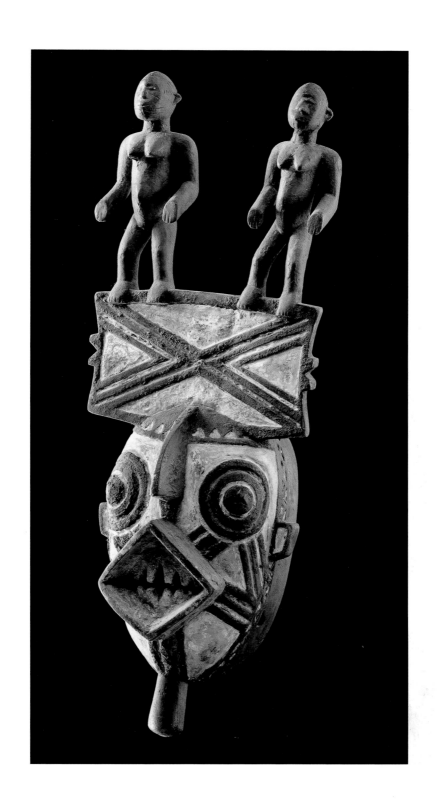

Face mask (*Wan-balinga*)

Mossi, Burkina Faso

Wood, painted in black, white, and red;
goatee partially restored
Height 38.5 cm (15 ⅛ in.)
Inv. 1005-12
Formerly collection of Josef Mueller;
acquired from the collection of Charles Vignier
before 1939
Cat. 36

The Mossi are farmers and herdsmen who live in central Burkino Faso. They are an ethnically diverse people divided into two social groups. Political power resides with the Nakomse, whose ancestors invaded the region in the fifteenth century and subjected the various autochthonous groups living there. From these, in turn, arose the Tengabisi, a heterogeneous population whose kinship groups have provided the religious leaders of the Mossi to this day.

Among the Tengabisi, only the large group of farmers (Nyonyose) and the group of smiths (Saaba) employ a variety of masks (*wando*, sing. *wango*). These are danced at annual memorial services for the dead and are kept in the shrine of the ancestral spirit they represent. The mask types evince regional differences, and are therefore classified in terms of five styles named after Mossi kingdoms: Ouagadougou, Yatenga, Risiam, Kaya, and Bulsa.

This full-face mask is carved in the Ouagadougou style. It shows influences of the neighboring Lela and Nuna (Gurunsi), who formed the original population of the southwestern and central Mossi region. In addition to numerous zoomorphic types of mask, anthropomorphic masks are characteristic of this stylistic region. These represent either an albino (*wan-mwega*) or a Fulbe woman (*wan-balinga*). Our mask with trefoil headpiece and goatee is of the latter type. Only its black face painting distinguishes it from the red-tinted *wan-mwega* type. The mask evokes the mythical figure of Poughtoenga (Bearded Woman), who was the daughter of a Nyonyose elder and mother of the first Mossi ruler, Oubri. Poughtoenga is honored by the Nyonyose and Nakomse as a common ancestor who united their peoples.

Bibliography: Kamer, 1973; Roy, 1981; Roy, 1983; Roy, 1984; Roy, 1987; Roy, 1988, p. 79; Skougstad, 1978

Performance to drum accompaniment of two maskers clad in the Bulsa style, prevalent in the eastern Mossi region.

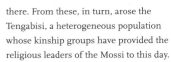

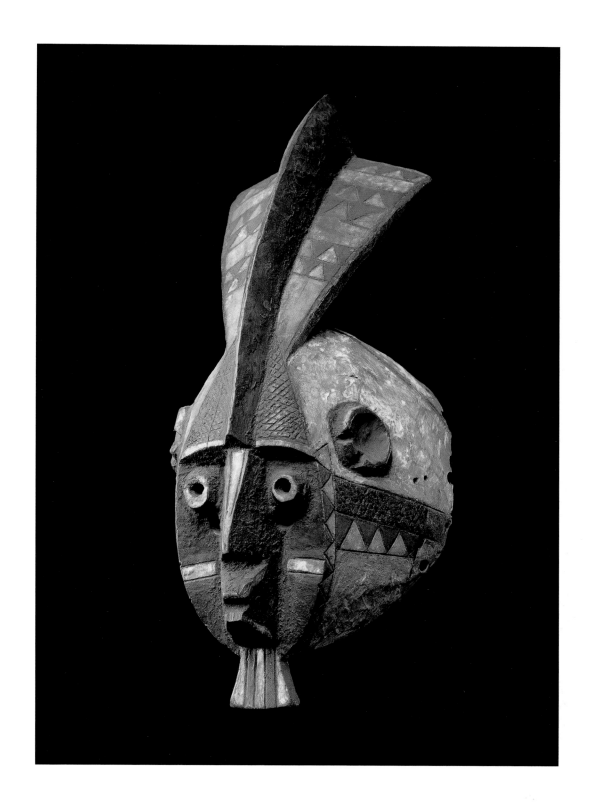

Plank mask (*Loniaken*)

Tusyan, Burkina Faso

Wood, *Abrus precatorius* seeds, cowrie shells,
kaolin, black plant fibers
Height 67 cm (26 ⅜ in.) (not including fringe)
Inv. 1005-11
Acquired in 1968 from the collection of Robert
Duperrier, Paris
Cat. 39

Only a small number of the zoomorphic masks of the Tusyan, a small ethnic group of southwestern Burkina Faso, have entered Western collections. These masks, called *loniaken*, were part of the Do or Lo cult into

Group of *loniaken* masks representing birds.

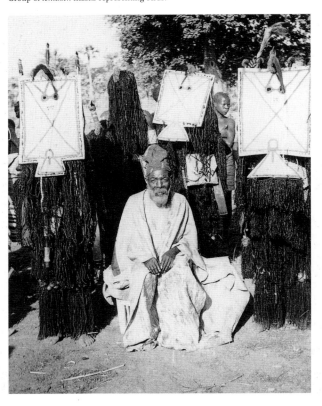

which all adolescents were initiated. During biannual ceremonies which were a precondition for marriage, the boys (but not the girls) were given new, secret names associated with birds or wild animals. About every forty years, a great initiation rite was held in which those already initiated took part. This was the only occasion on which masks of this type, specially made by smiths, were danced. The last of these ceremonies presumably took place in 1933, in the town of Toussiana, and in 1960, in Guena.

Characteristic of the *loniaken* mask is a flat, rectangular basic shape with a separate element attached to its upper edge. In some cases this represents a guardian spirit; in others it consists of two carved horns. The present mask is topped by a bird's head, representing the gray hornbill (*Tockus nasutus*). The head was carved separately and inserted into a wedge-shaped opening on the upper edge. The bird's tail is evoked at the lower edge by a trapezoidal extension. The rings around the closely spaced, round eyes, the line connecting them, and the X-shaped lines across the mask, were made by applying a layer of wax, into which red *Abrus precatorius* seeds were originally inserted (a few remain at the upper left). A fringe of dark-dyed, twisted plant fibers is attached to holes along the sides and lower edge. The same material was used in the masquerader's costume, which completely covered his head and body.

Bibliography: Haselberger, 1969; Hébert, 1961; Roy, 1987; Roy, 1988, p. 80

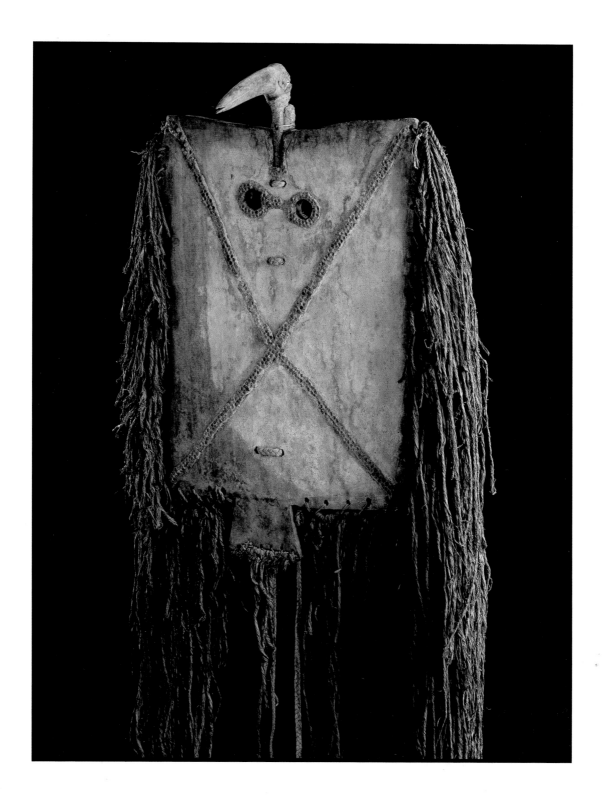

Double-headed helmet mask
(*Wanyugo*)

Senufo, Ivory Coast

Wood with traces of white, black, and ocher paint
Width 74 cm (29 ⅛ in.)
Inv. 1006-10
Formerly collection of Josef Mueller; acquired in
1952–53 from the collection of Emil Storrer
Cat. 51

The Senufo are a farming people who live in the northern and central regions of Ivory Coast and the southern regions of Mali and Burkina Faso. They have a vital masquerad-

Appearing at times of crisis, the dangerous and powerful *wanyugo* mask vanquishes destructive forces.

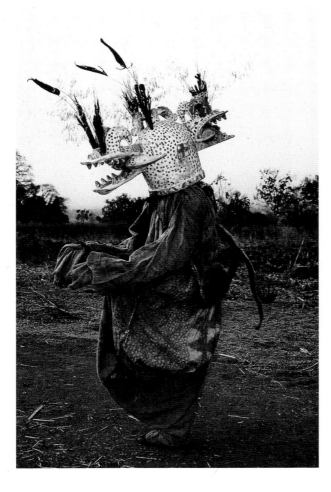

ing tradition associated with various male societies, including Poro. Zoomorphic *wanyugo* masks like the present one belong to the Wabele society, active among the southern Senufo in the densely populated area around the city of Korhogo. The task of this group is to detect and destroy negative forces (*dee bele*) and harmful spirits (*nika'abele*) who, in the shape of monsters or wild animals, threaten people in times of crisis or vulnerability, as, for instance, during burial ceremonies.

The threatening appearance of the *wanyugo* masks befits their purpose of battling evil. Powerful jaws with sharp teeth, recalling a crocodile's or hyena's snout, and tusks like those of a wart hog, underscore the aggressive nature of these masks, which on occasion are said to have emitted swarms of wild bees or blasts of fire. The masks derive their power from magical/medicinal substances (*wah*) placed in the small cup on their heads, which in this Janus-headed example is held by two chameleons. But the magic cannot take full effect until the mask is supplemented by a costume of cotton fabric (*wao*, pl. *wabele*), and danced to music in the context of a ceremony. Due to the dangerous forces they embody, masks, costumes, and appurtenances are treated with extreme caution, and kept in an isolated shelter in the bush, or stored together with the paraphernalia of the Poro society in a sacred grove.

Bibliography: Bochet, 1988; Bochet, 1993 I, pp. 54–85; Förster, 1988a; Glaze 1993 I, pp. 30–53; and II, pp. 19–20; Goldwater, 1964; Koloß/Förster, 1990

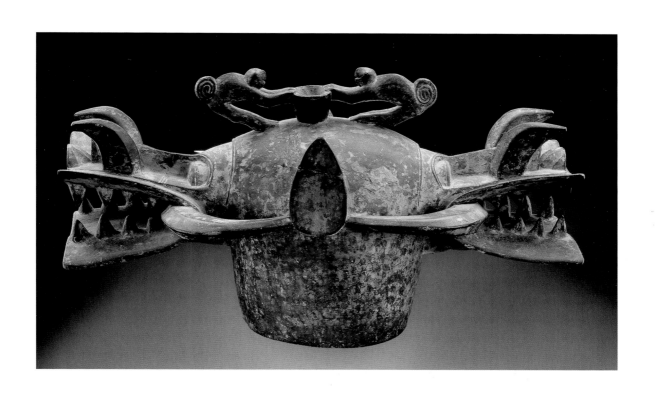

Mask head (*Kagba*)

Senufo, Ivory Coast

Wood, painted in black, white, and red
Height 81 cm (31 ⅞ in.)
Inv. 1006-91
Cat. 53

Nasolo masqueraders during an initiation cere-
mony in the village of Sinematiali, Korhogo
district, 1954. The dancers of both the *kagba*
and the larger *nasolo* masks announce their
appearance by deafening shouts. The perfor-
mance is directed by a *nyanbelege* masquerader,
and accompanied by members of the Poro
society.

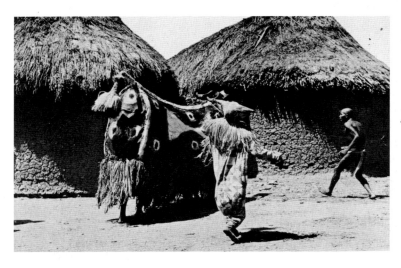

The Poro society of the Senufo uses numer-
ous types of masks that differ by region.
They appear both at funeral ceremonies for
Poro members and at the various ceremonies
that take place during the three initiation
cycles, each of which lasts seven years.

The most important mask among
the Nafara, a southern Senufo group, is the

kagba, danced by a single performer. There
is also a larger version called the *nasolo*,
which requires two dancers to move it. These
zoomorphic mask figures consist of a tent-
like structure of reeds, covered with orna-
mentally painted mats or blankets.

Mounted on its front end is a carved
head with various animal features: long
antelope horns, a gaping mouth studded
with teeth, and backward-curving tusks.
Older examples of the *kagba*, made in the
1950s prior to the iconoclastic ravages of
the Massa religious movement, are marked
by a strikingly simple composition. More
recent versions, in contrast, show great
elaboration, being ornamented with figu-
rative and symbolic elements and brightly
painted.

This *kagba* head, probably made dur-
ing the mid 1960s in the area of Sinematiali,
reflects this later development. An innovative
feature is the small animal head with erect
ears placed on the snout. Also between the
spiral horns, is, as is common, a chameleon
and a hornbill. Subdued colors emphasize
this mask's elegant forms. Its level of aes-
thetic quality matches earlier examples of
the same genre.

Bibliography: Bochet, 1993 I, pp. 45–85; and II,
p. 21; Goldwater, 1964; Koloß/Förster, 1990

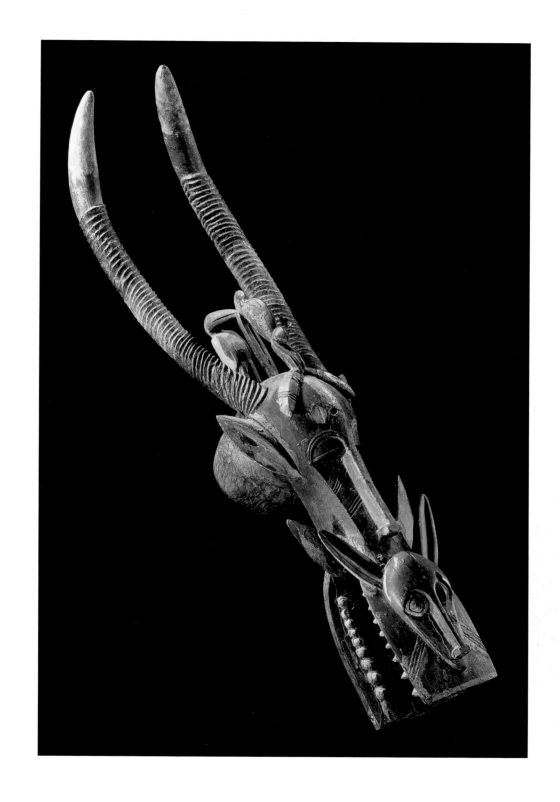

Helmet mask with female figure (*Degele*)

Senufo, Ivory Coast

Wood with dark patina
Height 103 cm (40 ½ in.)
Inv. 1006-36
Formerly collection of Josef Mueller; acquired in
1950-51 from the collection of Emil Storrer;
collected by Pater Clamens in Lataha
Cat. 54

The sacred grove of Lataha, 1951. In the center,
the *degele* mask now in the Barbier-Mueller
Collection, stands next to its male counterpart.

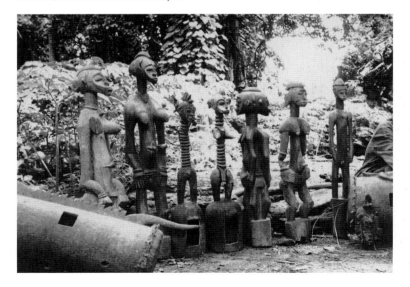

A few examples of this rare mask type came into Western collections in the 1950s, when the brief rise of the Massa religious movement led to the destruction or sale of numerous sacred objects. According to previous research, all of these masks originated from a few villages in the vicinity of the town of Korhogo, where a southern Senufo group lives. A photograph taken in 1951 by Pater Clamens in the sacred grove of the Fodonon village of Lataha shows the Barbier-Mueller mask and its male counterpart flanked by other sculptures. Such male and female mask pairs were owned by the Poro society, and appeared during the "Great Festival of the Dead" (*kuumo*), to commemorate the revered elders who had died over the past four or five years.

This mask is attributed to the woodcarver Do Koné (d. circa 1975), who was active in Korhogo and was known for his figurative staffs. The design of the female figure standing on the helmet is exceptionally compelling. The short legs, pointed breasts, and lack of arms are typical for this type of figure. The rings or bulges around the neck, a motif characteristic of other Senufo sculptures, continue through the entire torso, lending the body a zigzag contour which underscores the interplay of rounded and angular shapes throughout the design. This formal element, according to recent investigations, is thought to represent the twisted cloth in which bodies of the deceased are wrapped during funeral rites. In addition, similar to certain other sacred objects, the motif has a mnemonic significance in the oral tradition (*kaseegele*) of the Poro society. It is referred to, if obliquely, in sayings, verses, ritual texts, and stories.

Bibliography: Garrard, 1995; Glaze, 1988,
p. 84; Glaze, 1993 I, pp. 30–53; and II, p. 14;
Goldwater, 1964; Koloß/Förster, 1990

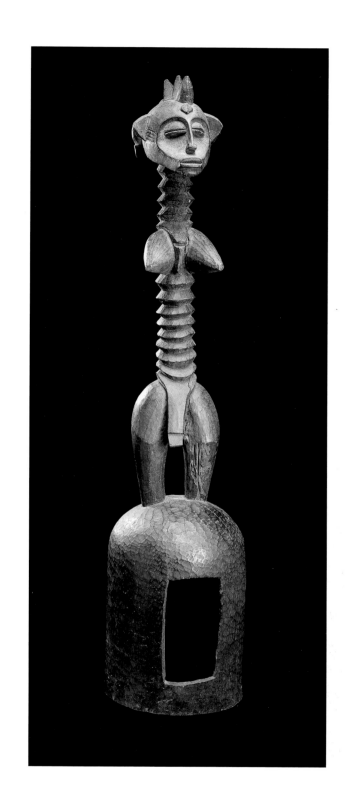

Face mask (*Kpeli-yehe*)

Senufo, Ivory Coast

Wood (partially restored)
Height 33.5 cm (13 ¼ in.)
Inv. 1006-11
Formerly collection of Josef Mueller;
acquired prior to 1953
Cat. 41

Numerous Senufo masks are kept by the Poro society, an organization based on age-grades that exerts social and political control, conveys traditional knowledge, and fulfills religious functions, especially during the elaborate funeral ceremonies. Worn at a funeral, the anthropomorphic *kpeli-yehe*

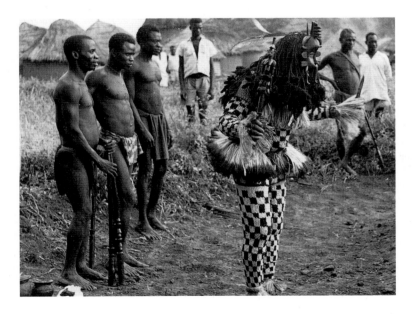

Mask dancers during a Poro ceremony. At this particular rite, the mask is called *korug*. Near Korhogo, mid 1950s.

masks serve to compell the spirit of the deceased to leave his house.

This mask, showing signs of wear, is thought to have been made at least three generations ago by a woodcarver in the important workshop at Kolia (northern Ivory Coast). A mask of great aesthetic appeal, its idealized female face is marked by scarifications either side of the narrow nose and on the forehead, and a protruding mouth with prominent teeth. The motifs around the face of the mask have been variously interpreted. The two protuberances extending from the lower cheeks have been described as legs or locks of hair, while the striking vertical shape rising from the head has been said to represent the stalk of a bunch of palm nuts, which has a sexual connotation. According to Garrard, who traces the *kpeli-yehe* back to the Do masks of the Islamized Dyula, the "legs" actually represent ear pendants of the type clearly recognizable as such in earlier Dyula pieces. At the same time, Garrard considers the jutting shape at the top to be a sophisticated representation of the thorn-like coiffure characteristic of the *fasigi muso* masks of the Dyula, which represent prostitutes.

Bibliography: Bochet, 1993; Förster, 1988a; Garrard, 1993, pp. 86–105; Glaze, 1993 II, p. 12; Goldwater, 1964

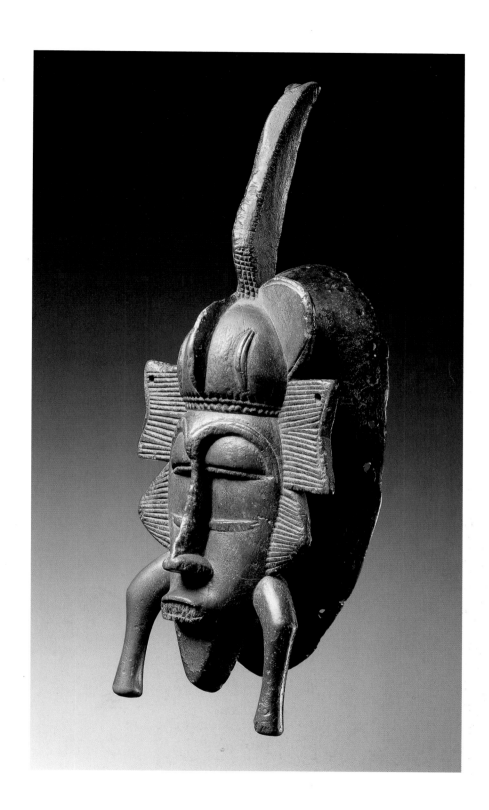

Face mask of the Do society

Dyula, Ivory Coast

Brass
Height 25 cm (9 ⅞ in.)
Inv. 1006-52
Formerly collection of William Moore,
Los Angeles; collected in the 1950s
Cat. 46

Like wooden masks, Do masks of brass or pewter were used during the funerals of important personages or on key Islamic holidays. They were disseminated among the Mande-speaking, Islamized Dyula trading communities who lived in Kong and in the Senufo region west of that city. Metal masks are still in use in some places even today.

This well-preserved mask was likely fabricated between the late eighteenth and the middle of the nineteenth century. This dating is supported by statements by members of Dyula communities, and is confirmed by the metal used in the casting, a copper-zinc alloy with small additions of lead and traces of tin and iron. This alloy was used in nineteenth-century Europe in the manufacture of brass armlets for export to West Africa.

Older masks of this type are characterized by fine workmanship and individualized features. They frequently lack the arched eyebrows typical of more recent masks. In this remarkable example, human facial features are combined with the curved horns of a goat or ram. Details of the face, such as the scarification lines on the chin and under the eyes, as well as in the ornamentation around the periphery and the small female head above the forehead are superbly executed. The small head, itself a miniature mask, wears an elaborate, braided coiffure with two downward-curving horns echoing those of the larger mask. Since similar motifs are found in other metal objects known from this region, a workshop context may be presumed.

Bibliography: Garrard, 1993 I, pp. 86–105; and II, p. 12

Dancer wearing a polished brass mask, in a Dyula village near Dikodougou, 1989.

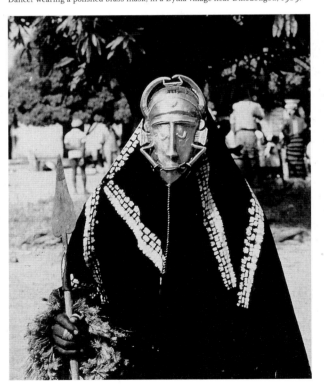

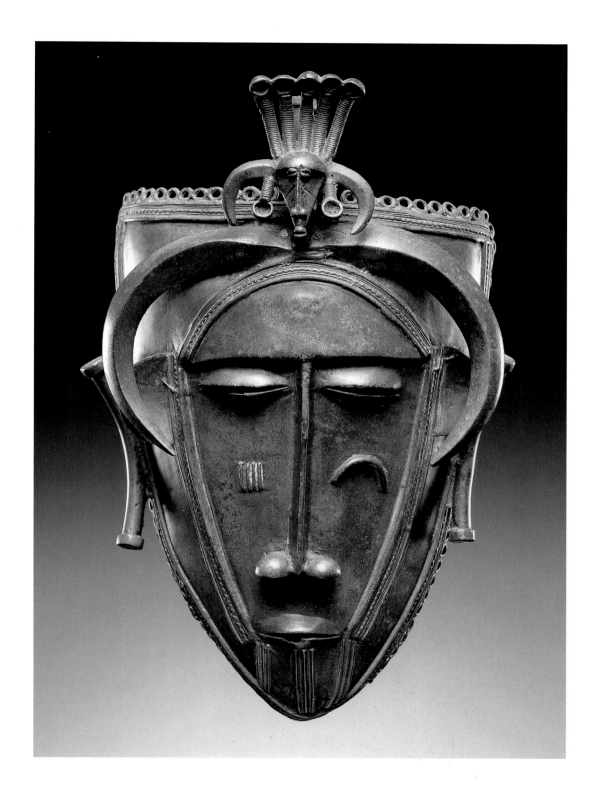

Face mask of the Do society

Ligbi, Bondoukou region, Ivory Coast

Wood with encrusted patina
Height 33.8 cm (13 ¼ in.)
Inv. 1006-38
Formerly collection of Charles Ratton
Cat. 56

The Islamized communities who live as traders and artisans among non-Moslem groups in extensive areas of northern Ivory Coast are known for an institution called

Do masqueraders in a Ligbi village, 1967.

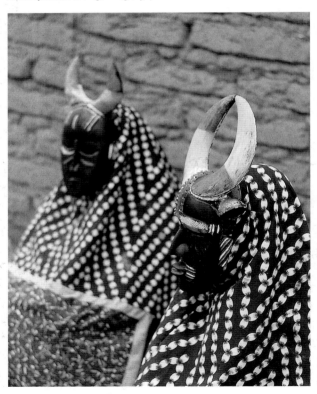

Do or Lo, one of whose most striking public manifestations is colorful masquerade dancing. In the area of Bondoukou, formerly a key trade center, this masquerading tradition is maintained by the Mande-speaking Ligbi, Dyula, and Hwela. Though in decline since the 1950s, the custom is still practiced on important Islamic holidays, especially in connection with the *'id al-fitr* ceremonies that mark the end of Ramadan, the month of fasting. The performance of the maskers, which takes place in the late afternoon and evening hours and is accompanied by singing and dancing, expresses the joy of the faithful that the period of fasting is over.

This classical Do mask, in style and design, recalls the *kpeli-yehe* masks of the Senufo, from which they are derived (cf. plate 15). Its regular features, detailed scarification patterns on forehead and cheeks, and graceful coiffure corresponding to that worn by Moslem women on festival days, all reflect the Ligbis' ideal of feminine beauty. To complete these masks, oil and make-up are applied and they are adorned with gold and silver jewelry before being donned by dancers clad in festive garments.

Bibliography: Bravmann, 1974; Bravmann, 1988, p. 92; Bravmann, 1993 I, pp. 116–126; and II, p. 54; Garrard, 1993 I, pp. 86–105

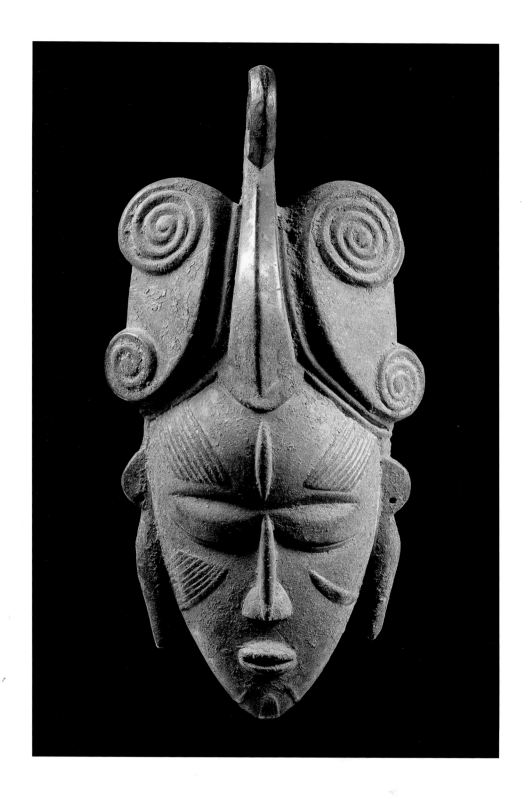

Face mask of the Do society (*Yangaleya*)

Ligbi, Bondoukou region, Ivory Coast

Patinated wood with white, blue, and red paint,
fiber and fabric remnants
Height 28.8 cm (11 ⅜ in.)
Inv. 1006-56
Cat. 57

Do masks in the Ligbi village of Bondo-Dioula, 1967. The *yangaleya* mask in the Barbier-Mueller Collection is flanked by thrush and bush cow masks (left), sheep and "maiden's husband" masks (right).

In this type of mask, human features are combined with the powerful bill of the *yangaleya* bird, or hornbill (*Bucorvus abyssinicus*). *Yangaleya* masks are among the most popular of those used by the Do society. They are danced during the funerals of distinguished Moslem holy men, and their performances mark the end of the *'id al-fitr* celebrations. The masqueraders are greatly admired for the grace of their dance movements, which they perform in pairs and in perfect unison. They are also valued for the positive qualities ascribed to the hornbill, whose behavior and family life are considered exemplary by the Ligbi and Dyula. Many other peoples of the Guinea coast, such as the Senufo, likewise attach great importance to this bird, considering it one of the mythical primeval animals, an attendant on the souls of the dead and a symbol of fertility.

This mask, carefully repainted repeatedly and covered with a glossy patina, belongs to a series of Do masks in Bondo-Dioula, a community northwest of Bondoukou populated by Ligbi, Nafana, and Hwela. A photograph taken by Bravmann in 1967 shows it flanked by masks of a thrush (*kokogyinaka*), a bush cow (*siginkuru-ayna*), a sheep (*saragigi*), and the "maiden's husband" (*fendyonana*).

According to the Ligbi, they did not carve their masks themselves but acquired them from Senufo and Mande sculptors from Satama Sokoura, a town located a few hundred kilometers west of their area.

Bibliography: Bravmann, 1974; Bravmann, 1993 I, pp. 116–126; and II, p. 55; Garrard, 1993 I, pp. 86–105; McCall, 1975; Vion, 1988, p. 93

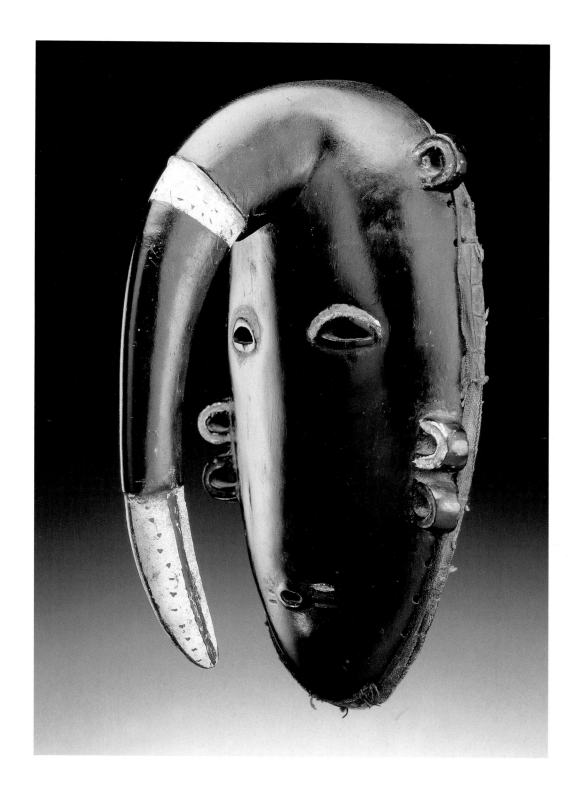

Plank mask (*Bedu*)

Bondoukou region, Ivory Coast

Wood, painted in black and white
Height 160 cm (63 in.)
Inv. 1008-11
Cat. 60

The *bedu* masquerading tradition is limited to the region of Bondoukou. The mask type used goes back to earlier masks, called *sakrobundi*, which were made by the Nafana. These were part of an institution which, in

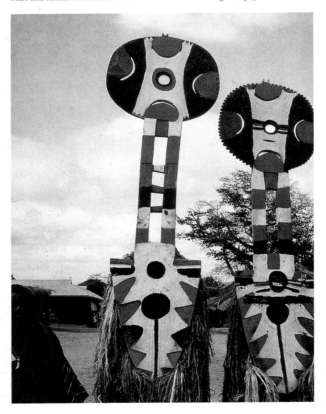

Male and female *bedu* masks of the Nafana. Bondoukou region, 1967.

the nineteenth century, was disseminated in the Jaman kingdom, a Bron state, and the adjacent areas of what is today western Ghana. Under the influence of Christian missionaries the *sakrobundi* mask dances were abandoned in the 1920s and 1930s. Yet at about the same time the first *bedu* masks appeared among the Nafana, and were soon adopted by the Degha and Kulango.

Up to almost nine feet tall and weighing as much as 110 pounds, *bedu* masks are danced by athletic young men with amazing agility and grace. They usually appear in male and female pairs at funeral rites and during month-long harvest festivals (*zaurau*). The masks keep disaster, illness, and infertility at bay and increase the community's sense of well-being.

At just over five feet tall, this *bedu* is among the smaller examples of the genre. Its circular horns decorated with a triangle pattern mark the mask as masculine. The feminine counterpart is usually characterized by a more elaborate disk-shaped superstructure. The elongated face-plate with two round eye-holes, slightly tapering to the rounded bottom edge, is decorated with a checkerboard pattern unusual for this mask type. It appears in similar form on only one other *bedu* mask, illustrated by Segy and erroneously ascribed to the Gurunsi.

Bibliography: Bravmann, 1974; Bravmann, 1979; Bravmann, 1988, p. 91; Bravmann, 1993 I, pp. 116–26; Bravmann, 1995; Freyer, 1974; Segy, 1976

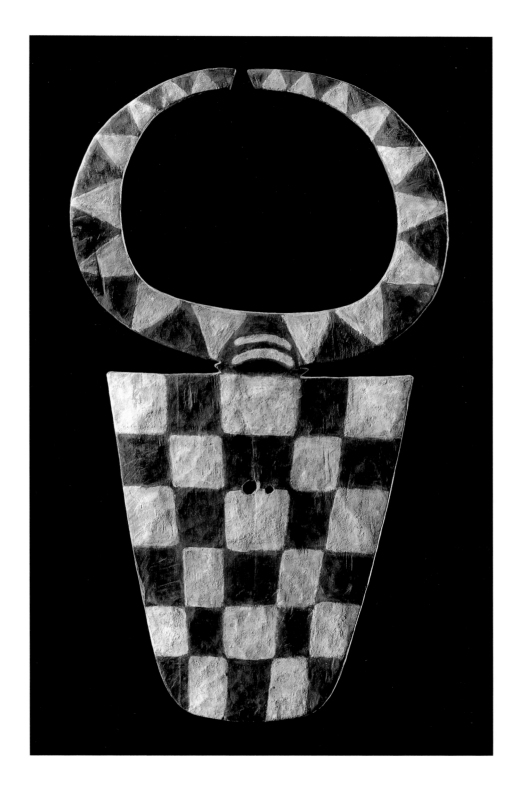

Helmet crest (*Ejumba*)

Diola, Senegal

Woven plant fibers, horns, leather, mussel shells,
Abrus precatorius seeds
Height 35 cm (13 ¾ in.)
Inv. 1000-2
Formerly collection of Josef Mueller;
acquired before 1942
Cat. 61

Various peoples of the Casamance region in southwestern Senegal maintain a masquerading practice which, according to European sources and oral tradition, has existed since the seventeenth century. The Diola presuymably adopted this custom from the neighboring Bagnun, who once dominated this region and who today still make horned masks of vegetable materials which resemble those of the Diola.

Such helmet crests (*ejumba*) are worn by young men when, after a period of seclusion in an initiation camp, they return to the village to dance in voluminous raffia costumes in a final ceremony (kahiçen). These performances are extremely rare, since an initiation (*bukut*), still observed even among the northern, Islamized Diola, takes place only every 20 to 25 years. In some villages the masks originally served to protect the community from destructive forces, worn by men with extraordinary supernatural powers.

This mask is among the finest and most well-preserved of the approximately thirty of its kind now in European, American, and Senegalese museums, some of which are over one hundred years old. It is woven of plant fibers, encrusted with seeds (*Abrus precatorius*) and mollusk shells, and adorned with horns. These components are considered symbolic of sexual and physical prowess. They recall that initiation, in earlier periods a precondition for marriage, still marks the transition from adolescence to adulthood.

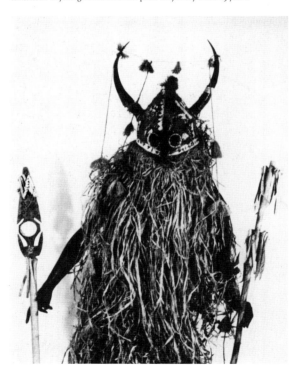

Ejumba mask dancers are rarely observed, since they perform exclusively at initiations of young males that take place only every 20 to 25 years.

Bibliography: Fagg, 1980; Frobenius, 1898; Mark, 1983; Mark, 1988; Thomas, 1965

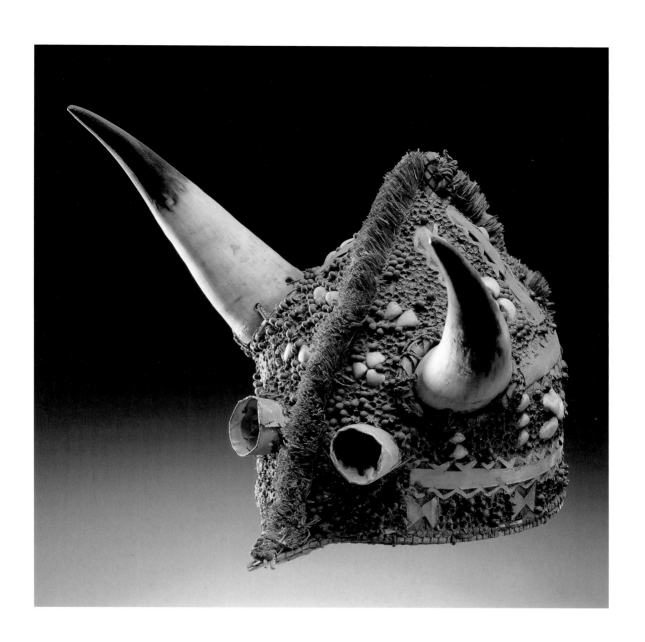

Helmet mask (*Dugn'be*)

Bidjogo, Guinea-Bissau

Wood, painted in black and white, glass, horns,
leather, cords
Width 64 cm (21 ¼ in.)
Inv. 1001-11
Collected on the island of Nago in 1971
Cat. 62

The Bidjogo live on the Bissagos Islands off
the coast of Guinea. They create various
types of realistic, zoomorphic masks, each
of which belongs to a certain age-grade and
marks its social status. The masks are
danced by boys and young men during the
ceremonies that precede and follow the
phases of initiation. Besides ritual occasions,

A *dugn'be* masquerader following the
instructions of an initiate.

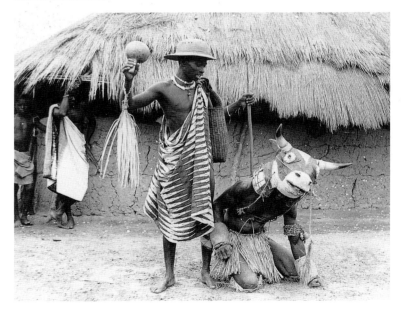

nowadays they also appear in secular con-
texts, on days that commemorate historical
events, and when important people visit.

The most common forms of mask
represent cattle, and are known in Creole as
vaca-bruto. The Bidjogo distinguish four
types of cattle mask, each with its character-
istic features and form. The *gn'opara*, worn
by boys in the first or second age-grade,
represents a cow with long horns that lives
in the bush. The *dugn'be* mask, that of the
third age-level, is described as a domesti-
cated cow, as indicated by its pierced nostrils.
This is the category to which the mask il-
lustrated here belongs. It has a compact,
powerful head, real horns, glass eyes, and
a lead inserted through its nostrils.

A third type of mask, *essenie* or *essie*,
which occurs primarily on the islands of
Formosa and Uno, is characterized by an
enormous head and a heavy roll of fat around
the neck, and occasionally by a red tongue
dangling from the open mouth. This mask
plays the role of a wild steer which must be
tamed in the course of initiation. Like the
rare *iare* mask, carved entirely of wood and
probably representing a zebu or buffalo, the
essenie is worn by young men entering the
final phase of initiation.

Bibliography: Bernatzik, 1944; Fagg, 1980;
Gallois-Duquette, 1976; Gallois-Duquette, 1981;
Szalay, 1986

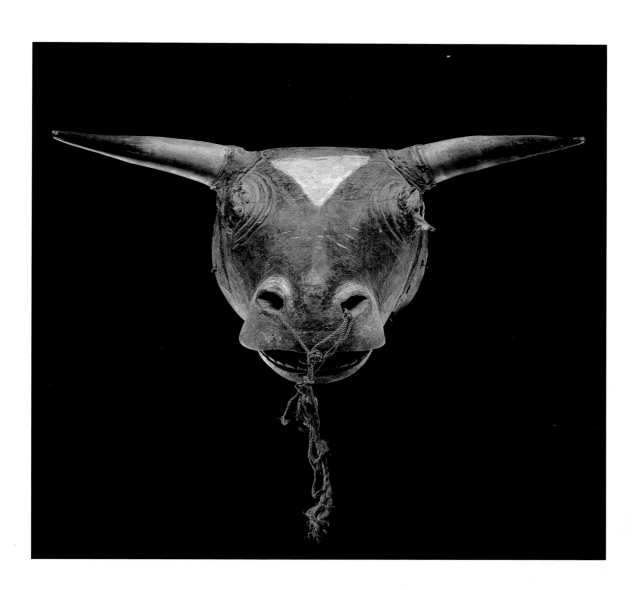

Headdress (D'mba)

Baga, Guinea

Wood, upholstery tacks, French coins
Height 135 cm (53 ⅛ in.)
Inv. 1001-1
Formerly collection of Josef Mueller; acquired
from the Emil Storrer collection about 1950
Cat. 65

The D'mba masks of the Baga, referred to as Nimba in previous literature, can weigh more than 130 pounds. They are among the most imposing of all African masks. According to Frederick Lamp, and Dauer previously, the name Nimba derives from the Susu language, in which today's Baga are fluent. The proper designation, however, is D'mba, the Baga Sitemu's own name for the headdress.

Performances of D'mba masks, which symbolized fertility, gradually disappeared during the 1950s. In recent years, however, D'mba dances have been revived in some Baga areas.

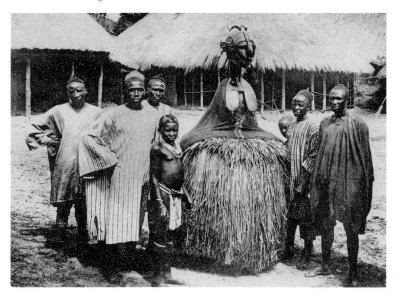

Until well into the 1950s, when the last older examples were collected, these masks were danced at funerals, marriages, and harvest time. While discontinued for decades, D'mba performances, beginning in 1984, have reemerged. D'mba symbolizes all that is good and beautiful. Its performance celebrates and ensures the earth's fertility and fecundity.

This mask, whose ornamentation goes beyond the usual engraved patterns to include upholstery tacks and French coins, is an example of the "classical" D'mba. The face, which in profile takes up about a third of the voluminous head, has a tiny, tubular mouth, slightly protruding eyes, and a huge hooked nose. From the bridge of the nose, a low crest extends over the receding forehead to the hairline. It is followed by a larger crest, carved in relief, that runs down to the back of the head. This mask's protruding ears have the form of a horizontal, open U-shape with a double contour, one of the most frequent ear variations seen in D'mba masks.

The impression of massiveness is increased by the bell-shaped ribcage and heavy, pendant breasts, from which the four shoulder rests extend. The holes in them, like the small boss at the back of the neck, served as points of attachment for the fiber costume. The wearer looked out through the two holes between the breasts.

Bibliography: Homberger, 1994; Lamp, 1986; Lamp, 1996; Paulme, 1988, p. 102; Van Geertruyen, 1979

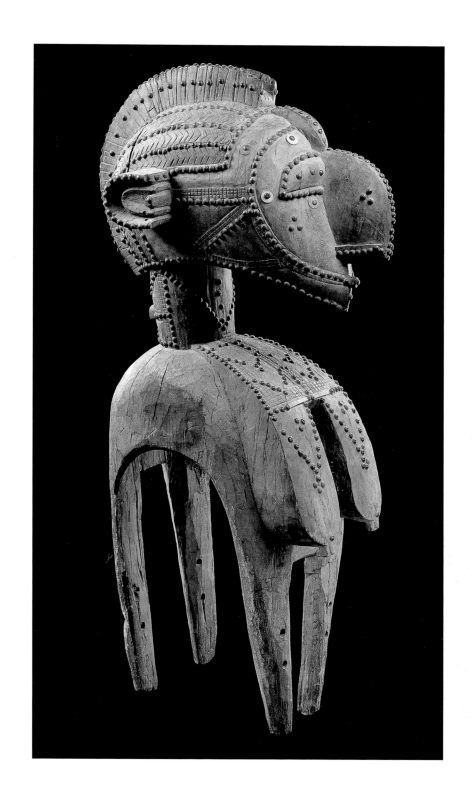

Face mask

Baga, Guinea

Wood with blackish-brown patina
Height 55 cm (21 ⅝ in.)
Inv. 1001-10
Formerly collection of Josef Mueller;
acquired prior to 1942
Cat. 66

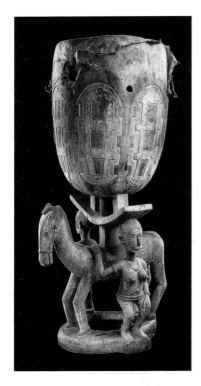

The head of the female figure on the base of this drum, belonging to the former Josef Mueller Collection, is very similar to the head surmounting the mask illustrated opposite.

The composite structure of this mask, representing a human head from which another, smaller, almost identical head emerges, is unusual in Baga masks. Yet the quite realistic treatment of the faces — in striking contrast to the stylized features of D'mba masks (cf. plate 22) — is also found in other Baga works, such as the Zigiren-Wöndë, or "young bride" headdress.

This mask shows definite affinities with the head treatment seen in a kneeling female figure formerly in the de Vlaminck Collection, suggesting their possible origin in a common workshop. The sculpture has the same oval face, slightly protruding mouth, low narrow forehead, almond-shaped eyes, and ridged nose bridge. Also comparable is the coiffure with long locks dangling beside high-placed ears, although the engraved herringbone pattern is simpler on the mask than on the figure.

We have no information at all concerning the function of this unique mask. Not even the most recent research has been able to shed light on the question. Frederick Lamp, who has published a long-awaited work on the Bagas' manifold masquerading customs, tells us that since the 1950s, most Baga communities have abandoned their traditional rituals and the use of masks associated with them. Only in recent years has an awareness of old customs reawakened, especially among younger members of Baga communities. Lamp was not only able to observe a gradual revival of earlier masquerading traditions but, during his field work, he learned of new forms, only recently developed.

Bibliography: Fagg, 1980; Lamp, 1986; Lamp, 1996

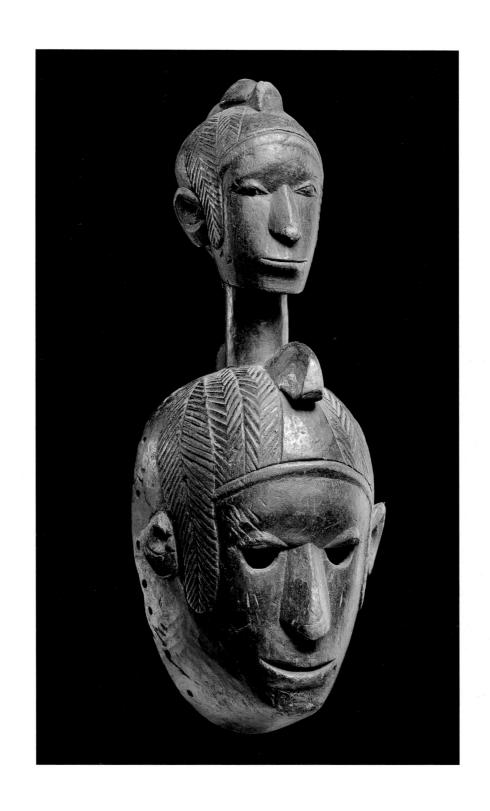

Stele headdress (*Bansonyi* or *a-Mantsho-ña-Tshol*)

Baga, Guinea

Wood, painted in white, reddish-brown, and black, mirrors
Height 215 cm (84 ⅝ in.)
Inv. 1001-21
Formerly collection of Dr. Mandelbaum
Cat. 67

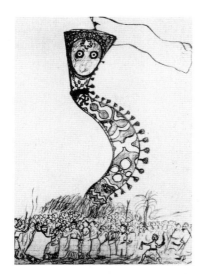

Moussa Bangoura, who provided information about Baga culture to Denise Paulme, drew this performance of a snake-mask that represented the female half of the village of Monchon.

This dynamic representation of a rearing snake, its body decorated with geometric patterns accented by inset mirrors, embodies the snake-spirit *a-Mantsho-ña-Tshol* ("master of medicine"), known in the literature by the Susu name of Bansonyi. Among most Baga subgroups, only adolescent males learn the secrets of the snake-spirit, during the kä-bërë-tshol initiation which marks the passage to adult status.

The available information about Bansonyi masks indicates a variety of functions. Besides appearing at funerals, they detect destructive forces, cure sterility, and end droughts. However, these functions have declined in importance as Baga society has changed. According to Frederick Lamp, these masks now appear in the context of initiation ceremonies at various age-grades, to which females as well as males belong. The age-grades are based on the kinship units in a village, which are associated with the male or female principle and assigned to represent half of the village. Denise Paulme says that the key occasion for the appearance of *a-Mantsho-ña-Tshol* masks is a ritual that marks the close of boys' initiations, at which two or sometimes more masqueraders perform. Clad in a raffia costume or in textiles and palm fronds, they carry the long wooden steles adorned with feathers, ribbons, and bells, presumably with the aid of a reed framework resting on their head. The masked figures representing the two halves of the village face each other, and, urged on by the spectators, they open the ceremony with an uproarious mock battle intended to inspire village unity.

Bibliography: Barley, 1996; Lamp, 1986; Lamp, 1996; Paulme, 1956; Paulme, 1988, p. 105; Roberts, 1995a; Sieber/Walker, 1987

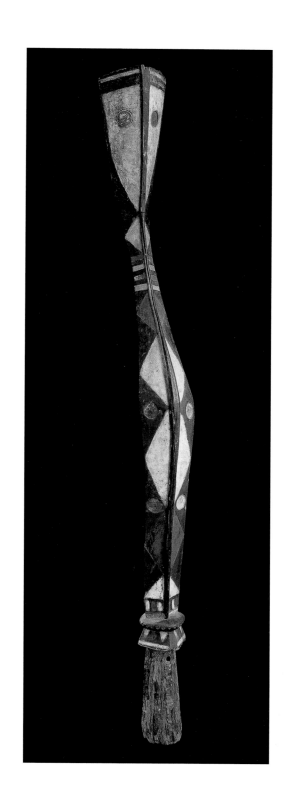

Forehead mask (Banda)

Nalu, Guinea

Wood, painted in ocher, black, white, and blue
Height 141 cm (55 ½ in.)
Inv. 1001-24
Formerly collection of André Lhote;
collected before 1935

Cat. 68

The mangrove swamps of the hot, humid northern coastal region of Guinea are home to the Nalu. Like their southern neighbors, the culturally related Baga, the Nalu cultivate rice as their main source of subsistence. Among both groups there is said to have once flourished a male society called Simo, which used various masks including Banda, also known in some Baga groups as Kumbaruba. Originally Banda mask was considered a very dangerous being, who appeared in times of crisis to protect human lives. Beyond this, harvest festivals, marriages, adolescent initiations, and the funerals of important persons, provided opportunities for Banda mask dances. Today these dances are performed only rarely, and solely for entertainment purposes.

Extraordinarily large, decorated with a variety of painted patterns, Banda masks combine human and animal traits. The elongated face with prominent eyes and hooked nose is based on the snout of a crocodile. The head ornaments, on the other hand, blend a woman's coiffure with the horns and ears of an antelope, a chameleon's tail, and a snake's body. In accordance with these physical features, the abilities and character traits of a variety of bush and water animals were attributed to the mask. It was considered as crafty as a crocodile, and as it was danced, it created the impression of being able to fly, creep, and swim. Since the dance movements were precisely choreographed and difficult to execute, only one or two usually young men in each village had mastered the dances. During their performance they wore the mask nearly horizontally, on top of the head, and their bodies were entirely concealed by an elaborate costume made of plant fibers.

Bibliography: Lamp, 1986; Lamp, 1996; N'Diaye, 1994

Performance of a Banda masquerader among the Baga Mandori in 1987. Dancing with the large, heavy mask required not only physical strength, but also agility and control.

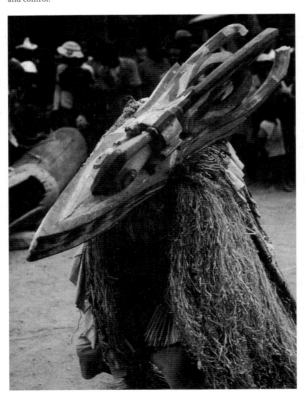

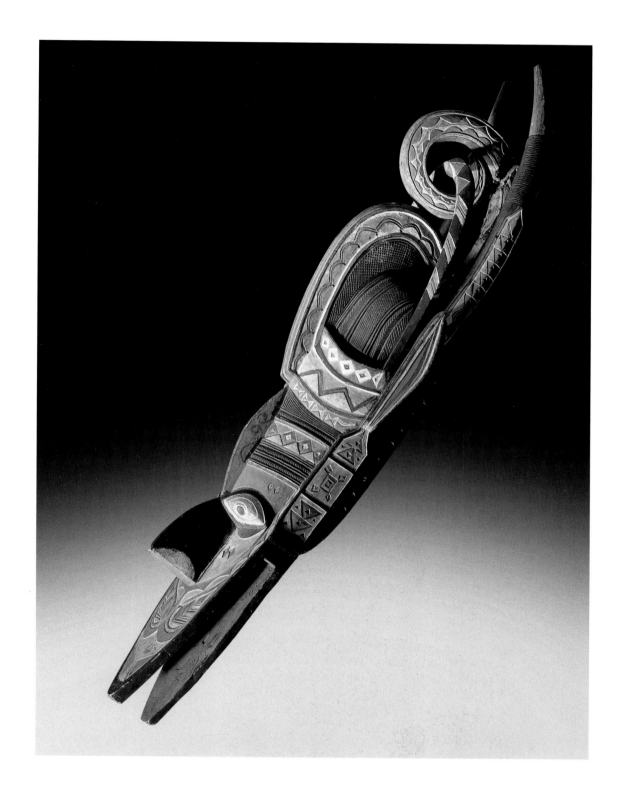

Helmet mask (*Gonde*)

Gola or Mende, Sierra Leone/Liberia

Wood, with dark patina and red paint
Height 36 cm (14 ⅛ in.)
Inv. 1002-17
Cat. 72

Since this mask was acquired in the border area between Sierra Leone and Liberia, it can be ascribed to the Mende or Gola, or possibly to their southerly neighbors, the Krim or Vai. The band marking the hairline and the ornaments on the back of the head distantly recall the *sowei* masks of the Sande women's association, which enjoys great respect among these peoples. However, the treatment of the expressive face with its deep-set, red-ringed eyes and protruding lips open to reveal rows of sharp teeth do not accord with the design of *sowei* masks. Perhaps this mask is one of the rare *gonde* masks, a comparable example of which is found in the Massie-Taylor Collection.

Gonde is a clownish female figure that occasionally appears together with *sowei* masqueraders and represents their opposite in both appearance and behavior. The black-painted *sowei* mask reflects the group's ideals of feminine beauty, and its dignified dance, which the female masquerader performs in a long raffia costume, meets the audience's aesthetic expectations. *Gonde*, in contrast, clad in a slovenly mixture of colorful rags and remnants of old raffia costumes and hung with tin cans, is considered a shameless hussy. She provokes the spectators, demands money, and tries to make them laugh. Often this figure makes use of old, damaged *sowei* masks, but sometimes *gonde* masks with grotesque, caricatured features are specially made just for this purpose.

Bibliography: Boone, 1986; Phillips, 1978; Schäfer, 1990; Sotheby's, 1983

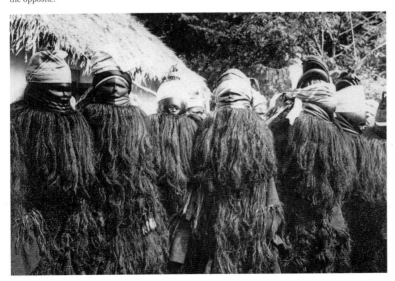

Performance of *sowei* masqueraders, which embody the group's ideals of feminine beauty. *Gonde* is a clownlike figure who represents just the opposite.

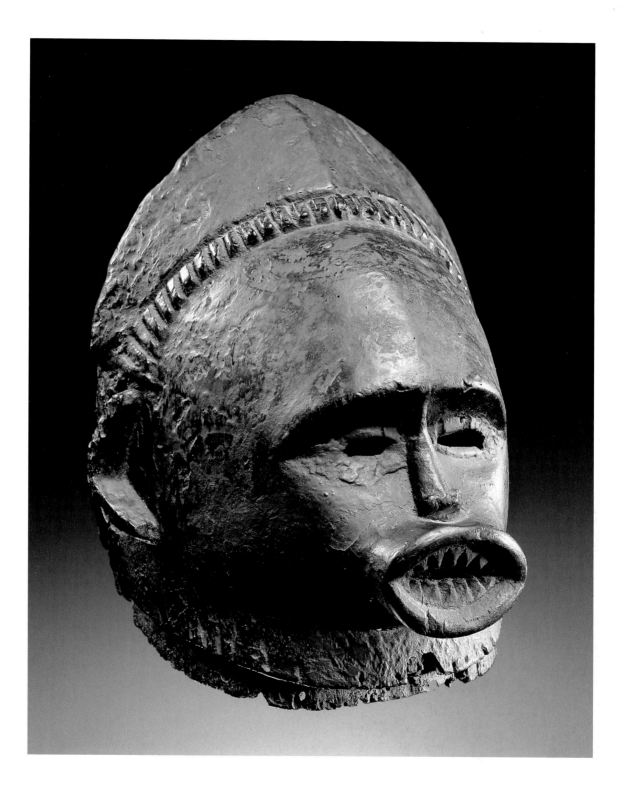

Face section of an *aron arabai* helmet mask

Temne, Sierra Leone

Brass
Height 29 cm (11 ⅜ in.) (not including bells)
Inv. 1002-16
Cat. 74

Numerous wooden masks belonging to men's associations have been documented and collected from the Temne, the second largest ethnic group in Sierra Leone after the Mende. Their brass masks, in contrast (*eron arabai*, sing. *aron arabai*), have re-mained largely unknown. Still in use today in many Temne chiefdoms, the masks represent the guardian spirit (*kärfi*) of the ruling clan and bear specific names relating to the dynasty concerned. For every ruling clan, there is only one mask that appears during the regent's ceremonial enthronement.

This mask is one of very few examples of its kind in Western collections. Presumably it is the face section of what was originally a helmet mask. Photographs and descriptions made of the majority of such masks on site indicate that they consist either of a leather helmet with a metal face sewn on, or of a number of attached brass plates which enclose the wearer's head. The holes in the edges of this mask likely served to attach it to a helmet.

The mask's face and its separate details were not cast, but modeled of sheet brass by careful hammering. The design of the mouth, nose, and eyes contrasts to the more finely detailed, chased and embossed decor on the separate sheet used to form the forehead. This was attached by means of small rivets below the eyebrow line and was likely done by another artist. Possibly this element was intended to cover a damaged spot in the mask's forehead, for a small plate affixed inside gives evidence of a makeshift repair.

Bibliography: Hart, 1986; Hart, 1990

An *aron arabai* masquerader from the chiefdom of Kolifa. The mask shown, called *nemankera*, is worn on the forehead; the dancer's head and body are concealed beneath a raffia costume.

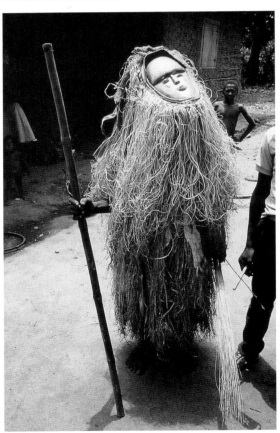

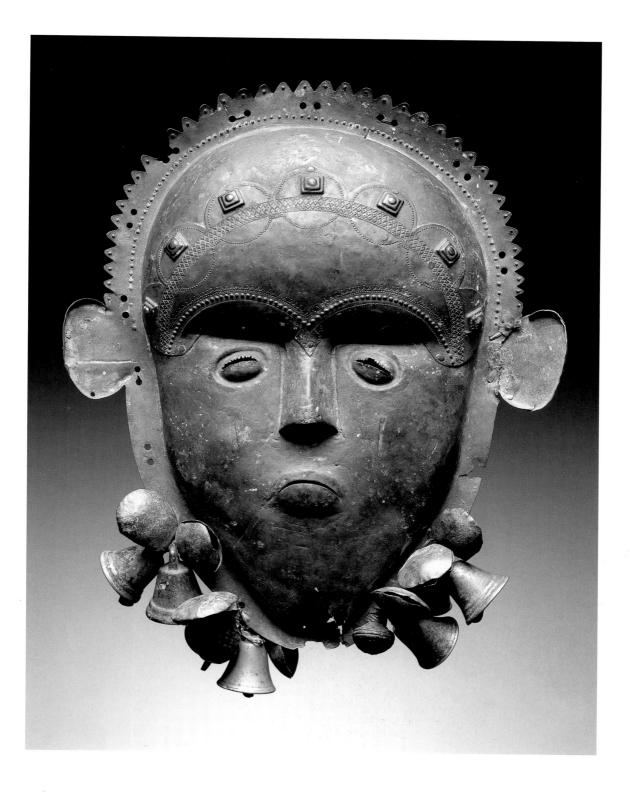

Helmet crest

Toma (Loma), Guinea/Liberia

Wood with encrusted patina, sack filled with
medicinal/magical substances
Height 75 cm (29 ½ in.)
Inv. 1003-16
Cat. 75

In a recent publication by Monni Adams,
this abstract mask was incorrectly ascribed
to the Kantana of northern Nigeria. It
consists of three segments: a central, oval-
shaped helmet with large, laterally located,
almond-shaped eyes outlined with incised
lines; short horns curving inwards; and a
snout-like protuberance in the shape of a

flattened, truncated cone. Attached to the
forehead is a small bag containing magical
substances intended to increase the mask's
power. The same purpose was likely
fulfilled by the encrustation, consisting
of layers of sacrificial blood, smoke, and
possibly chewn cola nuts. Both the formal
design and the magic substances point to
an origin among the Toma and their Poro
society, members of which were the only
people permitted to view masks of this type.
Although the Kantana do use similarly de-
signed abstract masks with emphasized
snouts and horns, worn horizontally on
the head, the horns in these masks emerge
from a plate mounted on the helmet portion.

The tripartite horizontal masks of the
Toma and Kantana are not unique phe-
nomena. Rather, as Patrick McNaughton
points out, this form is found among at
least 85 ethnic groups in western Africa.
McNaughton advances the hypothesis that
this type of mask is based on a fundamental
idea which was adapted, through artistic
creativity, to the needs of each community,
giving rise to the multifarity of designs seen
today. Yet while these range from largely
abstract to figurative, all share the same
basic, tripartite configuration of composite
animal forms.

Bibliography: Adams, 1995; McNaughton, 1991;
Siegmann, 1988, p. 111

A better-known Toma masquerader is the *dandai*,
who embodies a powerful supernatural being
that accompanies the ritual death and rebirth of
adolescent boys during initiation.

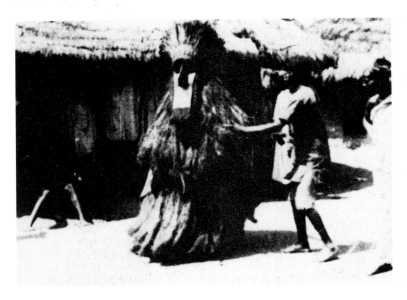

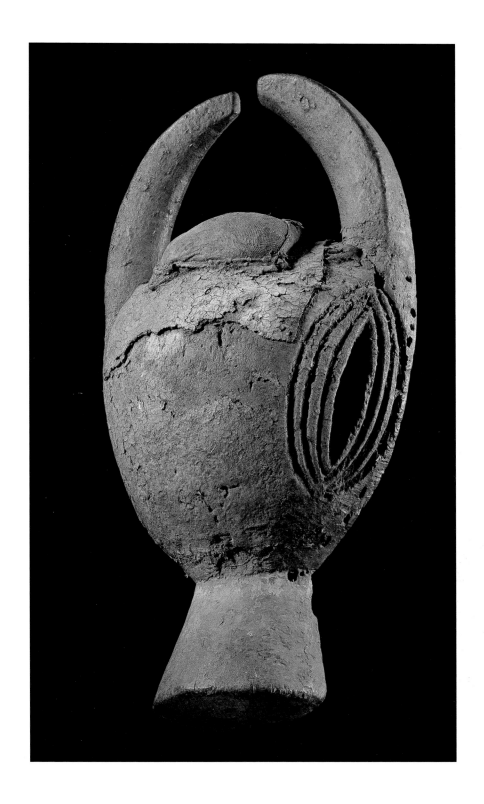

Helmet mask of the Sande women's society

Bassa, Liberia

Wood with dark patination
Height 36 cm (14 ⅛ in.)
Inv. 1003-26
Cat. 76

This helmet mask represents a type worn by members of the Sande women's society at funeral services, festive receptions, in the context of adjudication, and especially during and after initiations of new members into the society. The hierarchically ordered Sande, like its male complement, the Poro society, has for centuries been one of the central social institutions in Sierra Leone, in some areas of Guinea, and in parts of Liberia, where it has recently become established among the Bassa as well.

Two mask dancers of Sande, the only African women's society to use carved helmet masks, for the Mende.

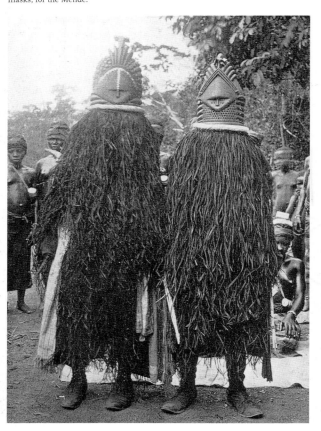

Sande masks always bear feminine features, even when they embody masculine ancestral spirits, as they do among some groups like the Gola or Vai. With the Mende, whom oral tradition credits with having developed this mask type, it is seen as the personification of a female water-spirit. The individual design elements of the mask — narrow, closed eyes, delicate lips and slender nose, smooth forehead and elaborate coiffure, and throat and neck rings (missing from this example) — reflect aesthetic values, philosophical and religious concepts. Although precise attribution of these masks is sometimes difficult, their coiffures and adornment, which reflect changing fashions, help to distinguish regional styles. These details also provide clues which help date masks.

This mask has a charming face which, by comparison to the schematized features of most Mende masks, is treated quite naturalistically. Both the design of the face and the unadorned, symmetrical coiffure with an arrangement of parallel braids swept back from the forehead suggest a Bassa attribution.

Bibliography: Boone, 1986; Dorsinville/ Meneghini, 1973; Fagg, 1980; Philipps, 1978; Philipps, 1980; Schäfer, 1990

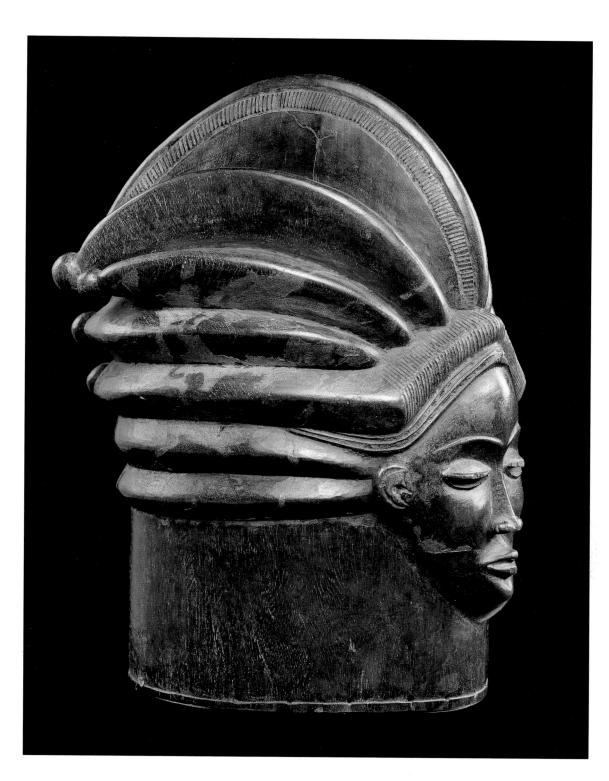

Forehead mask (*Geh-naw*)

Bassa, Liberia

Wood with glossy black patina, coin
Height 20 cm (7 ⅞ in.)
Inv. 1003-33
Cat. 77

The Bassa, one of the largest Kru-speaking peoples in the central coastal region and adjacent hinterland of Liberia, have been strongly influenced by their Mande-speaking

Geh-naw masqueraders entertain spectators with graceful dances on festive occasions.

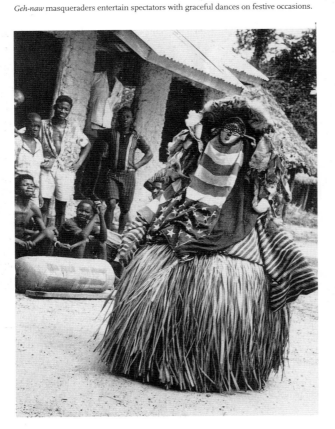

neighbors, especially the Dan and Kpelle. Like these groups, the Bassa have several female and male societies, including the Chu-den-zo, to whom *geh-naw* masks belong. With graceful, gliding dances the *geh-naw* masqueraders entertain the spectators when initiated boys return from bush camp, when important guests visit the village, and on other festive occasions. The dancer wears the mask, which is attached to a woven framework, on his forehead, and looks through a slit in the fabric which is part of the costume that covers his head and upper body. Because they are fixed on a framework, the interior of most such masks shows no signs of wear.

Covered with a glossy patina, this mask shows stylistic affinities with Dan masks, especially with its tapering, pointed chin and straight, if less graceful nose (cf. plates 32, 33). The mouth originally had teeth. The low, bulging forehead overshadows semicircular eyes with lowered lids, smoothly contoured. The coiffure is uniquely characteristic of Bassa masks with a row of variously sized hair knots and vertically arranged braids. Holes in two of the larger, hollowed knots suggest that coins were originally mounted on them, as on the third one (left).

Bibliography: Dorsinville/Meneghini, 1973; Siegmann, 1988, p. 110

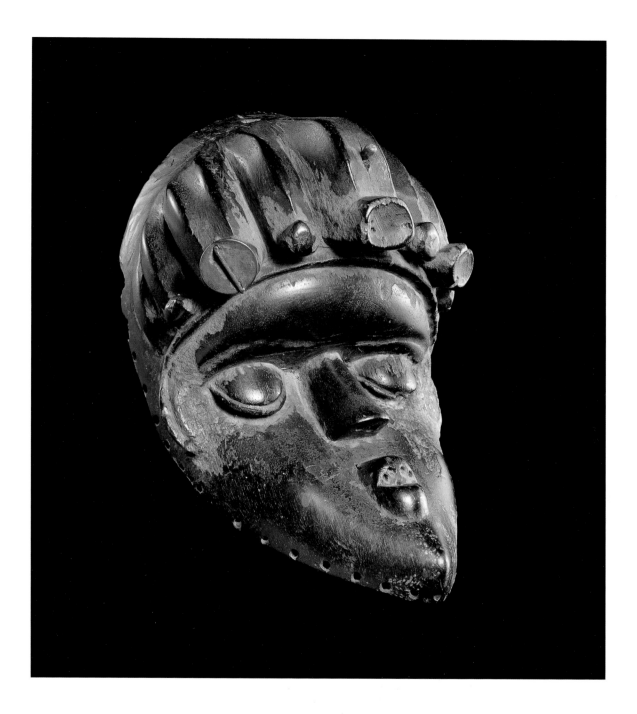

Female face mask

Grebo, Liberia

Wood with red, brownish, and white paint,
glass beads, mineral substances (teeth)
Height 47.5 cm (18 ¾ in.)
Inv. 1003-10
Formerly collection of Josef Mueller;
acquired prior to 1942
Cat. 78

The culture of the Grebo, a little-known
ethnic group inhabiting the coastal region
of eastern Liberia and the bordering forest-
lands, was shaped to a considerable degree
by their neighbors to the north, the Kran
and Dan. These influences are reflected in
their sculptural works, which for a long
period were ascribed to neighboring ethnic
groups rather than being recognized as of
Grebo origin.

This is true especially of their masks,
which are used in a ritual context or to
entertain spectators on festive occasions.
Their design distinguishes male and female
masks. While the former are often com-
posed of geometric shapes and sometimes
tend towards abstraction, female examples
have a comparatively naturalistic face that
conforms to Grebo ideals of feminine beauty.
This type was presumably adopted from the
Dan, whose stylistic influence is seen in
this extraordinarily carefully worked mask.
It has finely engraved eyebrows, a narrow
nose with an accentuated ridge and delicate
nostrils. Its mouth is slightly open, to reveal
teeth. A characteristic trait of Grebo masks
is polychrome painting, which often consists
of ornamental dots but can also take the
form of other abstract patterns. Here, the
area around the raised, narrow eyes is
tinted brown, and the forehead is adorned
with broad, white, vertical stripes. Accents
of color and inlaid glass beads decorate the
cheeks, corners of the eyes, and coiffure.
These accents concentrate in the headdress,
whose motif of curving horns is also found,
in a coarser version, in male masks. The
central element with its engraved herring-
bone pattern might represent the hair orna-
ment made of straw which young girls re-
ceive from admirers.

Bibliography: Fagg, 1980; Meneghini, 1974;
Verger-Fèvre, 1988, p. 113

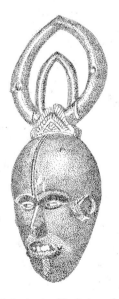

The female face masks of the Grebo, such as this
example in the British Museum, London, reflect
an ideal of femininity.

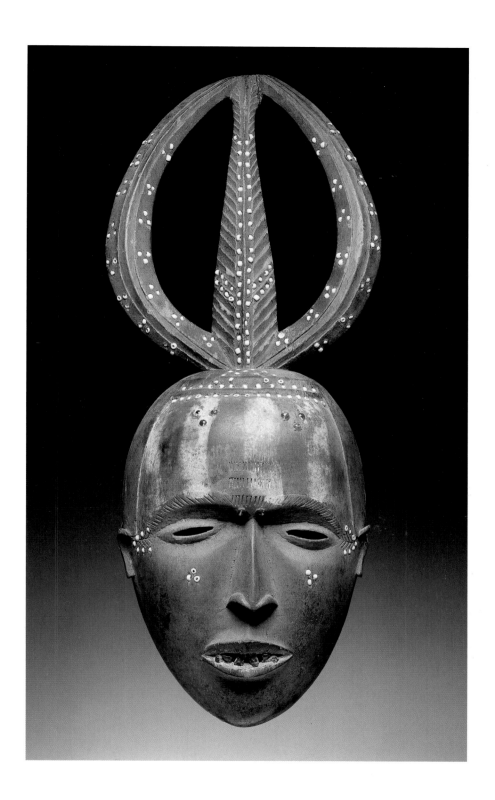

Face mask with round eye apertures
(*Zakpei ge* or *gunye ge*)

Dan, Ivory Coast/Liberia

Wood with glossy black patina, hood of
woven fibers, cotton
Height 36 cm (14 ⅛ in.) (not including hood)
Inv. 1003-14
Cat. 81

The Dan are a farming people who inhabit
the hinterland of western Ivory Coast and
Liberia. They have a great number of masked
figures who represent spirits of the bush,
and fulfill a variety of social, political, and

religious functions. According to Eberhard
Fischer and Hans Himmelheber, eleven
types of Dan masks can be distinguished
by formal criteria. This does not imply,
however, that the types can be associated
with specific functions, because the
meanings of masks change over time.

This mask, with its dark patina, origin-
ated from the northern Dan. This is indicated
by the carefully hollowed and smoothed
interior, as well as by the oval face with its
finely carved features, high forehead, raised
eyebrows, and strongly protruding mouth
with full lips. Circular eyeholes that permit
unhindered vision on the part of the wearer
are characteristic of the racer mask (*gunye
ge*) and the fire mask (*zakpei ge*), two sub-
ordinate mask types used by the northern
Dan. The *gunye ge* hold weekly running
contests during the dry season. Originally
these contests tested the prowess of young
warriors. The *zapkei ge* also appear at this
time of year, to inspect cooking fires and
prevent the ever-possible conflagration.
They chastize careless women with a switch,
knock pots over, and take objects as security
for a fine of money.

As a rule, racer and fire masqueraders
wear a scarf over their head which, in some
cases, is decorated with leaves or a piece of
sheepskin. If the masks have fiber wigs these
are entirely concealed. Since the present
mask is equipped with an extremely artfully
woven hood, Marie-Noël Verger-Fèvre
suggests that it might be one of the power-
ful *go ge*, or "king's masks," which appeared
in public only on very solemn occasions.

Bibliography: Donner, 1940; Fischer/ Himmel-
heber, 1976; Kecskési, 1982; Sieber/Walker,
1987; Verger-Fèvre, 1988, p. 114; Verger-Fèvre,
1993 I, pp. 128–183; and II, p. 60

This *go ge*, or "king's mask," from the canton of Gouroussé is known as *gie dagi*. In
spite of its female features, it embodies a male figure.

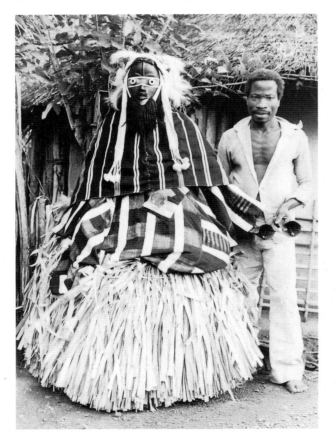

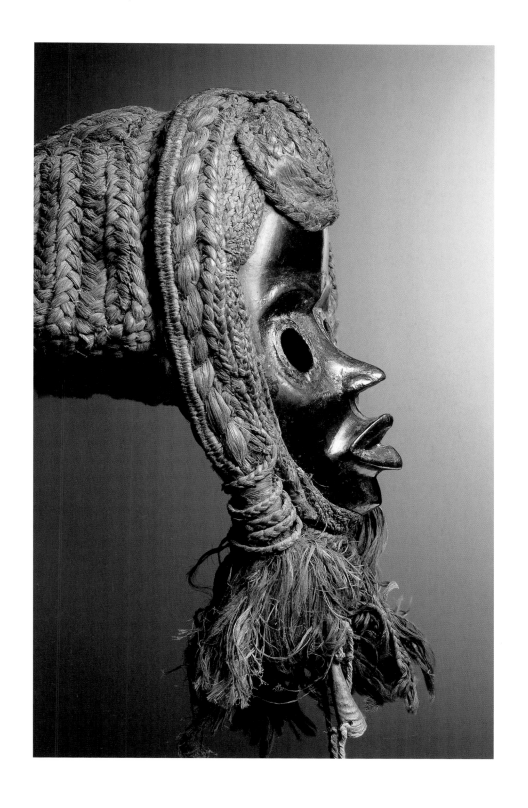

Face mask with female features
(*Takangle* or *deangle*)

Dan, Ivory Coast/Liberia

Wood with brown patina and traces of white
paint, cotton fabric and fibers, cowrie shells,
colored glass beads
Height 19.5 cm (7 ⅝ in.) (mask only)
Inv. 1003-8
Formerly collection of René Rasmussen
Cat. 82

Masks with delicate female features, narrow
eyes, and a band over the forehead decorated
with cowrie shells, serve a variety of pur-
poses. First, and foremost, they are danced
for entertainment. Known in this case as

takangle, the masqueraders frequently
specialize in singing. In their function as
singer masks (*gle sö*) they support the "great
mask" (*go ge*) and give expression to the
authority of the influential Go society. Great
masks act as judges and justices of the
peace. On the other hand, this type of mask
is also associated with the circumcision
camps for adolescent boys. Called *deangle*,
or guard masks, they serve as mediators be-
tween the camp and the village. Their eyes
are often painted with white clay (kaolin),
just as certain women's eyes are painted
during ritual celebrations. The color white
is a symbol of joy, but also of the realm of
the ancestors.

Stylistic traits such as the convex
cheeks and forehead, as well as the carefully
hollowed and smoothed interior, indicate
that this mask was made by a northern Dan
sculptor. The vertically incised eyebrows
evoke scarification patterns, which women
in the border territory of Liberia create for
aesthetic reasons, by means of shallow
incisions in the skin. Unusual are the four
raised, parallel lines which form a graceful
arc across the forehead. Missing, on the
other hand, is the vertical central forehead
scar which is more typical of guard masks.

Bibliography: Donner, 1940; Fischer/Himmel-
heber, 1976; Verger-Fèvre, 1988, p. 117; Verger-
Fèvre, 1993 I, pp. 128–183; and II, p. 62

Dance of an entertainment masker in a village in the Man region, 1991.

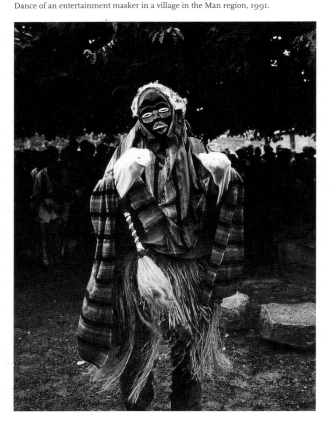

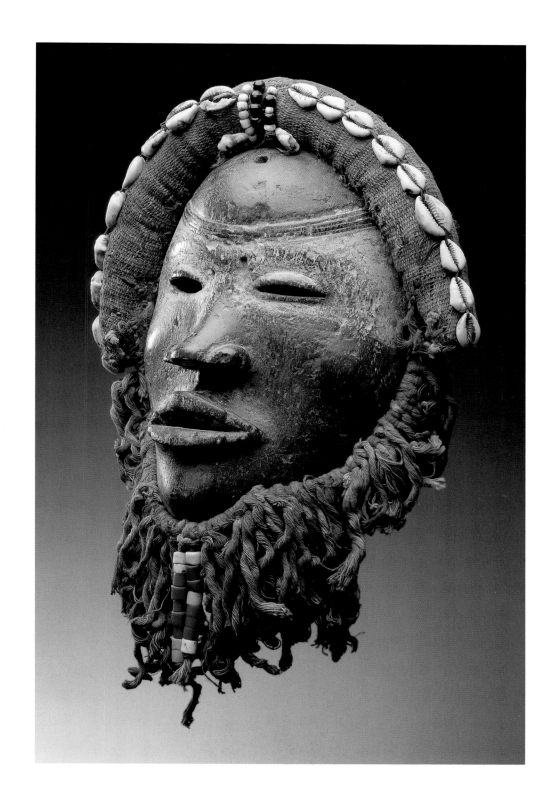

Mask

Dan, Ivory Coast

Yellow brass
Height 20.3 cm (8 in.)
Inv. 1007-185
Cat. 91

Dan works in metal, which served primarily as status symbols, include many types of jewelry or ornament, especially rings worn on the thumb, knee, arm, or ankle, as well as statues of human figures and objects for domestic use. Small metal masks, which were part of the treasures of a men's association or of the entire village, were looked upon as manifestations of beneficent spirits. They were not worn, but kept with other sacred objects in a safe place. Most of these sculptures were made of imported brass with a high percentage of zinc (yellow brass), by specialist metalsmiths using the lost wax process.

This unusually large cast mask has traits that typically reflect Dan ideals of beauty: regular features, a high, slightly bulging forehead, a narrow nose, and a protruding, slightly open mouth. The somewhat recessed eyes are set about halfway from the top or bottom of the face. Their horizontal axis is accentuated by narrow eye slits between raised lids, which are in turn emphasized by incised spiral lines. These patterns, characteristic of the cast masks and prestige objects of the Dan, are echoed in the half-spirals adorning the edges of the face. Two further spirals on the forehead are vertically divided by a twisted-cord motif that extends upwards from the bridge of the nose. This motif is based on the forehead scarification formerly favored by Dan women.

As the incomplete patterns in the chin area indicate, the face was apparently originally conceived as a full oval. Evidently the artisan underestimated the amount of molten metal needed to fill the mold, for the face contour ends abruptly and unevenly at the lower edge.

Bibliography: Bruyninx, 1993 I, pp. 222–233; and II, p. 65; Fischer/Himmelheber, 1976

Size and style of the miniature cast brass masks used in religious ceremonies or as amulets vary considerably. The two masks with an oval face (left and right) were acquired by Josef Mueller before the Second World War.

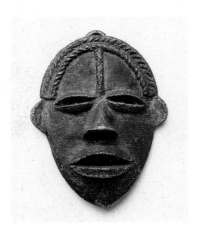 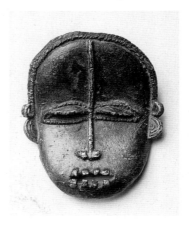 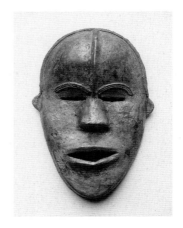

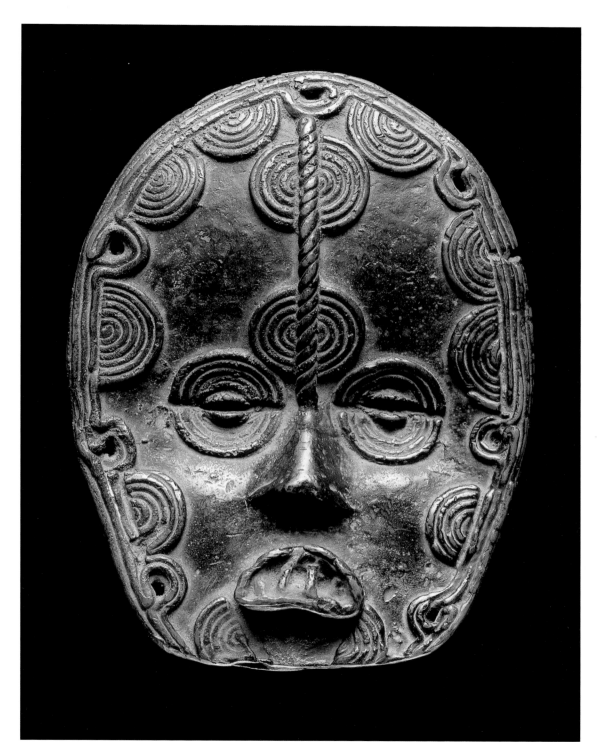

Face mask

Bete, Ivory Coast

Wood with blackish-brown patina, upholstery
tacks, plant fibers
Height 30 cm (11 ¾ in.)
Inv. 1008-15
Formerly collection of André Lhote
Cat. 99

The Bete are an agriculturalist group who live in southwestern Ivory Coast, between the Bandama and Sassandra rivers. Only the western Bete are known to have a masking

This Nyabwa mask from the Barbier-Mueller Collection shows formal similarities, on the one hand, with the masks of the Bete, and on the other with those of the We (cat. nos. 94–97), from whom this type passed initially to the Nyabwa and subsequently to the Bete.

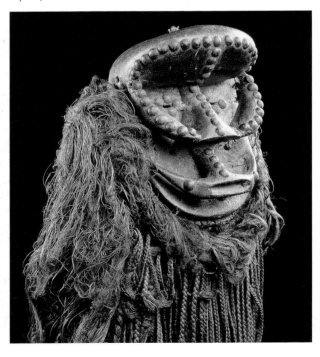

tradition, which goes back to the Gla society of the We, and which was adopted by the neighboring Nyabwa. This origin is underscored not only by the use of the Nyabwa language during masquerade dances, but by the fact that every Bete mask wearer is introduced to its use by an initiated Nywaba.

Masqueraders perform during burials, at the end of the mourning period, or in honor of important people. Sometimes they or one of their attendants carries a lance. This weapon possibly points to the mask's original function — that of a war mask.

The face of this mask is composed of geometric volumes that, as independent bodies, seem to emerge from a flat back panel. The separate features are arranged in horizontal tiers, interrupted in the vertical only by the hooked nose and a low crest extending from the lower edge of the protruding forehead over the crown of the head. The vertical line thus formed is repeated in the upward sweep of the oversized nostrils, which extend to the corners of the eyes. Between the narrow slit of the eyes and the arch-shape above them, two small rectangular openings have been cut to permit the wearer to see, at least partially. The arch extending from temple to temple may be derived from the front-mounted horns of those Gla masks which, among the We, accompanied warriors into battle or counteracted destructive forces.

Bibliography: Rood, 1969; Verger-Fèvre, 1993 I, pp. 128–143; and II, p. 90

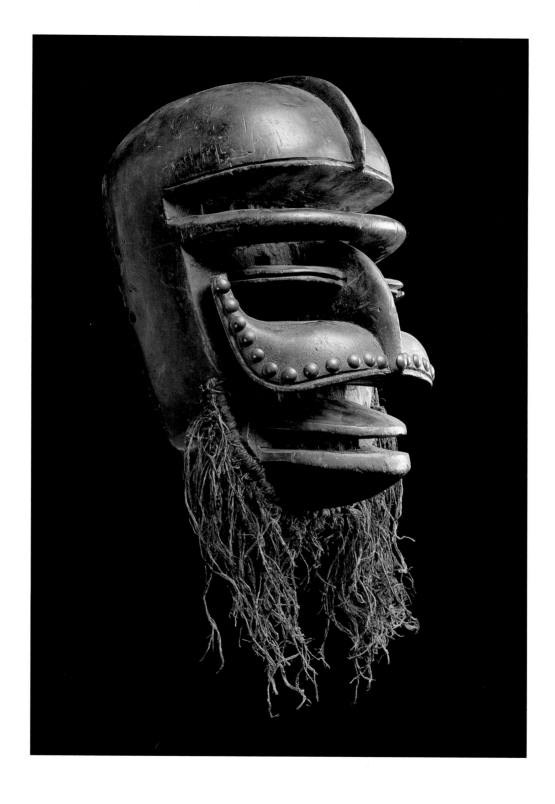

Forehead mask of the Je group, representing an antelope

Guro, Ivory Coast

Wood with peeling reddish-brown paint over light brown primer
Length 33 cm (13 in.)
Inv. 1007-25
Formerly collection of Josef Mueller;
acquired before 1942
Cat. 110

The Guro, sedentary farmers in the tropical rainforests and wooded savanna of the Ivory Coast interior, have no central political authority. Power is held on the village level by a council of elders comprised of the head men of the various village quarters, as well as inhering in a number of men's associations. The most significant in this respect is the Je society, which is responsible for social, political, and juridical questions, decisions of peace or war, policing tasks, and the detection of destructive forces, as well as appearing at funerals of its members. This male society uses a variety of anthropomorphic and zoomorphic masks, some fitted with staff-like superstructures, all ostensibly fatal for women to view. The masks are supplemented by voluminous, multipartite costumes of palm-frond strips or reed-grass, which completely conceal the dancer's body. At ceremonies the Je animal masks are the first to appear, and they prepare the audience for the performance of the more powerful, anthropomorphic figures.

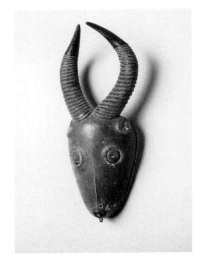

This reddish-brown painted mask originated either from the region around the town of Sinfra in the southern Guro area, or from the Dranu, a northern Guro subgroup. It is a strikingly naturalistic representation of an antelope head with large round eyes, tapering ears, and full nostrils that almost seem to sniff the air. On the basis of its fluted horns that gently curve together towards the tip, the mask can be identified as a depiction of a waterbuck (*Kobus defassa*). Dancers wearing this type of mask were assigned the task of lighting a fire over which the Je maskers leaped at the close of a ceremony.

Bibliography: Deluz, 1988, p. 125; Deluz, 1993 I, pp. 234–245; and II, p. 98; Fischer/Homberger, 1985

Depictions of the waterbuck (*Kobus defassa*) are found not only among the Guro (above) but also among the Yaure (below). Unlike Guro masks, however, those of the Yaure often have anthropomorphic features.

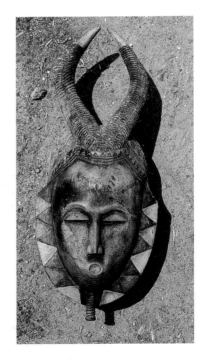

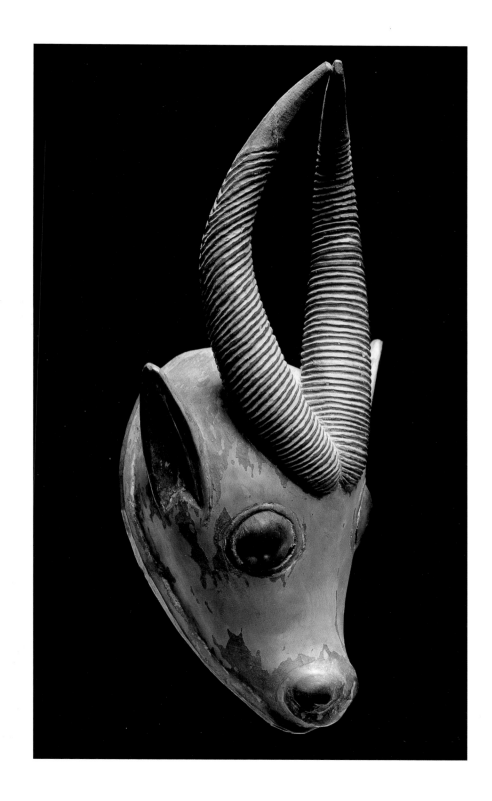

Female face mask (*Gu*)

Guro, Ivory Coast
Wood, black primer, red paint with traces
of white
Height 32 cm (12 ⅝ in.)
Inv. 1007-223
Cat. 101

The best-known cult among the northern Guro relates to a group of masks that is considered a family. It consists of *zauli*, a grotesque animal mask with long horns; *zamble*, a horned mask whose face is meant to recall a leopard or a crocodile; and *gu*, a human mask. *gu*, who is usually thought of as *zamble's* wife, performs after the two zoomorphic figures, who are responsible for resolving quarrels and detecting sorcerers, or who dance at funerals and other ceremonies. During her performance, which is accompanied only by flute music, *gu* moves slowly and gracefully, singing songs in honor of *zamble*.

Like all *gu* masks, this example represents a young woman with features that correspond to traditional Guro ideals of feminine beauty. The Guro find aesthetically pleasing a narrow, well-proportioned face with a small chin, a high forehead with an undulating, presumably shaven hairline, arching black eyebrows, lowered eyelids, a narrow nose with delicate nostrils, and a slightly open mouth with filed teeth. Tooth-filing and scarification, as represented here by the five bulges on the forehead, are nowadays seen only among elderly Guro women. Nevertheless, even recent *gu* masks still carry these marks. In the design of the coiffure, many variations are found. This one has the hair style once worn by the wives and daughters of influential, well-to-do men. Their hair was twisted into a chignon and held by a leather strip into which Koranic verses were sewn as a protective amulet (*sene*).

Bibliography: Deluz, 1993 I, pp. 234–245; Fasel, 1993 II, p. 93; Fischer/Homberger, 1985

Performance of *zamble* (right) and *zauli* (left), who, with *gu*, constitute a mask family.

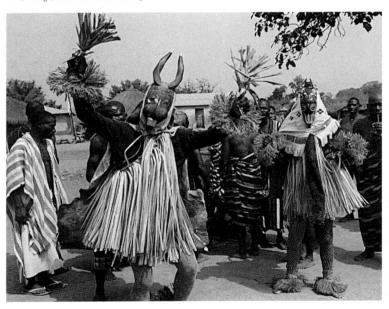

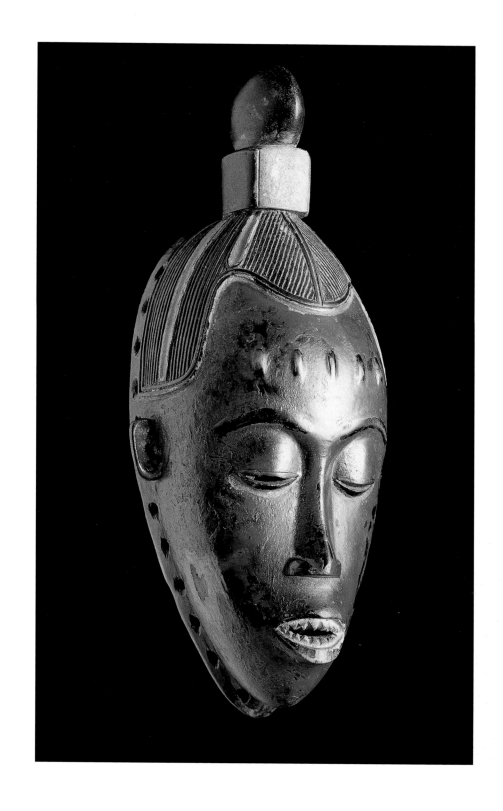

Face mask of the Je group
(*Tu bodu*)

Yaure, Ivory Coast

Wood, accentuation in white pigment
Height 20 cm (7 ⅞ in.)
Inv. 1007-34
Formerly collection of Josef Mueller;
acquired prior to 1942
Cat. 115

The best-known masks of the Yaure, a small ethnic group inhabiting the central region of Ivory Coast, represent human faces supplemented by animal attributes. They belong either to the Je or Lo, types of masks that, for outsiders, are difficult to distinguish from one another. With the aid of such masks, the people hope to influence supernatural powers, or *yu*, that can do harm to humans, but that can also ensure their

welfare. The masks are considered emblems of *yu*, extremely dangerous, to be handled with extreme caution, and absolutely kept out of the sight of women. Cases of death that jeopardize the social order are the principal occasions for an appearance of masqueraders. By means of their dance, they restore the social equilibrium of the community and accompany the deceased into the ancestral realm.

On the one hand, Yaure masks inspired the Baule to develop a mask type of similar design; on the other, they evince stylistic influences of the Guro, with whom the Yaure are related. In the present example, the slightly open mouth with rows of teeth, the narrow nose, and the treatment of the coiffure, recall the *gu* masks of the neighboring Guro (cf. plate 37).

This mask has been identified as a *tu bodu* (buffalo), a Je mask figure, although the finely fluted, downward curving horns suggest an imaginary beast more than a realistic representation. The horns frame an elaborate coiffure arranged in three semicircular locks, a coiffure the Yaure associate with power and prosperity. The finely modeled face, in which curved and straight lines perfectly complement each other, is contoured by a zigzag band that underscores the harmonious appearance of the mask and is typical of Yaure pieces.

Bibliography: Boyer, n.d.b; Boyer, 1993 I, pp. 246–289; and II, p. 106

A shelter in the sacred grove (*yu pro*) of the village of Kouassi-Perita, where masks and other ritual objects are kept.

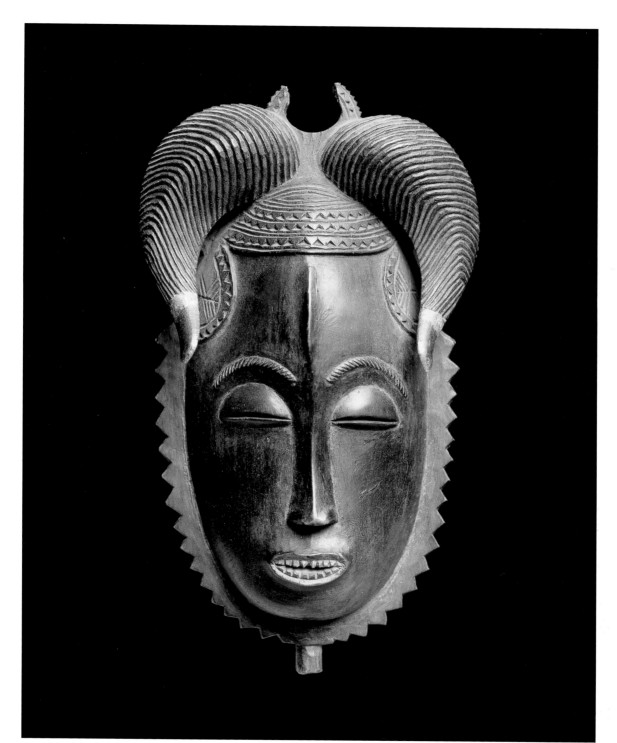

Face mask of the Je group (*Lomane*)

Yaure, Ivory Coast

Wood with accents in white and red
Height 43 cm (16 ⅞ in.)
Inv. 1007-60
Formerly collection of Josef Mueller;
acquired prior to 1939
Cat. 116

This mask type with a depiction of a hornbill (*Bucorvus abyssinicus*), or perhaps a species of woodpecker, is called *lomane*. The word derives from *anoman*, which means "bird" in the Baule language and occurs in the songs which accompany the maskers' performance. In most Yaure villages, the *lomane* belongs to the Je group of masks. Yet examples exist which, adorned with two bird figures, are considered part of the Lo ensemble, which appears after the Je at funerals of elderly men. The fourth of a total of seven Je masqueraders, the *lomane* dances around the body of the deceased, then bends over and touches it. Based on the statements of several Yaure, who say the mask kills the worms that decompose the body, this act could be interpreted as a symbolic purification.

The attractive face of this mask, set off by a zigzag band, is reduced to essential, concise forms: close-set eyes marked by a flat arch and a horizontal incision; a straight, narrow nose with well-defined nostrils; and a small, perfectly circular mouth that creates the impression of pursed lips. Though the face is completely without ornament, fine engraved lines suggest an elaborate coiffure which falls in three locks over the rounded forehead. Accents of color emphasize the mouth, eyes, and the plumage and bill of the bird, firmly perched on powerful legs surmounting the human head. Je masks, in contradistinction to the primarily black Lo masks, are often vividly painted.

Bibliography: Boyer, n.d.a; Boyer, 1993 I, pp. 246–289; and II, p. 111; Deluze, 1988, p. 133

Yaure village of Bokassou, shortly before a masquerade performance. Women are not permitted to see the mask dancers, nor do the Yaure allow photographs to be taken.

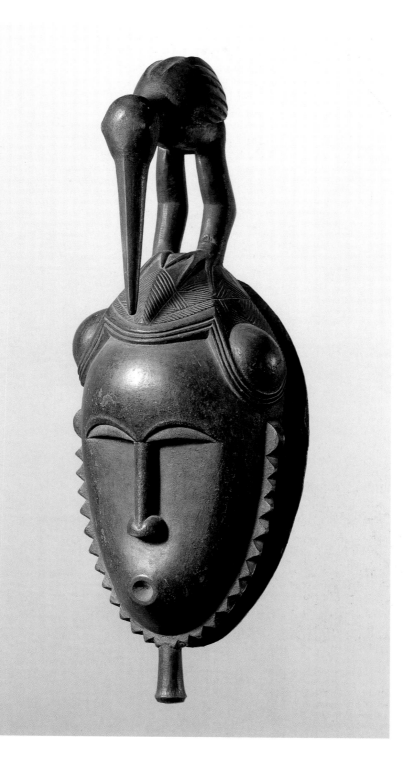

Female face mask of the Goli group
(*Kplekple bla*)

Baule, Ivory Coast

Wood, painted in reddish-brown, black,
and white
Height 42 cm (16 ½ in.)
Inv. 1007-21
Formerly collection of Charles Ratton
Cat. 130

Kplekple belongs to a group of various types
of mask known as Goli and considered a
family. The father is *goli glin*, a zoomorphic
mask, and the mother the anthropomorphic
kpwan; a mask of similar design called
kpwan kple represents their daughter, and
kplekple represents their son. Occasionally
there are two *kplekple* masks — one painted
black and considered masculine, called
Kplekple yaswa, and the other painted red,
the feminine *kplekple bla*.

The Baule adopted this masquerading
tradition in the late nineteenth or early
twentieth century from the neighboring
Wan, whose language is still used today in
the performers' songs. The Goli appear at
times of danger, as during epidemics or at
funeral ceremonies. They are considered
intercessors with supernatural forces, or
amwin, which can have a positive influence
on human affairs, or, if not appeased, a
negative one. *Kplekple*, the lowest ranking
of the Goli masqueraders, appears at dawn
and again, briefly, during the early afternoon
and evening, to announce the arrival of *goli
glin* or *kpwan*. The mask is worn by young
men with a goatskin over their back, who
perform a lively dance to music and the
singing of children and adolescents.

Kplekple masks are marked by a high
degree of stylization and minimal detail.
The curve of their disc-shaped face is echoed
by the horns, based on those of an antelope.
In some examples, ears, spiral horns, eyes
inset with bits of mirror, and contour deco-
ration are found. Yet even these minimal
design elements are missing from this
extremely simplified mask, whose reddish-
brown finish characterizes it as female in
gender.

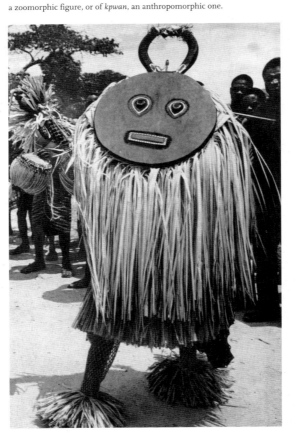

Dance of a *kplekple* masker, who announces the arrival of *goli glin*,
a zoomorphic figure, or of *kpwan*, an anthropomorphic one.

Bibliography: Boyer, 1993 I, pp. 302–367;
Garrard, 1993 I, pp. 290–301; Vogel, 1988,
p. 132; Vogel, 1993 II, p. 126

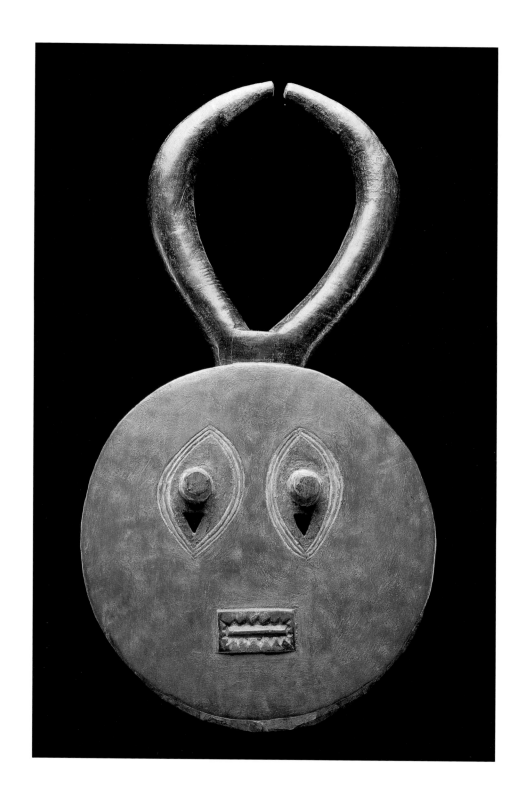

Twin mask of the Mblo group

Baule, Ivory Coast

Wood, with red and black paint
Height 29 cm (11 ⅜ in.)
Inv. 1007-65
Formerly collection of Roger Bédiat;
collected in the middle 1930s
Cat. 122

Numerous Baule masks are worn only in dances intended to entertain. This is the purpose of twin masks, a relatively rare type. They are part of a group called Mblo or Gbagba, which are looked upon as portraits of especially lovely young girls or brave men of the village. With the Baule,

the birth of twins is a happy event to be celebrated by special ceremonies, and which finds expression in twin masks of this kind.

The twin mask in the Barbier-Mueller Collection has two perfectly carved, symmetrically arranged faces that differ solely in terms of decorative elements. The artist took great care to individualize the coiffures and the scarification patterns on the twins' foreheads, cheeks, and corners of the mouth. Only the marks, or *ngole*, at the corners of their eyes and bridge of the nose are identical.

The face on the left originally had a red finish, which shows through the craquelé of the black paint layer later applied over it. Although the faces of a twin mask are generally of the same gender, the differing color scheme, as with Goli masks (see text to plate 40), indicates a sexual distinction. The colors used by the Baule reflect their philosophical conception of the dualistic organization of the universe, in which harmony is achieved by uniting two complementary principles.

Bibliography: Boyer, 1993 I, pp. 302–367; Rigault, 1995; Vogel, 1988, p. 131; Vogel, 1993 II, p. 118

The masks that belong to the group of Gbagba, Ajasu, or Mblo have no ritualistic function. They are meant to entertain, and thus can be viewed by women as well as men. The Baule describe some of these masks as portraits of beautiful women or brave men.

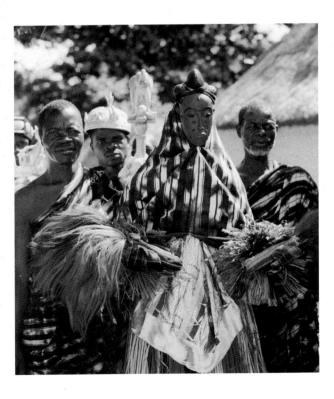

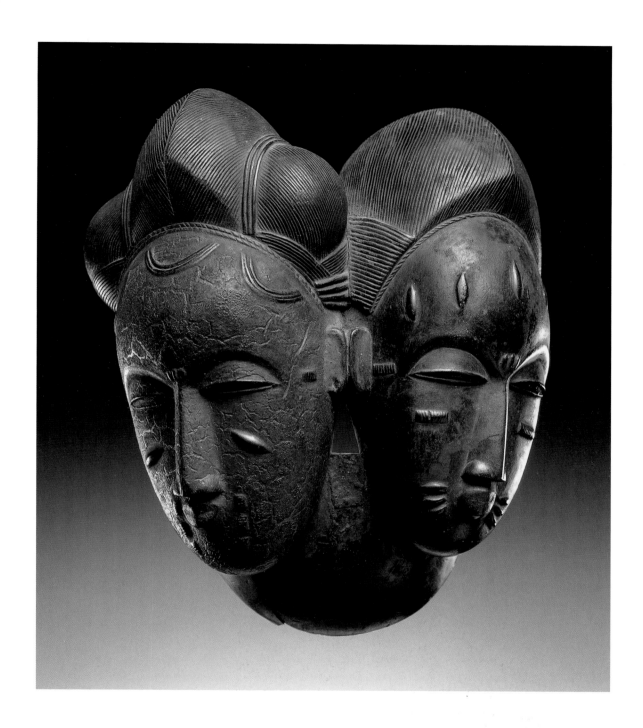

Helmet crest

Baule, Ivory Coast

Wood with remnants of white kaolin pigment
Height 38 cm (15 in.)
Inv. 1007-28
Formerly collections of Antony Moris and Josef
Mueller; acquired prior to 1939

Cat. 123

Like the twin mask (plate 41), this semi-abstract, expressive sculpture belongs to the group of entertainment masks variously termed Ajasu, Bedwo, Jela, and Gbabga, or Mblo, categories difficult for outsiders to distinguish. Apart from individual portraits, these masks represent a number of domesticated animals and species of game that play an important role in the daily life of the Baule.

This sparingly painted sculpture was acquired before 1939, a period when the entertaining masquerade dances were extremely popular. While the half-moon-shaped eyes and narrow nose suggest a human face, the blunt, snoutlike end of the nose and the gracefully curving horns mark the mask as representing a buffalo. The performance of this mask is accompanied by unmasked, costumed young men, who put on a dramatic show of hunting and killing a buffalo which sometimes verges on caricature.

The older, carefully carved masks of this type, marked by harmonious composition of the facial features and imaginative variation in coiffures and scarification patterns, compellingly reflect the aesthetic values of traditional Baule society. Especially in the area of entertainment masks, design approaches that diverge from earlier models have become apparent in recent years. Yet the application of new stylistic principles is often accompanied by a decline in quality, which not even vivid color schemes can entirely conceal.

Performance of a black, white, and red *goli glin* mask, in Bendé-Kouassikro, 1988. Representing a buffalo, it is danced both in nocturnal religious ceremonies and daytime entertainments.

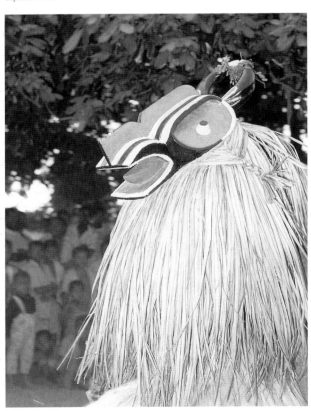

Bibliography: Boyer, 1993 I, pp. 302–367; Vogel, 1988, p. 133; Vogel, 1993 II, p. 118

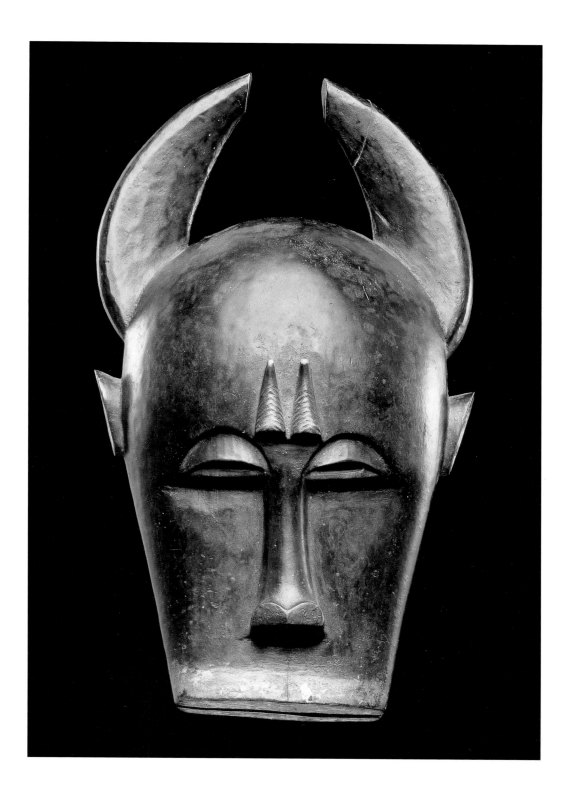

Helmet crest (*Epa*)

Yoruba (Ekiti), Nigeria

Wood with encrusted patina and reddish-brown, white, and black paint
Height 115 cm (45 ¼ in.); diameter 45 cm
(17 ¾ in.)
Inv. 1011-62
Cat. 137

To ensure the fertility and welfare of their community, the Ekiti, who live in the north-eastern Yoruba area, hold a three-day masquerade festival called *epa* every other March. The tall masks, carved from a single piece of wood and weighing up to nearly 70 pounds, are worn by young men who prove their strength and agility in dance performances that include great leaps through the air.

The base of the mask (*ikoko*) is formed by a grotesquely featured helmet-head, which often has two faces but otherwise generally shows little variation. In contrast, the superstructures of such masks, set off from the helmet by a thick disk, show a great variety of scenes imaginatively rendered in the realistic Yoruba style. Among the most frequent motifs are horsemen, warriors, groups of hunters, priests, women with children, and leopards bringing antelope down.

The main figure on this mask superstructure, seated on a chair as a sign of his authority, is characterized as a ruler and hunter by various other attributes. The necklace of cylindrical beads, a staff, or *opaga*, adorned with bells and medicinal calabashes in his right hand, and a walking stick, or *oba*, in his left, are emblems of a ruler's dignity. The hair put up in a long braid, the fly switch in his left hand, and a calabash with protective medicine, or *oogun*, worn around the neck, characterize the ruler as a hunter as well. He is surrounded by five smaller, standing figures, who represent subordinates: a priest of the *orisha* Osanyin, the god of medicinal herbs, with scepter and calabashes in his hands and around his neck; a hunting assistant with a dog on a leash; and three musicians with flute, *dundun* and *bongo* drums.

This sculpture may have originated in the town of Omu-Aran. However, its style points to the artist Fashiku Alaye, or his teacher, Roti Alari, both of whom were active in the village of Ikerin, south of Omu-Aran.

Epa mask with motifs of warrior chiefs who established the "Sixteen Ekiti Chiefdoms." The mask was created by the carver Bamgboye of Odo-Owa, who died in 1978.

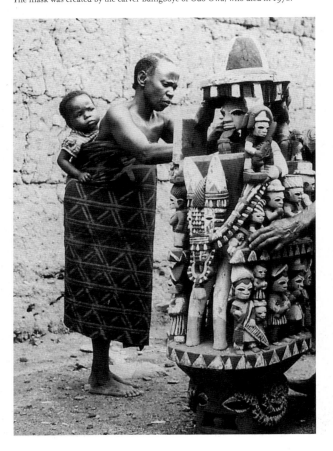

Bibliography: Drewal/Pemberton III/ Abiodun, 1989; Eyo, 1977; Fagg/ Pemberton, 1982; Kecskési, 1982; Pemberton III, 1989

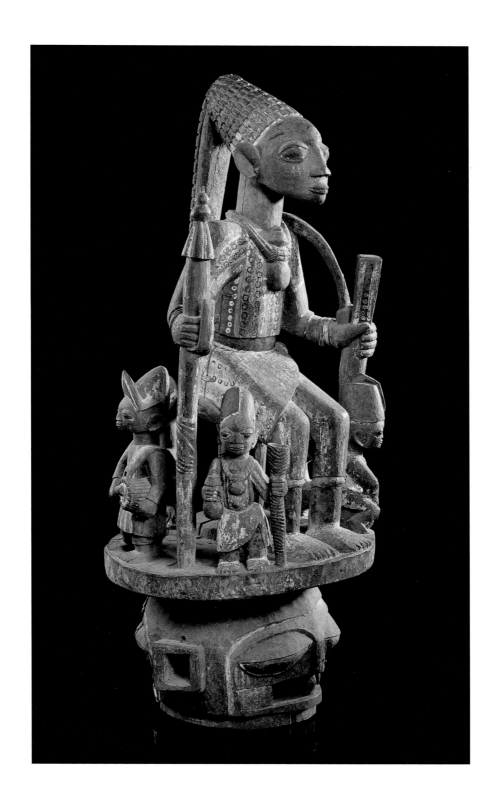

Pendant in mask form

Benin, Nigeria

Brass with encrusted patina, iron inlays
Height 17.9 cm (7 in.)
Inv. 1011-104
Formerly collection of Baudouin de Grunne
Cat. 139

According to oral traditions, the Edo king-dom of Benin originated in the fourteenth century, in the tropical rainforests of southern Nigeria. There exist large numbers of brass and bronze sculptures made for the king of Benin, or *oba*, by specialist metalfounders using the lost wax process.

This mask pendant is one of a series of three whose precise origin is not known. It is characterized by realistic representation of the recessed eyes, long nose with broad nostrils, and slightly open, protruding mouth. Based on the thin walls of the casting (only one millimeter thick), and on stylistic traits such as the inlaid iron pupils and forehead marks, and the concentric-circle design on the hair, the sculpture can be dated to the first, expansionist phase of Benin, between the middle of the fifteenth century and the end of the sixteenth. William Fagg believes that all three masks were presented to the *oba* by neighboring rulers around 1500, in order to confirm their submission. This purpose is also suggested by a stylistic detail — the four raised vertical scars over each eye — which mark the face as that of a foreigner.

Similar masks are still in use today as insignia of some Yoruba, Igbo, and Igala chiefs. As recent photographs indicate, the pendants are worn on the chest. Originally they were probably intended to be attached to a belt, like the mask pendants of ivory, which likewise have two rings on each edge for this purpose.

Bibliography: Ben-Amos, 1988; Eisenhofer, 1993; Eyo, 1977; Fagg, 1980; Kecskési, 1982

Deputy of an Igala ruler wearing a bronze pendant.

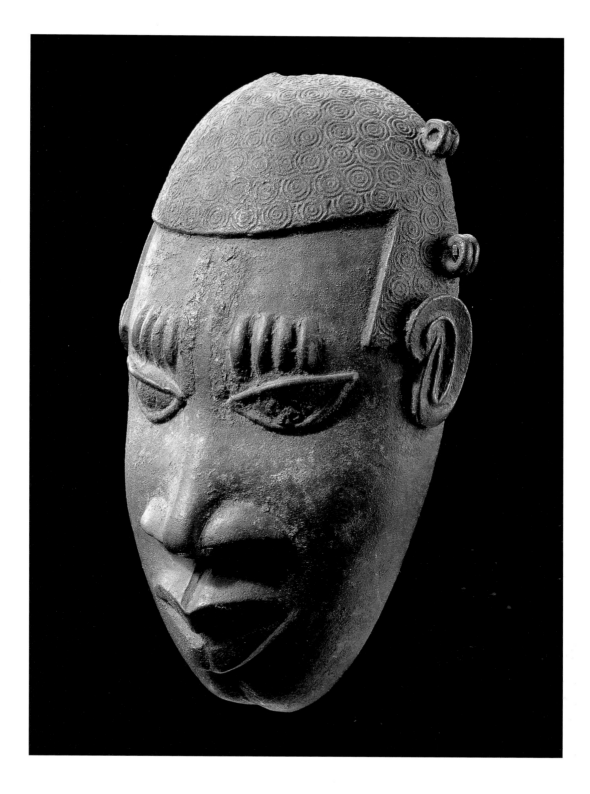

Face mask (*Elu*)

Owo, Nigeria

Wood with blackish-brown patina and remnants
of white and brown paint
Height 27 cm (10 ⅝ in.)
Inv. 1012-24
Cat. 142

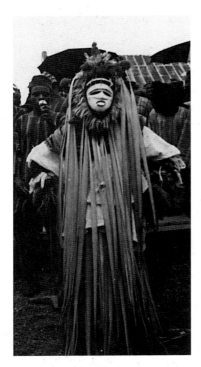

Performance of an *agbodogin* masquerader in
Owo, 1973. This mask type is distinguished by
white face painting from the black-face *elu* masks.

This sculpture is likely an *elu* mask, a type
in use until the 1920s in Owo, a former
Yoruba city-state. The almost entirely black
face of this mask distinguishes it from a
variety of *agbodogin* masks, which have a
white face with black or red accents, and
black-tinted hair and beard. The *agbodogin*
type was presumably adopted from the
areas southeast of Owo in the late nine-
teenth century. Subsequently, artistic in-
novation led to formal changes, and the
originally geometric conception of the
masks gradually made way for a more
realistic approach.

The traits of an early *agbodogin* variant,
seen in two examples in the Barclay Collec-
tion acquired as early as 1910, are also
present in this mask: a marked ridge whose
channel extends around the edge of the
mask from the napped coiffure to the hori-
zontally-ridged beard; a schematic nose
reduced to a thin vertical ridge and two
thicker, horizontal ridges beneath the wide
triangular eye openings; and a slightly pro-
jecting mouth with protruding teeth. All
of these features are known to reflect Owo
ideals of physical beauty.

The *elu* masquerader was clad in a
black garment and wielded a club. According
to members of Owo communities, he dis-
played aggressive behavior towards every-
one. Not even dignitaries or rulers were
exempt from his attacks, though they were
directed principally against women in the
audience.

Bibliography: Poynor, 1987; Poynor, n.d.

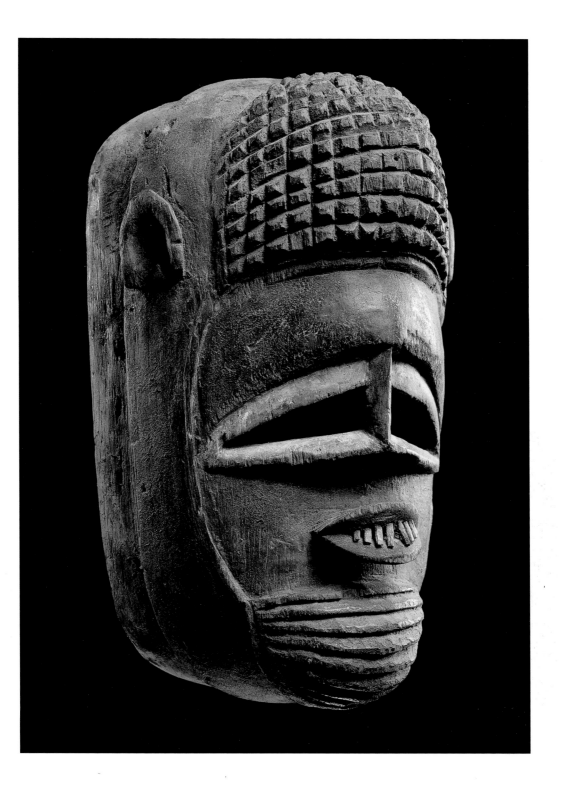

Face mask

Urhobo, Nigeria

Wood with encrusted patina and traces of
white and black paint
Height 46 cm (18 ⅛ in.)
Inv. 1012-2
Formerly collection of Philippe Guimiot
Cat. 143

The works of the Urhobo, a small Edo-speaking ethnic group inhabiting the northwestern part of the Niger delta, are little known but of high aesthetic quality.

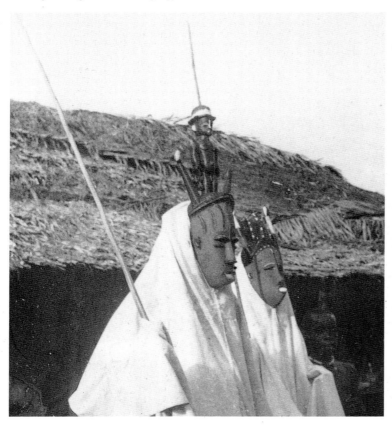

Maskers performing in an Urhobo village, 1950.

These include clay and wood sculptures used to honor ancestors and supernatural forces, as well as masks associated with water and earth spirits. Many of these sculptures show affinities with the art of the neighboring Edo, Igbo, Ijo, and Itsekiri.

Masks of the type illustrated, still in use in numerous southern Urhobo villages, are thought to have been adopted from the western Ijo. The information available about the mask's meaning is diverse, but suggests a basic link with Ohworu, a powerful water spirit. On the one hand, the mask is described as one of the "children of the spirit" (*emedjo*), who appear when the Niger River has reached its highest level in order to bring the "blessing of deep water" to the villages. On the other hand, this type of mask is said to represent a "girl with a youthful body" (*omotokpokpo*). According to Perkins Foss, the latter designation implies a girl of marriageable age (*opha*), who stands under the protection of water spirits and, when presented as a bride, wears an elaborate coiffure of a kind evoked in the mask by the gracefully arched superstructure and hornlike extensions.

That it is indeed a female depiction is underscored by the fine facial features: oval, tapering face, lowered eyelids, straight nose, and broad, closed mouth. Unlike newer, brightly painted masks of the type, this plain, slightly damaged example is carved of a hard variety of wood. Such traits lead Fagg to assume that the sculpture is over one hundred years old.

Bibliography: Fagg, 1980; Foss, 1988; Jones, 1984

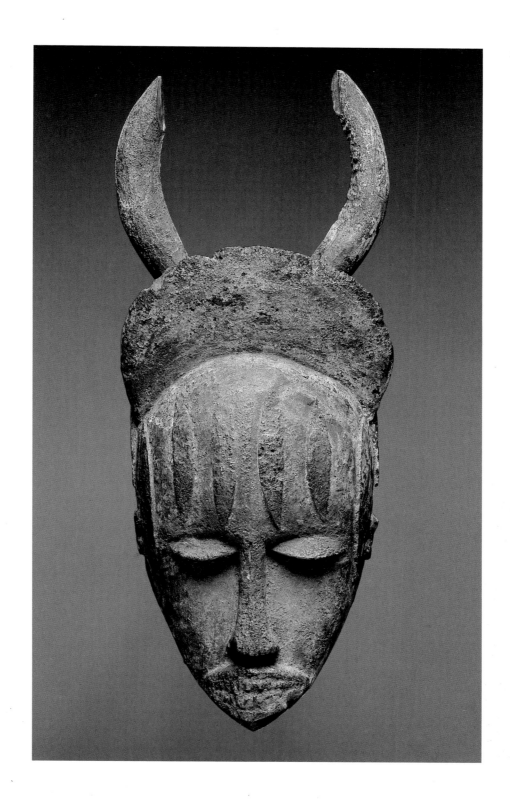

Forehead mask

Western or central Ijo, Nigeria

Wood
Length 118 cm (46 ½ in.)
Inv. 1012-39
Cat. 144

The Ijo, who inhabit the Niger delta between Lagos and the Andoni, are divided into two groups: the Kalabari-Ijo, east of the Nun River, and the western or central Ijo, who live to the west and northwest of this river. The art of both groups is characterized by a schematized approach, whereby most works of the central Ijo evince a higher degree of stylization and abstraction than those done in the Kalabari regional style. Yet also found in the western area are more realistic masks in the form of fish or other animals, which are worn on the forehead (cf. cats. 146 f.). However, the best-known forehead masks of the central Ijo, which embody water spirits (*owuamapu*), contain depictions of human heads built up of geometric shapes and combined with zoomorphic or abstract elements.

The characteristic traits of the central Ijo style are very much in evidence in the present mask, with its human face emerging from the slightly wider middle section of a plank with curving contours. Almost identical, smaller faces adorn the ends of the plank, the front end of which is divided by a deep cut into two projections. The heads are composed of four clearly separated segments: a rounded forehead with trapezoidal nose and — in the two larger heads — lateral extensions resembling stalactites; two cylindrical eyes; and a rectangular, tooth-studded mouth. The vertical ridge extending over forehead and nose has been interpreted as a scarification mark.

Bibliography: Eyo, 1977; Horton, 1965; Jones, 1984

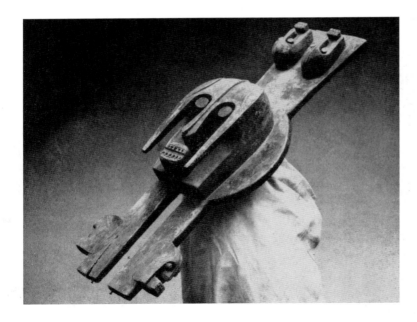

Crown mask with human heads, used in the village of Minebio during *ikulie* masquerade dances.

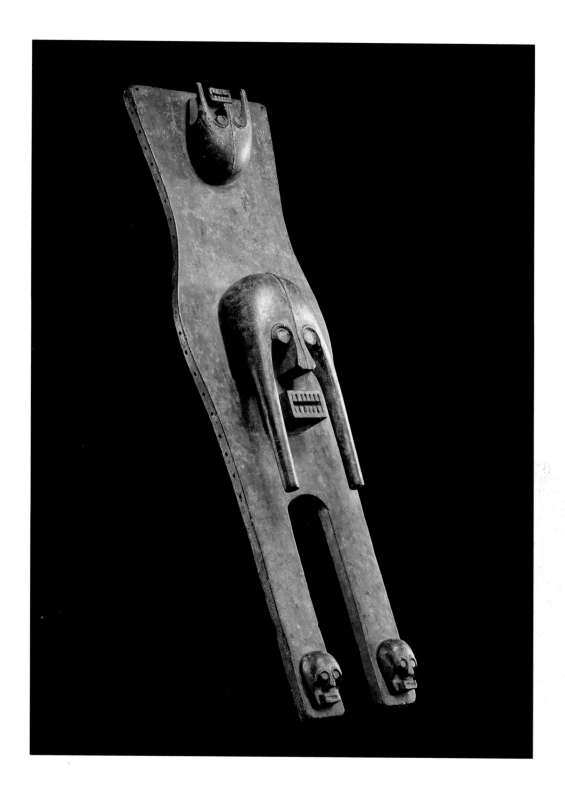

Forehead mask

Western or central Ijo, Nigeria

Wood with red pigments (redwood)
Length 67.8 cm (26 ¼ in.)
Inv. 1012-35
Cat. 145

Besides ancestors (*duen*) and deceased local heroes (*am'om*), water spirits (*owuamapu*) play an important role in the religious ideas of the Ijo. Celebrations in honor of the water spirits lasting several days are held annually, either at the beginning of the year or the time of high water, in order to gain the spirits' goodwill and insure the group's welfare. In the course of the festivities various masqueraders embodying the water spirits perform, and the presence of the spirits, by whom they feel possessed, is manifested in the intensity of their dancing.

The Ijo forehead masks represent not only specific water creatures but also anthropomorphic figures or hybrid creatures that bear traits of various animals and occasionally human features as well. These forms may be inspired by visions or dreams in which water spirits have appeared to carvers. The compositional possibilities this entails are infinite, and have led to a great number of mask variants.

In the present sculpture, the carved, hemispherical head rests on a flat plate resembling the shape of a fish. This is supplemented at the rear of the mask by a slightly curved, hornlike appendage and at the front by a small crocodile head. A snake between its eyes extends in zigzags to the chin of the schematic human head at the center of the mask. Cut into the round of the head is a heart-shaped face — atypical of Ijo sculptures — with protruding cylindrical eyes, pointed nose, and a very marked trapezoidal mouth. An unusual feature is the application of camwood pigment to the entire mask, a substance thought to have healing properties and associated with the spirit realm.

During a ceremony a drum beat tells an *otobo* masquerader that it is time to approach the shrine of the gods and point to it.

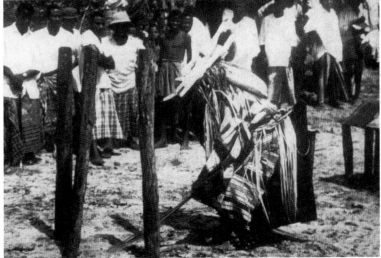

Bibliography: Anderson, n.d.; Eyo, 1977; Fagg, 1968; Horton, 1960; Horton, 1965; Kecskési, 1982; Segy, 1976

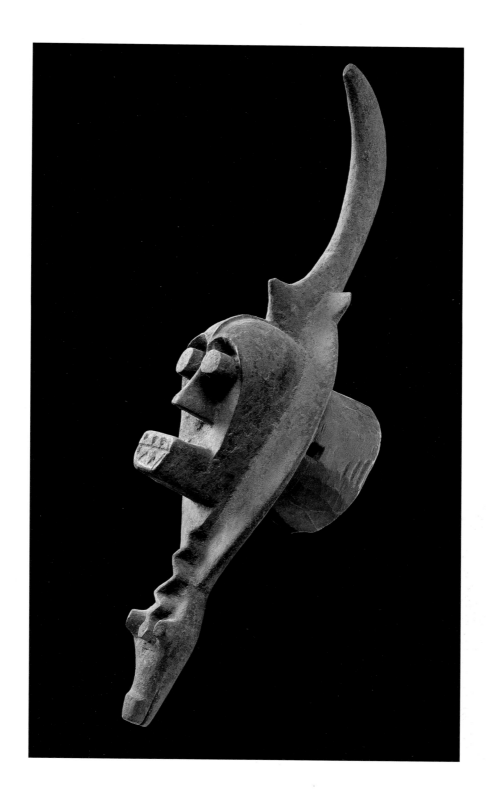

Female face mask (*Mfon*)

Anang, Nigeria

Wood with matte, dark patina
Height 23 cm (9 in.)
Inv. 1013-2
Cat. 148

A modern carved female head in the Kwa Ibo (Anang) style, whose braided hairdo presumably was inspired by that often worn by missionaries' wives.

The masks of the Anang, an Ibibio-speaking group of the southeastern Nigerian province of Calabar, are the property of the Ekpo, a men's association which once had great political influence among all Ibibio groups. The key masquerade performances take place after the yam harvest, and are considered to mark the visit among humans of the ancestral spirits (*ekpo*) represented by the masks.

In addition to masks with grotesque features (*idiok*), which are considered dangerous and may be viewed by ekpo members only, there are masks embodying the "beautiful" spirit (*mfon*), which serve principally as entertainment.

This painstakingly carved, rather realistic depiction of a female face probably belongs to the *mfon* category of mask. It has gracefully arched eyebrows, lowered eyelids, a narrow nose with rounded nostrils, a slightly open, full-lipped mouth, and scarification marks on temples and forehead. The hair, indicated by fine grooves, is parted in the middle and taken up in two twisted braids. According to William Fagg, this coiffure, found also in a number of other older and more recent masks, may have been based on the hairdos of missionaries' wives.

The mask probably originated from Uto Etim Ekpo in the southwestern Anang region, and was likely executed in the 1920s or 1930s by the famous carver Akpan Chukwu (who died in the 1950s) or by one of his assistants or pupils. This may be inferred from stylistic idiosyncracies such as the rounded nose, the rounded, protruding chin, and the clear contours of eyes and lips. These traits are also seen in a headdress mask evidently from the same hand.

Bibliography: Eyo, 1977; Forde/Jones, 1950; Jones, 1973; Jones, 1984; Messenger, 1973; Nicklin, 1988, p. 172; Nicklin/Salmons, 1984; Nicklin/Salmons, n.d.a

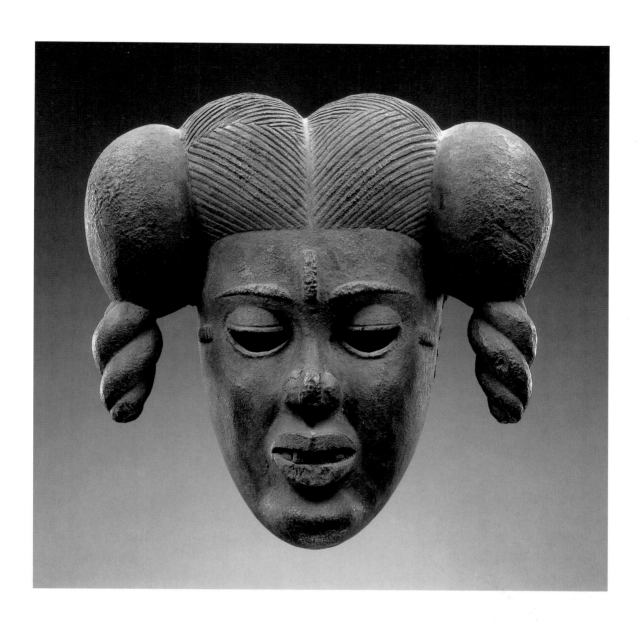

Female face mask with movable lower jaw (*Elu*)

Ogoni, Nigeria

Wood with smoked black patina, partly restored
in mouth area
Height 19.3 cm (7 ⅝ in.)
Inv. 1013-8
Cat. 150

The Ogoni live to the east of the Niger delta, in a fertile area rich in petroleum resources. Despite the efforts of Christian missionaries, they have retained a vital, regionally varied

Elu mask dancer during a yam harvest festival in Tai, 1992.

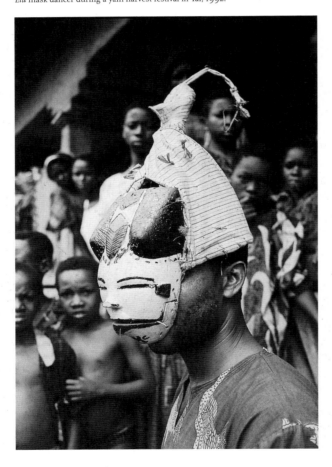

masquerading activity that is in part deeply rooted in their own tradition and in part adopted from neighboring ethnic groups such as the Ibibio or Ijo. Ogoni mask dances serve a great variety of functions, which, depending on the region, can extend from pure entertainment to participation in funeral services and harvest festivals, all the way to the implementation of judicial verdicts.

The present example with its movable lower jaw, full lips, and short nose, represents a classical type of Ogoni mask. Small in size, it was attached to a hood of textiles and plant fibers which covered the head of the costumed masquerader. Marked on forehead and temples by raised scars, the mask likely came from the area of the Kana clan, whose sculptural works are characterized by the type of emphasized nostrils seen here. Both the narrow eye slits and the coiffure indicate a female depiction.

Marcilene Wittmer and William Arnett associate this type of mask with the *ka-elu* performances held before the yam harvest celebrations in the Kana, Tai, and Gokana region. Keith Nicklin and Jill Salmons were not able to corroborate this link. In 1992, however, these investigators did observe young men wearing masks with a movable lower jaw, as well as zoomorphic *karikpo* masks, during the week-long celebrations held in connection with the yam harvest (*dua*). Dressed in costumes made of fresh foliage, groups of masqueraders moved through the lanes and farms from morning to night, repeatedly performing exuberant dances and receiving from the onlookers small gifts of money, food, or beverages.

Bibliography: Eyo, 1977; Jones, 1984; Nicklin/ Salmons, n.d.b; n.d.c; Wittmer/Arnett, 1978

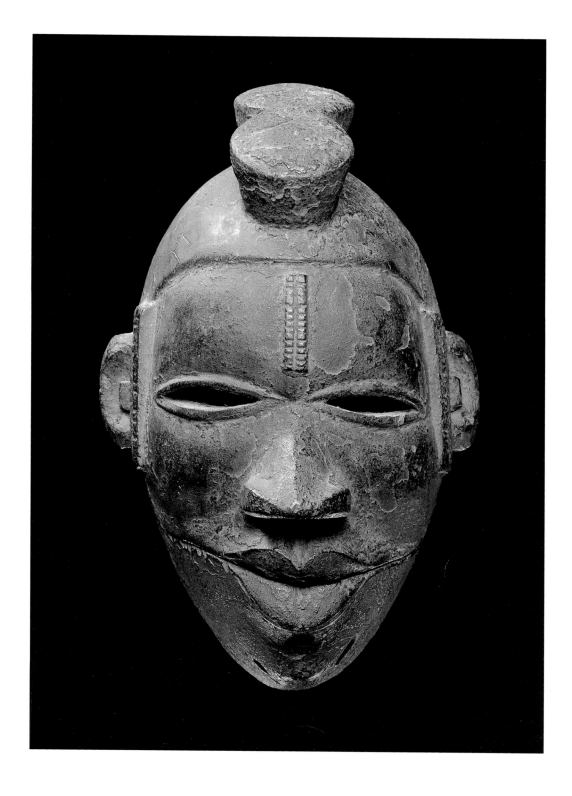

Headdress mask with female figure, used in *ogbom* dances

Ibibio (Eket), Nigeria

Wood, painted black; right arm missing
Height 66 cm (26 in.)
Inv. 1014-99
Cat. 152

This headdress with female figure, whose right arm is broken off, is of a type presumably used in dances known as *ogbom*, fertility rites that today are performed for entertainment. In the late 1940s Murray reported that *ogbom* were held in midyear, on every eighth day for a period of eight weeks. Two of the male dancers, he said, wore headdresses. It may be assumed that these dancers represented male-female pairs, since the known headdresses include male as well as female figures.

The figure on the present mask represents a nude young woman with a budding figure. With feet securely planted on the base, the legs are bent and buttocks, arms and shoulders thrown back. This posture recalls the movements of the *mbobo* dance, performed by adolescent girls when, well-fed and clad only in a narrow belt of beads, they return from a period of seclusion to the village, where their future husbands await them. The figure's serious facial expression and lowered eyes likewise correspond to the behavior expected of girls during this ceremony.

As field observations made by Jill Salmons and Keith Nicklin indicate, this headdress can be attributed with great certainty to the Eket. Stylistic affinities with works of the Ogoni on the one hand, and with those of the Bende-Igbo on the other, apparent especially in the treatment of the eyes and brows, can be explained by the close contacts that existed among these groups even in the precolonial period, when cultural exchange took place along the trade routes.

Bibliography: Neyt, 1979a; Roy, 1992; Nicklin/ Salmons, n.d.d

Group of various Ogoni and Pannang masks and figures, 1899.

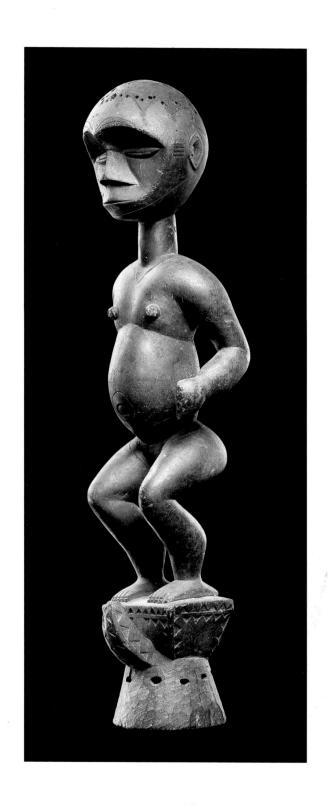

Face mask

Ibibio, Nigeria

Wood with dark patina
Diameter 28 cm (11 in.)
Inv. 1014-66
Formerly collection of J. Blanckaert, Brussels
Cat. 153

Based on François Neyt's research, round flat masks with a small human face have been attributed primarily to the Eket (southern Ibibio). Yet Kenneth Murray saw masks of this type among the neighboring Oron and Okobo, an observation recently confirmed by Jill Salmons and Keith Nicklin (in unpublished findings). In the Eket region the mask seems to be associated mainly with performances called *abubom*. With the Oron and Okobo, in contrast, it is used by the exclusive Ekong association, which is known for the impressive masked dance spectacles it stages for entertainment and for the elaborate funerals of its prosperous members.

In this mask, the nearly circular face is divided into two halves. The rounded forehead above the horizontal brow ridge has incised eyebrows and a narrow triangle whose point extends almost to the bridge of the nose. The eyes, a broad nose, and a thin mouth are located in the lower part of the face. The mask's rim is decorated with a continuous triangle pattern, interrupted by four arc segments opening outwards.

Salmons and Nicklin interpret the formal and ornamental elements of this and comparable masks as lunar symbols, seeing as the Eket are familiar with a corresponding symbolism, expressed in a connection between the female creation divinity, or "Great Mother" (*eka abbassi*), and the moon. The circular shape of the mask would accordingly represent the full moon and the triangular motifs its rays, while the shape of the eyes and the arc segments would suggest the new moon.

Round face masks, thought to represent lunar symbols, have been observed among various Ibibio subgroups. A face mask placed on the floor in Afaha, Ekpedebi Eket, 1992.

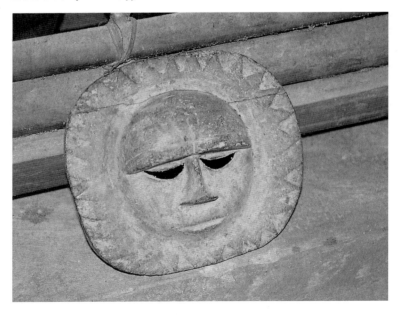

Bibliography: Eyo, 1977; Forde/Jones, 1950; Neyt, 1979a; Nicklin, 1988, p. 174; Nicklin/Salmons, n.d.e

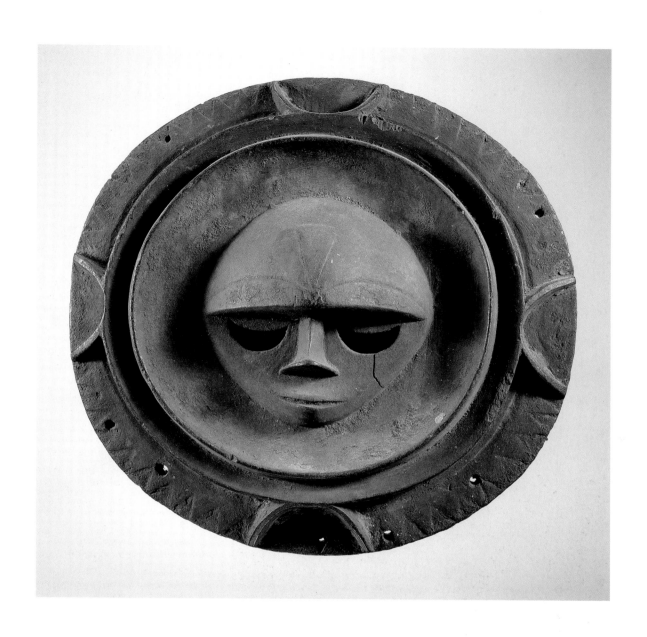

Headddress mask

Boki, Nigeria

Wood with reddish-brown primer and traces
of blackish-brown paint, metal teeth
Height 20.5 cm (8 ⅛ in.)
Inv. 1015-54
Cat. 155

Though the place of origin of this mask is not known, certain stylistic details speak for a provenance among the Boki. This ethnic group inhabiting the Cross River area of southeastern Nigeria uses various types of masks, including depictions of human heads. These are worn as a headdress, either individually, in pairs, or occasionally in threes, during the *nkuambuk* rite.

The present mask head evinces striking formal similarities with a two-headed Boki headdress mask offered in the trade in 1976: a hairline ending in a point in the middle of the forehead; emphasized eyebrows arching over recessed eye sockets; and especially, scarifications on the temples and in two lines that curve from below the eyes across the cheeks. At the same time, the narrow, almond-shaped eyes and the pursed lips, which were originally fitted with rows of metal teeth, recall the *okua* mask type, found in the Cross River region among ethnic groups ranging from the Idoma to the Boki and others (cf. plate 58).

Because of the circular hole at the back of the skull it was suggested that the mask was originally attached to another head at this point. Its location in the upper area of the back of the head, however, contradicts this assumption. More likely the head was individually attached to a basketweave cap, and, as is usually the case with this mask type, was covered with elaborately draped textiles. On the other hand, perhaps the mask, like the leather-covered headdresses, originally had bunches of feathers or even tufts of human hair inserted in the holes of the coiffure.

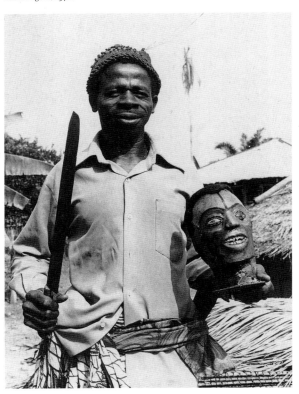

Dignitary of a warrior's association with leather-covered headdress mask, Keaka region, 1978.

Bibliography: Kamer, 1976; Nicklin, 1974; Nicklin/Salmons, 1984; Nicklin/Salmons, n.d.f; Vion, 1988, p. 162

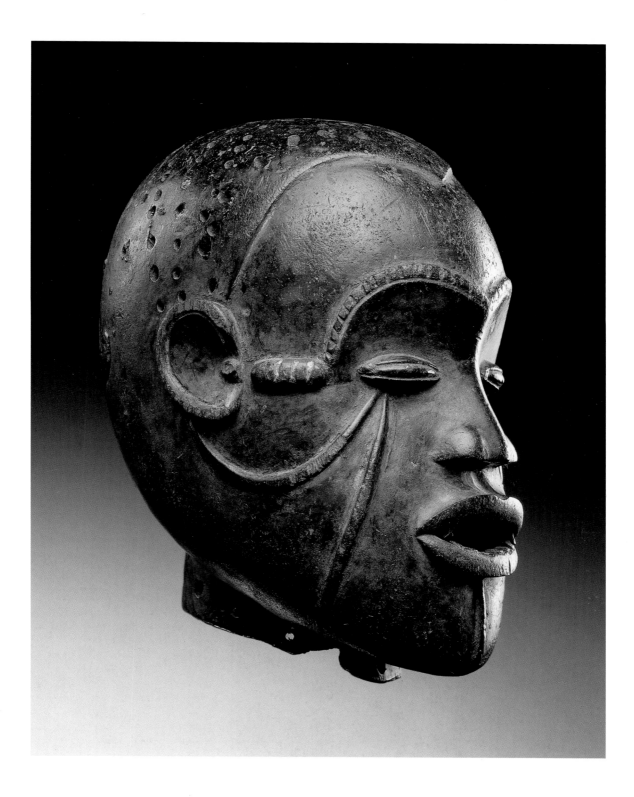

Female helmet crest, used in *okperegede* dances

Igbo (Izzi group), Nigeria

Wood painted in black and white
Height 49 cm (19 ¼ in.)
Inv. 1014-101
Cat. 157

A mask almost identical to the present one was observed in 1983, during a performance of an *okperegede* dance among the Izzi, who live in the northeastern Igbo region. Representing *eze nwanye*, or "Queen of Women," the masquerader embodied the maternal character in a group of masquer-aders who formed a family. She was described as the wife of the legendary warrior *asufu*, the main protagonist of the *okperegede* piece, whose appearance usually relegates the female characters to the back-ground. In this performance, a rare thing occurred. *Eze nwanye* accompanied two of her daughters onto the dancing ground, and as the rhythms of the orchestra mounted in intensity, all three female masquerade figures performed solo dances expressive of great pride, even hauteur.

Masks of this kind are not limited to a certain role. They can represent any number of characters, depending on the plot of the performance, and their meaning may differ from place to place or change over time.

Finely modeled in gentle convex and concave forms, the mask's narrow eye slits, straight nose, and protruding, slightly open mouth, convey a harmonious impression, augmented by the black-white contrast of the painting. Black lines and concentric circles on the temples evoke the scarifi-cation pattern typical of the northeastern region. These are supplemented by tattooed lines which run vertically over nose and forehead, and from the corners of the mouth toward the ears. The carefully carved hair forms four arches over the forehead, and on top it is twisted into a braid held by a comb. A figure with a white face, which François Neyt interprets as a depiction of a child, holds tightly to the back of the head and gazes expectantly.

Bibliography: Cole, n.d.; Cole/Aniakor, 1984; Neyt, 1985

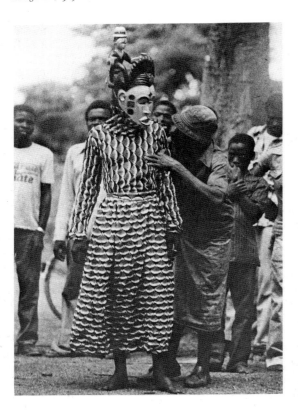

Eze nwanye, "Queen of Women," during an *okperegede* performance in Amagu Izzi, 1983.

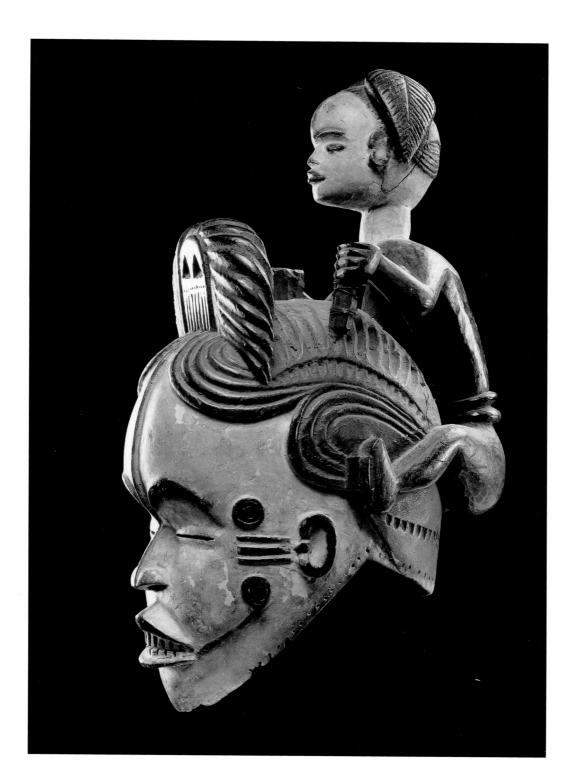

Helmet crest (*Ogbodo enyi*)

Igbo (northeastern Igbo), Nigeria

Wood, painted black and white with red accents
Length 59 cm (23 ¼ in.)
Inv. 1014-15
Formerly collection of Dr. W. Muensterberger
Cat. 158

Performance of an *ogbodo enyi* masquerader
among the Izzi.

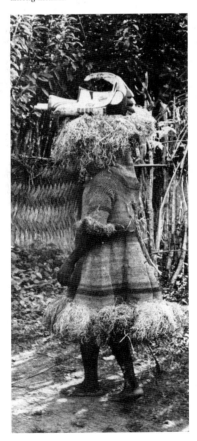

This type of helmet crest, representing an
elephant spirit (*ogbodo enyi*), is found in
the northeastern Igbo region, where it is
used by the Izzi, Ezzi, and Ikwo, as well as
by some of the neighboring groups. These
masks are supervised by the five or six age
ranks, members of the highest rank owning
the largest specimens, which embody the
most feared and powerful spirits. Originally
the masqueraders performed aggressive
and even violent dances intended to main-
tain law and order, but today their function
is limited largely to entertainment.

The front of this example consists of
an elephant's head, strongly schematized
and composed of geometric volumes (facing
right in the photograph). Its conical eyes
project from a semicircular plate, and its
short trunk lies along the boxy, concave-
sided lower part of the head. Two slightly
curved, short tusks emerge on either side
of a triangular mouth opening. The back
of the mask (facing left) displays a human
head projecting from a diamond-shaped
field. It has raised vertical scarification lines
on forehead and cheeks, semicircular ears,
a top-knot coiffure, narrow close-set eyes,
a thin nose, and an oval, tooth-studded
mouth in the conically tapering lower face.
A striking black and white color scheme
accented in red underscores the plasticity
and expressiveness of the mask. The holes
along the lower edge held the raffia fibers
which hid the head of the dancer, who wore
a knee-length costume woven of plant
fibers.

Bibliography: Cole, 1988; Cole/Aniakor, 1984;
Neyt, 1979b; Nicklin/Salmons, 1984

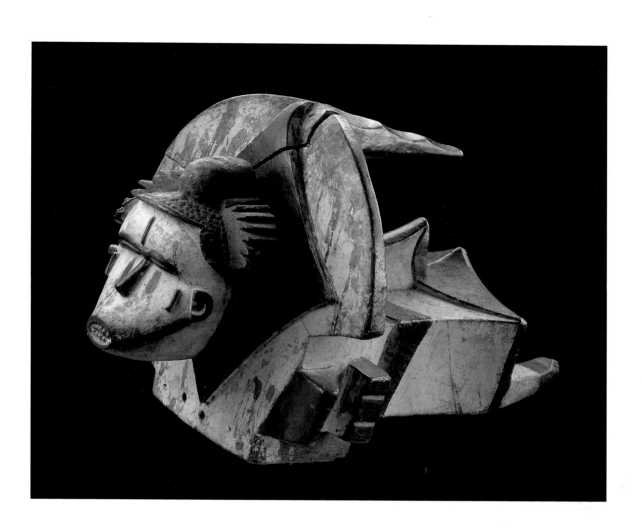

Face mask

Igbo (Uzouwani and southwestern Nsukka region), Nigeria

Wood with traces of white and red paint
Height 68.2 cm (26 ⅞ in.)
Inv. 1014-92
Cat. 159

Numerous types of mask have been recorded among the Igbo, who are divided into small territorial groups that inhabit southeastern Nigeria. Their forms range from quite realistic to schematic to completely abstract, with regional differences in style.

Semi-abstract mask styles, such as these *mma ji*, or yam knife masks, are also used by the Afikpo, in the eastern Igbo region.

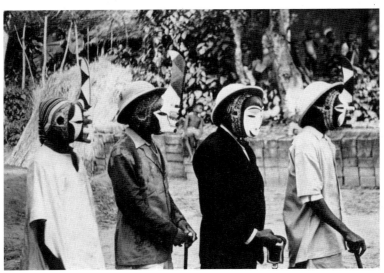

The abstract yam knife masks (*mma ji*) with sickle-shaped superstructures and striking color schemes, used by the Afikpo of the eastern Igbo region (cf. cat. 161) have become particularly well-known. The present example, in contrast, originated in the extreme north of the Igbo region, either from Uzouwani or from the adjacent southwestern Nsukka area.

This mask is marked by a lucid, geometric composition. The central cone, worn over the face, is framed by a flat, rectangular shape into which triangular openings have been cut. Its zigzag motif is repeated in the tall vertical plank rising from the base of the face-cone.

Though detailed information about the function and meaning of such masks is not yet available, some have been observed in performances held during celebrations to mark the conferring of men's titles. Such titles, acquired by the payment of high fees, are hierarchically ranked and determine the prestige and status of their bearers in the community. Beyond this, we may assume that masks of this type are danced in the context of harvest rites and funeral ceremonies, as they are in other Igbo groups.

Bibliography: Cole, n.d.; Elsas/Poynor, 1984; Ottenberg, 1975

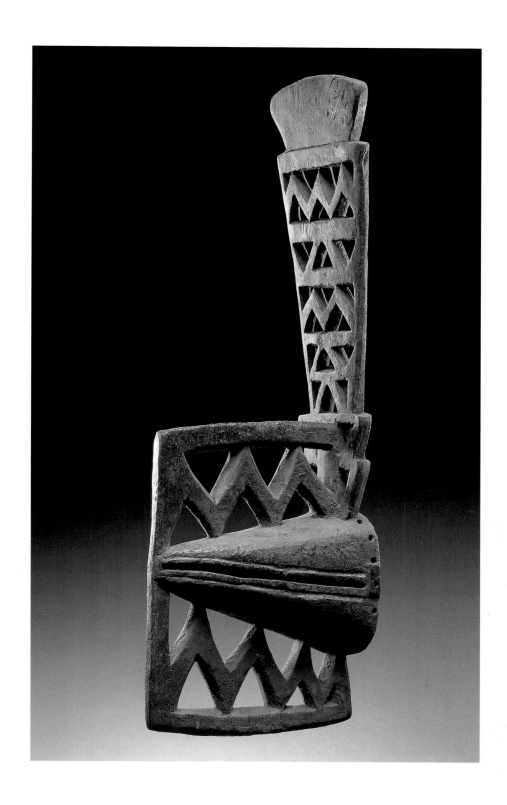

Face mask (*Opa nwa, agbogho okumkpa, agbogho mma*)

Igbo (Ada group), Nigeria

Wood painted in white, black, red, and yellow
Height 60.5 cm (23 ⅞ in.)
Inv. 1014-85
Cat. 160

This type of mask, whose face portion is surmounted by a female figure, is very popular among the Ada, an eastern Igbo group. It is known by various names. *Opa nwa* means "woman carrying a child," despite the fact that the seated figure here apparently represents a grown woman. *Agbogho akumkpa* refers to the "adolescent girl in the *okumkpa* dances," and *agbogho mma* means the "spirit of the adolescent girl." Although the mask represents a female figure, the dancers are invariably young or adult men, who entertain the audience by imitating or parodying women's behavior during the *okumkpa* performances or *njenji* dances. One of the most popular *okumkpa* skits is a sequence in which the masquerader imitates a young, marriageable girl who refuses to get married.

Stylistically, this mask conforms to the classical canon of the northern Igbo, combined with certain elements found in Ada masks. Characteristic of northern Igbo work are the white ground of the face, protruding mouth, high-bridged nose, arched eyebrows painted black, circular forehead ornamentation, and scarification patterns on the temples. On the other hand, it has features that recall Ada pieces — the cheek markings on both faces, the lack of ears in the mask proper, and the design of the seated figure.

Bibliography: Cole/Aniakor, 1984; Ottenberg, 1975; Ottenberg, n.d.

Dancer wearing an *opa nwa* mask in an *okumkpa* performance, 1960.

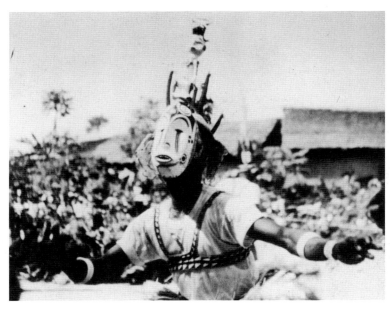

Face mask (*Ikpobi*)

Idoma (Akweya group), Nigeria

Wood with remnants of yellow ocher and black
paint over white ground
Height 24 cm (9 ½ in.)
Inv. 1014-87
Cat. 168

A group of face masks, photographed in the
village of Akpagedde. Except for the one at the
lower left, all were carved by Adaba, in the mid
1940s. Like Ochai, to whom the mask in the
Barbier-Mueller collection is attributed, Adaba
was born in Otobi, a village in the Akpa district.

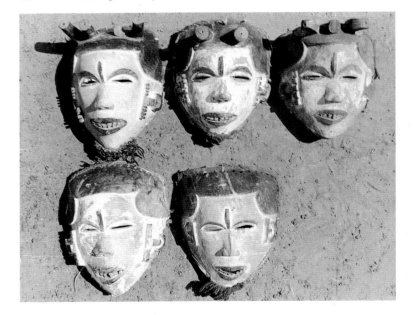

Anthropomorphic face masks are used both
by the northern Igbo and by the southern
Idoma. Among the Idoma, *ikpobi* masks
like this one belong to younger men's age-
grade associations. This masquerading
tradition presumably emerged from the
dances once performed by warriors return-
ing home from battle and presenting their
enemies' heads as trophies to the village.
The age-grades lost their military function
with the onset of the colonial period, and
such victory celebrations ceased. Today
ikpobi maskers appear primarily at funeral
ceremonies, and always in male-female
pairs.

The formal design of the face shows
the mask to be an Idoma work. It has the
typical traits of a hairline formed by three
arcs, narrow eye slits, a protruding, slightly
open mouth with two rows of teeth, and
characteristic scarification marks running
vertically from temples to cheeks and over
the middle of the forehead, nose, and chin.
Based on stylistic comparisons, the mask
was attributed to the workshop of the carver
Idoko, of Adim. It was probably fabricated
by Idoko's pupil, Ochai, who came of the
village of Otobi in the Akpa district, and
was active from 1920 to 1950.

Bibliography: Kasfir, n.d.; Neyt, 1985; Sieber, 1961

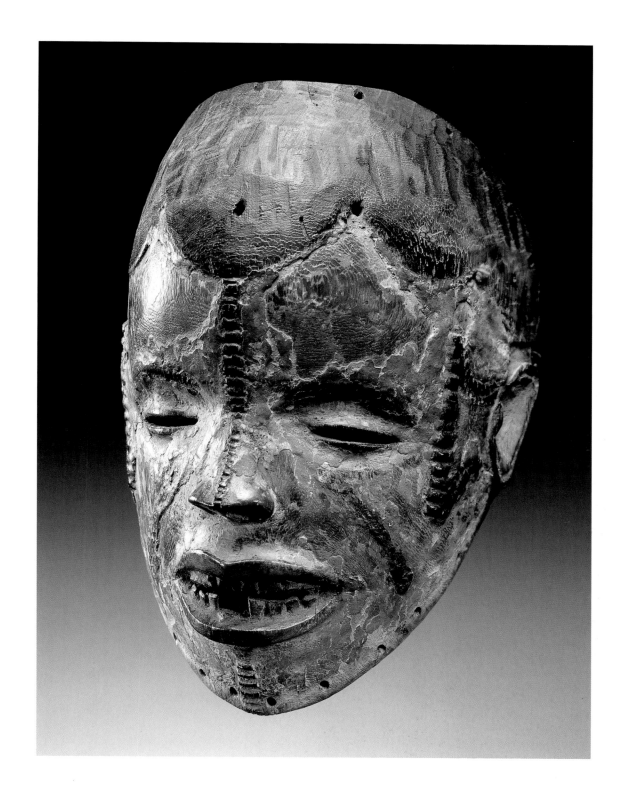

Forehead mask (*Kiavia*)

Mambila, Cameroon/Nigeria

Wood, painted in red, white, and blackish-brown,
cord of plant fibers
Height 30 cm (11 ¾ in.)
Inv. 1018-76
Cat. 171

The Mambila inhabit an area south of the
Adamaua Mountains that straddles the
border between Cameroon and Nigeria.
They use various types of masks during
celebrations called *suaga*, which take place
twice a year, at the beginning and end of

A masquerader in a striped fiber costume prepares for his performance.

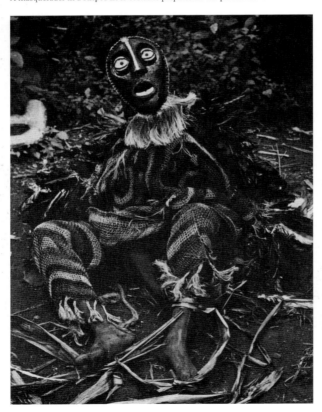

the agricultural cycle. In general, women
are excluded from these masquerades, both
as actors and as spectators.

Based on the scanty information we
have about these rare masks with human
features (*kiavia*), they are kept in the
possession of very old men. Also, as earlier
film and photo documents indicate, the
maskers wore colorfully striped costumes
and appeared in the company of the more
significant cap maskers, who wore *suaga*
(cf. plate 60).

Mambila works have a unique, un-
mistakable style. The formal design of this
kiavia mask corresponds to the faces of
Mambila carved figures. The face itself is
formed by a heart-shaped, concave de-
pression from which cylindrical eyes and an
unusually long curved nose emerge. At the
lower edge is an oval mouth whose lips are
accentuated by rows of vertical notches. Its
paint, a combination of red, white, and
blackish-brown characteristic of Mambila
pieces, emphasizes the striking, slightly
asymmetrical facial features and heightens
the mask's expressiveness. One can only
speculate about the symbolic meaning of
this color scheme, since detailed inves-
tigations have yet to be carried out. The
expensive camwood powder used, which is
imported from the forested region to the
west, may, as in the neighboring Grasslands,
serve to emphasize the solidarity of the
kinship community. Earlier, *kiavia* masks
were also made of clay, but these masks
were supposedly valued less highly than the
wooden ones on account of their fragility.

Bibliography: Gebauer, 1979; Northern, 1988,
p. 185; Schwartz, 1972; Zeitlyn, n.d.

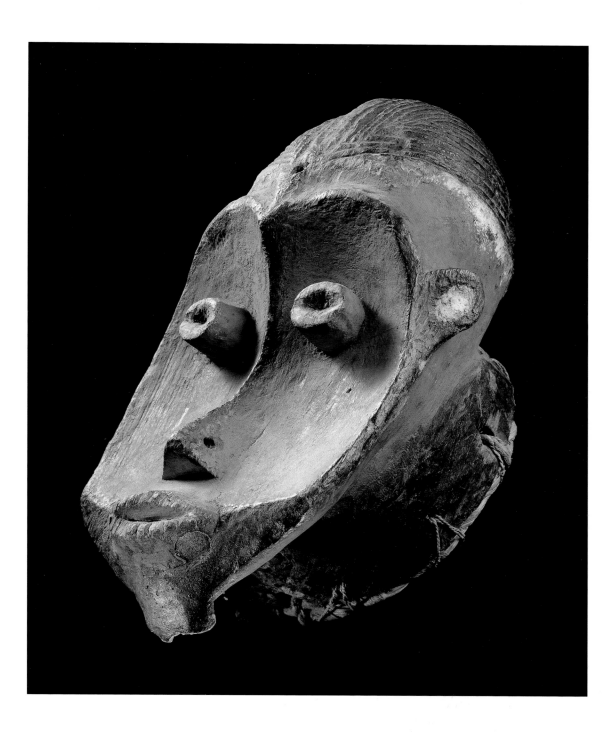

Helmet crest (*Suaga*)

Mambila, Cameroon/Nigeria

Wood, painted black and accented in white
and red, nails
Height 38 cm (15 in.)
Inv. 1018-77
Cat. 170

The most important masks used at Mambila *suaga* celebrations are called *suaga due* ("Big *suaga*") and *suaga bor* ("Dog *suaga*"), though investigators have as yet not been able to clarify the precise difference between the two types. In some Mambila villages the *suaga due* masqueraders are distinguished by costumes with an additional feather adornment; in other places, the designation *suaga due* is applied to every mask. Moreover, the masks have individual names which derive not from their appearance but from the magic substances which lend the masks their power. This circumstance has led David Zeitlyn to conclude that for the *suaga bor* masks substances might be used whose preparation requires the ritual sacrifice of dogs.

This *suaga* mask has zoomorphic features which are difficult to associate with any one species of animal. While the gaping mouth lined with sharp teeth calls a dog to mind, the head displays two long, curving horns. Viewed in profile, it shows a sweeping convex curve extending from the forehead to tip of the snout. A sparing application of white paint emphasizes the pointed ears with triangular ridges, the outer ring of the cylindrical eyes, the rows of teeth, three parallel notches on the horns, and a small, notched, central ridge along the upper snout. The holes on the sides of the headpiece were used to attach a voluminous woven costume that concealed the masker's body.

Bibliography: Gebauer, 1979; Schwartz, 1972; Zeitlyn, 1994; Zeitlyn, n.d.

Suaga due masquerader in a costume adorned with feathers.

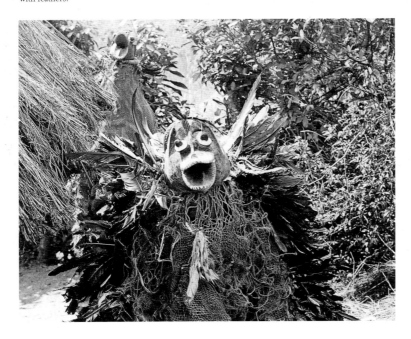

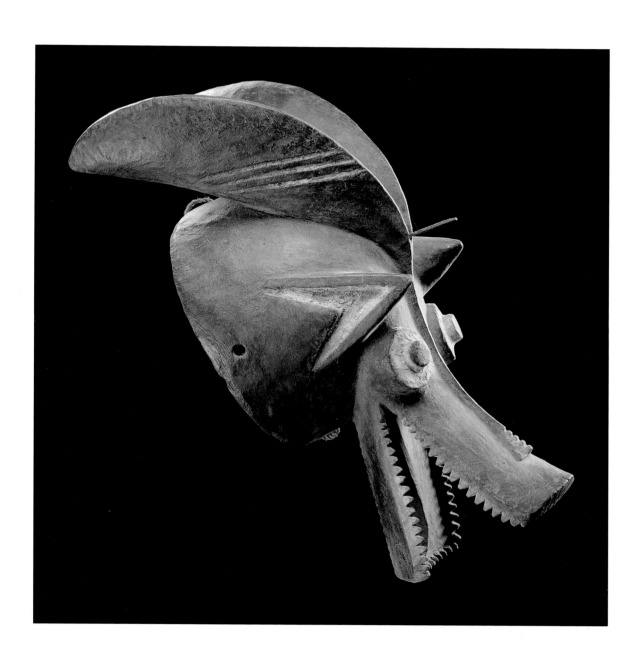

Helmet mask

Mambila, Cameroon/Nigeria

Wood with encrusted patina and remnants
of blackish-brown paint
Height 40 cm (15 ¾ in.)
Inv. 1018-85
Formerly collections of Charles Ratton
and Arman
Cat. 172

Although this sparingly painted anthro-
pomorphic helmet mask with large, drilled
ears cannot be associated with any known
Mambila mask type, it does share certain
typical traits with this ethnic group's figu-
rative sculpture and other masks with
human features (cf. plate 59). Underneath
the jutting forehead is a characteristically
shaped eye cavity ending in a small, trian-
gular nose. The large, almond-shaped eyes
with raised lids begin immediately at the
bridge of the nose. Although this eye form
is atypical of Mambila masks, most of which
have cylindrical, closed eyes, it is seen in a
number of figurative sculptures, especially
in *kike* figures (illus. this page). Also unusual
is the very large, open mouth, whose upper
lip is formed by a centimeter-wide band
emerging immediately beneath the convex
upper face, and whose lower lip, with sug-
gestion of a goatee, markedly protrudes.

A remarkable detail is the three rows
of ridges accentuating the eyebrows and ex-
tending vertically over the forehead to the
crest-like crown of hair. This pattern does
not correspond to the stylistic repertoire of
the Mambila, but is found in works of the
Cross River area and of the neighboring
Grasslands. Similar, sometimes dual-headed
helmet masks with large eye openings and
gaping mouths are known from these areas.
The Mambila maintained trade contacts
with their neighbors and were probably
familiar with Cross River and Grassland
masking traditions. These forms perhaps
inspired the carver to create the present
work.

Bibliography: Gebauer, 1979; Harter, 1986;
Zeitlyn, 1994

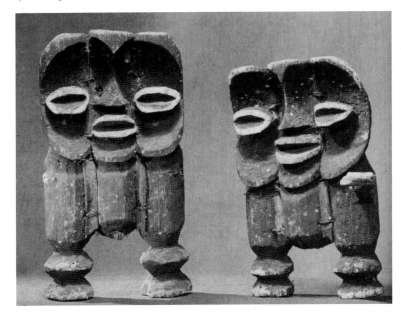

Male (left) and female (right) *kike* figures of the
Mambila. Like the helmet mask in the Barbier-
Mueller Collection, they display almond-shaped
eyes, a triangular nose, and a concave face area.

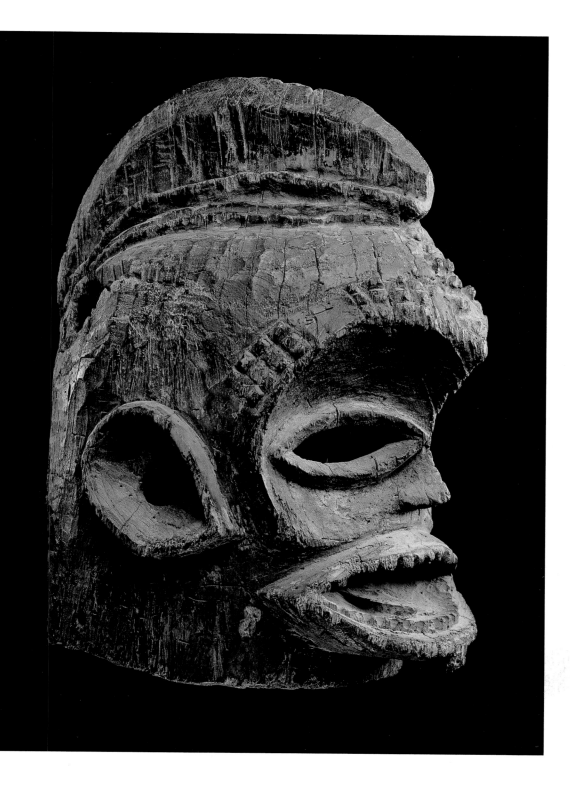

Helmet crest (*Ngoin*)

Western Grasslands, Cameroon; Babanki style

Wood painted blackish-brown with traces
of white
Height 50 cm (19 ⅝ in.)
Inv. 1018-43
Formerly collection of Josef Mueller;
acquired before 1939
Cat. 173

Ngoin masks are one of several types that appear in memorial ceremonies held for important deceased persons in the kingdoms of the Cameroon Grasslands (Bafut, Bekom, Big Babanki, Ndop, Oku, and others). These mask ensembles, in the possession of various lineages, can comprise more than twenty masks, most of which represent different figures. A few of the mask types are obligatory, such as *kam* (or *akam*), the leading male mask, and *ngoin*, which represents his wife. Frequently other female masks occur, and these are described either as subordinate wives or as daughters of *kam*.

In contrast to *kam*, a mask worn flat on the head, *ngoin* is invariably designed as a three-dimensional helmet crest. The male dancer's head is concealed by a thin cloth; his costume consists of a loose garment of cotton fabric which is often dyed bluish-white. A fly switch completes the outfit.

Since the facial features of the present *ngoin* mask permit no determination of gender, it can be identified as female only on the basis of the tongue-shaped coiffure, which, according to Tamara Northern, corresponds to that of royal wives. In addition, the headpiece recalls the cap worn by kings and various dignitaries in this region.

The formal design of the mask bears affinities with an example Marcilene Wittmer associates with the classical Babanki style, characterized by a rather narrow, long face and wide-spaced eyebrows outlined by an engraved contour. The inner corners of the almond-shaped, often white-bordered eyes lie close together and at the height of the bridge of the nose. The notches around the nostrils meet at the point of the nose.

Bibliography: Fagg, 1980; Förster, 1988b; Gebauer, 1979; Harter, 1986; Koloß, 1980; Northern, 1973; Northern, 1984; Northern, 1988, p. 190; Wittmer, 1991

Masquerade dance in Big Babanki, 1976.

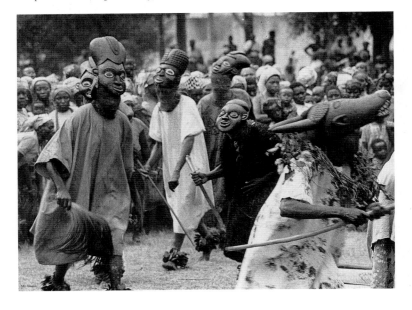

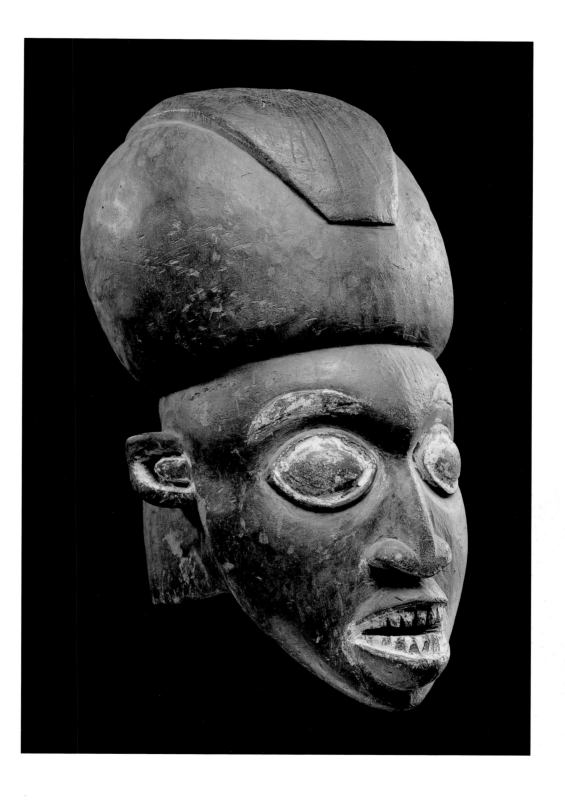

Helmet crest

Western Grasslands, Cameroon; Babanki style

Wood patinated by wear
Length 112.3 cm (44 ¼ in.)
Inv. 1018-82
Cat. 175

Most of the wooden masks from the Cameroon Grasslands now in Western collections were once in the possession of individual lineages. There are only rare examples of the dangerous masks used by the politically influential men's associations active under various names (Kwifon, Nwerong, Troh, etc.) in every kingdom of this region, or of the masks of the Ngirih association of princes and the Manjong military organization.

The lineage masks, which appear principally at memorial services for the dead, include both anthropomorphic and zoomorphic types, the latter representing such animals as buffaloes, apes, sheep, bats, and various species of birds. Elephant masks are only occasionally included in this group, since the elephant, like the leopard, is considered a royal animal and the use of an elephant mask is therefore the special privilege of certain lineages. Whenever an elephant masquerader is present, he assumes the second most important position after the human *kam* masquerader. The elephant figure is the first to appear on the dance ground and the last to leave it, and in accordance with his status, his movements are stately and slow.

This fine elephant mask, worn horizontally on the head, can be classified in the well-known Babanki style of the northwestern Grasslands. Although the proportions of head, ears, trunk, and tusks do not correspond to the natural model, the realistic tendency of the depiction is striking and characteristic.

The neighboring Bamileke primarily use hood-shaped cotton masks adorned with glass beads which combine human features with stylized elephant traits. They are worn by members of the elephant society, which is subordinate to the ruler.

Bibliography: Gebauer, 1979; Harter, 1986; Koloß, 1980; Northern, 1984; Perrois, 1994; Wittmer, 1991

Elephant masks seldom belong to the mask groups of the lineages. This performance was observed in Oku in 1976.

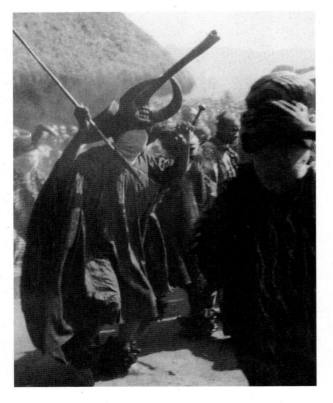

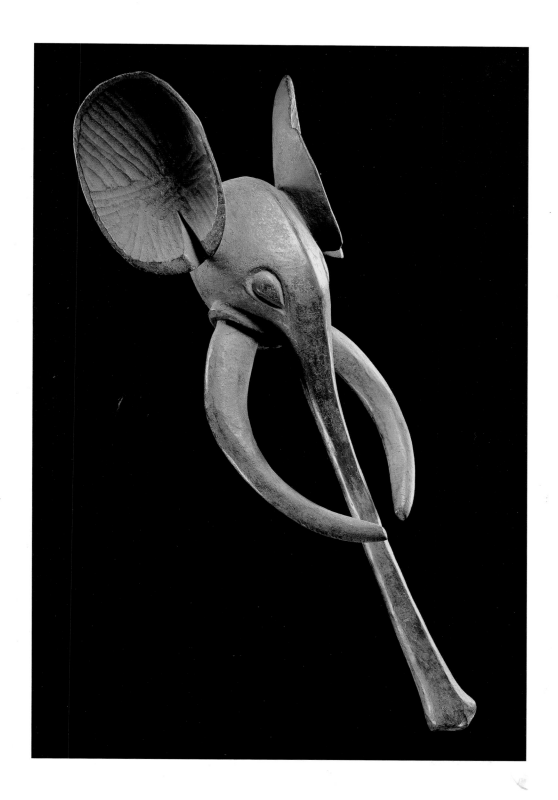

Dual-faced mask of the Troh night society

Bangwa, Cameroon

Wood with traces of kaolin
Height 41.5 cm (16 ⅜ in.)
Inv. 1018-65
Cat. 176

The settlement area of the Bangwa in the southwestern Grasslands is divided into several smaller, autonomous chiefdoms whose rulers govern with the aid of the nine highest-ranking members of the Troh, a men's association known as a "night society." These men play an important role at the funerals of deceased chiefs and in the enthronement of their successors; they also maintain law and order by pursuing criminals and other evil-doers. Each of the nine notables of a chiefdom owns a mask as symbol of his authority. It is considered extremely dangerous, and must be treated with the greatest caution under the strict observance of ritual stipulations. Though designed as headdresses, Troh masks are carried on the shoulder to avoid contact with the head. They are kept in storehouses outside the village, and guarded by a servant.

Most Troh masks have two faces, though three- and four-faced examples exist as well. They can be classified in terms of two general styles, a more realistic one that recalls the work of the neighboring Bamileke, and a more abstract style based on cubic volumes. The present mask has eyebrows in the form of sweeping, semicircular projections that meet in the middle to form an anchor-shaped nose; the outer edges continue around the eye sockets to meet over the mouth. The broad lips are notched to represent rows of teeth, and the spherical protuberances flanking the mouth are apparently stylized representations of cheeks. This configuration can still be seen today in the works of Atem, a woodcarver active in the western Bangwa region.

Bibliography: Brain/Pollock, 1971; Harter, 1986; Lintig, 1994; Northern, 1988, p. 188

Since Troh masks are considered to be extremely dangerous, the members of this night society carry them on their shoulders instead of wearing them.

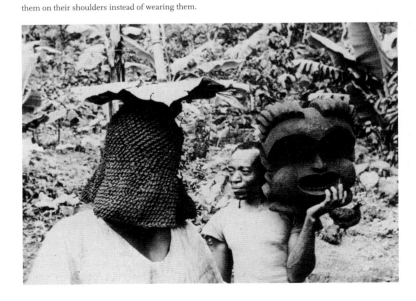

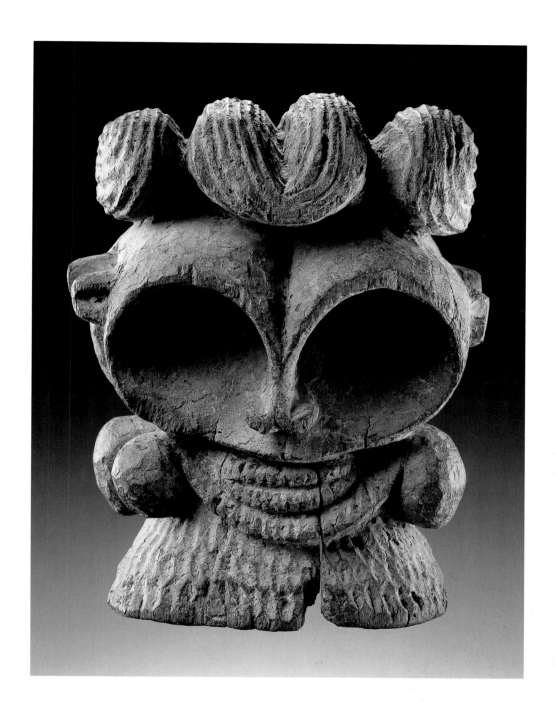

Forehead mask (*Nyatti*)

Duala, Cameroon

Wood, painted in black, white, and red,
iron tongue
Length 76 cm (29 ⅞ in.)
Inv. 1018-2
Formerly collection of Josef Mueller;
acquired before 1939
Cat. 177

The Duala, who inhabit the coastal area of Cameroon between the rivers Wuri and Sanaga, were subjected to European influences at an early date, through commercial contacts and missionary activity. Their artistic repertoire includes polychrome zoomorphic masks, colorfully painted boat prows with figurative motifs, boat models, and chairs. Duala masks were used by various men's associations (known as Losango), including the Ekongolo society, whose members, according to Schurtz, wore antelope masks in the context of funeral rites. However, the majority of Ekongolo masks now in Western collections represent

Shelter with various ritual objects of the Duala, including a *nyatti* mask. Display at an exhibition of the Basle mission, 1927.

buffalo, and according to the records of one of their collectors, Zintgraff, were called *nyatti*.

The idea of horned masks might possibly go back to the influence of the Grasslands, where this type was, and still is, widespread. With the Duala, however, it underwent a stylistic modification. In place of a full, three-dimensional design, the masks from the coastal region evince a low-relief, geometrical approach which is echoed in the painted decoration. The patterns applied in casein or oil colors may have a symbolic significance as well, though scholars are still as uncertain on this point as they are about the meaning and function of the masks themselves.

This aesthetically compelling buffalo mask is painstakingly crafted and has a finely proportioned composition that attests to the carver's mastery of form and color. The elongation of the trapezoidal face is emphasized by a narrow, vertical black ridge along the nose, and by diagonally protruding, pointed ears. This linear articulation is counterbalanced by the ring-shaped horns, the concentric eyes, and the round and ellipsoid elements in the decor. The animal's tongue is formed by an old iron hoe blade, also painted.

The Museum of Ethnology in Munich has a stylistically similar mask, with a simpler decor in white lime and poker work, acquired as early as 1888.

Bibliography: Fagg, 1980; Frobenius, 1897; Gardi, 1994; Himmelheber, 1960; Karutz, 1901; Kecskési, 1982; Krieger/Kutscher, 1960; Northern, 1984; Perrois, 1988, p. 199; Schurtz, 1902

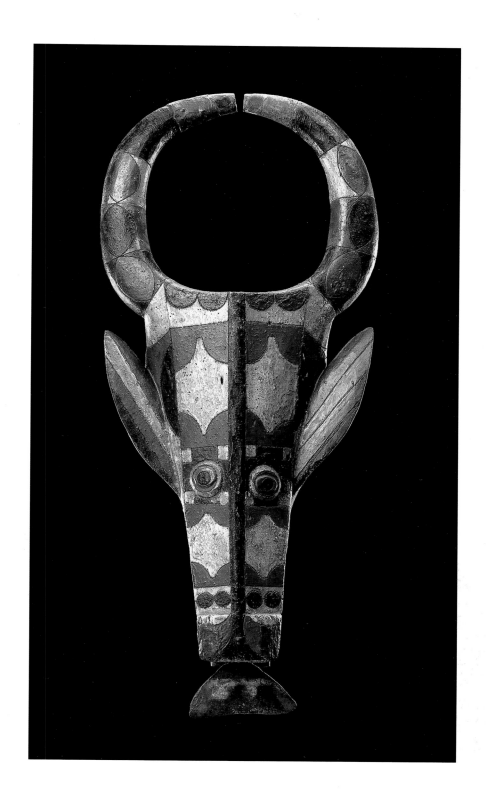

Face mask (*Ngil*)

Fang, Gabon or Equatorial Guinea

Wood, painted in white, yellow ocher,
and gray-green
Height 44 cm (17 ⅜ in.)
Inv. 1019-14
Formerly collection of Josef Mueller; acquired
from Mme. Charles Vignier before 1939
Cat. 178

Various *ngil* and *ngontang* masks of the Fang,
as recorded in the sketchbook of the missionary
Fernand Grébert between 1913 and 1917.

The white-faced *ngil* masks of the Fang, a people of Equatorial Guinea, northwest Gabon, and south Cameroon, represent a masquerading tradition that waned over sixty years ago. Our knowledge about these masks is accordingly scanty, though it would appear that they were worn by members of a male society of the same name during the initiation of new members and the persecution of wrong-doers. Masqueraders, clad in raffia costumes and attended by helpers, would materialize in the village after dark, illuminated by flickering torchlight.

The present *ngil* mask has the elongated head and heart-shaped, concave face characteristic of the type. Three incised lines lead from the point of the long nose over its flattened bridge and the round forehead to a sagittal comb, a typical stylistic feature of southern Fang masks. This linear decor recalls that of a mouthless *ngil* mask in the Munich Museum of Ethnology, though our example has a thin-lipped mouth protruding just below the nose. The poker-work ornaments on the temples and below the narrow eye-slits resemble certain tattoo patterns observed by Günter Tessmann among the Ntumu and Mvai groups of the Fang. The typical face-painting with white kaolin clay, invoking the power of the ancestors, indicates that the mask was intended to embody spirits of the deceased.

Bibliography: Bay, 1975; Bolz, 1966; Kecskési, 1982; Perrois, 1985; Perrois, 1988, p. 207; Perrois, 1996; Sieber/Walker, 1987; Tessmann, 1913

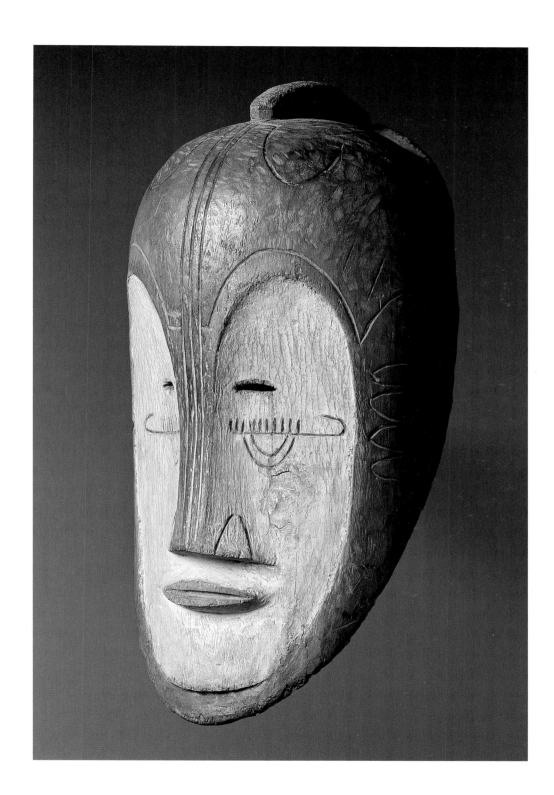

Helmet mask with four faces
(*Ngontang*)

Fang, Gabon or Equatorial Guinea

Wood, painted in white and dark brown
Height 39 cm (15 ⅜ in.)
Inv. 1019-23
Formerly collection of Josef Mueller; acquired
from Mme. Charles Vignier around 1935
Cat. 179

Though *ngontang* masks are danced only for
entertainment purposes nowadays, they were
apparently once used in rituals of the Bieri
ancestor association and to punish wrong-doers.

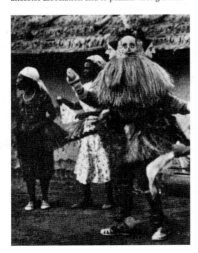

Fang *ngontang* masks, which may have two,
four, five, or six faces, probably developed
from earlier single-faced examples. The
morphology of the multiple-faced form can
be traced back to the first decades of the
century. A number of such masks were
recorded by the missionary Fernand Grébert
in a sketchbook used from 1913 to 1917.
According to Louis Perrois, they were worn
in rituals of the Bieri ancestor association
and to detect wrong-doers. Today such masks
serve primarily to entertain audiences on
festive occasions.

The four ovoid faces of the present
helmet mask slightly differ from one another
in terms of size and decoration. All evince the
heart-shaped depression below arched eye-
brows, the narrow eye-slits, and small, rec-
tangular mouth opening which are typical
of the Fang style. The two horizontal lines
of holes across the cheeks recall face tattoo
patterns used by this ethnic group. Other
patterns, in the form of punctured or in-
cised arcs, are found below the projecting
nose and on the forehead of the three
smaller faces. The major, somewhat larger
face has parallel vertical lines of holes on
the forehead and a square of punctures on
the chin, which may have been intended to
represent a beard. The mask's wearer looked
out through the two rectangular openings
cut into the helmet portion below the face.

As a stylistically comparable, likewise
four-faced *ngontang* mask in the Munich
Museum of Ethnology indicates, raffia fibers
were originally inserted in the holes at the
lower edge to form a sort of ruff.

Bibliography: Bay, 1975; Binet, 1972; Bolz, 1966;
Fagg, 1980; Kecskési, 1982; Perrois, 1985;
Perrois/Sierra Delage, 1990

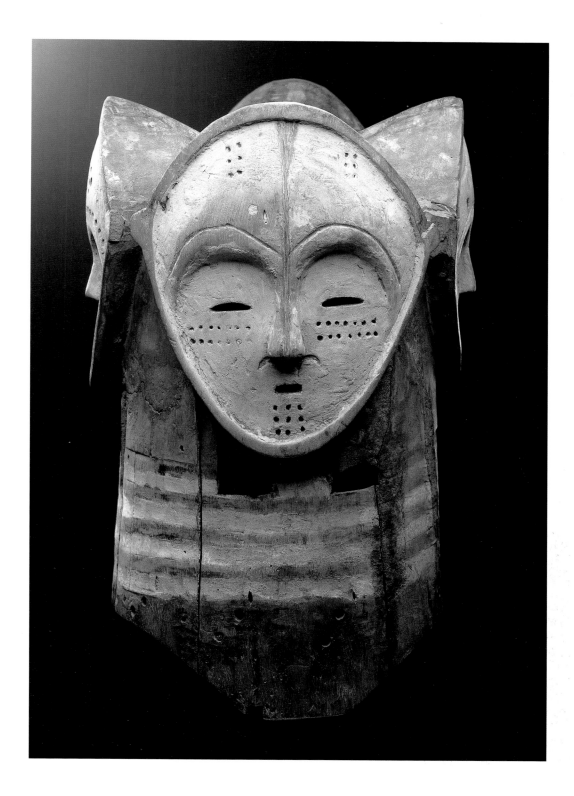

Face mask

Fang, Gabon or Equatorial Guinea

Wood, painted in white and brownish tones,
brass nails
Height 24 cm (9 ½ in.)
Inv. 1019-16
Formerly collection of Josef Mueller;
acquired before 1939
Cat. 184

No precise information is available concerning the origin and function of this mask. The task of classification is made even more difficult by the stylistic affinities it evinces with works both of the Fang and of the Punu and Lumbo of south Gabon. The rounded cheeks and chin, the narrow eye-slits between arched, almond-shaped lids, and the figure-eight contour of the mouth, bear a striking resemblance to certain Punu-Lumbo masks (cf. plate 75). The coiffure with its lateral bunches of hair and flat, shield-like arrangement above, is also found in works of these ethnic groups. However, nineteenth-century travelers reported seeing just such hairstyles among the Ntumu in Equatorial Guinea and the Betsi in northern Gabon, two southern subgroups of the Fang. An attribution to the Fang would also seem supported by the bulging forehead, the shape of the nose, and especially by the narrow vertical band running from the tip of the nose to the hairline. Other characteristic features are the semicircular eyebrows emphasized by two incised lines and angled upward at the temples. Louis Perrois attached special importance to this decor and on its basis attributed the mask to the Fang.

Bibliography: Bolz, 1966; Fagg, 1980; Perrois, 1985; Perrois, 1988, p. 206

Mask from the sketchbook of the missionary
Fernand Grébert executed between 1913 and 1917.
Though it is said to stem not from the Fang but
from the area of the "upper Ogowe and Masango,"
the mask, like that in the Barbier-Mueller Collection, nevertheless displays stylistic characteristics
of Fang sculptures.

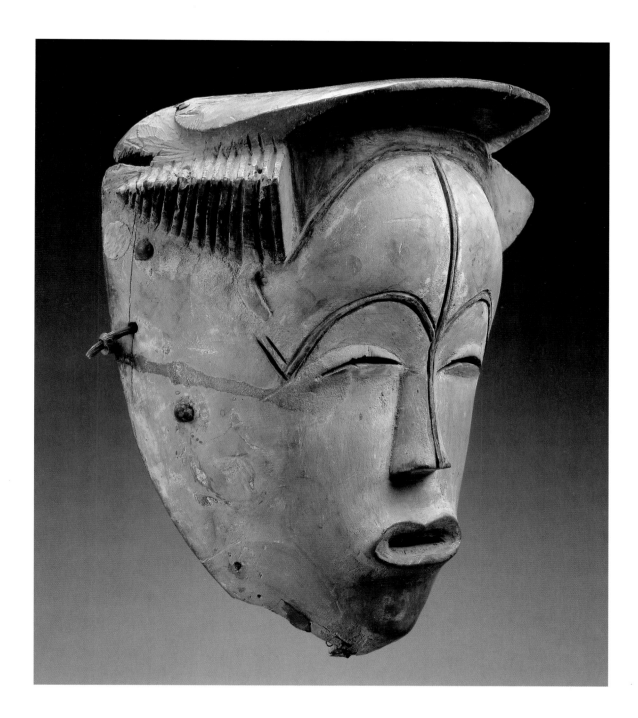

Face mask with curved horns

Kwele, Gabon

Wood, painted in white and black
Height 42 cm (16 ½ in.); width 62.5 cm
(24 ⅝ in.)
Inv. 1019-15
Formerly collection of Josef Mueller; acquired
from Mme. Charles Vignier before 1939;
collected by Aristide Courtois, a government
official, before 1930
Cat. 186

The rare masks of the Kwele, a little-investigated ethnic group of northeast Gabon and the adjacent area of the Republic of Congo, are associated with the Bwete association, which maintains social order. The masks are also used in initiation rites and at the end of periods of mourning. Representing benevolent forest spirits, they have zoomorphic or anthropomorphic traits, or a combination of the two. The faces are usually painted in white kaolin earth, a pigment associated by the Kwele with light and clarity, the two essential factors in the fight against evil.

Only a few of these masks, such as the present one, have eye slits and are thus suitable for wearing as a face mask. As field research has shown, however, the masks used in ceremonies had no eye apertures and were merely shown to the onlookers rather than being worn.

The meaning of the masks with a human face and curved horns is not known.

They have been interpreted as representing antelopes (by Louis Perrois) or rams (by Leon Siroto), but no explanation of the underlying belief system was given.

In this carefully crafted example the horns, composed of several flat, curving surfaces and painted black and white, form wide arcs around the face. The two small mask-faces carved on the tip of the horns repeat the features of the central face, which are typical of the Kwele style: a slightly concave, heart-shaped face with a triangular nose and raised, narrow eyes that extend from the bridge of the nose almost to the edge of the mask. A small, arc-shaped mouth is carved below the concave area, near the chin. Sparing accents of black contrast with the white kaolin, highlighting the mask's curving lines and increasing its plasticity.

Bibliography: Bay, 1975; Bolz, 1966; Fagg, 1980; Perrois, 1985; Perrois, 1988, p. 211; Sieber/ Walker, 1987; Siroto, 1979

In many Kwele masks, the curved-horn motif echoes the heart shape of the face.

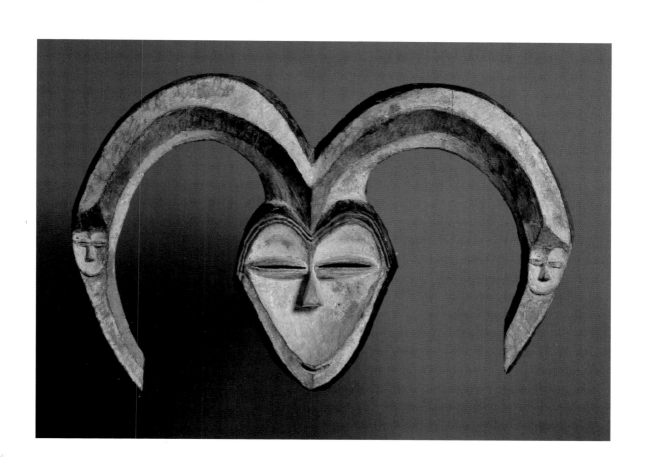

Mask

Kwele, Gabon

Wood, painted in white and black
Height 38 cm (15 in.)
Inv. 1019-49
Cat. 187

This sculpture is one of the rare Kwele masks with vertical horns, which evidently represent antelopes. Though no information is available concerning their function and significance, we may assume that, like other Kwele mask types, they embody spirits of the bush. Unlike an antelope mask in the British Museum, London, which has elongated, rounded volumes, this example evinces a harmonious, symmetrical composition based on vertical and diagonal lines, convex and flat planes. Beginning at the narrow, horizontal nose and mouth line, the face contours gradually widen toward the forehead, where they abruptly break off at nearly a right angle and extend towards the emphasized vertical axis of the slightly convex forehead. The forehead contour is interrupted by the gently curving, pointed ears with a shallow central groove. The diagonal of this groove visually rhymes with the diagonal slits of the eyes and lids carved in low relief. Black paint is used to accentuate the lateral surfaces and the upper end of the projecting horns, which form a diamond shape. The face, ears, and lower horns are finished in white.

A striking feature is the careful hollowing and smoothing of the mask's interior, though there is no indication that it was ever intended for wear.

Bibliography: Bolz, 1966; Perrois, 1985; Perrois, 1988, p. 210

The rare Kwele masks with vertically projecting horns exhibit a range of stylistic differences. Some examples, such as the one illustrated here and those in Göteborg (left) and London (right), depict antelopes; others, like a second Göteborg mask (center), have anthropomorphic faces.

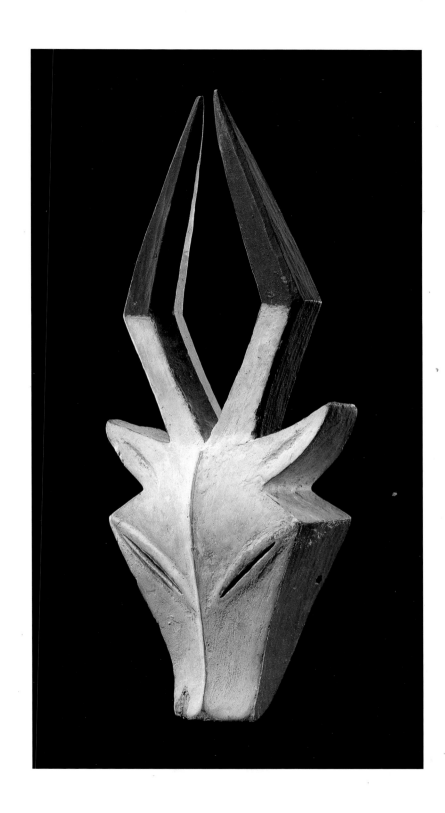

Face mask (*Pibibuze*)

Kwele, Gabon

Wood, painted in white and black,
patinated by use
Height 25.4 cm (10 in.)
Inv. 1019-80
Formerly collection of Tristan Tzara;
collected before 1930
Cat. 188

The masks with a human face used by the Bwete association in initiation and funeral rites were called *pibibuze* ("man") by the Kwele. Whereas today they are only displayed on ritual occasions, at earlier periods they apparently were worn as well. In the case of the present *pibibuze* mask, this is indicated not only by a rich, homogeneous patina resulting from wear, but by three holes for the attachment of the mask, perhaps to a headdress.

First exhibited in 1930 at Galerie Pigalle, Paris, this mask is one of the finest of its type known. It has the characteristic heart-shaped, slightly concave face with contours emphasized by black paint, heightening the contrast between the white face area and the wide, dark brown rim. Accents of black are also seen on the triangular, projecting nose and the vertical channel below it. The configuration of the projecting eyes, carved in a half-moon shape curving downwards from the bridge of the nose, is also found in a roughly carved dual-headed Kwele mask in the Rautenstrauch-Joest Museum, Cologne, and in a mask with zigzag superstructure in La Rochelle. The outer rim, tapering towards the chin and interrupted by a groove at the narrowest point, alludes to downward-curving horns, a design element known from other Kwele masks (cf. plate 69).

Bibliography: Bay, 1975; Bolz, 1966; Perrois, 1985

Here another example of the highly abstracted style of *pibibuze* masks, from the Musée des Arts d'Afrique et d'Océanie, Paris, which also has the characteristic heart-shaped, concave face.

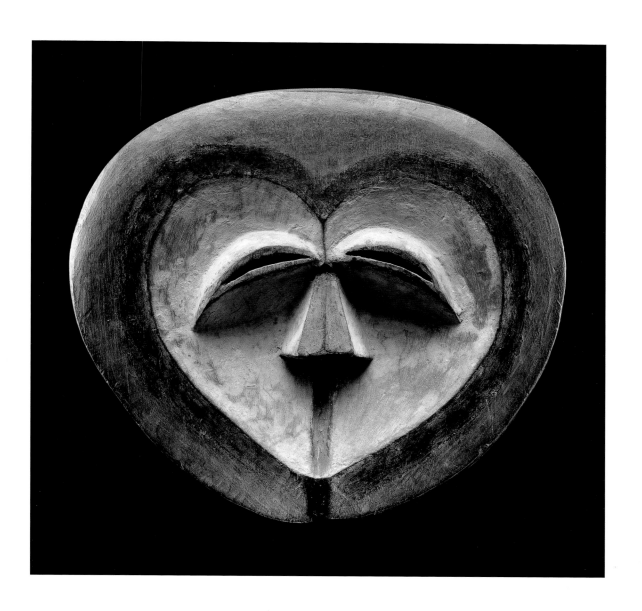

Face mask

Pomo, Republic of Congo

Wood, painted in reddish-brown,
blackish-brown, and white
Height 23.8 cm (9 ⅜ in.)
Inv. 1021-41
Formerly collection of Max Itzikowitz, Paris
Cat. 189

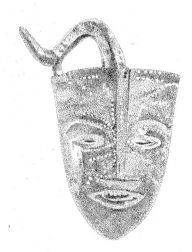

The Barbier-Mueller mask, opposite, might
originally have had a horn similar to that of a
mask which became a part of the collection of
the Göteborg Museum in 1955, illustrated here.

This rare mask has been ascribed to the
Pomo, a small ethnic group inhabiting the
upper Sanga, culturally related to the eastern
Kwele. An unusual feature is the shallowly
curved face with a broad forehead cut off
straight at the top. A band of white paint on
the forehead emphasizes the curve of the
eyebrow ridge and the contour of the lower
half of the face, reminiscent of the heart
shape typical of Kwele masks. The slender
nose and narrow eye slits, emphasized by
flat, pointed oval grooves painted white, like-
wise suggest Kwele influence. Uncharacter-
istic of their stylistic repertoire, on the other
hand, is the mouth opening in the dark-
brown tinted lower half of the face, with its
row of pointed teeth accented in white.

The shape of the present mask's con-
tour and its eyes, nose, and mouth recall a
sculpture that was acquired together with
other works in the Kwele region and that be-
came a part of the collection of the Göteborg
Museum in the mid 1950s. Ingeborg Bolz
doubts that this mask is actually a Kwele
work, but suggests no alternative attribution.
A striking detail of the Swedish mask is a
carved horn extending from the middle of
the forehead edge and describing an S-curve
to the side. A breakage point on the upper
edge of the present mask suggests that it,
too, once had such a horn.

Information about the use of such
masks is sparse. The mask collected from
the Kwele is said to have been used in the
context of elephant hunting. However, this
information cannot be considered reliable,
because masquerading waned among the
Kwele in the 1920s.

Bibliography: Bay, 1975; Bolz, 1966;
Duponcheel, 1981

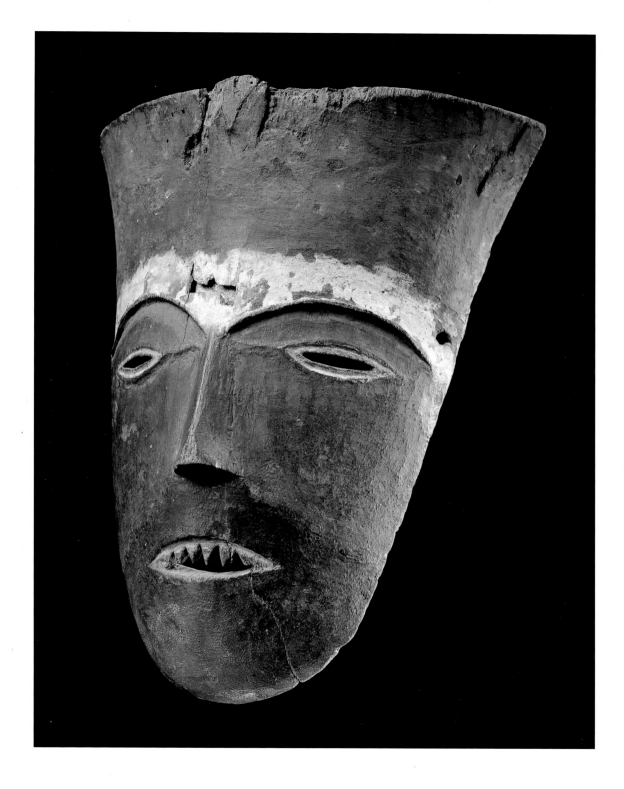

Face mask

Mahongwe or Ngare, Republic of Congo

Wood, painted in black, white, and red
Height 35.5 cm (14 in.)
Inv. 1021-33
Formerly collections of Aristide Courtois
(before 1930), Charles Ratton, and The
Museum of Modern Art, New York (1939)
Cat. 190

Of all African masks, this is one of the best-known forms, because since the late 1940s masks of this type were repeatedly named as one of the sources of inspiration of Pablo Picasso's famous painting, *Les Demoiselles d'Avignon* (1907). It was not until 1984 that this hypothesis was proven untenable. Writing in the catalogue to the exhibition "'Primitivism' in 20th-Century Art," William S. Rubin pointed out that the extremely rare masks from the Etumbi region, where the present example was collected, did not enter Western collections until some time after the *Demoiselles* was painted.

The village of Etumbi lies on the upper Likuala in an area inhabited by various ethnic groups, including the Mboko, Ngare, and a few Mahongwe groups. Though it has yet to be determined which of these groups produced the mask illustrated, various attempts at stylistic classification have been made. In Leon Siroto's opinion, this and a mask of comparable design in the Brooklyn Museum, New York, reflect a specific style of the Babangi, among whom he includes the Ngare. In a more recent study by Louis Perrois, however, these masks are linked to works of the Kota and Shamaye, who live in Gabon.

Characteristic features of this mask type are the elongated concave face, the almost perpendicular rim, and facial features in high relief. The nose is formed by an elongated triangle whose upper point, in this case, merges into a narrow ridge. This, in turn, leads into a bulging upper forehead and arched eyebrows. The result is a heart-shaped face which, like the form of eyes and nose, recalls works from Gabon. A localization of the mask in the Etumbi region is corroborated by the diagonal grooves on the left cheek, which have been identified as an Ngare scarification pattern.

Bibliography: Perrois, 1988, p. 218; Siroto, 1954

This mask from the Brooklyn Museum, New York, shows a basic design similar to that of the mask in our collection. Both masks were acquired in the vicinity of the Likuala River, and are said to have come from different subgroups of the Babangi.

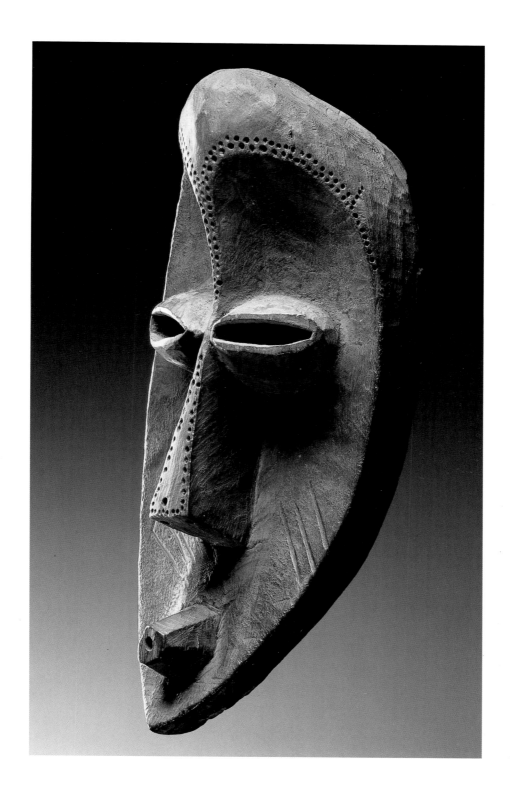

Face mask

Vuvi, Gabon

Wood, with black, white, and blue paint
Height 34 cm (13 ⅜ in.)
Inv. 1019-32
Formerly collection of Josef Mueller;
acquired before 1939
Cat. 191

Little is known about the masquerading tradition of the Vuvi (also called Pubi or Puvi) of central Gabon. Each mask apparently had a special name related to the spirit (*moghondzi*) it embodied. During nocturnal performances announced by drum music, the leader of the rite would intone a specific song that reminded the onlookers of the individual traits of the spirit represented by the masqueraders.

Vuvi masks are characterized by the relative flatness of their design and the emblematic nature of the facial features and markings. The flattened ovoid face has strongly arched eyebrows extending from the bridge of the nose to the edge of the mask. The eyebrows demarcate a heart-shaped area with narrow eye slits and a slightly open, thin-lipped mouth. In the present example, the white-painted face is set off by a narrow, continuous ridge accented in black, which widens slightly above the forehead and suggests a coiffure. The painted vertical strokes on the cheeks are based on *mwiri* initiation marks. The dark stroke running from mouth to chin represents a beard, a symbol reserved for Vuvi dignitaries.

The holes along the edge served to attach plant fibers which, together with textiles, formed a voluminous costume that concealed the dancer from sight.

Bibliography: Perrois, 1985

After use the masks were kept in a special house together with other ritual objects.

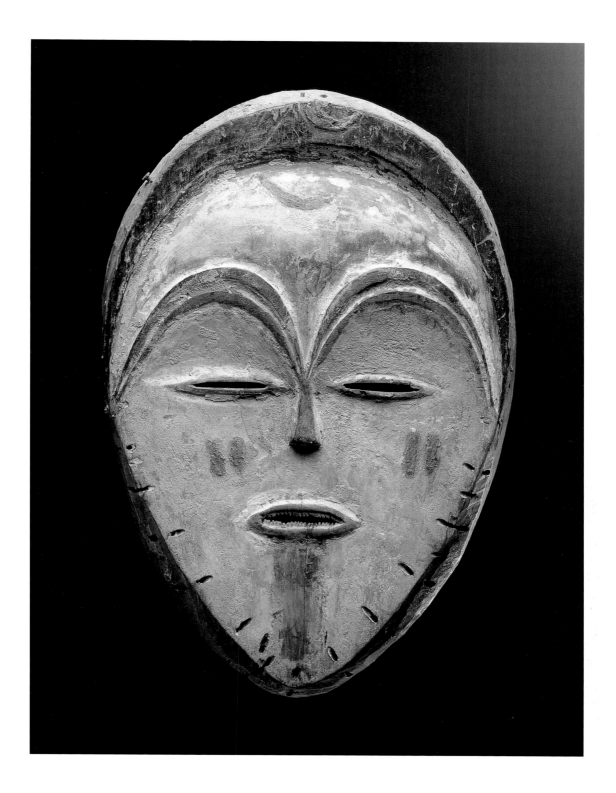

Face mask (*Okuyi*)

Punu/Lumbo, Gabon

Wood, painted in white and blackish-brown
Height 28 cm (11 in.)
Inv. 1019-31
Formerly collection of Josef Mueller;
acquired before 1939
Cat. 192

This mask is a variant of the "white masks of Ogowe," which are found throughout western and central Gabon, from the area around Lambarene in the north to the southern ethnic groups inhabiting the region bordering on the Republic of Congo and the peoples of the Kota complex in the east.

Okuyi masqueraders with stilts during a performance. Once part of a ritual context, such performances now take place mainly for entertainment.

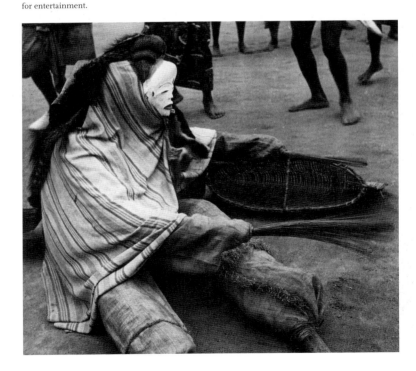

The performances of such masks, known as *okuyi* or *mukuyi*, are nowadays intended primarily to entertain audiences on festive occasions. Only rarely do the masqueraders fulfill a ritual function of officiating at funerals, when they dance as embodiments of the spirits of female and male ancestors. In performances the dancers, wearing costumes of raffia or cotton fabric and animal pelts, move with amazing agility on stilts up to six and a half feet in height.

This *okuyi* mask, which originates from the Punu/Lumbo in southwest Gabon, represents an idealized female face. This is indicated by the scale-like scarification patterns on the forehead and temples, each consisting of nine dots arranged in a square or diamond, which, according to field researchers, have a sexual connotation. Another sign of female gender is its coiffure. With hair piled high on the head and arranged in two braids at the sides, this coiffure recalls the hair style used by women in this region at the beginning of the twentieth century. In the present example, the hairline over the rounded forehead is emphasized by a narrow, woven hairband. Arched eyebrows carved in low relief, narrow eye slits between convex lids, a short, finely formed nose, and a closed mouth pursed in a figure-eight shape, characterize the sensitively modeled face, whose harmonious features exude serenity.

Bibliography: Bolz, 1966; Fagg, 1980; Felix, 1995; Homberger, 1994; Perrois, 1985; Perrois, 1988, p. 225; Sieber/Walker, 1987

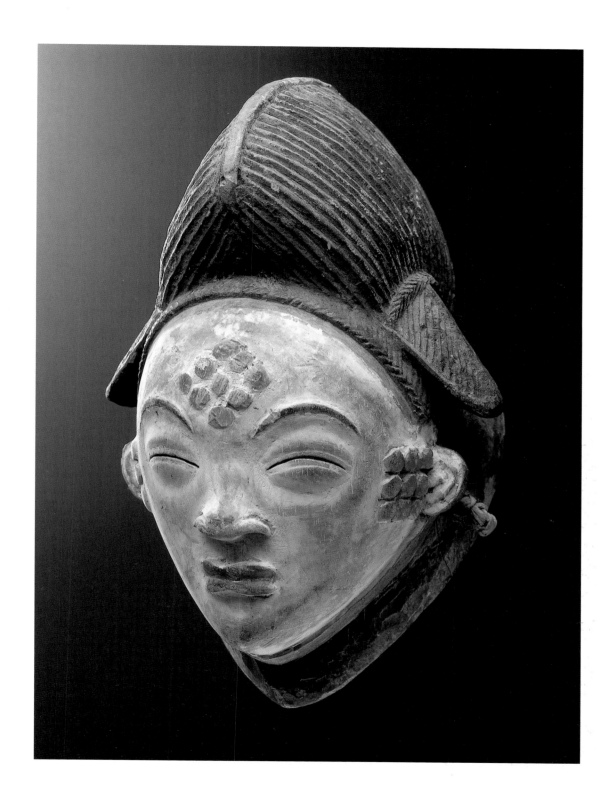

Face mask (*Ndunga*)

Vili (?), Republic of Congo/Kabinda/Democratic
Republic of Congo

Wood, painted in blackish-brown and white
Height 30 cm (11 ¾ in.)
Inv. 1021-23
Formerly collection of Josef Mueller;
acquired before 1939
Cat. 195

This mask, now in the Pitt-Rivers Collection
in Oxford, was collected in 1867 from the Ivili in
the vicinity of Lambarene. Painted in white kaolin
earth and red ocher, it has a visor-like coiffure
similar to that of the Vili mask illustrated here.

Among the Kongo and their culturally re-
lated neighbors in the coastal region of the
Democratic Republic of Congo, the Republic
of Congo, and Kabinda, *ndunga* masquer-
aders are still responsible for maintaining
order in the community. Dressed in a
voluminous costume of banana leaves or
feathers, they appear at ritual or political
occasions, to arbitrate conflicts or punish
wrongdoers. Only among the Vili has this
custom waned since about the late 1970s.
The face masks of the Vili, Yombe, Woyo,
and Sundi are characterized by a realistic
design and a striking color scheme in black,
white, and red, white and red, or white and
black. The sculptures of these groups, espe-
cially those of the Vili and Yombe, are stylis-
tically very similar, which often makes a
definite attribution impossible.

This carefully crafted example, too,
shows design elements characteristic both of
Yombe and Vili works: an oval face, gently
arched, wide-spaced eyebrows, a long, narrow
nose with delicate nostrils, and a slightly
open mouth with finely proportioned lips.
Especially in the nose and mouth area, our
specimen recalls a face mask painted white
and ocher in a private collection, which is
attributed to the Vili. In addition, it bears
stylistic affinities to a Vili mask in the
Lindenmuseum, Stuttgart, whose white-
painted area around the nose and mouth
likewise extends diagonally across the cheeks
to the lower edge of the mask. Untypical of
works of the Congo region, on the other
hand, are the visor-like hairline and the
shape of the narrow eyes with low-relief lids.
Although these details are also found in
older masks of the Punu-Lumbo, the mask's
overall conception belies an attribution to
these northern neighbors of the Vili.

Bibliography: Fagg, 1980; Felix, 1995; Habi
Buganza, 1995; Lehuard, 1993; Perrois, 1985;
Perrois, 1988b; Volavka, 1976

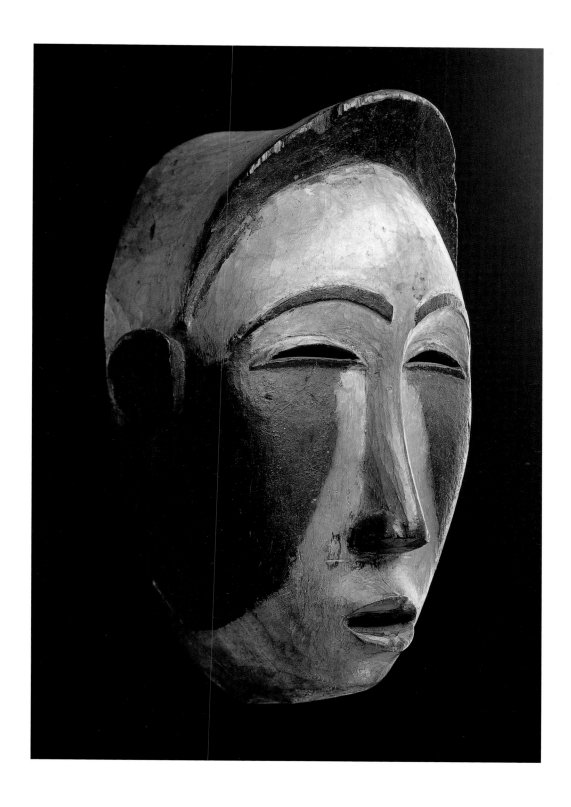

Face mask

Teke-Tsaayi, Republic of Congo

Wood, painted in white, red, and black
Height 34 cm (13 ⅜ in.)
Inv. 1021-20
Formerly collections of André Derain,
Charles Ratton, and Josef Mueller (1939)
Cat. 196

This disk-shaped face mask, which was exhibited as early as 1931 in Paris and in 1935 in New York, is one of the very rare old examples of its type in Western collections. It originated from the upper Ogowe region, possibly from the Tsaayi, the only Teke group to have used wooden masks since the middle of the nineteenth century. Their *kidumu* masquerade dances originally served to confirm and maintain the social and political structure in a ceremonial context. With the onset of French colonial rule this tradition began to go into decline, and it was not until the Congo gained independence that it was revived, if only for entertainment purposes. The carvers of the new masks drew on the old canon of motifs, though no new masks with the graphic composition of this mask are known.

Unlike other older Tsaayi masks, this example's profuse geometric motifs are arranged nearly symmetrically along both vertical and horizontal axes. Other unusual features are the quatrefoil motif and the arrow-shaped element above the nose, which may have been carved during a later re-working of the mask. Reminiscent of other Tsaayi masks, however, are the arcs at top and bottom, which have been interpreted as representing half moons.

The narrow eye slits flanking the small nose enabled the dancer to see as he held the mask by gripping a woven cord on the back between his teeth. A raised ridge on the reverse served to hold the mask in place on the dancer's face. More recent examples, especially those made for the trade, lack these details, as well as the holes along the edge, which held plant fibers and feathers as part of the mask's costume.

Bibliography: Dupré, 1968; Dupré, 1979; Dupré, 1988; Fagg, 1980; Lehuard, 1977

Masquerade performance in the village of Lekana, 1969.

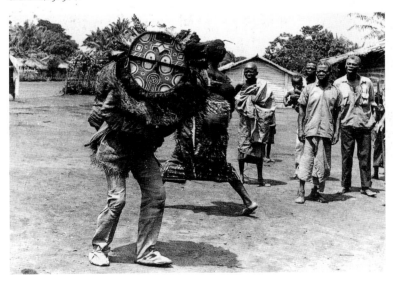

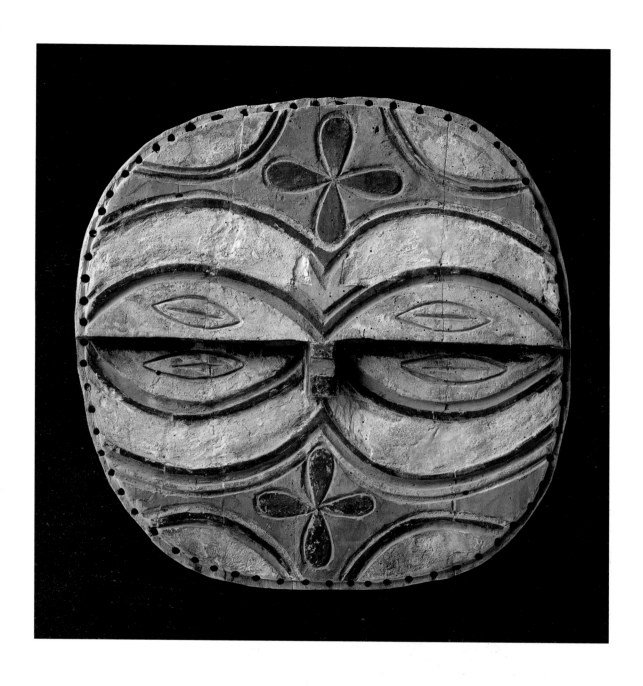

Helmet crest (*Kholuka*)

Northern Yaka, Democratic Republic of Congo

Wood, painted in blackish-brown, blue, ocher,
and white; raffia cloth and fibers; rattan
Height 70 cm (27 ⅝ in.)
Inv. 1026-99
Formerly collection of Josef Mueller;
acquired before 1942
Cat. 197

The Yaka of central Africa maintain a masquerading tradition associated with boys' initiation and circumcision rites (*mukhanda*). The ceremonies are intended to further the adolescents' social and physical maturity, and in particular to insure their virility as a guarantee of the community's future.

The northern Yaka consider the *kholuka* (or *mbala*) mask to be one of the most significant types used in this context. It is worn only by the supervisors of the initiates. Its dance concludes the ceremony that marks the end of seclusion. The dances are accompanied by songs concerned with adult masculinity, intended to confirm the new social status of the young men.

Kholuka masks consist of several parts. Their composition is related to that of the subordinate, sometimes grotesque dance masks worn by adepts and destroyed or sold after use. The central face element with protruding spherical eyes and sharply upturned nose is mounted on a framework of rattan and woven raffia, which is covered with a thick layer of bast fibers to represent coiffure and ruff. This arrangement is topped by a seated male figure with a disproportionately large penis — a feature characteristic of *kholuka* masks. Both the colors and the various elements of the mask have symbolic meanings related to the Yaka cosmology. At the same time, the composition encompasses a variety of elements of both male and female connotation, pointing to an androgynous character that mitigates the emphasis on masculinity expressed in the ritual.

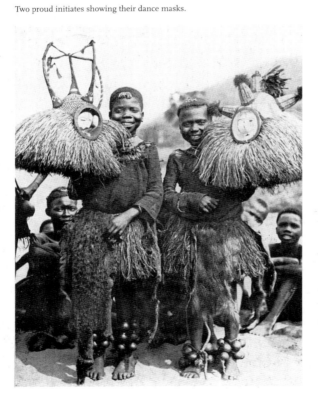

Two proud initiates showing their dance masks.

Bibliography: Biebuyck I, 1985; Blades, 1985; Bourgeois, 1984; Bourgeois, 1993; Cornet, 1973; Devisch, 1995; Gardi, 1986; Plancquaert, 1930

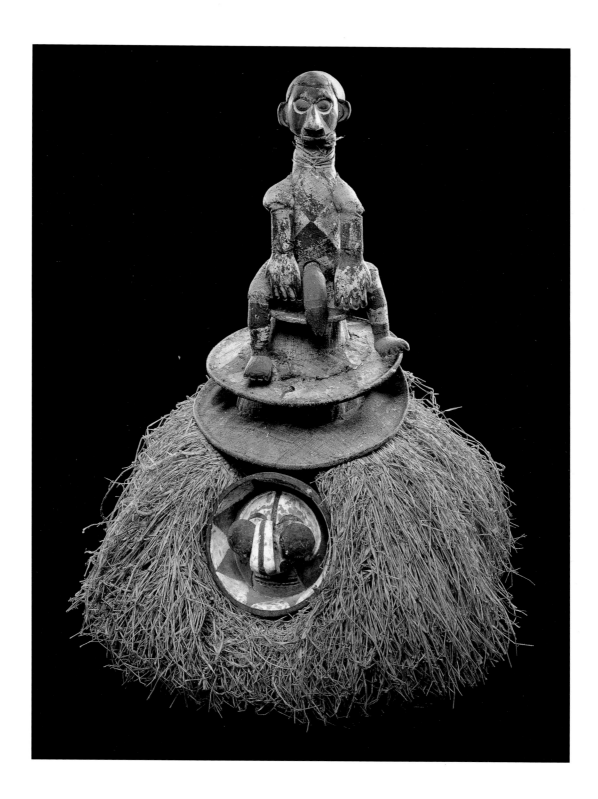

Helmet mask (*M-bawa*)

Yaka, Democratic Republic of Congo

Cane framework, woven bast with traces of light
red, black, and white paint, metal, raffia fibers
Width 146 cm (57 ½ in.)
Inv. 1026-42
Cat. 202

The Yaka use not only masks carved of wood but
also numerous types made of a variety of other
vegetable materials.

In addition to various types of masks with
carved components or made entirely of
wood, the Yaka also use masks of woven or
knotted raffia which are fabricated not by
carvers but by experts in the associated
ritual. These masks are usually given their
final form by the addition of bast fibers,
feathers, calebashes, birds' bills, and animal
horns.

The colossal *m-bawa* or *kambwamba*
masks consist of a cane framework covered
with raffia cloth. In the present, spherical
example the usual animal horns are replaced
by cones made of woven bast and decorated
with concentric circles, filled with pieces of
metal that rattle when shaken. In front of
these "horns," a roll of fabric extends around
the head, demarcating the face area. Its
central axis is marked by another, vertical
roll, to which two small cones of fabric
representing the nose are attached. White,
red and black areas and patterns underscore
the design of the face, which is reduced to
essentials.

This type of mask, which embodies
the buffalo, *mpakasa* (*Syncerus caffer*) and
appears during Yaka initiation ceremonies
as a threatening specter, is found only rarely
in Western collections.

Bibliography: Biebuyck I, 1985; Bourgeois, 1993;
Fagg, 1980

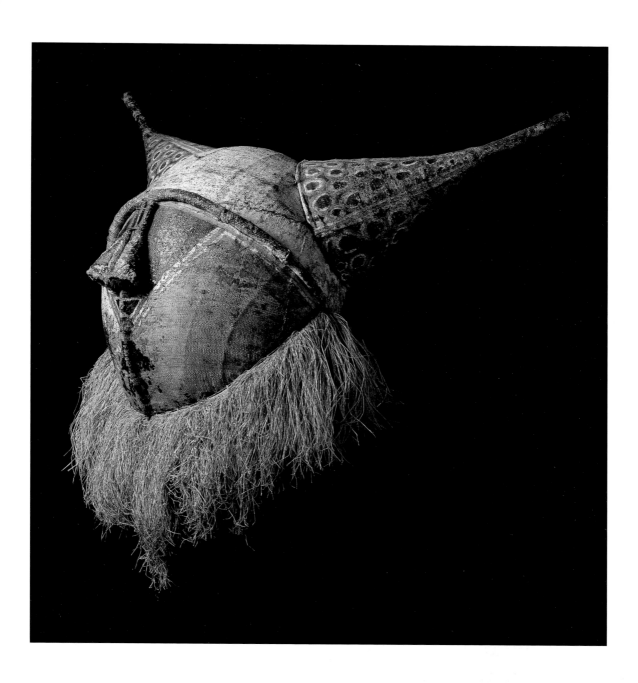

Bell-shaped helmet crest

Kwese (?), Democratic Republic of Congo

Wood, painted in white, red, and black,
upholstery tacks
Height 37.5 cm (14 ¾ in.)
Inv. 1026-233
Cat. 204

This mask is characteristic for the Kwese and
shares many similarities with the helmet mask
illustrated opposite. The heart-shaped face and the
coiffure, however, are reminiscent of the sculptures
of the Mbala.

Bell-shaped helmet crests, danced at boys'
circumcision ceremonies, are known by
various names (*hemba*, etc.) among a
number of central African peoples.
Especially common among the Suku, they
are also used by their western neighbors,
the Yaka, by the Mbala, Hungaan, and Pindi
to the east, as well as by the Kwese and
Pende. Migration of these groups and their
close contacts among one another have led
to an exchange of stylistic forms and a
blurring of stylistic borders, which often
makes an attribution of the masks difficult.

The problem of provenance also
arises in the case of the present mask, which
is missing its collar of bast fibers. It is a
strikingly realistic depiction of a man's full
face with lowered eyes under rounded lids,
a short nose, and mouth slightly open to
reveal teeth. The high-set ears have pierced
lobes. The central ridge of the braided, or
moukotte coiffure was originally decorated
with close rows of upholstery tacks along
the sides. These details recall an example in
Tervuren (MRAC RG 48.40.14), which was
acquired west of the Kwilu. Among the
Pende population of this region also live
Kwele and scattered groups of Suku, to
whom Louis de Sousberghe attributes this
mask. Unlike the Tervuren mask, which is
painted brown with white accents, this
mask is painted black, red, and white. The
shiny black coiffure, bands of white and red
across the eye, nose, and lower half of the
face, as well as the marking of eyebrows,
forehead nose line, and tears under the eyes
in black (or occasionally blue) characterize
masks both of the eastern Suku and the
western Pende, permitting no conclusions
to be drawn concerning the precise origin
of this mask. However, it is quite likely that
it was made in the same region as the
Tervuren mask, perhaps by the Kwese.

Bibliography: Baeke, 1995; Biebuyck I, 1985;
Bourgeois, 1981; Bourgeois, 1984; de Sousberghe,
1959; Neyt, 1981

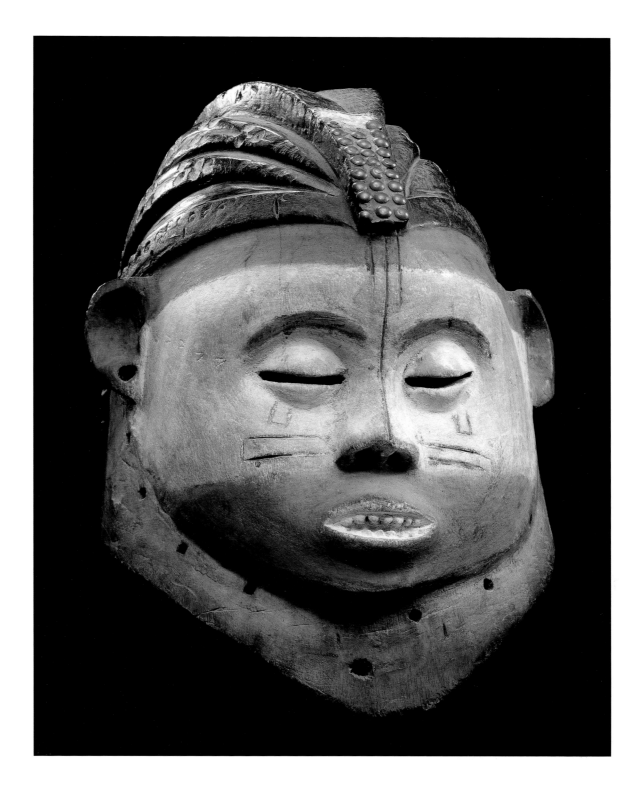

Forehead mask (*Mbuya* type: *giwoyo, muyombo,* or *ginjinga*)

Western (Kwilu) Pende, Democratic Republic of Congo

Wood, with white, rust-brown, and blackish-brown paint
Height 53.4 cm (21 in.)
Inv. 1026-216
Cat. 206

This mask represents one of the three most important and typologically oldest of the over twenty different *mbuya* masqueraders of the Pende. Known as *giwoyo, muyombo,* or *ginjinga,* they can be identified solely on the basis of their costume, headdress, paraphernalia, and dance style. All three mask figures are characterized by a carved face with an elongation under the chin which apparently represents a beard (*mwevu*), sign of the authority and wisdom of the ancestors. Danced at hunting and harvest rites, during initiation and circumcision ceremonies, and on other festive occasions, the masks ensure the community's well-being.

This carefully carved mask with its slightly asymmetrical features has traits characteristic of the Mbuji-Munga style of the Gatundo (Katundu) region of the western Pende area. It has three vertical scarification lines (*mishita*) on the bulging forehead, a raised, continuous eyebrow line in the form of a wide "V" repeated at the chin line, high cheekbones cut with eye openings, trapezoidal ears, a turned-up nose, and a triangular, low-relief mouth. White paint has been rubbed into the elaborate pattern of incised lines, lozenges, and triangles (*njege*) which adorn the mask's chin and beard. These patterns are thought to represent fertility symbols. Raffia fibers were originally inserted through the holes along the edge of the head and beard, forming a wreath that covered the face of the dancer, who wore the mask horizontally on top of his head. The cylindrical projection on top of the mask was decorated with parrot feathers or goat hair.

Performance of a *muyombo* masquerader, whose costume, headdress, accessories, and dance movements distinguish him from *giwoyo* and *ginjinga* maskers.

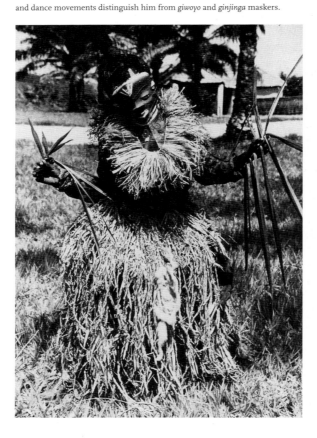

Bibliography: Biebuyck I, 1985; Cornet, 1973; de Sousberghe, 1959; Gardi, 1986; Petridis, 1993, pp. 63–76; Klieman, 1985; Mudiji-Selenge, n.d.; Neyt, 1981

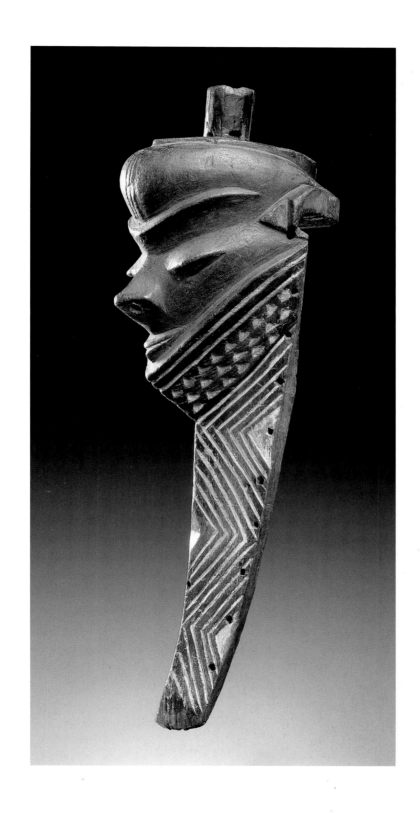

Face mask (Ngaady a Mwaash)

Kuba, Democratic Republic of Congo

Wood, with white and ocher paint, red textile,
bark cloth, cord, cowrie shells, and colored glass
beads
Height 32.4 cm (12 ¾ in.)
Inv. 1026-189
Cat. 211

The Kuba, a confederation of nineteen
ethnic groups dominated by the Bushong,
have over twenty different mask types
considered embodiments of spirits. The
three most significant types, Mwaash
Amboy, Bwoom (cf. plate 83), and Ngaady a
Mwaash, belong to the royal family. When
they appear together during public cere-
monies, initiation celebrations for boys, or
rituals concerning the sacred king (*nyim*),
the masqueraders invoke the Bushong myth
of creation and also historical events. Ngaady
a Mwaash represents the sister and wife of
Woot, progenitor of the Bushong, who is
personified by Mwaash Amboy. Bwoom
figures as the progenitor's opponent.

Ngaady masks consist of a rather
naturalistic face painted with geometric
patterns, supplemented by a raffia hood
sewn with cowrie shells and glass beads.
In this example the cowries are arranged in
rosette designs on the top and back of the
head. In addition, painted bark cloth has
been used as a neck covering. Below the
elaborately decorated arched front of the
hood, the forehead is entirely covered by a
characteristic triangle pattern associated with
the scales of the pangolin (*Manis tricuspis*).
This ornamentation is interrupted only by
diagonal stripes on the cheeks, representing
tears. Nose and mouth are covered by a strip
of fabric, a feature typically found on royal
masks. Instead of being decorated exclu-
sively with beads, as is usually the case, the
strip has a central row of cowries framed by
blue beads.

Bibliography: Cornet, 1973; Gardi, 1986; Mack,
1995; Roberts, 1995a; Rogers, 1979; Szalay, 1995;
Torday/Joyce, 1911; Weston, 1985

A group of Kuba dancers with various types
of masks.

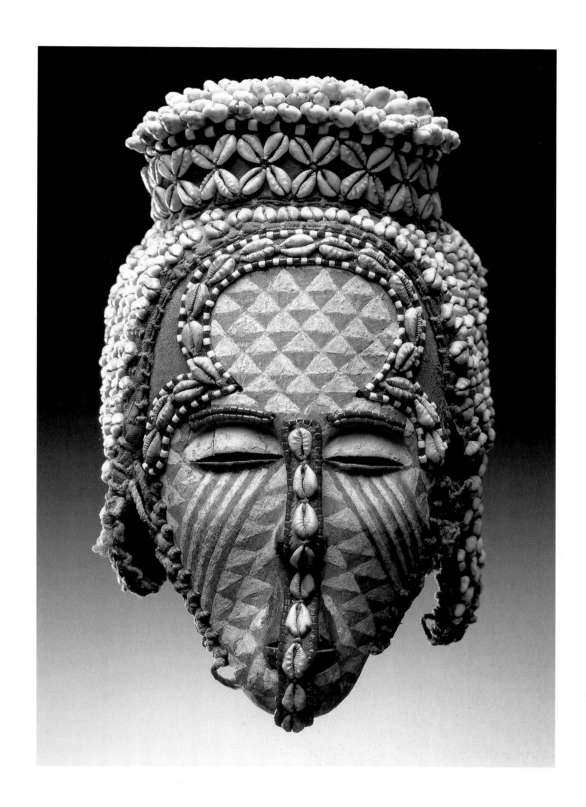

Helmet crest (Bwoom)

Kuba, Democratic Republic of Congo

Wood, with traces of black, red, and white paint
Height 40 cm (15 ¾ in.)
Inv. 1026-61
Cat. 210

One of the three royal masks, the Bwoom is also one of the oldest mask types used by the Kuba. It is said to have been introduced in the seventeenth century by King Miko mi-Mbul, who, according to tradition, received it from a Cwa Pygmy. In addition to funerals, Bwoom masqueraders appear on numerous ceremonial occasions, embodying different characters depending on the context. At boys' initiations, Bwoom represents the nature spirit Ngeesh. As part of the royal mask trio (cf. plate 82), he personifies an oppositional, recalcitrant character who struggles with his brother, Mwaash Amboy, for power and for the possession of his wife and sister, Ngaady a Mwaash. In his role as an insurgent who challenges the throne and its system, Bwoom is moreover associated with the non-aristocratic, common man. This rebellious aspect of the Bwoom masquerader is expressed in a proud and aggressive style of dancing.

This highly simplified and sparingly painted example shows the protruding forehead typical of Bwoom masks. This feature has led to various, sometimes rather dubious interpretations, some observers seeing the mask as representing a pygmy, while others trace it back to a king's son suffering from hydrocephalus. Another typical feature is that the slits in the coffee-bean shaped eyes do not go through the mask. The nostrils are drilled through instead, permitting the dancer to see as he wore the mask at an angle on his forehead. The rows of holes along the hairline and edge presumably served for the attachment of a headdress of raffia material, or a beard of raffia plush. Since this example does not have the elaborate face ornamentation of glass beads, cowrie shells, and thin copper plates typical of royal Bwoom masks, we may assume that it was used outside the royal court.

Bibliography: Burssens, 1995; Cornet, 1973; Gardi, 1986; Rogers, 1979; Szalay, 1995; Torday/Joyce, 1911, Vansina, 1988; Weston, 1985

The royal mask trio Ngaady a Mwaash, Bwoom, and Mwaash Amboy (from left to right) in the Bushong village of Mushenge, 1909.

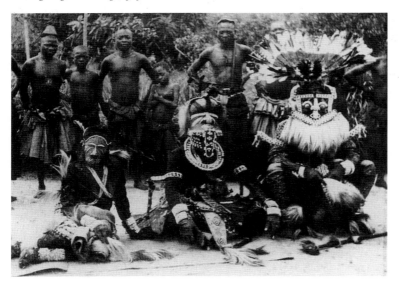

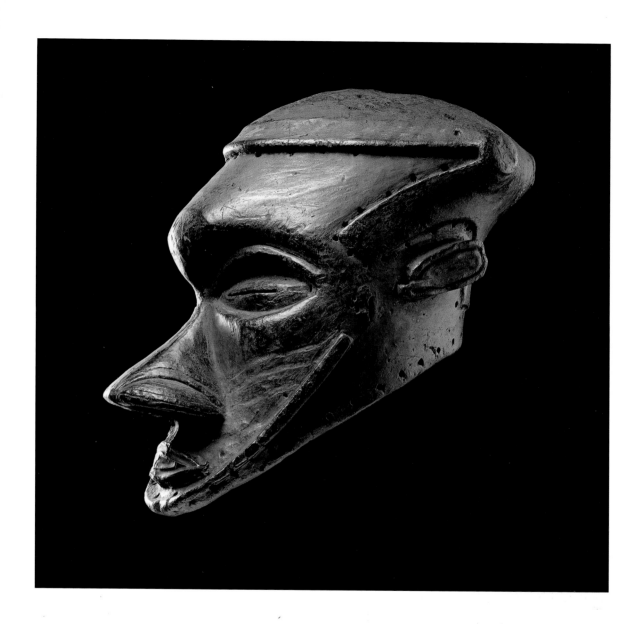

84

Forehead mask

Luluwa, Democratic Republic of Congo

Wood, with traces of white, black,
and ocher paint
Length 43 cm (16 ⅞ in.)
Inv. 1026-30
Formerly collections of André Lhote
(before 1930) and Olivier Le Corneur
Cat. 214

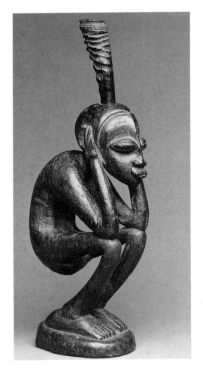

The stylistic traits of the forehead mask are also
seen in this crouching Luluwa figure in the
Barbier-Mueller Collection.

The Luluwa, an ethnically heterogeneous
group living in scattered small chiefdoms
east of the Kasai, are represented in Western
collections principally by figurative sculp-
tures decorated with elaborate scarification
patterns. Their masks are less well-known,
but like the figurative works, they show
various regional styles influenced by neigh-
boring ethnic groups.

This mask of compellingly simplified
design is attributed to the Bakwa Ndolo, a
subgroup of the Luluwa. It recalls masks
of the southern Kete, as well as those of the
Nsapo, a Songye group who migrated into
Luluwa territory in the second half of the
nineteenth century. The mask is charac-
terized by an elongated face with pointed
chin and bulging forehead, above which a
flat disk suggests a coiffure. The large pon-
derous, closed eyes and short, sharp-edged
nose contrast strikingly to the small, thin-
lipped mouth set with teeth, carved into the
slightly protruding jaw area. Two incised
grid patterns of different size form the only
scarification marks on the face, which has
traces of white paint interrupted by sweeping
black lines. A cord was pulled through the
holes above the U-shaped ears to attach the
mask — which has no eye slits — to the
dancer's forehead. A net costume of raffia
fiber painted with horizontal black stripes
covered the dancer's head and body. These
masqueraders performed at ceremonies
marking the completion of adolescent boys'
initiation (*mukhanda*), but they also appeared
at a variety of public events, to suppress evil
forces and negative influences.

Bibliography: Cornet, 1973; Cornet, 1988, p. 263;
Petridis, 1995

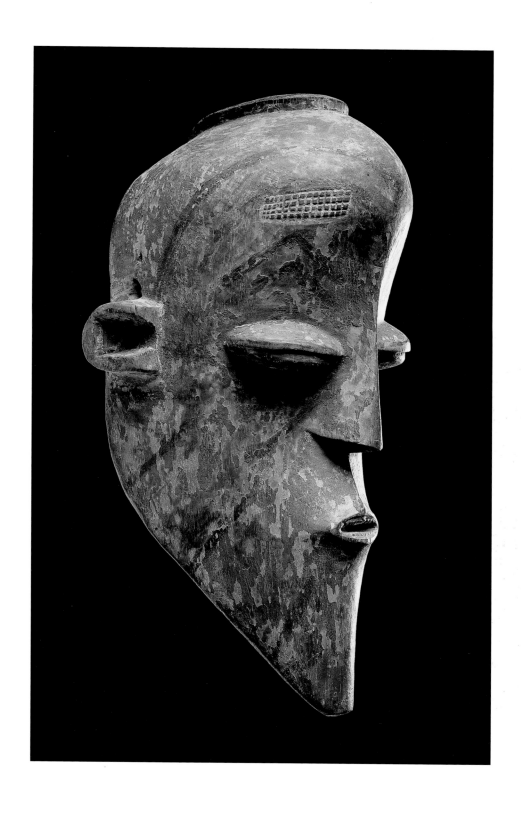

Face mask (*Mfondo*)

Lwalwa (Lwalu), Democratic Republic of Congo

Wood, with blackish-brown stain and
traces of white paint
Height 31.8 cm (12 ½ in.)
Inv. 1026-218
Formerly Vrancken Collection, Brussels
Cat. 217

The Lwalwa are known principally for their masks, which are marked by a balanced composition of geometric surfaces and projections. Besides a female *mushika* or *kashika* mask, which has a comb-like coiffure, three different categories of male mask can be distinguished. Two of these, *mkaki* and *mfondo* (or *mvondo*), are similar in design except for the shape of the nose, which in each case is associated with the bill of a certain bird.

This mask represents *mfondo*, whose strongly projecting triangular nose is meant to evoke the powerful bill of the hornbill. The nose, the narrow, lidless eyes, and the protruding rounded lips lie in a concave face, set off from the forehead by a projecting browline. This extends downwards from the high bridge of the nose to the temples and ends at the corners of the eyes, merging into small, schematized ears in a rounded projection which represents a scarification pattern (*kankolo* or *edjindula*). The cap-like coiffure is adorned by a characteristic incised geometric pattern which, like the eye holes, bears traces of white paint. The hole under the nose was used to attach a cord which the dancer held between his teeth to keep the mask from slipping.

Such masks are thought to have been originally danced at initiations of adolescent boys performed by the *ngongo* association, as well as at hunting and fertility rites, to propitiate spirits and gain their good will. Today the mask dances are performed for payment, and their magic has largely given way to entertainment.

Bibliography: Ceyssens, 1995; Cornet, 1973; Fagg, 1980; Petridis, 1993, pp. 100 and 102; Roy, 1992

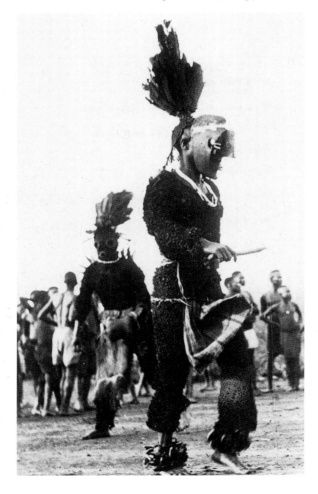

Performance of two Luluwa dancers in *mfondo* masks, Dundo, 1948.

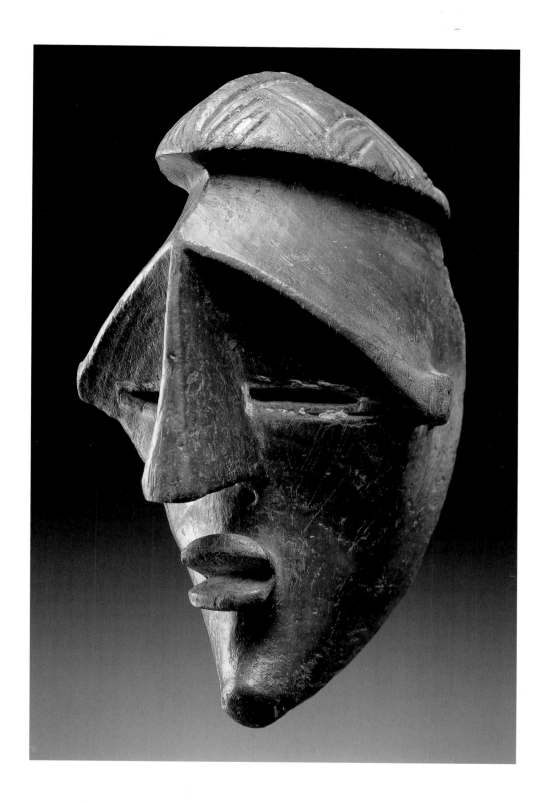

Forehead mask (*Mwana phwevo*)

Lwena (Lurale), Angola

Wood, disk of shell, colored glass beads,
bone, raffia fibers, and weave
Length 19 cm (7 ½ in.)
Inv. 1028-32
Cat. 221

The *mwana phwevo* masquerader is pre-valent among various peoples in the upper Zambesi the southern Kasai regions. Accord-ing to a controversial hypothesis the Lwena adopted the form and function of the mask from the Chokwe. Marie-Louise Bastin and Gerhard Kubik say that its name, "Young Woman," refers to a mythical female per-sonage who died young and whose painful loss was recalled by the masquerader's dance. In keeping with this role, the mask has a female face with regular features and elaborate tattoo patterns on forehead, nose, chin, and cheeks, reflecting Lwena ideals of beauty. The eyes, narrowed to a slit, have been said to evoke death. According to other traditions, the artisans who carve such masks base their features on the woman they desire.

The origin of this fine piece has been localized by Wastiau (letter of Nov. 6, 1996) with the Angolan Lwena, who live near the confluence of the Zambesi and Lugwuebungu rivers. The sculptor's skill is seen in the careful carving of the grace-fully arched eyebrows, the nostrils, and the furrow between nose and mouth, as well as in the double channel around the coffee-bean-shaped eyes. The puncture motif on forehead and cheeks, in the form of a square standing on one corner with loops at the angles, corresponds to a tatooing pattern characteristic both of the Lwena and the Chokwe. Apart from these patterns, there are three vertical incisions beneath each eye which might be read as tears. The face is supplemented by a wig of plant fibers, adorned at the hairline by a string of glass beads and a shell disk. The inserted, real teeth show no sign of the artificial deforma-tion which was practiced in this area into the 1940s. This leads Wastiau to conclude that the mask may either have been carved after this custom was abandoned, or that it could represent one of the occasional de-pictions of a European woman.

Mwana phwevo masks, danced by men, appear at various festivities in order to enter-tain the village, and especially its female inhabitants, with performances in which sexual references play a key part.

Bibliography: Bastin, 1969; Bastin, 1988; Kubik, 1993; Kubik, 1995

The *mwana phwevo* mask embodies a beautiful young woman who entertains the audience with graceful dances. Village of Mpidi, Zambezi district, Zambia.

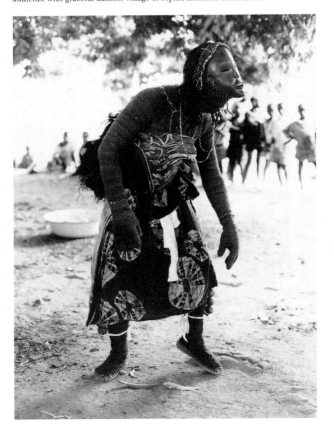

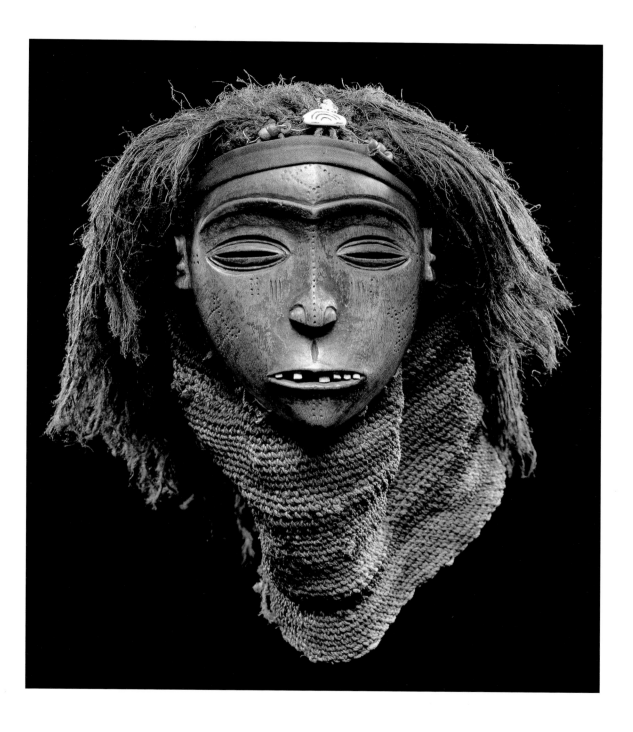

Face mask (Sachihongo)

Mbunda, Zambia

Wood, with blackish-brown paint and
traces of white pigment
Width 42.5 cm (16 ¾ in.)
Inv. 1028-34
Cat. 222

This object represents Sachihongo, a hunter
with bow and arrows, who is the only mas-
querade figure of the Mbunda to wear a
mask carved of wood. It displays a high,
bulging forehead with characteristic arched
channels, small ears, and narrow eye slits
in raised lids, whose shape is repeated in
the open, tooth-studded mouth. Based
on the flat cheek area, this mask can be
classified as in the Mbalango style, which
encompasses not only round but rectan-
gular Sachihongo masks with a rectangular
mouth opening or a forehead plate. It has
yet to be determined whether these different
mask forms represent individual carver's
workshops or regional styles.

Sachihongo masks belong to the six
most important of the twenty-two masquer-
ade characters of the Mbunda in eastern
Angola and western Zambia. Among the
Zambian groups, who migrated in the early
nineteenth century into the settlement area
of the Lozi on the upper reaches of the
Zambesi, masquerades are nowadays
performed only for entertainment and in
honor of high-ranking guests. The western
Mbunda, in contrast, have maintained the
original character of their masquerade tra-
dition, which is linked with boys' initiation
(*mukhanda*). The masks (*makisi*), viewed by
non-initiates as embodiments of ancestors'
spirits, appear in bush camp after the cir-
cumcision of the neophytes during their
recovery period. They also perform in the
villages, where they dance to the accom-
paniment of songs sung by male and female
onlookers. The protagonists' costumes are
elaborate. The Sachihongo figure, for in-
stance, wears a feather headdress, a beard,
and several shirts made of grass, palm
leaves, and reeds over a net suit made of the
fibers of the *mushamba* tree (*Brachystegia
bolchini*).

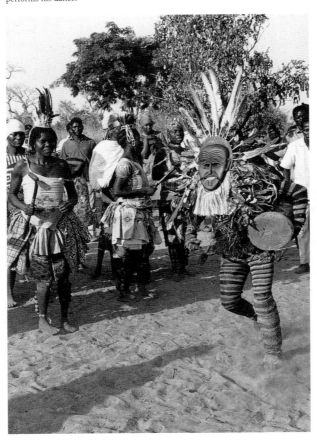

Accompanied by the singing of onlookers of both sexes, a Sachihongo masquerader
performs his dance.

Bibliography: Kubik, 1993; Vrydagh, 1993;
Yoshida, 1995

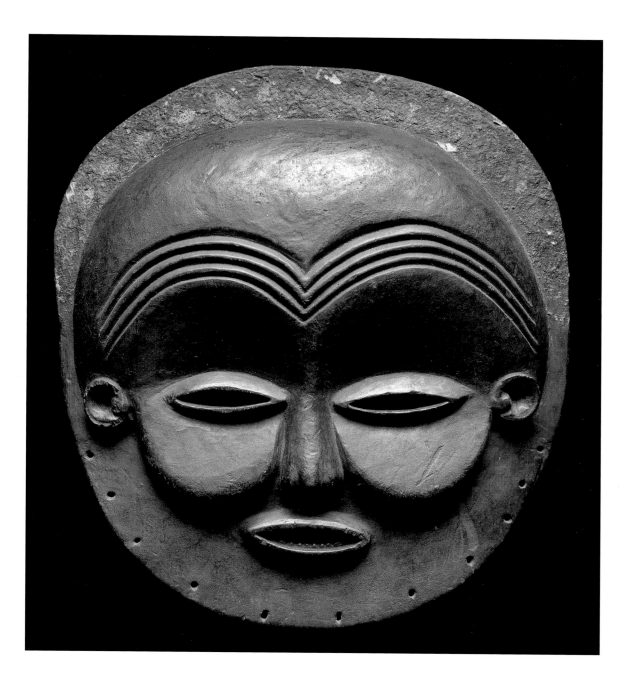

88

Face mask, female Kifwebe type, *kikashi*

Eastern Songye, Democratic Republic of Congo
Wood, with remants of red and white paint
Height 34 cm (13 ⅛ in.)
Inv. 1026-110
Cat. 224

Bifwebe (sing. Kifwebe) masks belong to the accoutrements of a society of the same name that to this day enjoys extreme respect among the eastern Songye. The society includes individuals with supernatural

Performance of a male Kifwebe mask, whose gender is indicated by the high comb.

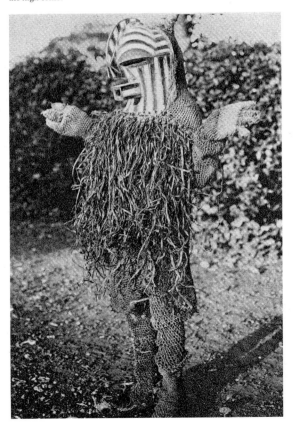

power (*basha masende*) who are believed to manipulate spirits by means of magical techniques. The masks, supplemented by a woven costume and a long beard of raffia bast, dance at various ceremonies. They are worn by men who act as police at the behest of a ruler, or to intimidate the enemy in case of war.

The mask shown here embodies the rarer female type of Kifwebe (known as *kikashi*, pl. *bikashi*), which, in contrast to the male type (*kilume*, pl. *bilume*), lacks a high comb extending over the center of the head. Also characteristic of female masks is the fine, grooved pattern on the face, into which white paint has been rubbed. Red has been used to accentuate the sharply delineated eyes between half-moon-shaped lids, the jutting triangular nose, and the angular mouth, whose opening might be compared to an hourglass lying on its side.

Mask, colors, and costume all have symbolic meaning. Facial elements are associated with certain animals, such as lions, zebras, bushbucks, crocodiles, and porcupines, whose particular behaviors are considered intrinsic to the mask. The use of white on the mask symbolizes positive concepts such as purity and peace, the moon and light. Red is associated with blood and fire, courage and fortitude, but also with danger and evil. Female masks essentially reflect positive forces and appear principally in dances held at night, such as during lunar ceremonies and at the investiture or death of a ruler.

Bibliography: Cornet, 1973; Cornet, 1988, p. 269; Hersak, 1986; Hersak, 1993; Hersak, 1995, pp. 349–350; Hersak, n.d.; Maes, 1924; Merriam, 1978; Mestach, 1985

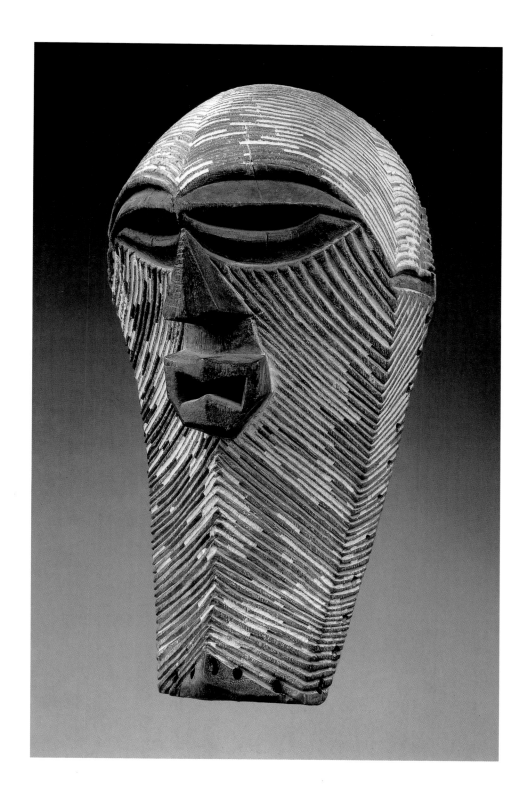

Face mask

Tempa Songye, Democratic Republic of Congo

Wood with ocher, brown, black, white, and red
paint, remnants of a net costume of raffia bast,
raffia fiber
Height 69 cm (27 ⅛ in.)
Inv. 1026-44
Formerly collection of Berthe Hartert
Cat. 225

Like the example in the Barbier-Mueller
Collection, this mask, in the British Museum
since 1904, is of a rare variety which was
originally ascribed to the Tetela.

This mask with three carved horns, like two
comparable pieces in the British Museum
and the White Collection of the Seattle Art
Museum, was long ascribed to the Sungu.
In a recent study, Luc de Heusch challenged
the previously held assumption that this
southernmost group of the Tetela, inspired
by the neighboring Songye, made masks
which were supposedly worn by diviners
and healers to control the populace. Based
on a critical review of collectors' information,
de Heusch arrived at the conclusion that
these masks, like other works ascribed to
the Sungu, actually originated from their
immediate neighbors, the Tempa Songye.

Although this mask differs consider-
ably from the known, groove-patterned
Bifwebe masks of the eastern Songye (cf.
plate 88), it nevertheless has features char-
acteristic of this ethnic group's style: narrow
eyes set off by deep grooves, a jutting trian-
gular nose, and a protruding, rectangular
mouth. The mouth displays two rows of
teeth; the upper incisors are missing in
keeping with an extraction process common
in this group. The three hornlike extensions
on the skull originally bore a fur covering
similar to that seen on the horns of the
London mask.

The unusually elaborate polychrome
pattern extends across the face in four hori-
zontal bands separated by narrow bands
composed of black and white rectangular
fields. François Neyt, who considers the
mask a Tetela work, interprets these patterns
as cosmological symbols.

Black-dyed raffia bast fibers and
remnants of a woven net knotted in the holes
along the mask's edges give an indication
of the voluminous costume that once com-
pletely hid the masquerader from view.

Bibliography: Cornet, 1988, p. 265; de Heusch,
1995; de Heusch, n.d.; Fagg, 1980; Merriam,
1978; Neyt, 1992

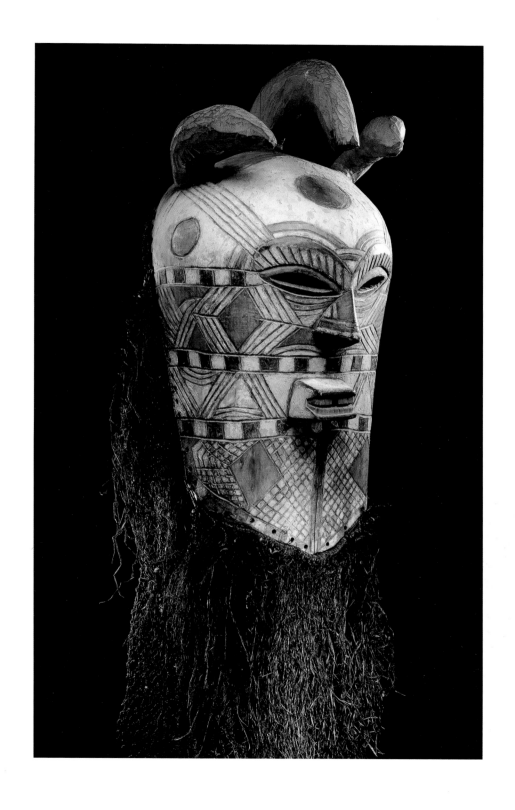

Face mask

Acquired from the Songye, Democratic Republic
of Congo

Wood, with white paint and traces of blue and
brown decor, upholstery tack, metal teeth, bast
fibers, bast weave
Height 30 cm (11 ¾ in.)
Inv. 1026-291
Formerly collection of Berthe Hartert
Cat. 228

This white-faced mask was acquired together
with the following mask (plate 91) at an un-
known location in the Democratic Republic
of Congo. According to the collector, who
lived for over twenty years in the Songye
and Luba region, the two masks were danced
as a pair. Their design suggests a differing
provenance, for the only elements they
share in common are the vertical marks on
the cheeks and a wig of short bast fibers.

The mask cannot be ascribed with
certainty to any central African ethnic group,
though it does distantly resemble a small
Pende mask, likewise white with blue
accents, in the Tervuren Museum (MRAC
37174). This mask also has a plant-fiber wig
and two marks painted in blue below the
eyes. Also comparable are the shape of the
nose and the gently projected slightly open
mouth. However, the quite different cut of
eyes and face speak against an attribution
of the present mask to the Pende.

This mask also recalls the "White
Masks of Ogowe," although these are char-
acterized by an elaborate carved coiffure,
eye slits in a crescent-moon shape, marked
nostrils, and full, closed lips — elements
absent from this mask. It bears an even
greater resemblance to a *ngontang* mask
of the Fang in the Mestach Collection,
Brussels, which not only has a similar eye,
nose, and mouth design and two vertical
scarification marks on the cheeks, but, like
this mask, has eyebrows that begin at the
bridge of the nose and turn upwards at the
temples. Yet the circumstances in which
the mask was found and its plasticity would
make a Fang origin seem doubtful. It is
nonetheless conceivable that it belongs to
the oeuvre of a carver who was familiar
with Gabon works, and who possibly came
from this region but worked elsewhere.

The face of this Fang *ngontang* mask in the
Mestach Collection has features similar to those
of the Barbier-Mueller mask, which was acquired
in the Songye region.

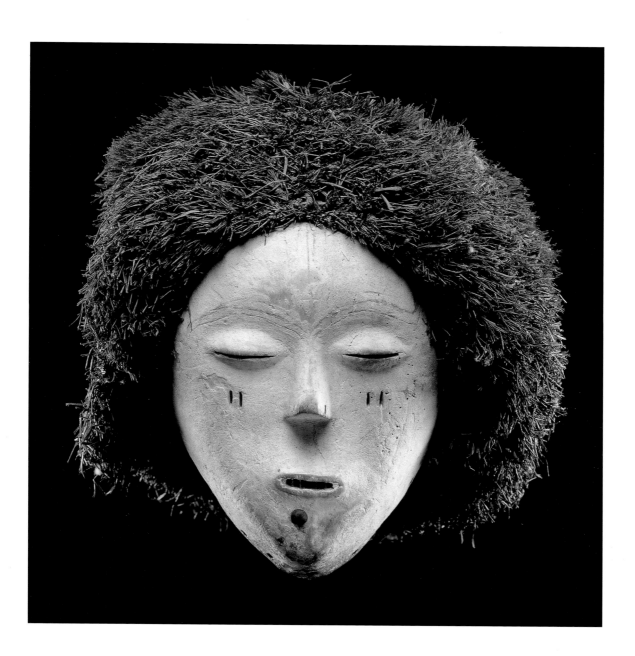

Face mask

Songye (?), Democratic Republic of Congo

Wood, painted in white, red, and blue,
leather, bast fibers
Height 30 cm (11 ¾ in.)
Inv. 1026-286
Formerly collection of Berthe Hartert
Cat. 227

This strikingly expressive face mask displays a number of stylistic characteristics of Songye works. Yet the artist, instead of relying on the canon of the white-grooved, often cubically composed masks of this

A *nkisi* statuette of the Songye in the Barbier-Mueller Collection. Figures of this type may have served as a model for our unusual face mask, which was acquired in the Songye region.

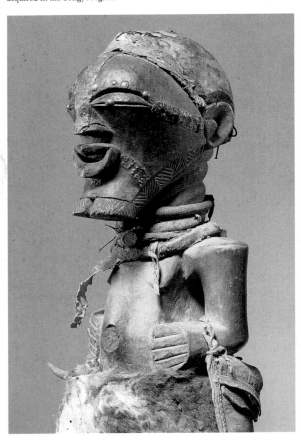

group, oriented himself to its figurative sculpture, as is indicated both by a neck treatment atypical of masks, and by the shape of the face. This mask recalls many *nkisi* sculptures with square chins associated with the Kalebwe style of the central Songye region. Stylistic affinities with these figures are moreover seen in the coffee-bean-shaped eyes, the short nose, and the semicircular mouth opening in which two rows of teeth are visible. The wide space above the upper lip, emphasized by a shallow furrow painted red, the pairs of vertical incisions below the eyes, and the grooved eyebrows are not among the stylistic features characteristic of Songye works, though they are occasionally seen.

The way in which sections of the face are painted red and white points, on the one hand, to the face-painting of Songye ritual experts, and on the other to the color schemes of Kifwebe masks or to the metal fittings of many *nkisi* statues.

Atypical of Songye works are the vertical incisions over the brows and the wig of bast fibers knotted into a leather cowl. These uncharacteristic elements, as well as the overall conception of the mask, which may have been modeled on Songye *nkisi* statuettes, make it seem conceivable that the mask was carved neither in the Songye region nor by a Songye artisan. Yet whoever created it must have been familiar with this group's art, especially its figurative sculpture, which were widely distributed beyond the Songye region.

Bibliography: Hersak, 1986; Hersak, 1995, pp. 346–347

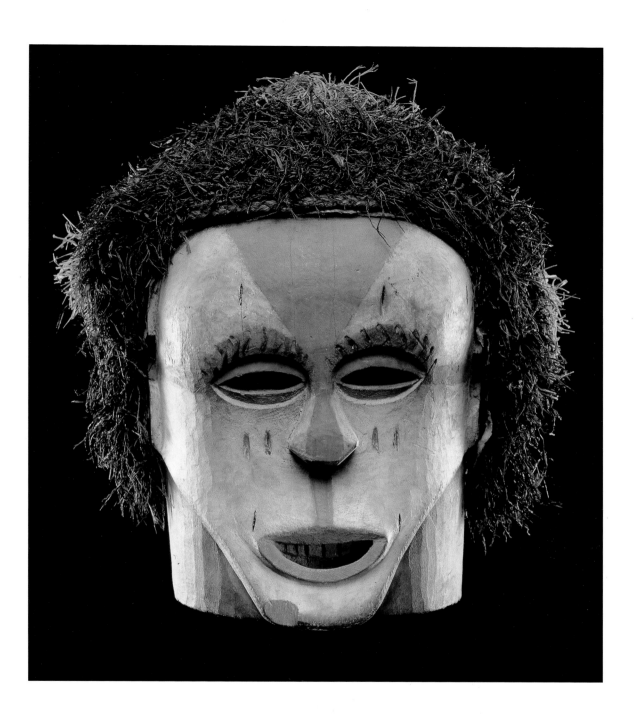

Face mask (*Mwisi gwa so'o*)

Hemba, Democratic Republic of Congo

Wood, with black paint
Height 23 cm (9 in.)
Inv. 1025-7
Cat. 229

The Hemba, who live in the southeastern region of the Democratic Republic of Congo, are known particularly for their noble figurative sculptures of ancestors. Less interest

A Hemba *mwisi gwa so'o* masquerader in a cloak of bark cloth and wig and beard made of the fur of the colobus monkey.

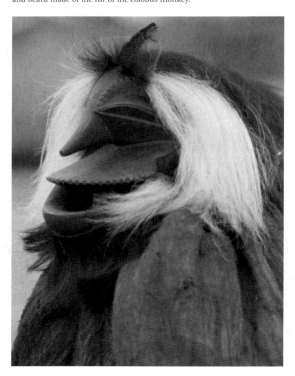

has been attracted by their often extremely stylized chimpanzee masks, which are known in the literature by various designations. According to a more recent study, they are called *mwisi gwa so'o*, a term that alludes to the "spirit-invested object of the chimpanzee-human" that inhabits such masks.

Their characteristic features include convex eyelids with narrow slits emerging from shallow sockets beneath arched brows, and a thin, sometimes pointed nose strongly set off from the face area. The occasionally bizarre look of these masks is underscored by a broad, narrow mouth opening, which gives them the appearance of grinning. While some masks are hardly recognizable as depictions of chimpanzees, this mask's protruding, snoutlike mouth and flat upper lip give away its identity. A horizontal row of triangles is incised beneath the eyes, and a raised plate on the skull runs down to the temples, evoking the hairline.

Mwisi gwa so'o masqueraders wear a costume of animal skins and bark cloth, supplemented by the black and white hair of colobus monkeys. To the Hemba they are frightening apparitions whose grin means rage and impending disaster. Their raucous dances, performed at funeral and memorial ceremonies, reflect Hemba ideas about death and social chaos and stand in diametrical opposition to the otherwise ordered world of the living.

Bibliography: Blakeley, 1987; Leuzinger, 1985; Neyt, 1993; Roberts, 1995a; Roy, 1992

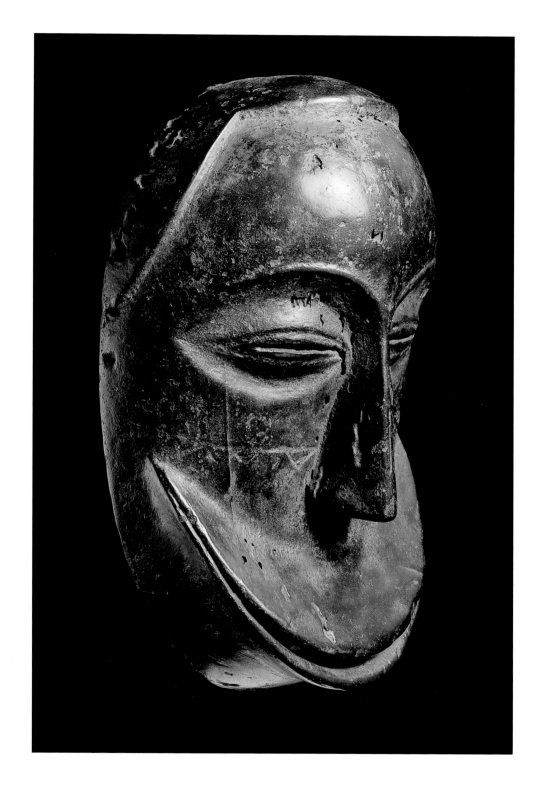

Face mask (*Nsembu*)

Kumu (Komo), Democratic Republic of Congo

Wood, painted in red, black, and white
Height 27.3 cm (10 ¾ in.)
Inv. 1026-226
Cat. 230

The art of the Kumu or Komo, who inhabit the forested areas of central Africa, is little known and insufficiently studied. What can be said with certainty is that the use of masks among the Kumu, as among their southern neighbors, the Lega, is linked with the activities of a strong men's association.

A male-female pair of masqueraders during a performance in the village of Benekwa-Babatume, 1973.

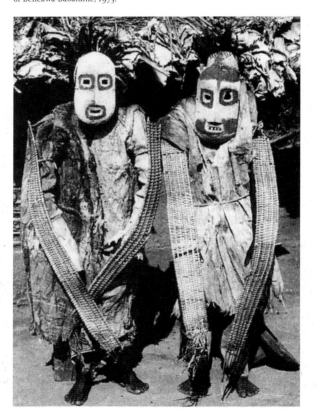

The use of masks seems to be limited to the Nkunda society, which is the preserve of diviners (*babankundu*). The masks are considered embodiments of the diviner's spirit, and may be viewed only by initiates. Occasions for appearances of the masks, which are kept by the eldest men in the society, include the initiation of adepts or memorial services for deceased members. At these nocturnal ceremonies a male-female pair of masqueraders clad in costumes of bark cloth and reeds sit on a bench and perform a dance consisting only of arm and head movements.

This *nsembu* mask is one of the very few Kumu works in museum or private collections. Characteristic of the type are a nearly rectangular, slightly rounded facial contour, large eye openings, short nose, and a wide-open mouth, which, in this example, is set with teeth and has a horizontal oval shape repeating that of the eyes. Occasionally accents of color are used to emphasize the features. Here, white and black bring out the gaping mouth and eyes that dominate the face, as well as accenting the nose, forehead, and cheeks, lending the mask a formulaic expression.

Bibliography: Felix, 1989; Felix, 1993; Petridis, 1993, p. 199; Roy, 1992

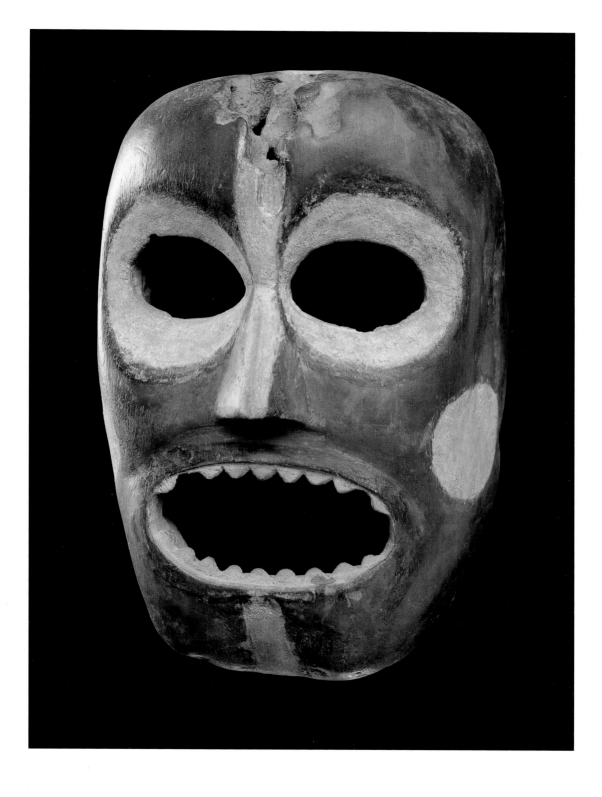

Mask (*Lukwakongo*)

Lega (Rega), Democratic Republic of Congo

Wood, with traces of blackish-brown and
white paint, raffia fibers
Height 18 cm (7 ⅛ in.) (not including beard)
Inv. 1026-3
Cat. 231

The manifold arts of the Lega, a group in-habiting central African rain forests, are related to the activities of an initiation association called Bwami, whose hierarchy is open to both men and women. The Bwami plays a key role in the social and religious life of the Lega, conveying ethical principles and establishing social norms. These values are evoked by the vocally accompanied presentation of diverse

During the Lutumbo Lwa Kindi rite a member of the Bwami society hangs miniature bone and ivory masks around a larger *muminia* mask on a fence-like framework.

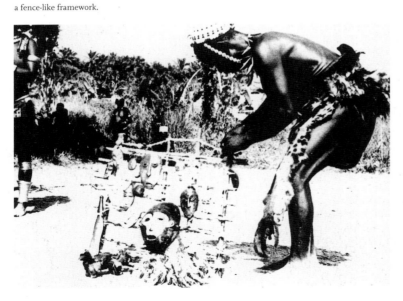

artifacts during initiation rites that mark acceptance of new members into the associa-tion or members' advancement to a higher rank. This is the context in which *lukwakongo* masks are used. They belong to members of the Lutumbo Lwa Yananio, a rank within the second highest degree (Yananio) of the Bwami. Besides being emblems of rank, the masks are also visible signs of the link between the dead and the living, between former initiates and their successors. They are danced at several phases of the initiation, whereby varying music, singing, dancing, and manipulation of the masks — picked up, carried, or attached to different parts of the body — signify changes in the symbolic message of the performance.

This small, oval wooden mask, which still has its original fiber attachment, has a pointed chin and a rounded forehead set off from the concave lower face by a sharp, arched browline. There are narrow eye slits under hooded lids, a finely modeled trian-gular nose, and a rectangular mouth with teeth indicated by grooves. Affixed to the holes along the mask's edge is a long beard (*lunzelu*) of raffia fiber, a symbol of the ancestors — that is, of former initiates.

Bibliography: Biebuyck II, 1986; Biebuyck, 1988, p. 284; Biebuyck, 1993; Biebuyck, 1995, pp. 375–376; Cornet, 1973; Hunn, 1985; Kingdon, 1995

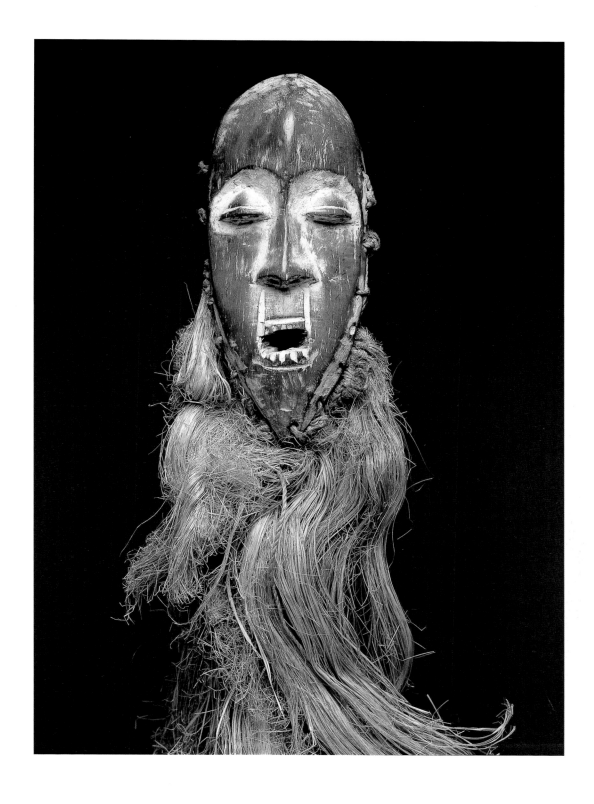

Miniature mask (*Lukungu*)

Lega (Rega), Democratic Republic of Congo

Bone, patinated by wear
Height 8 cm (3 ⅛ in.)
Inv. 1026-1
Formerly collection of Dr. med. van den Bergh;
collected during the Second World War
Cat. 232

Pala fence for the Lutumbo Lwa Kindi rites of the Bwami society of the Lega with various miniature masks, 1952.

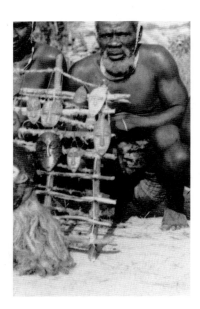

The masks of the Lega can be classified in five categories, differentiated by size, material, and form. The *lukungu* masks, carved of ivory, bone, wood, or occasionally copal, are the smallest type, measuring two and a half to six and a half inches in height. This mask is likely carved from elephant bone. It has an oval face and a flattened forehead area, a stylistic trait seldom seen in such masks. The coffee-bean-shaped eyes begin right at the bridge of the nose, and lie in a concave surface cut into the face below the arched browridge, which is emphasized by rows of punctures. Though no mouth has been carved, it is suggested by the slightly upturned lower edge of the inset face.

Lukungu masks belong to the highest-ranking members of the Bwami society, who gain the greatest degree of authority and prestige when they reach the top rank (Lutumbo Lwa Kindi) of the Kindi degree. Like other types of mask which serve as emblems of rank and change hands as soon as an initiate rises to a higher rank or dies, these masks are passed on to the successor of a deceased society member. The term *lukungu* means "skull," and alludes to the mask's function of keeping alive the memory of dead Kindi members. When used in the context of initiation ceremonies, which last several days, the masks are first carefully oiled before being attached to a fence or to a larger *muminia* or *idimu* mask. They form a focus for the often dramatic dances and didactic songs and chants which serve to convey ethical and moral values.

Bibliography: Biebuyck II, 1986; Biebuyck, 1993; Biebuyck, 1995, p. 377; Cornet, 1973; Hunn, 1985

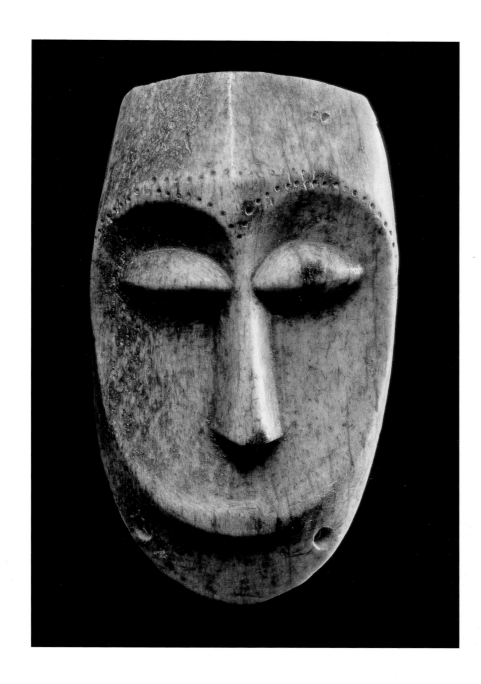

Dual-faced helmet mask
(*Ibulu lya alunga*)

Bembe, Democratic Republic of Congo

Wood, painted in black, red, and white
Height 47 cm (18 ½ in.)
Inv. 1026-38
Cat. 234

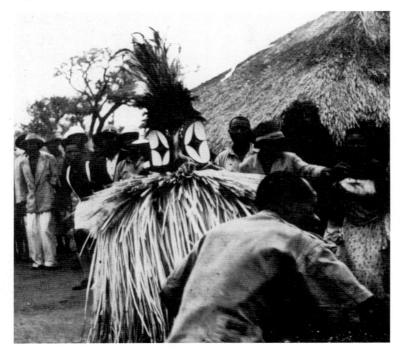

Performance of a Bembe dancer wearing a dual-faced helmet mask and a multilayer fiber costume. Members of the Alunga society and their wives accompany the performance with songs and dances.

The Bembe, who live mainly west of Lake Tanganyika, have been influenced culturally by various neighboring groups. These influences are reflected in the stylistic and typological diversity of Bembe art, which, in addition to three-dimensional sculptures, encompasses numerous other object types, including the plank and helmet masks used by initiation associations or by healers.

This mask represents a type of mask which, according to the Bembe, goes back to the Bahonga, a hunting and gathering people whose collecting of honey is said to have been done under the tutelage of this mask. With the Bembe it is called *ibulu lya alunga* or *echwaboga*, represents a bush spirit (*m'ma mwitu*), and belongs to the accessories of the hierarchically ordered Alunga men's association. The mask is used during acceptance ceremonies for new, usually young members, as well as in hunting rites. For public appearances the carved helmet is decorated with an elaborate headdress of feathers and porcupine (*ehala*) quills, and a neck fringe of fibers. The dancer is clad in a multilayered fiber costume (*asamba*).

These impressive Alunga masks are invariably conceived in the form of cylindrical helmets with two, as it were, Janus faces, whose black rhombic or cross-shaped eyes with protruding pupils are set in large oval hollows painted white. Due to these striking facial features the masks have been interpreted as representing owls, with which the masqueraders in fact occasionally identify. In addition, the two faces are intended to invoke the all-seeing nature of the mask spirit, a capacity which enables him to reconcile the opposing forces of nature, such as male/female or day/night.

Bibliography: Biebuyck, 1972; Biebuyck, 1993; Felix, 1989; Petridis, 1993, p. 186; Roy, 1992

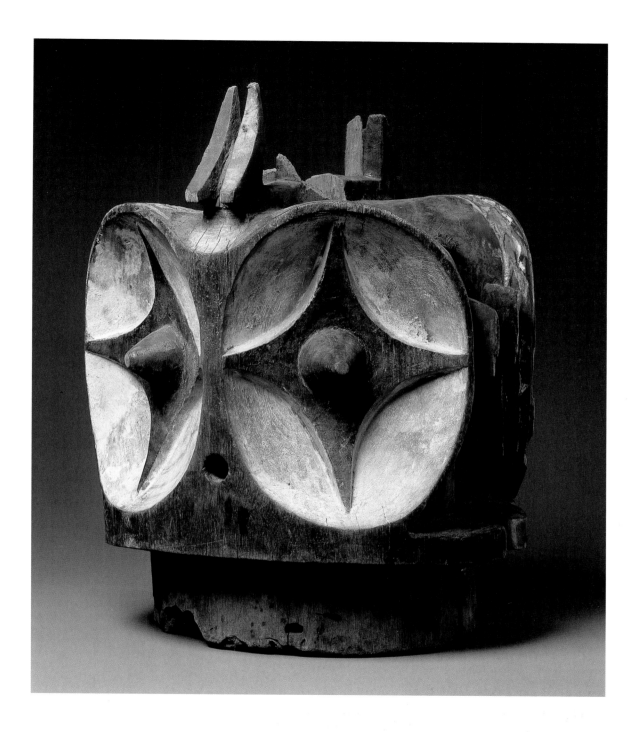

Face Mask

Tabwa (?), Democratic Republic of Congo

Wood with glossy patina and traces of white
and black paint
Height 32 cm (12 ⅝ in.)
Inv. 1027-5
Cat. 235

The exact provenance of this mask has not
been determined. According to the dealer
from whom it was purchased (Mathias
Komor, New York), it comes from the
Ngombo. However, the mask is not related
stylistically to works of this group, who
inhabit the northwestern area of central
Africa. The facial features and scarification
patterns are more closely related to sculp-
tures from the region of Lake Tanganyika in
central Africa.

Several formal traits also seen in figu-
rative works of the Tabwa suggest an attribu-
tion to this ethnic group: an elongated face
that tapers from the temples to the flat chin;
cowrie-shaped eyes (cf. plate 98); a long
triangular nose; an open, slightly projecting
mouth with thin lips; and large, semicircular
ears. The scarification pattern that runs
vertically over the center of the forehead to
the bridge of the nose is likewise a charac-
teristic feature of works from this region.
The flat, round cap reflects the influence of
Moslem slave and ivory traders, who gained
a footing among the Tabwa in the latter half
of the nineteenth century.

Bibliography: Maurer, 1988, p. 278

Back view of the mask, showing a carefully
hollowed and smoothed interior.

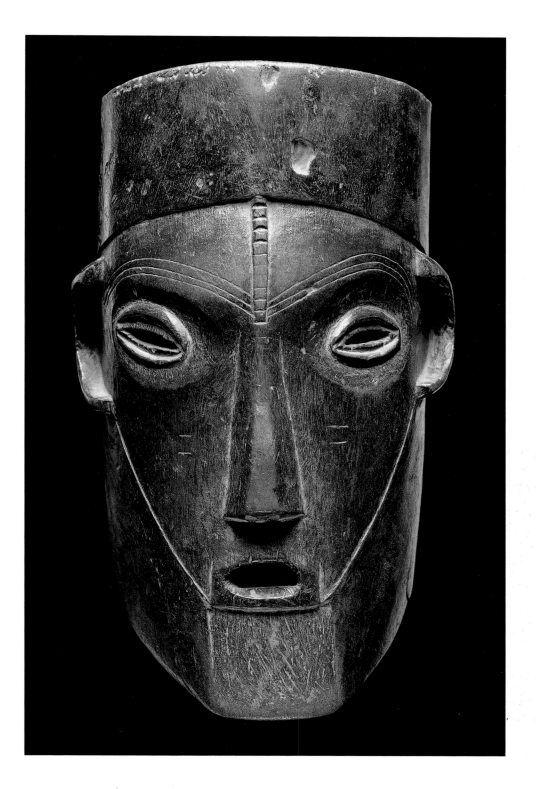

Pseudo-helmet mask (*Kiyunde*)

Tabwa, Democratic Republic of Congo

Wood with glossy patina, cowrie shells,
upholstery tacks
Width 73 cm (28 ¾ in.)
Inv. 1026-58
Cat. 236

To the Tabwa, whose settlement area in the southeastern part of central Africa borders on Lake Tanganyika, the water buffalo is an ambivalent creature, both in physical appearance and behavior. The reddish color of

females' coats contrasts to the deep black of older males. Wild buffaloes have a gentle temperament, but they can attack without warning when disturbed; they spend the day concealed in the bush and emerge only at dusk. These opposing traits lead the Tabwa to associate the buffalo with culture heroes, as well as with rulers who insure the welfare of the populace but are simultaneously considered sorcerers capable of doing great harm to their subjects.

This striking sculpture of a buffalo head with spreading horns represents the best-known Tabwa mask type. The horizontal and vertical pattern of upholstery tacks is based on the scarification marks once commonly found among Tabwa men and women. The eyes are represented by inlaid cowrie shells. Inside the mask, two grips are provided for the dancer to hold the mask over his head. His body was concealed by a voluminous costume made of raffia fiber and animal pelts.

The name of the mask and its performance, *kiyunde*, apparently goes back to legendary figures and stories. The term *kiyunde* alludes to the craft of metalsmithing, whose introduction is attributed to local cultural heroes. The buffalo dancer is accompanied in his performance by another dancer wearing a female mask, and together they represent a mythical couple.

Bibliography: Fagg, 1980; Maurer, 1988, p. 279; Neyt, 1993; Roberts, 1995a; 1995b

Performance of a *kiyunde* masquerader, 1973.

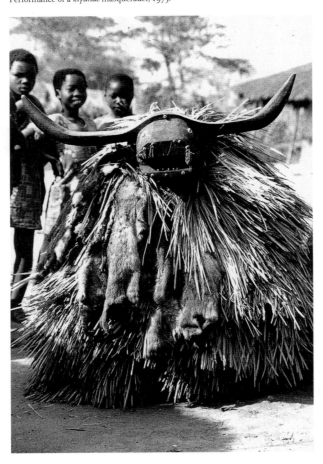

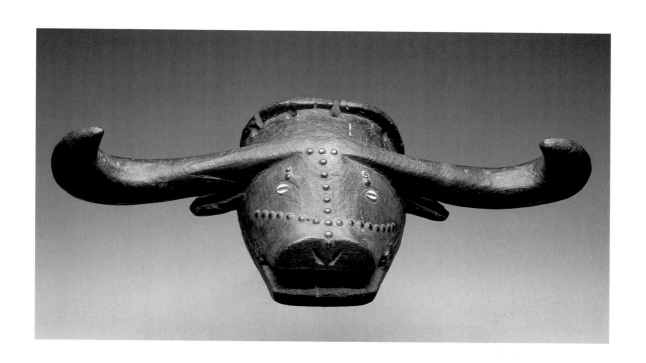

Face mask

Makonde, Tanzania

Wood with red paint, plant fibers, glass, wax
Height 21.5 cm (8 ½ in.) (not including beard)
Inv. 1027-2
Formerly collection of the Linden-Museum,
Stuttgart; collected by Seyfried in 1906
Cat. 238

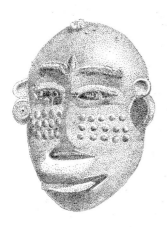

Makonde face mask with elaborate scarification
decor, ear plugs, and applied eyelashes. The lip
plug identifies the mask as female in gender
(Völkerkundemuseum, Munich).

The Makonde have two mask types: helmet
crests, used principally by the groups in
Mozambique, and face masks, prevalent
among the Tanzanian Makonde. The an-
thropomorphic face masks portray partic-
ular individuals or occasionally represent
sickness. Yet entirely realistic examples are
seldom found; most masks show a conven-
tionalized or schematic approach. Design
elements frequently include scarification
marks, and eyebrows, lashes, and coiffure
made of real hair affixed with wax. Female
masks often have a lip plug, and male
masks a beard.

This face mask lacks scarification and
hair. While the mouth and eyes are only
slightly raised above the convex surface of the
oval face, the long, thin nose, and rounded
ears markedly protrude. Inside the mask,
two pieces of glass are affixed with wax
behind the eye openings. The holes along
the edge served to attach a piece of cloth
that held the mask in place and covered the
dancer's head. His disguise was completed
by a costume of fabrics, foliage, or feathers,
supplemented by various accessories such
as fly whisks, dance staffs, noisemakers, or
weapons.

The Makonde still hold masquerade
dances at the end of initiation ceremonies
(*unyago*), when adolescent boys and girls
return from their separate bush camps after
a period of seclusion. In this context the
anthropomorphic masks embody ancestral
spirits (*midimu*), whose apparition serves
to remind the initiates of their new position
in the community and the rights and duties
it entails.

Bibliography: Blesse, 1994; Castelli, 1988; Kubik,
1993; Wallace, 1985

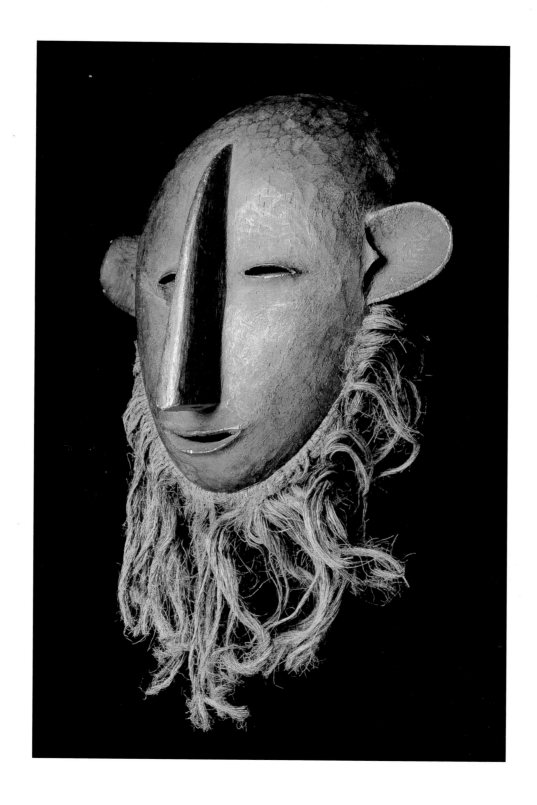

Face mask (*Lingwele*)

Makonde/Andonde (?), Mozambique

Wood with glossy black patina, remnants of
animal hide, plant fibers; left ear restored
Height 24.8 cm (9 ¾ in.)
Inv. 1027-42
Cat. 237

This expressive mask attests to the great
skill of its carver. Emphasizing the contrast
between geometric volumes and flat sur-
faces, he has produced a strikingly vivid
image of a baboon, whose bulging forehead

Andonde performances of *lingwele* masqueraders representing baboons are
accompanied by music played on drums and tin rattles.

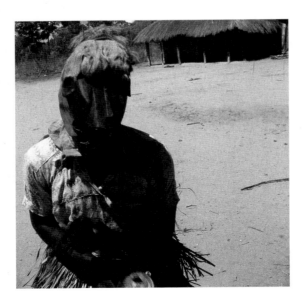

overshadows narrow eye slits similar in
form and execution to those seen in other
Makonde works (cf. plate 99). The charac-
teristic snout protrudes between rounded
cheeks, and the long nose is accentuated by
a thin ridge. Around the gaping mouth with
its powerful teeth, pieces of hide have been
attached with wooden pins. The broken
ends of the pins on the forehead and above
the unusually shaped and superbly carved
ears indicate that the skull was originally
covered by a wig of hide.

Based on the circumstances of its
acquisition and stylistic criteria the mask
was ascribed to the Makonde. Though
Makonde masks are of great diversity and
variety, only a few depictions of monkeys
are known, and these, moreover, are often
highly stylized. As a field photo by Gerhard
Kubik shows, expressive baboon masks
known as *lingwele* are worn by an Andonde
group in the region of the Rovuma River.
This ethnic group, like their immediate
neighbors, the Makonde, practice initiation
ceremonies for adolescents of both sexes in
which such masks are apparently used. Yet
Kubik does not tell us whether the Andonde
themselves carve their masks. It is not im-
probable that they obtain them from the
Makonde, who are known to have executed
sculptures on commission from neighboring
peoples and whose masks are today still
extremely popular among other groups.

Blesse, 1994; Castelli, 1988, p. 301; Kubik, 1993

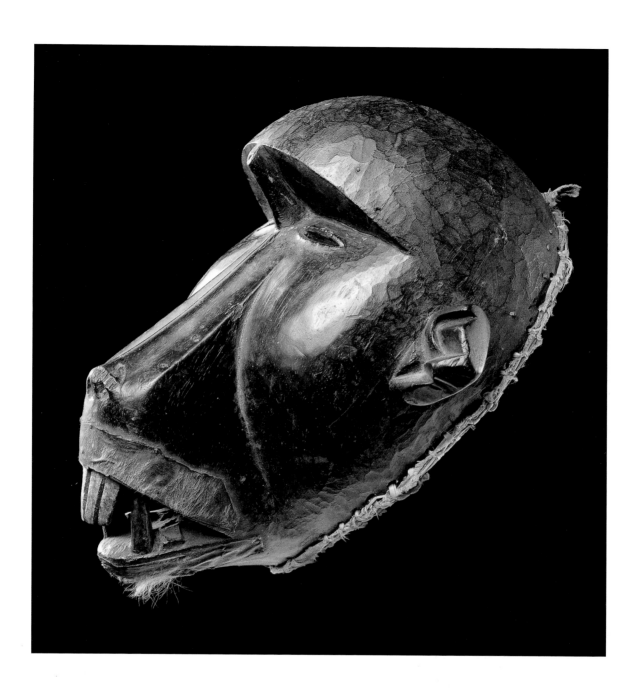

CATALOGUE

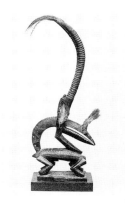

1 Headdress mask (Chi Wara)

Bamana, Mali
Hardwood, dark patina, hair, glass
pins and beads
Height 52 cm (20 ? in.)
Inv. 1004-58
Formerly collection of Josef Mueller;
acquired before 1939

This mask represents a roan
antelope, whose sweptback
buck's horns characterize the
mask as male in gender. It is
an example of the abstract
"Ouassoulou" style, which
was described in 1980 by
Dominique Zahan and named
for a tributary of the Niger, near
Bamako. Most sculptures in this
style combine the features of
several animals; in this case the
head, ears, and horns of an
antelope are set on the body of
an aardvark or pangolin. The
protuberance on the antelope's
nose may have once borne a
human figure, since replaced
by a tuft of hair.

Such masks were worn dur-
ing ceremonies of the Chi Wara
initiation society. According to
Zahan, each of the six initiation
societies, or Jow, of the Bamana
are open only to men who have
passed through the preceding
one. The sequence of levels is
Ndomo, Komo, Kama, Kono,
Chi Wara, and Korè. Each level
conveys a specific body of
knowledge intended to help the
members to gain access to
supernatural power.

2 Headdress mask (Chi Wara)
Plate 3

Bamana, Mali, Ouassoulou region
Wood, remnants of ochre painting,
red and white glass beads, plant
fibers
Height 40.5 cm (16 in.)
Inv. 1004-187
Formerly collection of Armand
Trampitsch

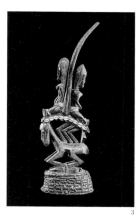

3 Headdress mask (Chi Wara)

Bamana, Mali
Wood with dark stain, cowrie shells,
white beads, plant fibers,
basketwork
Height 60 cm (23 5/8 in.)
Inv. 1004-57
Formerly collection of Josef Mueller;
acquired before 1942

Two headdresses of similar
composition and execution in

the Musée de l'I.F.A.N. in
Dakar, Senegal, come from
Bougouni, a town in the south-
west Bamana region. This
region is known for an abstract
type of Chi Wara headdress
whose base is frequently in the
form of an aardvark (*Orycteropus
afer*; cf. plate 3). The present
headdress, however, apparently
represents a roan antelope
(*Hippotragus equinus*) or a
hybrid of the two animals, with
a schematic pangolin (*Manis
tricuspis*) perched on its back.
These animals, symbolic of
farming activities, are supple-
mented by two seated female
human figures flanking the
carved antelope horn. As a
whole the composition alludes
to the fact that both the fertility
of the fields and the fecundity
of the people are necessary for
human survival.

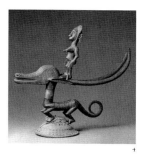

4 Headdress mask (Chi Wara)
Plate 2

Bamana, Mali, Beledougou region
Wood, upholstery tacks, sheet metal
strip, red glass bead, plant fibers,
basketwork
Height 55 cm (21 5/8 in.)
Inv. 1004-100
Formerly collection of Josef Mueller;
acquired from the collection of Emil
Storrer about 1950

Bibliography: Schmalenbach, 1953,
p. 59, no. 55; Leuzinger, 1977, p. 120;
Brett-Smith, 1988, p. 71, no. 15;
Meyer, 1991, p. 80, no. 59; *Historia
del Arte*, 1996, p. 261

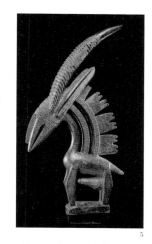

5 Headdress mask (Chi Wara)
Plate 1

Bamana, Mali, Segou-Koutiala
region
Wood with dark brown and blackish-
brown stain, metal nails
Height 78 cm (30 ? in.)
Inv. 1004-36
Formerly collection of Josef Mueller;
acquired from the collection of
Antony Moris before 1939; collected
before 1931 Bibliography: Galerie
Pigalle, 1930, no. 13; *Kunst der Neger*,
1953, fig. 16; Bassani, 1982; Fagg,
1980, p. 38; Brett-Smith, 1988,
p. 42, no. 16; Newton, 1995, p. 68

6 Helmet crest *(Tonsun kun)*

Malinke, Mali
Hardwood, homogeneous dark
patina
Height 58 cm (22 7/8 in.)
Inv. 1004-49
Acquired by Josef Mueller before
1952

This mask is the subject of an unpublished study by Sarah Brett-Smith. Her attribution is based on information from research she did in Mali in 1984 and 1985. In the Malinke language the mask is called *tonsun kun*, or "bat's head". It originally came from the region of Kita Kangaba. Its form was probably derived from the textile masks which are worn with a foliage costume by the Mande in Gambia, who share a linguistic and cultural heritage in common with the Malinke. According to a personal communication by Leon Siroto to Brett-Smith, the scarification patterns on the present mask conform to the adornments of woven cotton threads seen on Mande textile masks. An identical mask was recently attributed to the Senufo (see *Masques* [exh. cat.], Musée Dapper, 1995, p. 60).

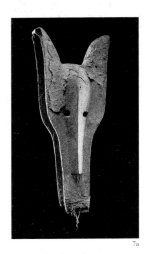

7a Forehead mask (Kono)

Bamana, Mali
Wood with encrusted patina and traces of ochre paint, plant fibers
Height 93 cm (36 5/8 in.)
Inv. 1004-31
Formerly collection of Josef Mueller

This mask belongs to the Kono, the fourth of a total of six Bamana initiation societies, or Jow, which promulgates a deeper insight into the group's ethical values. This knowledge is communicated to neophytes through the songs that accompany the mask dancer's performance. With the aid of a reed pipe, the singer uses a nasal tone to imitate the voice of conscience and to point out the path of proper behavior. According to Dominique Zahan (1974), the Kono mask simultaneously represents a bird and an elephant, the former symbolizing the human spirit and the latter intelligence. The large erect ears allude to the fact that Kono adepts are expected to learn to listen to their "inward voice."

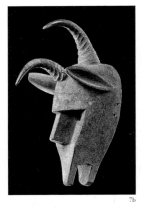

7b Face mask

Bamana, Mali
Wood, encrusted patina, plant fibers
Height 37 cm (14 5/8 in.)
Inv. 1004-169
Formerly collection of Marie-Ange Ciolkowska

This mask is reminiscent of the hyena masks (*sukuru*) of the Bamana, which are associated with Korè, the sixth and highest level of Bamana initiation societies (cf. plate 4). These masks bear similar characteristics to this example: although they do not have horns, they share the schematic, wide open mouth and usually vertically pointed ears, which occasionally – as in this mask – point forward. Sarah Brett-Smith (personal communication, July 24, 1996) acquired a similar piece, without horns, in the Kita area of the western Bamana region by the sculptor Basi Fane. He described the mask as *nama kun* (head of *nama*), although this type of mask is not used by the third initiation society of the same name, but by the Chi Wara society. Brett-Smith believes that the term *nama*, which also means "hyena" among the Bamana, refers to the shape of the mask, which has been inspired by the animal. Because of stylistic traits such as the sharp edge of the forehead above deep-set eyes, Brett-Smith thinks that the mask may have originated from the Malinke.

Bibliography: Harter, 1991; Zahan, 1974

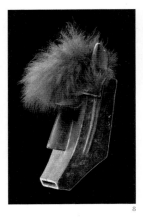

8 Face mask (Korè Dugaw)
Plate 4

Bamana, Mali
Wood, colored dark brown, animal skin
Height 37 cm (14 ? in.)
Inv. 1004-11
Formerly collection of Josef Mueller; acquired before 1942

Bibliography: Fagg, 1980, p. 38

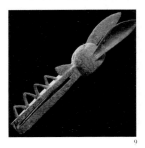

9 Helmet crest (Komo)
Plate 5

Bamana, Mali
Wood, encrusted patina, iron nails, remnants of feathers
Length 110 cm (43 ? in.)
Inv. 1004-172

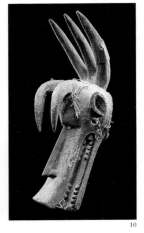

10 Helmet crest (Komo-kun)

Malinke, Mali
Wood with traces of black paint, metal rings, nails, plant fibers
Height 98 cm (38 5/8 in.)
Inv. 1004-173

Based on its stylistic traits, such as the elongated snout, open mouth with sharp teeth, horns, and metal fittings, this mask can be identified as a *komo-kun* (head of Komo), whose apparition, respected equally by the Malinke and Bamana, signals great power and danger. It belongs to the paraphernalia of the Komo society (see plate 5), which, though open to men of all occupations, is always headed by metalsmiths. Only they have the right to wear and to make such masks, in the process of which they must observe special rules of behavior in order to ensure the masks' effectiveness (Sarah Brett-Smith, personal communication, July 24, 1996). The influence of Komo masks and hence their owners, the smiths, is far-reaching, since they oversee practically all aspects of daily

life, track down wrong doers, and are believed to be able to foresee future events.

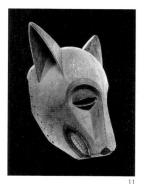

11 Face mask

Bamana, Mali
Wood, with red, orange, and black paint
Height 41 cm (16 1/8 in.)
Inv. 1004-188
Formerly collection of Josef Mueller; acquired before 1942

The purpose and origin of this carefully carved animal mask with its long nose, prominent eyelids, and pointed ears, have not been clearly established. Possibly it was used in combined masquerades and puppet plays, entertainments put on by young men's age-grade associations (*kamalen-ton*) especially in the region around Segou. In addition to human marionettes carved of wood which embody various characters, movable animal figures and masks (*sogo-kun*) also appear in these entertainments. The performance of each animal character is accompanied by a certain song and expresses social and ethical values (see Arnoldi, n.d.). However, it is doubtful that the present mask was fabricated by an artist living in the Segou region. Due to its rounded forms Sarah Brett-Smith considers that it may be the work of a carver from the Sikasso region who was active in the northern Bamana area (personal communication, July 24, 1996).

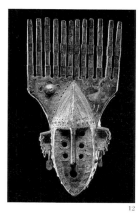

12 Face mask

Marka, Mali
Wood and aluminum
Height 60 cm
(23 5/8 in.)
Inv. 1004-190

This mask belongs to a well-known type that emerged in the 1930s, when brass was replaced by aluminum . A similar mask is in the collection of the Royal Ontario Museum (Goldwater, 1960, fig. 60). Masks with a comb, similar to the Ndomo masks of the Bamana, are used by various peoples affiliated with this ethnic group. They are probably danced in the context of adolescent boys' initiation rites.

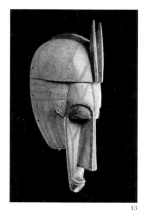

13 Face mask

Marka, Mali
Hardwood, poker-work, painted in ochre, pink, and blue
Height 40 cm (15 ? in.)
Inv. 1004-171
Acquired by Josef Mueller before 1952

The Marka are a Mande (Soninke) subgroup whose settlement region extends from the north of the Bamana to the Senegalese border, where they are called Sarakole. A part of this ethnic group that has settled in Burkina Faso is known as Dafing (see cat. 27). Their elongated masks are often more or less completely covered with copper plates. Along the Niger the Marka use the masks in ceremonies related to fishing and farming. This beautifully worked mask, which Elsy Leuzinger uses to illustrate Marka art, lacks a metal sheathing.

Bibliography: Leuzinger, 1962, p. 70, no. 14

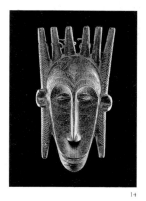

14 Face mask (Kufen)

Bolon, Mali or Burkina Faso
Hardwood with dark patina, seeping oil resulting from sacrificial anointments, iron and fiber rings
Height 31 cm (12 ? in.)
Inv. 1004-51
Acquired by Josef Mueller before 1942

This rare mask is occasionally described as belonging to the ritual objects of the Ndomo initiation society of the Bamana. However, a number of features challenge this attribution. The long delicate nose, the coffee-bean-shaped eyes, the placement of the mouth close to the chin, and above all the lateral tapering extensions, or "legs" (also found in Dyula masks, which in turn inspired the Senufo *kpeli-yehe* type), would indicate an origin among the Bolon, a small Mande-speaking group who live in the border area of Burkino Faso and Mali. Most *kufen* masks of this ethnic group are completely sheathed in brass plates (see Roy, 1987, p. 357). They always have a "comb coiffure" derived from the masks of the Bamana Ndomo society.

Like the Bamana, the Bolon use such masks in multiphase initiation rites.

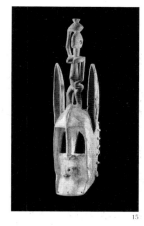

15 Face mask (Walu)
Plate 6

Dogon, Mali
Wood, remnants of white paint, plant fibers
Height 63 cm (24 ? in.)
Inv. 1004-8
Formerly collection of Josef Mueller; acquired from the collection of Emil Storrer about 1952

Bibliography: Fagg, 1980, p. 41; Dieterlen, 1988, p. 66, no. 11; Meyer, 1991, p. 98, no. 82

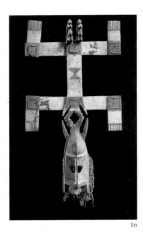

16 Face mask (Kanaga)
Plate 7

Dogon, Mali
Wood, painted in white, black, red,
and blue, leather and fur cords,
raffia net
Height 115 cm (45 ? in.)
Inv. 1004-35
Formerly collection of Josef Mueller;
acquired before 1952

Bibliography: Fagg, 1980, p. 40;
Schmalenbach, 1988, p. 26, fig. 18

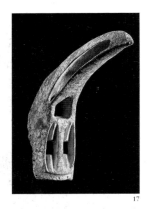

17 Face mask

Dogon, Mali
Hardwood, encrusted ochre patina,
traces of black pigment
Length 63 cm (24 ? in.)
Inv. 1004-9

This mask represents a "picking
bird" (a *dyodyomini*, according to
Marcel Griaule, 1938, p. 492). It
may be a *dobu*, a variety of horn-

bill. The head of such masks is
often adorned by a female fig-
ure, yet some lack this feature,
such as that in the Rockefeller
Collection and that illustrated
by Marcel Griaule (ibid., p. 493).
Unlike the *kanaga* mask, which
likewise evokes a bird, the *dyo-
dyomini* was not intended to be
worn in group performances.

Bibliography: Fagg, 1980, p. 40

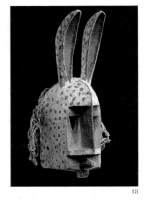

18 Face mask *(Dyommo)*

Dogon, Mali
Wood, encrusted patina, painted in
white and ochre, fibers
Height 39 cm (15 3/8 in.)
Inv. 1004-176
Acquired by Josef Mueller before
1952; formerly Emil Storrer
collection

This mask type represents a
rabbit *(dyommo)*, and its wearer
danced to rhythms known by
the same name. The rabbit's
nostrils form a horizontal bar
like that seen in a mask discov-
ered by Marcel Griaule in the
cliffs near Ireli (Griaule, 1938,
fig. 100).

19 Helmet crest

Dogon, Mali
Wood, uniform gray hue
Height 38 cm (15 in.)
Inv. 1004-177
Acquired by Josef Mueller before
1942

This mask belongs to a rare type
which was not classified by Mar-

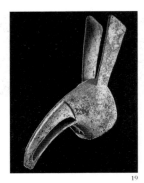

cel Griaule. Hélène Leloup sus-
pects that no more than four
examples exist. She once owned
a similar mask, which belonged
to the "picking bird" category.

According to Leloup these
masks originally came from
the mountains of Saruyere,
east of Douenza, where a few
(since Islamized) Dogon clans
mounted a long resistance to
the French. After embittered
fighting French troops finally
succeeded in 1921 in subjecting
the clans and driving them into
the plains (communication of
September 11, 1996). The masks
were presumably sold in the
1920s and 1930s, and came to
France in a group. Josef Mueller
bought the present mask in
Paris, where he lived until 1942.

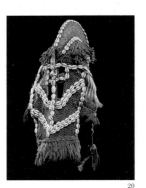

20 Helmet or cowl mask

Dogon, Mali
Plant fibers, cowrie shells, beads of
various colors
Height 50 cm (19 5/8 in.)
Inv. 1004-185
Acquired by Josef Mueller before
1952

Old helmet masks made of fiber
are seldom found in private col-
lections, though they are just as
numerous and varied in form as
wooden masks. They apparently
had no value for collectors who
lacked ethnographic knowledge.

Iconographically, the helmet
masks are sometimes inter-
changeable with wooden types.
The Fulbe type, for instance,
exists in both genres, However,
certain types such as the Fulbe
woman are found only in hel-
met form.

Based on a photograph, this
piece was identified by the
Dogon as a female mask. Some
members of the community
described it as a Bamana and
others a Fulbe. The comb
adorned with cowrie shells
would suggest the latter inter-
pretation.

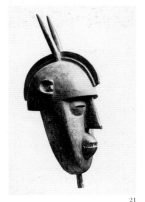

21 Helmet crest *(Bolo)*

Bobo (Zara), central region of
Tanzila, Burkina Faso
Hardwood, with traces of red, black,
and white paint
Height 62 cm (24 3/8 in.)
Inv. 1005-27
Acquired by Josef Mueller before
1952, probably from the collection of
Emil Storrer

The Bobo and the Bwa, their
easterly neighbors, are often not
distinguished from one another
by researchers. Yet the Bobo
speak a Mande language, not a
Voltaic one. Their metalsmiths
wear either masks of foliage or
three types of wooden mask,

including the present one, which is called *bolo* (pl. *bole*) and is danced for entertainment. Christopher Roy (Roy, 1987, p. 339) illustrates a similar mask without horns, attributing it to the Zara, a subgroup of the Bobo who do not practice farming.

Bibliography: Vion, 1988, p. 76, fig. 5

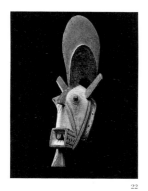

22 Face mask *(Kobiay)*

Bwa, Burkino Faso
Hardwood, painted in black, red, and white; ears restored
Height 80 cm (31 ? in.)
Inv. 1005-28
Acquired by Josef Mueller from Emil Storrer before 1952

This mask, known as *kobiay*, is used by *kaani* smiths (Roy, 1987, p. 274). It is intended to appeal to the good offices of a spirit called *hombo*, who lives in a swamp. Legend has it that *hombo* once appeared in the guise of an eel to help the ancestors of the Didiro clan to escape from the village of Houndé.

Bibliography: Roy, 1991, p. 54, fig. 8

23 Plank mask

Bwa, Burkina Faso, Houndé area
Hardwood, painted in black, red, and white
Width 130 cm (51 1/8 in.)
Inv. 1005-9
Acquired by Josef Mueller from Emil Storrer before 1952

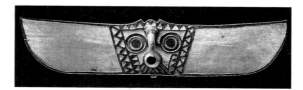

All Bwa masks represent nature spirits. The present one depicts a falcon, sparrow-hawk, or bat, but not a butterfly, as is frequently maintained. Butterfly masks are characterized by a number of target-like circles distributed across the face.

The zigzag motif framing the face in this mask signifies the "ancestral path" which every Bwa must follow in order to master life (Roy, 1991, p. 51).

Bibliography: Fagg, 1980, p. 50; Roy, 1987, p. 271, no. 226; Roy, 1991, p. 52, no. 4

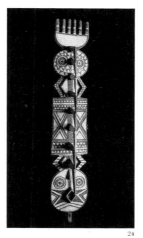

24 Plank mask *(Bayiri)*

Bwa, Burkina Faso, from the village of Boni
Hardwood, painted in black, red, and blue
Height 167 cm (65 ? in.)
Inv. 1005-55

Such masks are called *bayiri*, a name that stands for small sculptures of female bush spirits. Six of these appear on this mask. According to Christopher Roy they represent an ancient female nature spirit associated with human fertility and the

earth. The same author adds that the mask served to thank the spirits and ancestors for protecting the village and ensuring good harvests. This type of mask is rarer than the *nwantantay* masks (cat. 25).

Bibliography: Roy, 1991, p. 54, no. 7

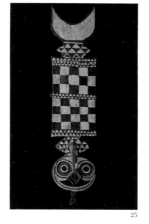

25 Plank mask *(Nwantantay)*
Plate 8

Bwa (Bobo Ule), Burkina Faso
Wood, painted in black, white, and red
Height 23 cm (79 7/8 in.)
Inv. 1005-10
Formerly collection of Josef Mueller; acquired from the Emil Storrer collection in 1953

Bibliography: Fagg, 1980, p. 51; Roy, 1987, p. 278, no. 238; Roy, 1988, p. 78, no. 19; Roy, 1991, p. 52, no. 5; Meyer, 1991, p. 100, no. 83

26 Face mask *(Basi)*

Bwa, Burkina, Faso, from the village of Boni
Hardwood, painted in black, red, and white, plant fibers
Height 88 cm (34 5/8 in.)
Inv. 1005-48

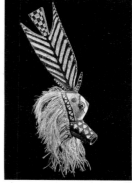

Basi fish masks are danced in a ceremony that tells the story of a fish that once rescued the Nyumu clan from Boni. According to Christopher Roy, the dances, accompanied by balafon music, take place during the dry period between October and May, on several evenings a month, in the Bwa villages of the south. The masks recall the meeting of the forefathers with the nature spirits who protected them from devastation, famine, and other calamities.

Bibliography: Roy, 1991, p. 43, no. 1

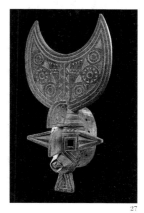

27 Face mask *(Barafu)*

Dafing, Burkina Faso
Hardwood, barely visible traces of black, red, and white paint
Height 72 cm (28 3/8 in.)
Inv. 1005-16
Formerly collection of Josef Mueller; acquired before 1952

The Mande-speaking Dafing, also known as Sarakole or, in Mali, as Soninke, call themselves Marka. Their works reflect a variety of stylistic characteristics adopted from their neighbors to the south, the Bwa, which are evident in this sculpture. This mask type, known as *barafu*, has frequently been ascribed to the Bobo, who in turn have been confused with the Bwa. According to Christopher Roy (communication of March 23, 1990), these masks, which are danced at funerals and initiation rites, are worn exclusively by religious experts.

Josef Mueller presumably acquired the mask from a European collection. This source is indicated by traces of wax, with which African sculptures were treated at a period when little thought was given to the authenticity of their state of preservation.

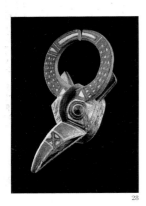

28 Face mask

Nunuma, Burkina Faso
Hardwood, painted in black, red, and white
Height 65 cm (25 5/8 in.)
Inv. 1005-47

The Nunuma live southwest of the Mossi Plateau, to the east of the Marka Dafing and the Bwa. They are often referred to as "Gurunsi," even though the Nunuma themselves consider this a pejorative term.

In this mask traits of a buffalo are combined with those of a bird, both animals signifying

nature spirits. Such masks were worn by initiated young men at burial services, or in order to rid the village of destructive forces (Christopher Roy, personal communication, March 23, 1990).

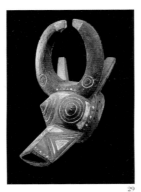

29 Face mask

Nunuma, Burkina Faso
Hardwood, painted in black, red, and white
Height 49 cm(19 ? in.)
Inv. 1005-49

Obtained from the southern Nunuma, this mask represents a buffalo, a bush spirit. Two masks illustrated by Christopher Roy (Roy, 1987, fig. 192 f.) point to the difficulty of distinguishing the Nunuma from the Nuna style.

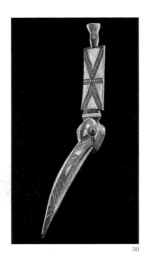

31 Face mask with wooden blade (Keduneh)

Winiama, Burkina Faso
Hardwood and plant fibers, painted black, red, and white
Height 116 cm (45 5/8 in.)
Inv. 1005-56

The Winiama are often identified as a "Gurunsi" subgroup. This type of mask with a wooden blade mounted vertically on the forehead is called *keduneh*. According to Christopher Roy (communication of March 23, 1990), it is worn in initiation or funeral rites, or in order to dispel destructive forces. On market days such masks are also danced for entertainment.

30 Face mask

Nunuma, Burkina Faso
Hardwood, painted in black, red, and white
Height 157 cm (61 ? in.)
Inv. 1005-54

This mask depicts a bird, which according to Christopher Roy (communication of March 23, 1990) symbolizes the spirit of a deceased person, endowed with supernatural power. An identical mask is reproduced in the often-cited work by Roy (Roy, 1987, fig. 184), where its erroneous attribution to the Nuna resulted from a misprint.

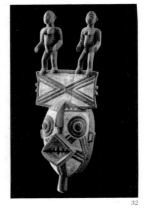

32 Face mask
Plate 9

Winiama, Burkina Faso
Wood, painted in white, black, and red
Height 57.5 cm (22 5/8 in.)
Inv. 1005-51

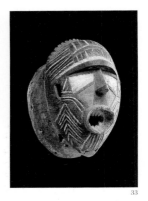

33 Face mask

Nuna, Burkina Faso
Hardwood, painted in black, red, and white
Height 30.5 cm (12 in.)
Inv. 1005-45

This monkey mask is characteristic of the Nuna style (Christopher Roy, communication of March 23, 1990). Apart from being used in a sacred context, the type serves above all to amuse crowds on market days. The young men who dance these masks do their utmost to impress marriageable girls by their performance.

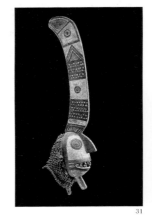

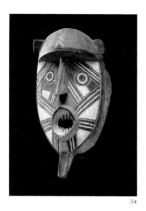

34

34 Face mask

Nuna, Burkina Faso
Hardwood, painted in black, red,
and white
Height 41 cm (16 1/8 in.)
Inv. 1005-50

This is another monkey mask
which serves the same purposes
as that illustrated in cat. 33.
Christopher Roy illustrates a
Nuna monkey mask alongside
three Nunuma masks of the
same type (Roy, 1987, figs. 189,
186–188), a juxtaposition that
shows the difficulty of distin-
guishing the two group's styles
from one another.

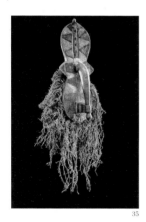

35

35 Face mask

Sisala, Burkina, Faso or northern
Ghana
Hardwood, painted in black, red,
and white, plant fibers
Height 75.5 cm (29 ? in.)
Inv. 1005-52

The Sisala form a splinter group
of the "Gurunsi" and live in the
border area between Burkina
Faso and Ghana. This rare mask
type is known especially from
the remarkable example pub-
lished by William Fagg (Fagg,
1970, p. 119, no. 139).
Noteworthy is the asymmet-
rical pattern on the forehead of
the mask, which represents an
indeterminate species of animal
and embodies a bush spirit.

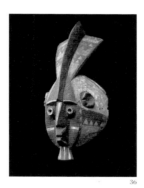

36

36 Face mask *(Wan-balinga)*
Plate 10

Mossi, Burkina Faso
Wood, painted in black, white, and
red; goatee partially restored
Height 38.5 cm (15 1/8 in.)
Inv. 1005-12

Formerly collection of Josef
Mueller; acquired from the
Charles Vignier collection
before 1939

Bibliography: Fagg, 1980, p. 47;
Roy, 1981, Roy, 1987, pp. 12 and 101,
no. 66; Roy, 1988, p. 79, no. 20

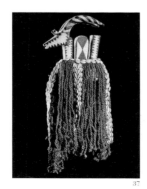

37

37 Headdress mask *(Zazaigo)*

Mossi, Burkina Faso
Hardwood, painted in black and
white, cowrie shells, woven plant
fibers
Height 65 cm (25 5/8 in.)
Inv. 1005-60
Acquired by Josef Mueller from Emil
Storrer around 1950

This mask belongs to a group of
masks characterized by a range
of animal depictions – large and
small antelopes, ducks, roosters
– but also by human figures
(Roy, *African Art*, 1987, p. 149).
Some masks have two animals'
heads. It is not unlikely that they
were originally inspired by the
famous antelope masks of the
Bamana (cf. cats 1 ff.). Christo-
pher Roy (Roy, 1980, p. 42 ff.)
devoted an extensive article to
these masks, which are known
as *zazaido* (sing. *zazaigo*).
The masks are typical of the
style of the northern Mossi.
Known as the Kongussi or Yako
style, it features the two ani-
mals' heads painted red as in
the present example. Often such
masks are arbitrarily attributed
to the Bobo (Rubinstein cat.),
the "Gurunsi" (Delange, 1974,
no. 18), or the Bwa (Segy, 1976,
no. 108 f.), despite the fact that
they were reported among the
northern Mossi as early as 1973
by Henri Kamer, a businessman
and traveller (Kamer, 1973, p.
97, nos. 61–63).
The *zazaido* represent totem
animals which confronted the
group's ancestors in the bush.
These masks are used at funer-
als but also for entertainment.

Bibliography: Roy, 1987, fig. 114

38 Helmet crest *(Wiskoamba)*

Mossi, Burkina Faso
Leather, wood, cowrie shells, black
pigments, fibers
Diameter 20 cm (7 7/8 in.)
Inv. 1005-58
Acquired by Josef Mueller before
1952, probably before 1939

This *wiskoamba* mask was worn
by young non-initiates at burial

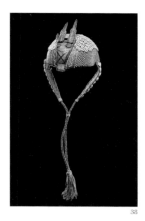

38

rites. There is an identical mask
in the collection of the Musée
l'Homme, Paris.

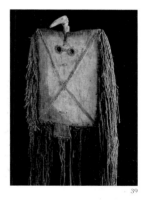

39

39 Plank mask *(Loniaken)*
Plate 11

Tusyan, Burkina Faso
Wood, *Abrus precatorius* seeds,
cowrie shells, kaolin, black plant
fibers
Height 67 cm (26 3/8 in.) (not
including fringe)
Inv. 1005-11
Acquired in 1968 from the
collection of Robert Duperrier, Paris

Bibliography: Fagg, 1980, p. 49;
Rubin, 1984, cover; Musée Barbier-
Mueller, 1987, p. 42, no. 2; Roy,
1987, pp. 24 and 365, no. 314; Roy,
1988, p. 81, no. 22; Newton, 1995,
p. 72

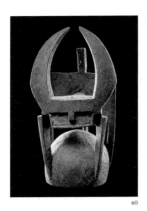

40

40 Helmet crest *(Kablé)*

Tusyan, Burkina Faso
Hardwood, dark gray encrusted
patina
Height 55 cm (21 5/8 in.)
Inv. 1005-35
Acquired by Josef Mueller before
to 1952

The name Tusyan (Tusia, Tuss-
ian) was given by the Dyula to
this small, Voltaic-language
group of south-western Burk-
ina-Faso. It derives from Tus-
siana, the capital of the
southern Tusyan, who call
themselves Win, while the
northern Tusyan call themselves
Tento (Roy, 1987, p. 360). The
caps or cowls of the *kablé* type,
which in this case is adorned
by a stylized buffalo – a totem ani-
mal – are danced at various
occasions, primarily at funerals,
to drive evil spirits out of the vil-
lage. A rare mask type, it has
often erroneously been ascribed
to the Senufo. Nor is it likely
that it appears as a male mask
in conjunction with the *loniaken*
mask, which, according to
William Fagg, represents its
female complement.

Bibliography: Fagg, 1980, p. 48;
Roy, 1987, p. 366, no. 315

41 Face mask
(Kpeli-yehe)
Plate 15

Senufo, Ivory Coast
Wood (partially restored)
Height 33.5 cm (13 ? in.)
Inv. 1006-11

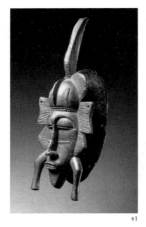

41

Formerly collection of Josef Mueller;
acquired before 1953

Bibliography: Fagg, 1980, p. 45;
Glaze, 1993 II, p. 12, no. 3

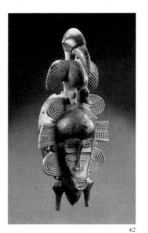

42

42 Face mask
(Kpeli-yehe)

Senufo, northern Ivory Coast or
southern Mali
Hardwood, dark patina
Height 37.5 cm (14 ? in.)
Inv. 1006-37

Another variety of *kpeli-yehe*
mask. Even though the hornbill
is a favorite motif of the *fonobele*
sculptor-metalsmiths, Anita
Glaze believes (Glaze, 1993 II,
p. 11, no. 1) this mask should be
ascribed to the *kulebele* sculptor-
metalfounders. The type is com-
monly used in performances of

the Poro male initiation society,
at funerals, but also in simple
dance ceremonies, where
women too may view the mask
with impunity.

Bibliography: Glaze, 1988, p. 86,
no, 27; Glaze, 1993 II, p. 11, no. 1

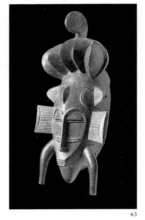

43

43 Face mask
(Kpeli-yehe)

Senufo, northern Ivory Coast
Hardwood, homogeneous dark
patina
Height 34 cm (13 3/8 in.)
Inv. 1006-9
Formerly collections of Bochet and
Storrer

According to Anita Glaze, this is
another *kpeli-yehe* mask from the
western Senufo region.

Bibliography: Glaze, 1993 II, p. 11,
no. 2

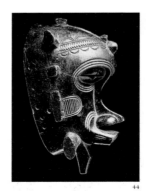

44

44 Face mask *(Kpeli-yehe)*

Senufo, northern Ivory Coast
Black-stained hardwood, glossy
patina (lateral extensions missing)
Height 24.5 cm (9 5/8 in.)
Inv. 1006-86
Formerly Modeste Collection,
Abidjan

The marked profile of this piece
is atypical of *kpeli-yehe* masks.
It bears strong similarities with
a mask photographed by Gilbert
Bochet in the 1950s, worn
by a dancer (*yööfölö*) during a
Poro ceremony near Korhogo
(Bochet, 1993 I, p. 103, fig. 100).
It seems never to have had the
comb superstructure usually
found on masks of this kind.
The mouth recalls the muzzle of
a monkey (*dalu or kodalu*), the
animal which provides the occa-
sion for *kpeli-yehe* masquerades,
which are also known as *kodal-
yehe*, or "kodal's face."

Bibliography: Glaze, 1993, no. 99

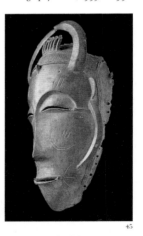

45

45 Face mask of the Do society
(Do muso)

Dyula, northern Ivory Coast
Tin-lead alloy
Height 26.7 cm (10 ? in.)
Inv. 1006-64

This mask is ascribed to the
Dyula, probably of Kong, for
two reasons. First, it is the work
of a metalcaster of the Lorhon
(a group descended from the
Kulango of northeastern Ivory

Coast), whose members today still make masks frequently intended for the trade. Assimilated by the Senufo but proud of their ethnic uniqueness, the Lorhon live in Dikondougou and Korhogo (see the studies by Timothy Garrard and Jean Paul Babier, in Art of *Côte d'Ivoire*, 1993 II, pp. 94 ff. and 106 ff.). Second, the face masks of the Dyula-Lorhon, which personify Do *muso* (Do woman) in Dyula ceremonies, served the Senufo as the model for their *kpeli-yehe* masks.

Approximately ten of these remarkable masks exist. Though traces of soil on the surface would suggest they originated from graves, this is not the case. These traces resulted from the Dyula custom of burying the masks after each use. Garrard dates the present specimen to the eighteenth century or later.

Bibliography: Garrard, 1993 II, p. 13, no. 5

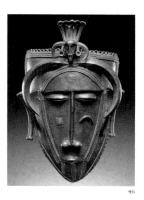

46 Face mask of the Do society
Plate 16

Dyula, Ivory Coast
Brass
Height 25 cm (9 7/8 in.)
Inv. 1006-52
Formerly collection of William Moore, Los Angeles; collected in the 1950s

Bibliography: Meyer, 1991, p. 108, no. 91; Garrard, 1993 II, p. 12, no. 4

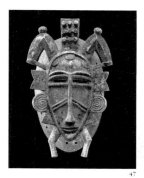

47 Face mask of the Do society

Senufo, northern Ivory Coast
Aluminum, traces of red, white, and blue (Reckitt blue) paint
Height 23.3 cm (9 1/8 in.)
Inv. 1006-73

Kpeli-yehe masksprobably began to be disseminated among the Senufo in the first quarter of the twentieth century, by metalcasters of the Lorhon, who lived among them. Inspired by the Do *muso* masks of the Dyula, these masks were immediately imitated by Senufo metalrafters. Some time in the 1920s they began using aluminum from melted European pots to cast traditional masks of the type seen here, which likely comes from the Boundiali region.

Various types of aluminum amulettes are still sold today at markets in the towns and larger villages of the Senufo. However, aluminum is never used for objects intended for tourists or the trade, which are invariably made of brass.

Bibliography: Garrard, 1993 II, p. 13, no. 6

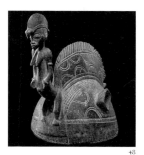

48 Helmet crest

Senufo, northern Ivory Coast
Wood, dark patina,m traces of white paint
Height 30 cm (11 ? in.)
Inv. 1006-49
Acquired by Josef Mueller before 1939

Based on Anita Glaze's investigations, this mask was attributed to a *kuleo* workshop in the region of Dabakaha. It represents a "trophy cap" of a type awarded to the victor in a contest among young men to see who could draw a furrow in a field with his axe the fastest.

Bibliography: Glaze, 1993 II, p. 15, no. 8

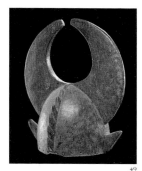

49 Helmet crest

Senufo, northern Ivory Coast
Hardwood stained black
Height 39 cm (15 3/8 in.)
Inv. 1006-48
Formerly collection of Josef Mueller

The powerful horns of a wild buffalo surmounting this helmet symbolize the potency of the Nöökaariga society of traditional healers and diviners. In her study on this rare example, Anita Glaze notes that the *nöö* cap was never displayed in public.

Bibliography: Glaze, 1993 II, p. 17, no. 10

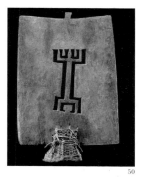

50 Headdress mask *(Kwonro)*

Senufo, Ivory Coast
Hardwood, dark patina, traces of white pigment, willow switches
Height 100 cm (39 3/8 in.)
Inv. 1006-16
Acquired by Josef Mueller about 1950 from the collection of Emil Storrer

This large ceremonial headdress was worn during the *kwonro* phase of the initiation rite of the Poro society, among the Nafara in the center of the Senufa area.

The central figure cut into the heavy wooden plank is known as *ndeo* or *mandeo* (pl. *mandebele*), names for a nature spirit.

Only very few headdresses of this type have survived.

Bibliography: Glaze, 1993 II, p. 18, no. 11

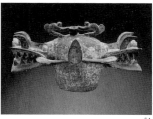

51 Double-headed helmet mask *(Wanyugo)*
Plate 12

Senufo, Ivory Coast
Wood with traces of white, black, and ochre paint,
Width 74 cm (29 1/8 in.)
Inv. 1006-10
Formerly collection of Josef Mueller;

acquired in 1952-53 from the collection of Emil Storrer

Bibliography: *Kunst der Neger*, 1953, fig. 6; *Sculptures de l'Afrique noire*, 1955, no. 93; Leiris and Delange, 1967, p. 292, no. 331; *Die Kunst von Schwarzafrika*, 1971, p. 67, no. D4; Leuzinger, 1977, p. 125; Fagg, 1980, p. 43; Musée Barbier-Mueller, 1987, p. 146, no. 1; Bochet, 1988; Meyer, 1991, pp. 76, 77, 78, no. 55; Bochet, 1993 II, p. 19, no. 12; *Historia del Arte*, 1996, p. 2615

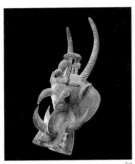

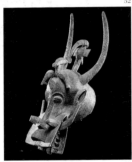

52 Helmet masks *(Wanyugo)*

Senufo, Ivory Coast
Hardwood, traces of black, ochre, and white paint
Length 90 cm (35 5/8 in.) and 93.8 cm (36 7/8 in.) (restored)
Inv. 1006-70, 1006-74
Acquired by Josef Mueller around 1942 (1006-70)

These two *wanyugo* masks are of a type considered especially potent and aggressive. They are often called "fire-spitters," because their mouths were reported to have been filled with hot coals. When the masks performed the dancers blew on the

coals producing showers of sparks.

This type of mask was kept in a small shelter in front of a sacred grove known as *sinzanga*.

Bibliography: Bochet, 1993 II, p. 20, nos. 14/15

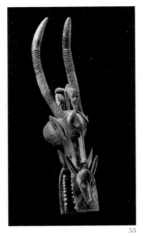

53 Mask head *(Kagba)*
Plate 13

Senufo, Ivory Coast
Wood, painted in black, white, and red
Height 81 cm (31 7/8 in.)
Inv. 1006-91

Bibliography: Bochet, 1993 II, p. 21, no. 15

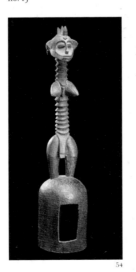

54 Helmut mask with female figure *(Degele)*
Plate 14

Senufo, Ivory Coast
Wood with dark patina
Height 103 cm (40 ? in.)
Inv. 1006-36

Formerly collection of Josef Mueller; acquired in 1950-51 from the collection of Emil storrer; collected by Pater Clamens in Lataha

Bibliography: Glaze, 1988, p. 84, no. 24; Glaze, 1993 II, no. 7; Meyer, 1991, p. 103, no. 85; Newton, 1995, p. 780

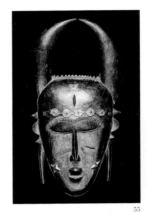

55 Face mask of the Do society

Ligbi Dyula (?), Bondoukou or Kong region, Ivory Coast
Hardwood, brass fittings and nails, traces of red and black paint
Height 36.5 cm (14 3/8 in.)
Inv. 1006-4
Acquired by Josef Mueller before 1942

The cattle horns of this mask used by the Do society, as René Bravmann writes, indicate the importance of cattle as sacrificial animals among the Moslem Mande. The clan leaders are responsible for holding sacrificial ceremonies at the end of Ramadan and on Aid al Kabir, the tenth day of the last month of the Islamic year (Bravmann, 1993, p. 54, no. 76).

Though Bravmann does not ascribe this mask to any particu-

lar ethnic group, Timothy Garrard tends to think it originated from the Dyula, in the town of Kong (1993 II, fig. 92). Both authors view it as a type of mask used by the Islamized Mande-speaking groups in Ivory Coast. As Garrard writes, the Do society is a pre-Islamic institution comparable to the Senufo Poro society (cf. Bravmann, 1974). In the region of Kong, Bouna, and Bondoukou, the Do society, in its role of fraternity, organizes celebrations in the context of key Islamic holidays and on other occasions (Garrard, 1993, p. 88). In northern Ivory Coast Do masks are also found among the Dyula of Mbengue. Garrard has shown that Do masks served as models for the *kpeli-yehe* of the Senufo, refuting Bohumil Hola's hypothesis of a precisely opposite influence.

Bibliography: Fagg, 1980, p. 44; Bravmann, 1993 II, p. 54, no 76

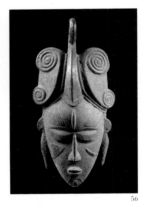

56 Face mask of the Do society
Plate 17

Ligbi, Bondoukou region, Ivory Coast
Wood with encrusted patina
Height 33.8 cm (13 ? in.)
Inv. 1006-38
Formerly collection of Charles Ratton

Bibliography: Bravmann, 1988, p. 92, no. 32; Bravmann, 1993 II, p. 54, no. 77; Newton, 1995, p. 81

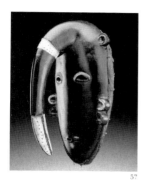

**57 Face mask of the Do society
(Yangaleya)**
Plate 18

Ligbi, Bondoukou region, Ivory
Coast
Patinated wood with white, blue, and
red paint, fiber and fabric remnants
Height 28.8 cm (11 3/8 in.)
Inv. 1006-56

Bibliography: Vion, 1988, p. 93,
no. 33; Meyer, 1991, p. 72;
Bravmann, 1993 II, p. 55, no. 78

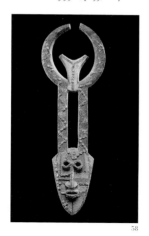

58 Plank mask *(Bedu)*

Nafana, Kulango, Hwela (?),
Bondoukou region, Ivory Coast
Hardwood, remnants of black, red,
and white paint, cowrie shells,
jequirity beans
Height 127 cm (50 in.)
Inv. 1007-61
Acquired by Josef Mueller before
1942

This *bedu* mask differs from the
"second generation" of such
large masks, two examples of
which are also described here
(cats. 59 and 60). Possibly it
belonged to the earliest known
objects of an association that
emerged in the late 1920s
among Moslem Mande groups.
René Bravmann writes (Brav-
mann, 1993a, p. 125) that *bedu*
masks were danced annually,
after the yam harvest, in villages
inhabited by a variety of ethnic
groups in the vicinity of Bon-
doukou, in north-eastern Ivory
Coast. They performed in pairs
or individually. *Bedu* masks
performed in purification cere-
monies to invigorate the com-
munity and renew its sense of
well-being.

Bibliography: Bravmann, 1993 II,
p. 55, no. 79

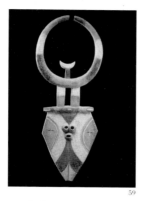

59 Plank mask *(Bedu)*

Nafana, Kulango, Hwela (?),
Bondoukou region, Ivory Coast
Hardwood, painted in black, red,
and white
Height 152 cm (59 7/8 in.)
Inv. 1008-12

According to René Bravmann
(Bravmann, 1993 II, p. 56, no.
80), the Bedu association arose
in 1930 in the Nafana village
Oulike, and rapidly spread to
neighboring communities,
whether Voltaic-speaking like
the Nafana and Kulango or
Mande-speaking like the Hwela.
With the Kulango the month in
which *bedu* masks are danced is
called Zaurau.

Male *bedu* masks are recog-
nizable by their horns, and
female masks by a round disk
above the face.

Bravmann attributes the
present mask to the Kulango
sculptor Sirikye, who was active
in the 1950s and 1960s.

Bibliography: Bravmann, 1988, p. 91;
Bravmann, 1993 II, p. 56, no. 80

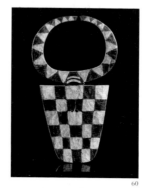

60 Plank mask *(Bedu)*
Plate 19

Bondoukou region, Ivory Coast
Wood, painted in black and white
Height 160 cm (63 in.)
Inv. 1008-11

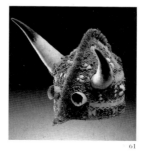

**61
Helmet crest *(Ejumba)***
Plate 20

Diola, Senegal
Woven plant fibers, horns, leather,
mussel shells, *Abrus precatorius*
seeds
Height 35 cm (13 ? in.)
Inv. 1000-2
Formerly collection of Josef Mueller;
acquired before 1942

Bibliography: Fagg, 1980, p. 31;
Mark, 1988, p. 17

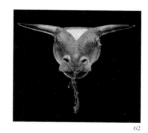

**62 Helmet mask
*(Dugn'be)***
Plate 21

Bidjogo, Guinea-Bissau
Wood, painted in black and white,
glass, horns, leather, cords
Width 64 cm (21 ? in.)
Inv. 1001-11
Collected on the island of Nago
in 1971

Bibliography: Fagg, 1980, p. 33;
Gallois-Duquette, 1981; Musée
Barbier-Mueller, 1987, p. 45

63 Forehead mask

Bidjogo, Bissago Islands, Guinea-
Bissau
Soft wood, painted in black and
white
Width 55.6 cm (21.7/8 in.)
Inv. 1001-34

This mask in the form of a ham-
merhead shark was affixed to
the head of the dancer, who
leaned forward during the per-
formance, by means of a bas-
ketweave cap. Mask of this type
were worn by young men in the
early phase of initiation. The
adept called himself *kabaro*; as
an initiate he was known as
kamabi (Gallois-Duquette, 1976,
p. 30, no. 18).

Other species of shark were
represented in masks as well
Though such masks once surely
existed in great numbers, only
a few have survived.

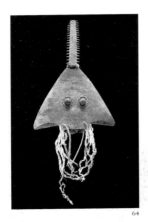

64 Forehead mask

Bidjogo, Bissago Islands, Guinea-Bissau
Soft wood, sawfish snout, plant fibers, painted in black and ochre
Height 59.8 cm (23 ? in.)
Inv. 1001-36

Another variety of *kabaro* mask (cf. cat. 63). A remarkable feature is the integrated, real sawfish snout. The mask was worn in a horizontal position by a dancer who swayed his body from side to side.

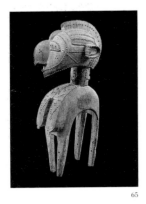

65 Headdress (D'mba)
Plate 22

Baga, Guinea
Wood, upholstery tacks, French coins
Height 135 cm (53 1(7 in.)
Inv. 1001-1
Formerly collection of Josef Mueller; acquired from the Emil Storrer collection about 1950

Bibliography: Savary, 1977, p. 75, no. 8; Fagg, 1980, p. 35; Bastin, 1984, p. 123; Paulme, 1988, p. 102/3, no. 36; Meyer, 1991, pp. 74-75; Newton, 1995, p. 44; *Historia del Arte*, 1996, p. 2621

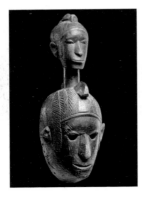

66 Face mask
Plate 23

Baga, Guinea
Wood with blackish-brown patina
Height 55 cm (21 5/8 in.)
Inv. 1001-10
Formerly collection of Josef Mueller; acquired prior to 1942

Bibliography: Fagg, 1980, p. 37

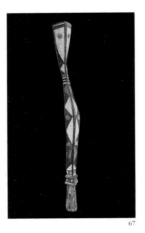

**67 Stele headdress mask
(Bansonyi or a-Mantsho-ña-Tshol)**
Plate 24

Baga, Guinea
Wood, painted in white, reddish-brown, and black, mirrors

Height 215 cm (84 5/8 in.)
Inv. 1001-21
Formerly collection of Dr. Mandelbaum

Bibliography: Paulme, 1988, p. 105, no. 38; Meyer, 1991, p. 91, no. 69; Newton, 1995, p. 45

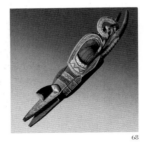

68 Forehead mask (Banda)
Plate 25

Nalu, Guinea
Wood, painted in ochre, black, white, and blue
Height 141 cm (55 ? in.)
Inv. 1001-24
Formerly collection of André Lhote; collected before 1935

Bibliography: Fagg, 1980, p. 34; Newton, 1995, p. 49; *Historia del Arte*, 1996, p. 2620

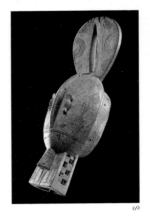

**69 Helmet crest
(Tönköngba or tabakän)**

Landuman, Guinea
Hardwood, light-colored patina, traces of ochre pigment
Length 87 cm (34 ? in.)
Inv. 1001-22
Acquired by Josef Mueller before 1942

This type of mask is usually attributed to the Landuman, but it is also used by the Baga, their culturally and linguistically related neighbors. According to a recent study by Frederick Lamp (Lamp, 1996), the Baga use the mask in connection with *a-tshol*, a carved shrine sculpture employed by healers. At earlier periods, such masks were worn with a raffia costume and danced on various ceremonial occasions, and the character they embodied was looked upon as omniscient.

Adorned with complex patterns, *tönköngba* masks consist of three components: a central helmet, a long, triangular or rectangular snout, and, at the opposite end, a pair of flat horns joined together at the tips. Some members of Baga communities have described the mask as a creature with a wide, flat tail and a cowlike head which lives in the sea. It has also been said to represent a narwhal or a dolphin.

Bibliography: Fagg, 1980, p. 34

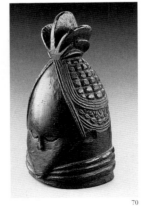

70 Helmet mask (Sowei)

Mende, Sierra Leone
Hardwood, glossy black patina
Height 45.5 cm (17 7/8 in.)
Inv. 1002-11
Acquired by Josef Mueller before 1939

This Mende mask type, known as *sowei*, is worn only by members of the Sande women's

society. Representing female water spirits, the masks have an idealized female face whose aesthetic reflects religious and philosophical ideals. The design of the facial features conforms to strict conventions and has symbolic content. The coiffures, on the other hand, display a great range of variations which reflect changing fashions and thus facilitate the dating and localization of the masks. The hair done up in parallel combs, as seen in this mask, was a style prevalent in the core area of the Mende around the turn of the century (see Boone, 1986, and Schäfer, 1990).

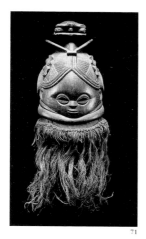

71 Helmet mask *(Sowei)*

Mende, Sierra Leone
Soft wood, black patina, fibers
Height 37 cm (14 5/8 in.)
Inv. 1002-5
Acquired by Josef Mueller before 1942

This *sowei* mask represents a woman with an elaborate coiffure (cf. cat. 70), crowned by a tortoise. The Mende depict a great variety of animals on their masks, including fish, snakes, and birds. A few of the masks collected in the early years of the twentieth century even wear European hats and crowns.

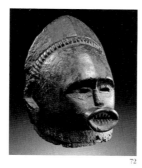

72 Helmet mask *(Gonde)*
Plate 26

Gola or Mende, Sierra Leone/Liberia
Wood, with dark patina and red paint
Height 36 cm (14 1/8 in.)
Inv. 1002-17

Bibliography: Newton, 1995, p. 53

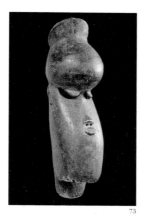

73 Face mask

Unknown ethnic group, Sierra Leone (?)
Soft wood, dark patina
Height 46 cm (18 1/8 in.)
Inv. 1002-15

This mask from Sierra Leone, acquired in New York, was shown to scholars familiar with the Guinea Coast. In a letter of September 5, 1989, Frederick Lamp described it as mysterious. He was able to detect no more than a slight similarity with stylistic traits of certain Sande masks of the Mende or the Gola. William Hart, writing on September 12, 1989, pre-

sumed the mask's origin to be Sierra Leone, although he had never seen comparable pieces on site. We illustrate the mask in the present publication due to its great age and beauty, in the hope that one of our readers will be able to provide more information concerning it.

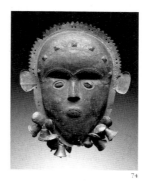

74 Face section of an *aron arabai* helmet mask
Plate 27

Temne, Sierra Leone
Brass
Height 29 cm (11 3/8 in.) (not including bells)
Inv. 1002-16

Bibliography: Hart, 1990, cover, p. 3, no. 1; Meyer, 1991, pp. 89, 75, no. 75; Newton, 1995, p. 52

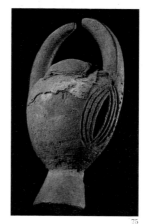

75 Helmet crest
Plate 28

Toma (Loma), Guinea, Liberia
Wood with encrusted patina, sack

filled with medicinal/magical substances
Height 75 cm (29 ? in.)
Inv. 1003-16

Bibliography: Fagg, 1980, p. 52; Siegmann, 1988, p. 111, no. 45; Adams, 1996, p. 362, no. 5.23

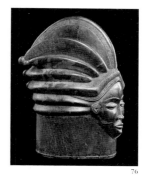

76 Helmet mask of the Sande women's society
Plate 29

Bassa, Liberia
Wood with dark patination
Height 36 cm (14 1/8 in.)
Inv. 1003-26

Bibliography: Fagg, 1980, p. 53

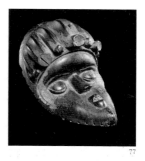

77 Forehead mask *(Geh-naw)*
Plate 30

Bassa, Liberia
Wood with glossy black patina, coin
Height 20 cm (7 7/8 in.)
Inv. 1003-33

Bibliography: Siegmann, 1988, p. 110, no. 44

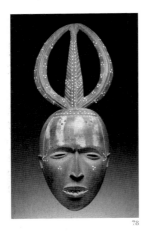

78

78 Female face mask
Plate 31

Grebo, Liberia
Wood with red, brownish, and white
paint, glass beads, mineral
substances (teeth)
Height 47.5 cm (18 ? in.)
Inv. 1003-10
Formerly collection of Josef Mueller;
acquired prior to 1942

Bibliography: Fagg, 1980, p. 54;
Verger-Fèvre, 1988, p. 113, no. 46

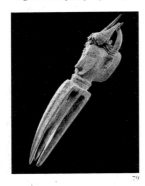

79

79 Small face mask *(Koma ba)*

Mau, Ivory Coast
Hardwood, sacrificial patina (dried
blood), fibers, horns
Height 40 cm (15 ? in.)
Inv. 1007-216

Too small to be worn on the
head, this mask was held by
its long snout in front of the
dancer's face. Known as *koma
ba*, it was a magical object kept
in men's houses. It received sac-

rificial libations and was used
in the Koma rite of the Mau,
a Malinke group living north
of the Dan. A female mask, it
danced and sang to attract evil
forces, which were then dis-
pelled and destroyed by its male
counterpart, the roughly carved
köma su (Verger-Fèvre, 1993 II).

Bibliography: Verger-Fèvre, 1993 II,
p. 59, no. 85

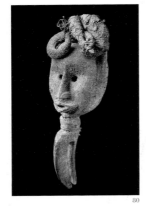

80

80 Large face mask *(Koma ba)*

Mau, Ivory Coast
Hardwood, sacrificial patina, filling
of medicinal/magical substances
in animal horns on forehead, fabric,
nails, and fibers
Height 78 cm (30 ? in.)
Inv. 1008-13

The Koma men's association is
active not only among the Mau,
but spreads as far as the Wobe
and into the northern Dan
region. *Koma ba* masks were
given sacrificial libations
intended to combat destructive
forces. As these consisted pri-
marily of dog's blood, a heavy
encrustation built up over the
years. The masks' wearers were
protected from malevolent
forces by horns filled with medi-
cinal/magical substances on the
mask's forehead. Due to the
great weight of such masks, the
dancers gripped them by the
snoutlike handle and held them
in front of their face.

Bibliography: Fagg, 1980, p. 56;
Verger-Fèvre, 1993 II, p. 59, no, 84

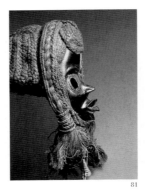

81

81 Face mask with round eye apertures *(Zakpei ge or gunye ge)*
Plate 32

Dan, Ivory Coast/Liberia
Wood with glossy black patina, hood
of woven fibers, cotton
Height 36 cm (14 1/8 in.) (not
including hood)
Inv. 1003-14

Bibliography: Fagg, 1980, p. 55;
Verger-Fèvre, 1988, p. 114, no. 47;
Verger-Fèvre, 1993 II, p. 60, no. 86;
Meyer, 1991, p. 83, no. 64; Newton,
1995, p. 57

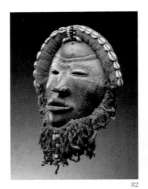

82

82 Face mask with female features *(Takangle or deangle)*
Plate 33

Dan, Ivory Coast/Liberia
Wood with brown patina and traces
of white paint, cotton fabric and
fibers, cowrie shells, colored glass
beads
Height 19.5 cm (7 5/8 in.) (mask
only)
Inv. 1003-8
Formerly collection of René
Rasmussen

Bibliography: Muensterberger, 1979,
p. 53; Verge-Fèvre, 1988, p. 117, no. 50;
Verger-Fèvre, 1993 II, p. 62, no. 90

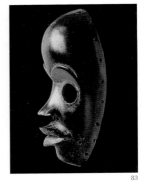

83

83 Face mask *(Gunye ge)*

Dan, Liberia or Ivory Coast
Wood with glossy black patina
Height 22 cm (8 5/8 in.)
Inv. 1003-3
Acquired by Josef Mueller in Paris
before 1939

This is a racer's mask of the
gunye ge type. The typical round-
eyed face in this case has very
harmonious proportions. Marie-
Noël Verger-Fèvre believes it
represents an idealized portrait
of its wearer.

Bibliography: *Westafrikanische Tage*,
1982, no. 13; Verger-Fèvre, 1988,
p. 115, no. 48; Verger-Fèvre, 1993 II,
p. 60, no. 87

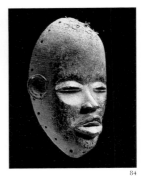

84

84 Face mask *(Nyomu nea [?])*

Dan, Liberia or Guinea
Wood, sacrificial patina, nails
Height 22.8 cm (9 in.)
Inv. 1003-27

This female face mask is characteristic of the northern Dan region (see Verger-Fèvre, 1993 II). According to this author it was made by a sculptor from Liberia or southern Guinea, or perhaps from the land of the Manon, Guerze, or Kono. Possibly it represents *nyomu nea*, a female spirit who accompanies the *nyomu sine gbloa* masquerader, the initiation master, in the sacred grove. A remarkable detail of this example is the ears, which are seldom represented on Dan masks.

Bibliography: Verger-Fèvre, 1993 II, p. 63, no. 92

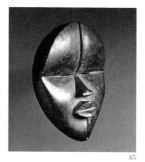

85 Face mask

Southern Dan, Ivory Coast
Wood, homogeneous black patina
Height 29 cm (11 3/8 in.)
Inv. 1003-13
Acquired by Josef Mueller before 1942

This mask shows a clear division between forehead and cheek areas, emphasized by eye slits which extend to the temples. The vertical welt on the forehead is a characteristic feature of all works created by carvers associated with the We. Yet it is also found in masks of the Guro-Bete (cf. cat. 100).

In this case, no information is available concerning the purpose of the mask.

Bibliography: Fagg, 1980, p. 54; Verger-Fèvre, 1993 II, p. 63, no. 93

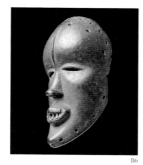

86 Face mask

Dan, Ivory Coast
Wood, uneven dark brown patina
Height 21.8 cm (8 5/8 in.)
Inv. 1003-47

This mask evinces various traits of the art of the southern Yacuba (designation for Dan who live in Ivory Coast): a vertical welt in the middle of the forehead, high, raised cheekbones, and a protruding mouth. According to Jan Vandenhoute, who quotes Marie-Noël Verger-Fèvre, only the southern Dan cover their masks with a grainy pigment instead of dipping them in mud and polishing them thoroughly.

The mask's friendly facial expression would suggest that it was worn during singing and games.

Bibliography: Verger-Fèvre, 1993 II, p. 64, no. 94

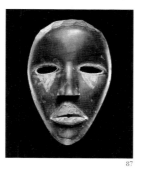

87 Face mask *(Gunye ge [?])*

Dan, Ivory Coast
Soft wood, black patina, red pigments
Height 20.5 cm (8 1/8 in.)
Inv. 1003-48
Acquired by Josef Mueller before 1942

The pierced mouth opening and open eyes suggest that this is a racer's mask, although these usually have completely circular eyes (cf. cats. 81 and 83). The red coloring stands for a *nogon*, a depiction of a young man. Red is a symbol of courage and endurance, traits of excellent runners, Sometimes such masks are painted with a lynx motif, or are adorned with a lynx-like figure made of cloth.

Bibliography: Verger-Fèvre, 1993 II, p. 61, no. 88

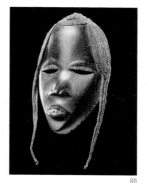

88 Face mask

Dan, Liberia or Ivory Coast
Soft wood, black patina, braided fibers, aluminum teeth
Height 23.5 cm (9 ? in.)
Inv. 1003-6
Acquired by Josef Mueller before 1942

This type of mask is found throughout the northern Dan region. Its female gender is apparent from the delicacy of the features and the coiffure, which conforms to that of Mande women. Presumably the mask was worn in entertaining pantomimes and dances.

Bibliography: Verger-Fèvre, 1993 II, p. 62, no. 91

89 Face mask

Dan, Ivory Coast
Wood, dark patina, nails, fibers, metal teeth, feathers

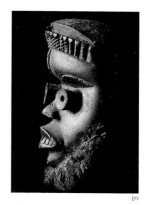

Height 26 cm (10 ? in.)
Acquired by Josef Mueller before 1942

The vertical ridge on the forehead of this mask suggests on origin in the southern Dan area. The projecting tubular eyes and large protruding mouth characterize it as a male mask which performs in pantomime plays (see Verger-Fèvre, 1993 II).

The miniature antelope horns arranged in the shape of a diadem remind Marie-Noël Verger-Fèvre of the real horns filled with magical substances which are often used to deflect evil.

Bibliography: Fagg, 1980, p. 54; Verger-Fèvre, 1988, p. 116, n. 49; Verger-Fèvre, 1993 II, p. 61, no. 89

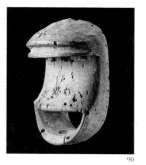

90 Forehead mask (?)

Dan, Liberia (?)
Hardwood, gray patina
Height 24 cm (9 ? in.)
Inv. 1003-35
Acquired by Josef Mueller before 1942

This mask symbolizes the dangerousness of a wild animal of the bush, perhaps an ape. It was worn like a visor, the dancer looking out through the mouth. Marie-Noël Verger-Fèvre describes a similar mask from the village of Zeile, on the vorder of the Kran region. This mask represented a *kagle*, or "battle mask."

Dan masks with such strongly reduced forms are quite rare. They differ considerably from their betterknown naturalistic counterparts.

Bibliography: Verger-Fèvre, 1993 II, p. 65, no. 96

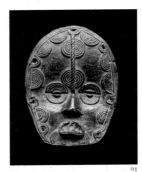

91 Mask
Plate 34

Dan, Ivory Coast
Yellow brass
Height 20.3 cm (8 in.)
Inv. 1007-185

Bibliography: Bruyninx, 1993 II, p. 65, no. 97

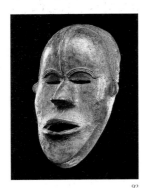

92 Mask

Dan, Liberia, Ivory Coast
Brass, light-colored patina
Height 18.5 cm (7 ? in.)
Inv. 1003-40
Acquired by Josef Mueller before 1952

Brass masks made using the lost wax process are seldom as large as cat. 91. There are also small wooden masks which serve travellers as talismans and have erroneously been described as "passports."

Conceivably miniature metal masks had certain defined purposes as well. Marie-Noël Verger-Fèvre quotes an author who maintains that such masks adorned elders who held high cultural offices. She herself vonsiders them personal adornment, amulets, or requisites for religious ceremonies, yet to be investigated.

Bibliography: Verger-Fèvre, 1993 II, p. 66, no. 98

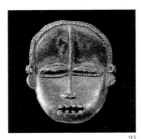

93 Small mask

Dan (?), northern Dan region, Ivory Coast Brass, dark patina
Height 18.5 cm (7 ? in.)
Inv. 1003-44

According to Elze Bruyninx, this small mask differs from others of its kind especially in the narrow welt extending over forehead and nose. She favors an attribution of the piece to neighbors of the Dan, the less well-known Diomandé (Mau, Famosi, Sakulaka).

Bibliography: Bruyninx, 1993 II, p. 66, no. 99

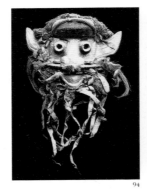

94 Face mask (Kpanhi)

We, Wobe (?), Ivory Coast
Wood, hair, plastic, leather, fur, black, red, and white oil paint, fibers
Height 26 cm (10 ? in.)
Inv. 1008-16

Modern ethnology puts the Wobe and Guere together under the name We, despite the fact that the people themselves still use the old names. No self-respecting Wobe would ever refer to himself as a We.

Angèle Gnonsoa has thoroughly researched We masks, and Pierre Harter's last field study on them was published by the Musée Barbier-Mueller shortly before his death in 1993. Their most striking feature is the combination of diverse materials that lends these masks tremendous expressive force. Perfect forgeries have lately come to light in Abidjan and on the Western market.

The represent example likely represents *kpanhi*, or the dog-headed ape. In cases of conflict it served as the "great mask", and when customs were violated it pointed out who committed the offense.

Bibliography: Verger-Fèvre, 1993 II, p. 81, no. 132

95 Face mask (Dhi gla)

We, Ivory Coast
Wood, white, red, and yellow pigments, cloth, fibers
Height 30 cm (11 ? in.)
Inv. 1003-9

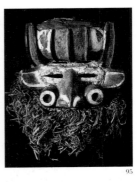

Acquired by Josef Mueller in 1950

This frequently reproduced mask probably originally had a movable lower jaw, which is now missing.

It belongs to the group of "dancer" masks known as *dhi gla*. The two slits above the mask's eyes permitted the wearer to see. The projecting cylinders either side of the nose do not represent nostrils, but cheekbones.

Bibliography: Fagg, 1980, p. 57; Schmalenbach, 1988, p. 20, fig. 10; Verger-Fèvre, 1993 II, p. 133

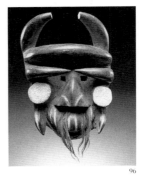

96 Face mask (Tee gla)

We, Ivory Coast
Black-stained whood, remnants of fur, accented with white pigment
Height 40 cm (15 ? in.)
Inv. 1007-206
Acquired by Josef Mueller before 1942

Pierre Harter classifies this mask in the category of "fighter", or *tee gla* masks, whose purpose was to oversee

order in the community. In the absence of the costume that once belonged to it, however, we cannot be entirely certain of the mask's true function.

Bibliography: Harter, 1993 II, p. 82, no. 134

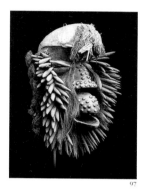

97 Face mask

We, Ivory Coast
Black-stained wood, skin, cloth, fibers, hair, brass and iron nails
Height 40 cm (15 ? in.)
Inv. 1003-34

This composite mask has features of a monkey, a crocodile, and a leopard – strings of leopard fangs adorn the sides of the face. The two last-named animals symbolize the mask's supernatural powers. The color black is associated with sorcery.

The mask probably had an aggressive function or served to help maintain order in the community.

Bibliography: Verger-Fèvre, 1993 II, p. 83, no. 135

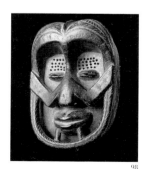

98 Face mask *(Gla)*

Nyabwa, Ivory Coast
Wood
Height 23.8 cm (9 3/8 in.)
Inv. 1007-215

This type of anthropomorphic mask is used by the Nyabwa Gla association, and its principal task is to detect sorcerers who bring harm on the community. In keeping with this purpose the masquerader's appearance is intended to be frightening, an effect already achieved in the composition of the carved face mask itself, with its strongly protruding forehead, W-shaped, raised cheek area, and free-standing chin contour. The large, full-lipped mouth may have been intended to recall the muzzle of a leopard, or *gi*, which is often associated with this style of mask. Narrow eye slits prevented eye-contact between audience and dancer, who nevertheless could watch them through the rows of small holes drilled above the eyes.

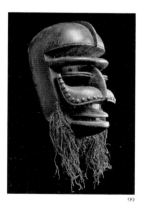

99 Face mask
Plate 35

Bete, Ivory Coast
Wood with blackish-brown patina, upholstery tacks, plant fibers
Height 30 cm (11 ? in.)
Inv. 1008-15
Formerly collection of André Lhote

Bibliography: Verger-Fèvre, 1993 II, p. 90, no. 148

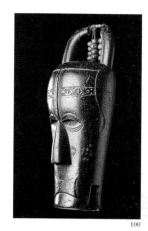

100

100 Helmet crest

Bete (?), Ivory Coast
Wood, glossy black patina, fibers, seeds
Height 44 cm (17 3/8 in.)
Inv. 1007-197

Jean Paul Barbier has researched this half human, half animal mask among the Guro and Bete. He compares it with the masks with a human face that originated in the southern Guro region, including the famous example once owned by Tristan Tzara (Musée des Arts d'Afrique et d'Océanie, Paris). Both this and the present mask share common stylistic and morphological features. The coiffure and vertical forehead welt (which recall We masks and certain examples by the southern Dan), but especially the multiple rings under the eyes indicate that animal masks like this one and human masks like Tzara's emerged from the same tradition. Other similar Guro-Bete masks include those in the Rietberg Museum and in a private collection (sold in Paris on October 16, 1989).

Bibliography: Barbier, 1993 II, p. 92, no. 152

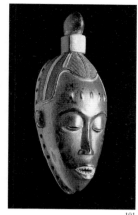

101

101 Female face mask *(Gu)*
Plate 37

Guro, Ivory Coast
Wood with black primer, red paint with traces of white
Height 32 cm (12 5/8 in.)
Inv. 1007-223

Bibliography: Fasel, 1993, p. 93, no. 153; *Historia del Arte*, 1996, p. 2502

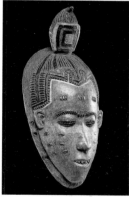

102

102 Female face mask *(Gu)*

Guro, Ivory Coast
Hardwood, light-colored patina, remnants of blue (Reckitt blue) and white paint
Height 33.5 cm (13 ? in.)
Inv. 1007-7
Acquired by Josef Mueller before 1939

Ariane Deluz considers this mask to be a *gu* representation, the female counterpart to the

zamble mask. Its crest of hair, known as *kowogni*, recalls a large hornbill (*Coraciformes bucerotidae*).

Bibliography: Deluz, 1993 II, p. 93, no. 154

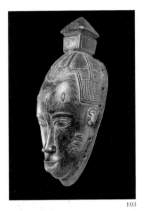

103

103 Female face mask *(Gu)*

Guro, Ivory Coast
Hardwood, dark patina, remnants of white paint
Height 33.5 cm (13 ? in.)
Inv. 1007-88

This *gu* mask represents a new-lywed girl who is ready to go to her husband.

Bibliography: Deluz, 1993 II, p. 93, no. 155

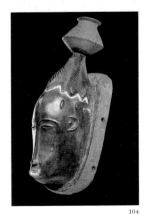

104

104 Female face mask *(Gu)*

Guro, Ivory Coast
Hardwood, dark patina, painted in

red, orange, and white
Height 33 cm (13 in.)
Inv. 1007-35
Acquired by Josef Mueller before 1952

This *gu* mask has a small wooden vessel surmounting the coiffure known as *palani gu*, which indicates its female gender.

Gu is a family cult. The mask is kept by a family member who is obliged to perform certain duties and observe certain taboos. During the ceremonies the mask is not necessarily worn by its owner, but by a family member who is an exceptionally good dancer.

Bibliography: Fasel, 1993 II, p. 95, no. 157

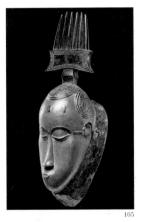

105

105 Female face mask *(Gu)*

Guro, Ivory Coast
Hardwood, face area painted later with dark brownish-red oil-based paint
Height 31.6 cm (12 ? in.)
Inv. 1007-209
Formerly collection of René Rasmussen, Paris

This is another *gu* mask in the northern Guro style. In Ariane Deluz's opinion, the comb above the coiffure suggests an affluent woman or ghe wife of a rich man; the comb prevents her carrying burdens on her head. In real life the comb worn by noble women is made of ivory.

Bibliography: Deluz, 1993 II, p. 95, no. 158

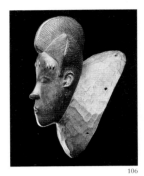

106

106 Female face or forehead mask *(Gu)*

Guro, Ivory Coast
Hardwood, traces of red paint in face area
Height 31 cm (12 ? in.)
Inv. 1007-173

Like the preceding example, this *gu* mask depicts a well-to-do woman, whose elaborate coiffure precludes the carrying of burdens on her head. According to Ariane Deluz's information, the woman represented is no longer young. As the widow or sister of a noble person she becomes an androgynous "womanboy," or *ligŏné*. Not required to do daily physical labor, she can devote herself to trading.

Bibliography: Deluz, 1993 II, p. 95, no. 159

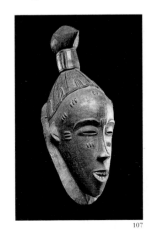

107

107 Female face mask *(Gu)*

Guro, Ivory Coast
Hardwood, reddish-brown patina, traces of white pigment
Height 26 cm (10 ? in.)
Inv. 1007-36
Acquired by Josef Mueller before 1942

Another *gu* mask of the same type as cat. 106.

Bibliography: Himmelheber, 1960, p. 206, no. 154; Fasel, 1993 II, p. 94, no. 156

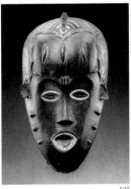

108

108 Face mask of the Je group

Guro, Ivory Coast
Hardwood, traces of white pigment
Height 26 cm (10 ? in.)
Inv. 1007-9
Acquired by Josef Mueller in 1930

Ariane Deluz describes this mask with its elaborate masculine hairstyle as follows: "This Je mask serves a double function: with the other Je it participates in activities women are not allowed to watch, but it can also be lent by the cult priests to his 'mother,' the priestess from the women's *kne* cult....During their secrets rituals, the women uncover it and place it in the center of their circle. At the end of the girl's circumcision ceremony, they return the mask to the men smeared with blood and clitoral remains, which strengthen the Je's power."

William Fagg traced the scar-ifications on the cheeks back to the influence of the Baule. It is

256

more likely, as Deluz maintains, that the difference between mask groups with four welts (a male number) and three welts (a female number) symbolizes the two sexes.

Bibliography: Fagg, 1980, p. 59; Deluz, 1988, p. 124, no. 57; Deluz, 1993, p. 96, no. 160

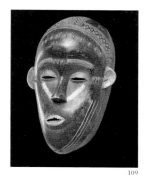

109

109 Face mask of the Je group

Guro, Ivory Coast
Hardwood, glossy patina, painted in white and brown
Height 23 cm (9 in.)
Inv. 1007-63
Acquired by Josef Mueller before 1942

This is another Je or Die mask. The white-accented scarification marks on the cheeks suggest that it depicts a slave. This mask type was worn by descendants of a respected slave.

Bibliography: Deluz, 1993, p. 97, no. 161

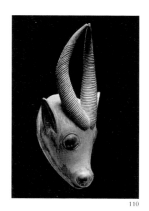

110

110 Forehead mask of the Je group, representing an antelope
Plate 36

Guro, Ivory Coast
Wood with peeling reddish-brown paint over light brown primer
Length 33 cm (13 in.)
Inv. 1007-25
Formerly collection of Josef Mueller; acquired before 1942

Bibliography: Schmalenbach, 1953, p. 39, no. 35; Fagg, 1980, p. 58; Deluz, 1988, p. 125, no. 58; Deluz, 1993 II, p. 98, no. 163; Newton, 1995, p. 84

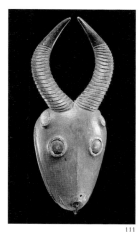

111

111 Forehead mask of the Je group, representing an antelope

Guro, Ivory Coast
Wood, remnants of black, red, and white paint
Height 38.5 cm (15 1/8 in.)
Inv. 1007-69
Formerly collection of Gertrud Dubi-Mueller

This Je Mask represents a Defassa waterbuck (*Kobus defassa*). Known as a *goro*, its function is to ignite a fire over which the wearers of Je masks with a human face leap at the end of the ceremony.

Bibliography: Deluz, 1993 II, p. 98, no. 164

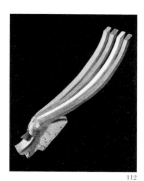

112

112 Large face mask *(Zewe)*

Guro, Ivory Coast
Hardwood, painted in black, red, and white
Height 95 cm (37 3/8 in.)
Inv. 1007-170
Acquired by Josef Mueller in 1955

Ariane Deluz attributes great potency to this *zewe* mask, because the southern Guro look upon it as the boss or spokesman of the Je. Among the northern Guro this is the "fire-breathing" mask. Its dimensions require acrobatic abilities on the dancer's part.
Bibliography: Deluz, 1993 II, p. 97, no. 162

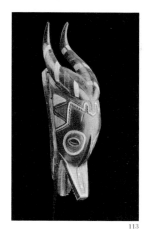

113

113 Face mask *(Zamble)*

Guro, Ivory Coast
Hardwood, painted in black, red, and blue
Height 47.5 cm (18 ? in.)
Inv. 1007-177

The *zamble* mask type represents a bushbuck antelope (*zru*). *Zamble* is one of the three *yu* masks found among the northern Guro. The term *yu* can designate the association, all its objects, ore one mask. Occasionally the trinity consisting of *zauli*, a horned mask with distended cheeks, *zamble*, and its daughter, *gu*, is reduced to a *zamble-gu* pair, with *gu* representing the wife in this case (see Deluz, 1993 II).

Women are not forbidden to see *zamble* masks. They are used to detect and extinguish evil forces. In quarrels and conflicts, the *zamble* figure serves as arbitrator.

Bibliography: Deluz, 1993 II, p. 99, no. 165

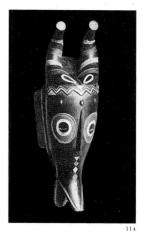

114

114 Face mask *(Zamble ple ple)*

Guro, Ivory Coast
Hardwood, painted in black, brown, and white
Height 42 cm (16 ? in.)
Inv. 1007-10
Acquired by Josef Mueller together with cat. 108 in 1930

This is a variant of the previous mask, which in this case is known as *zamble ple ple*, or "strong, strong" *zamble* (Ariane Deluz). This author points out that for several dancers, this somewhat shorter-horned mask can embody *zaule*, who

is normally represented by a horned mask with distended cheeks.

Bibliography: Fagg, 1980, p. 58; Deluz, 1988, p. 124, no. 56; Deluz, 1993 II, p. 99, no. 166

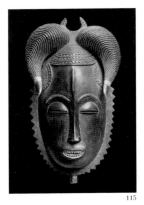

115

115 Face mask of the Je group (Tu bodu)
Plate 38

Yaure, Ivory Coast
Wood, accentuation in white pigment
Height 20 cm (7 7/8 in.)
Inv. 1007-34
Formerly collection of Josef Mueller; acquired prior to 1942

Bibliography: Boyer, 1993 II, p. 106, no. 180

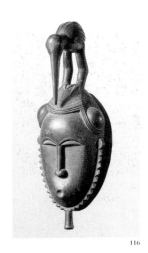

116

116 Face mask of the Je group (Lomane)
Plate 39

Yaure, Ivory Coast
Wood with accents in white and red
Height 43 cm (16 7/8 in.)
Inv. 1007-60
Formerly collection of Josef Mueller; acquired prior to 1939

Bibliography: Schmalenbach, 1988, p. 13, no. 4; Boyer, 1993 II, p. 111, no. 185; Newton, 1995, p. 87

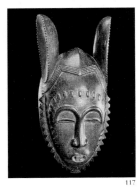

117

117 Face mask of the Je group

Yaure, Ivory Coast
Hardwood, glossy dark patina
Height 31 cm (12 ? in.)
Inv. 1007-23
Formerly collection of Emil Storrer

Storrer acquired this Je mask in Zurich in the early 1950s, and it remained in his personal collection until 1978. Ariane Deluz associates the prominent ears with human sacrifices which were once offered to *yu*, a spirit or supernatural being. Such ears are found on other Guro objects as well, such as a ladle illustrated in Deluz (Deluz, 1993 II, p. 102, no. 174).

Bibliography: Muensterberger, 1979, p. 55; *Westafrikanische Tage*, 1982, no. 17; Deluz, 1988, p. 125, no. 59; Boyer, 1993 II, p. 107, no. 181; Newton, 1995, p. 86

118 Face mask of the Je group

Yaure, Ivory Coast
Wood, painted in black and white

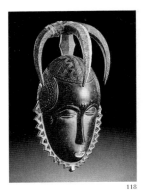

118

Height 31 cm (12 ? in.)
Inv. 1007-204

Alain-Michel Boyer's Yaure contacts associated this mask with the Je group, saying it was intended to represent the he-goat, *bla*. Yet as the author reminds us, such masks are not straightforward depictions or portraits of legendary figures or mythical beings, but more in the nature of "homages to secondary divinities" known as *yu*.

Bibliography: Boyer, 1993 II, p. 112, no. 186

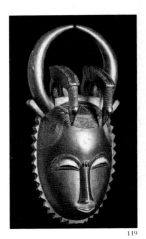

119

119 Face mask (Anoman or klomle)

Yaure, Ivory Coast
Wood, ochre pigments, black stain, white kaolin
Height 41 cm (16 1/8 in.)
Inv. 1007-8
Collected by Hans Himmelheber;

acquired by Josef Mueller from the Charles Tatton collection in 1939

The mask types of the Yaure are difficult to identify, because the group of masks they are included in and the names they bear differ from village to village and clan to clan. This mask is called *anoman* when it is part of the Je group, and *klomle* when it belongs to the Lo group.

Alain-Michel Boyer a brilliant description of the mask: "This immutable face, seemingly withdrawn within its own world of perfection and unfathomable secrets, clearly evokes the twofold notion of exterior physical beauty and interior moral superiority, which often form a pair in Yohure [Yaure] thinking."

Bibliography: Himmelheber 1935, fig. XII (the author cites the sculptor's name, Kouakoudili); Schmalenbach, 1953, p. 39, no. 36; Boyer, 1993 II, p. 110, no. 184

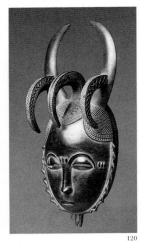

120

120 Face mask

Yaure, Ivory Coast
Hardwood, blackened
Height 34.5 cm (13 5/8 in.)
Inv. 1007-24
Acquired by Josef Mueller in 1955

Alain-Michel Boyer mentions an almost identical mask from Kuassi-Perita (Yaure Namanle),

which belongs to the Lo mask group and is called *tu*. He adds, however, that neither the name nor the classification of this mask type are unchanging, but vary from place to place. Frequently the Lo group masks are black, while those of the Je group have accents of color. This distinguishing criterion does not always hold, however.

Bibliography: Boyer, 1993 II, p. 109, no. 183

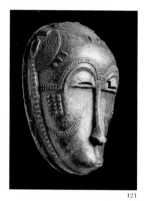

121 Face mask

Baule, Ivory Coast
Hardwood, glossy brown patina
Height 22 cm (8 5/8 in.)
Inv. 1007-29
Acquired by Josef Mueller before 1942

Possibly this mask once had a shock of hair which has since been lost. It was worn at festivities for entertainment. Depending on the region, it belonged to a group known as Mblo, Blo, Ngblo, Gbo, Ajusu, Gbagba, etc. Many such masks are thought to be portraits of young girls who were known for their beauty (see Boyer, 1993 I, p. 340).

Bibliography: Vogel, 1993 II, p. 117, no. 195

122 Twin mask of the Mblo group
Plate 41

Baule, Ivory Coast
Wood, with red and black paint

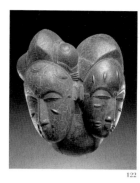

Height 29 cm (11 3/8 in.)
Inv. 1007-65
Formerly collection of Roger Bédiat; collected in the mid 1930s

Bibliography: Delange, 1958, fig. XVI, cat. 114; Laude, 1966, p. 102, no. 115; Meauzé, 1967, p. 65; Fagg, 1980, p. 63; Vogel, 1988, p. 131, no. 64; Vogel, 1993 II, p. 118, no. 196; Newton, 1995, p. 91; *Historia del Arte*, 1996, p. 2617

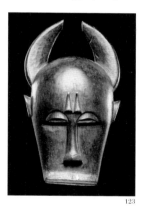

123 Helmet crest
Plate 42

Baule, Ivory Coast
Wood with remnants of white kaolin pigment
Height 38 cm (15 in.)
Inv. 1007-28
Formerly collections of Antony Moris and Josef Mueller; acquired prior to 1939

Bibliography: Fagg, 1980, p. 64; *Westafrikanische Tage*, 1982, no. 18; Vogel, 1988, p. 133, no. 67; Vogel, 1993 II, p. 118, no. 197; Newton, 1995, p. 93

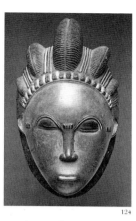

124 Face mask

Baule, Ivory Coast
Hardwood, face probably originally tinted red, black coiffure with remnants of white paint
Height 30 cm (11 ? in.)
Inv. 1007-5

In the early 1960s this mask was in the collection of art dealer Robert Duperrier in Paris. It possibly belongs to the Gbagba or Mblo group. A "portrait" of a beautiful woman, the mask was worn in entertaining dances. Alain-Michel Boyer emphasizes that a faithful likeness of the model was not the point, for, as one of his Baule contacts explained, "a sculptor is no photographer" (Boyer, 1993 I, p. 342).

Bibliography: Fagg, 1980, p. 62; *Westafrikanische Tage*, 1982, no. 21; Vogel, 1988, p. 130, no. 63; Boyer, 1993 II, p. 117, no. 194

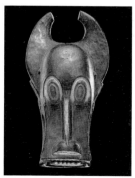

125 Helmet Crest (Bonu Amwin)

Baule, Ivory Coast
Black wood, stained black, painted in red and white
Length 70 cm (27 5/8 in.)
Inv. 1007-40
Acquired by Josef Mueller before 1942

Josef Mueller's small collection of masks of the Bonu Amwin type was remarkable. Until recently, hardly another collector valued these finely proportioned sculptures, but their reservations are subsiding. Alain-Michel Boyer writes: "Each mediumsized village has a Bonu Amwin symbolized by several helmet masks which evoke a mythical animal with elements of the bush cow and antelope, belonging to an all male cult association."

An Amwin group often consists of seven masks of varying design and designation. Dié, Do, Klölö, Gbo, Botiwa, are only a few of the names given them (Boyer, p. 322).

To simplify matters they are often called "*ban* masks," because one of their key purposes is to ward off evil. Beyond this, the masks are used to help maintain communal order. They also appear at funerals of initiates.

Bibliography: Vogel, 1993 II, p. 120, no. 200

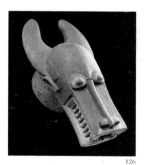

126 Helmet crest (Bonu Amwin)

Baule, Ivory Coast
Wood, originally stained black, traces of red and white paint, brass nails

Length 66 cm (26 in.)
Inv. 1007-44
Acquired by Josef Mueller before 1942

A mask of the Bonu Amwin type (see cat. 125).

Bibliography: Vogel, 1993 II, p. 120, no. 201

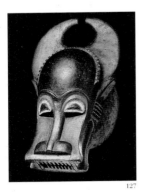

127 Helmet crest (Bonu Amwin)

Baule, Ivory Coast
Black wood, stained black, traces of red and white paint, white and red accents, restored horn
Length 49 cm (19 ? in.)
Inv. 1007-51
Acquired by Josef Mueller before 1942

A mask of the Bonu Amwin type (see cat. 125).

Bibliography: Schmalenbach, 1953, p. 69, no. 61; Duerden, 1974, p. 13; Fagg, 1980, p. 64; Vogel 1993 II, p. 121, no. 202

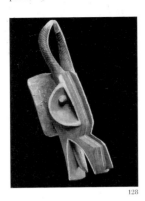

128

128 Helmet crest of the Goli group (Goli glin)

Baule, Ivory Coast
Wood, painted in black, red, and white
Length 81 cm (31 7/8 in.)
Inv. 1007-42
Acquired by Josef Mueller before 1942

The popular Goli masks include four different types: the "father," *goli glin*, who is represented here; his wife, *kpwan* (see cat. 129); the disk-shaped, horned *kplekple* (see plate 40); and, in some villages, *goli dandri*, which is similar to *kplekple*, only larger. In the southern Baule area the *kplekple* mask is replaced by *kpwan kple*, which has a human face and represents the "daughter" of *goli glin*.

These masks originated from the Wan, an ethnic group who live north of the Kossu Reservoir. This originj is indicated by the use of the Wan language in Goli masquerade performances.

Bibliography: Boyer, 1993 II, p. 124, no. 208

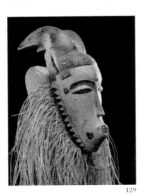

129

129 Face mask of the Goli group (Kpwan)

Baule, Ivory Coast
Wood, face area painted over with red oil-based paint, forehead and horns black, fringe of fibers
Height 35 cm (13 ? in.)
Inv. 1007-193

This *kpwan* mask, of a type very rarely represented in Western collections, belongs to the Goli group (see cat. 128).

Bibliography: Boyer, 1993 II, p. 125, no. 210

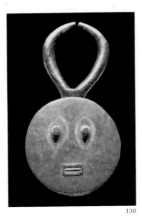

130

130 Female face mask of the Goli group (Kplekple bla)
Plate 40

Baule, Ivory Coast
Wood, painted in reddish-brown, black, and white
Height 42 cm (16 ? in.)
Inv. 1007-21
Formerly collection of Charles Ratton

Bibliography: *African Sculpture Lent by New York Collectors*, 1958, p. 21, no. 19; Elisofon and Fagg, 1958, p. 58, no. 55; Fagg, 1980, p. 65; Vogel, 1988, p. 132, no. 65; Vogel, 1993 II, p. 126, no. 212; Newton, 1995, p. 90; *Historia del Arte*, 1996, p. 2616

131 Helmet mask (Botiwa)

Baule, Ivory Coast
Wood, painted in black, red, and white
Length 65 cm (25 5/8 in.)
Inv. 1007-195
Acquired by Henri Barbier in Paris in 1952, from the collection of Ernest Ascher

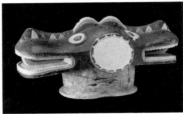

131

Alain-Michel Boyer describes this impressive mask as a *botiwa*, which originated from the vicinity of Tiébissous, from the Nanafoué subgroup who inhabit the left shore of Kossou Reservoir. Like the Gbösö, Klölö, and Die masks, this type serves to avert evil and harm. With its aid destructive forces (*baefive*) can be combated, epidemics contained, and the cosmic order disturbed by the death of a key member of the community can be restored (see Boyer, 1993 II).

This helmet mask is the emblem of the feared supernatural powers known as *amwin*. The two heads allude to the watchfulness of the mask, which is continually on guard and omnipresent. A connection between this and the dual-headed masks of the Senufo is conceivable. Possibly both go back to an old masquerading tradition that still exists in this region.

Bibliography: Boyer, 1993 II, p. 121, no. 203

132 Helmet crest

Fante (?), Ghana
Hardwood, repainted in black, red, and white oil-based paint, fibers, metal
Length 112 cm (44 1/8 in.)
Inv. 1009-149A

This unusual mask and the following example form a pair. Masks of the type are seldom found in Western collections. Both stem from the Fante, an Akan group in Ghana, one of the peoples generally thought to not possess a masquerading tradition. Still, on old photograph

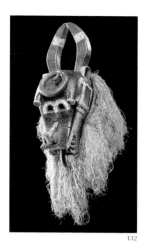

132

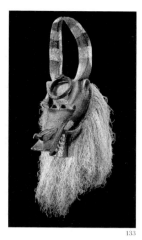

133

reproduced in *People of All Nations* shows a horizontal animal mask of this type being danced (fig. 5; see also the figure on p. 25 of the present volume). Patrick McNaughton writes: "Southern (Akan) Thana has generally seemed a lean art space for masking traditions. But Doran Ross, Roy Sieber etc. have shown that horizontal masks are well known there." The title page of the magazine in which his article appeared illustrated a similar mask to the one in *People of All Nations*, and a further photo of two masks "from Asafo 2 Company, photographed at the annual celebration of Fetu Afahye, Cape Coast, Ghana, September, 1979."

Nevertheless, in the well-known 1977 book *The Arts of Ghana*, Doran Ross noted, "...the public display associated with royalty or military groups like the Fante Asafo is involved in proclaiming and exalting individuals, who would lose their identities as such if they wore masks. Moreover, spiritual values are adequately served, without masks, by various shrines."

The history of the large horizontal masks of the southern Akan remains obscure.

Bibliography: McNaughton, 1991, p. 40 ff., no. 2

133 Helmet crest

Fante (?), Ghana
Hardwood, repainted in blac, red, and white oil-based paint, fibers, metal
Length 120 cm (47 ? in.)
Inv. 1009-149B

A further example of the previous mask type, with which it forms a pair. Each is carved of a single piece of wood with various plastic elements attached. The significance of the snake on the forehead as well as the indigenous name of the mask have not been documented.

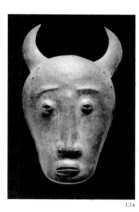

134

134 Face mask

Fon, Republic of Benin
Iron, hammered and chased
Height 29.1 cm (11 ? in.)
Inv. 1010-21
Acquired by Josef Mueller in Paris

from the collection of Antony Moris in 1939

This rare mask is visible in a pre-1939 photograph taken by Charles Ratton in the Montmartre apartment of "Père Moris." It was identified by Suzanne Blier, who writes that the mask "belongs to one of six mask types from Dahomé (Fon). It was worn by the members of a society of young men. Known as Zangbeto, the society was responsible for maintaining order in the community."

The five other Fan mask types are "half masks," usually of silver or brass, which cover only the nose and upper part of the face; wooden masks of animals called *so*; gourd masks used in farces (*klan*); shapeless textile masks known as *kulito*; and finally, children's masks made of paper or light wood (*kaleta*).

Bibliography: Blier, 1991, p. 19, no. 1

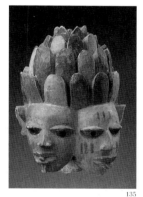

135

135 Helmet crest *(Gelede)*

Yoruba, Nigeria
Wood, painted in red, white, and blue
Height 36 cm (14 1/8 in.)
Inv. 1010-1
Acquired by Josef Mueller in Paris from the collection of Antony Moris in 1941

This two-faced mask (*gelede*) served to honor and propitiate the ambivalent spiritual forces of women, who ensure the fertility and well-being of the com-

munity, but who are also held responsible for human barrenness and death. The two faces represent twins, who in the eyes of the Yoruba are gifts of god who can bring either happiness or sorrow. The red face with a lip plug is female, the other male.

John Picton's description of the mask underscores the red-white color contrast, a mark of the Shango association. Possibly the "scales" of the headdress stand for *edun ara*, axe blades that symbolize Shango's power. According to this author, the style is typical either of the region around Anago in the southwest, or of Ago-Asha. Henry John Drewal, in an unpublished study, believes to have pinpointed the sculpture's origin in the workshop of mastercarver Arobatan, of Pobe, who was active in the first half of the twentieth century. Drewal adds that the Yoruba believe twins share a single soul, which might explain the unification of two faces in a single mask.

Bibliography: Schmalenbach, 1953, p. 51, no. 47; Duerden, 1974, p. 73; Fagg, 1980, p. 7; Picton, 1988, p. 144, no. 76

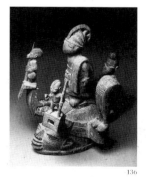

136

136 Cap mask *(gelede)*

Yoruba, Nigeria
Wood, dark patina, attached elements
Height 46 cm (18 1/8 in.)
Inv. 1011-31

William Fagg identified the figures surmounting the mask a Egungun dancers. In

a unpublished study, Henry John Drewal recalled that the task of the Egungun masking fraternity was to pay honor to the ancestors. Drewal observed several persons who appeared one after the other during the *p'idan* ceremonies of the Egungun and cursed the statuettes on the mask.

This type of mask originated from the region of Oyo, and in the seventeenth and eighteenth century was disseminated in the west (Ketu). Drewal believes the present mask originated from the workshop of the sculptor Duga, who was active in the town of Meko in the Ketu-Yoruba area.

Bibliography: Fagg, 1980, p. 68

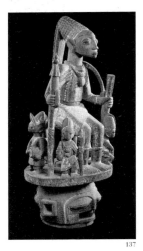

137

137 Helmet crest *(Epa)*
Plate 43

Yoruba (Ekiti), Nigeria
Wood, encrusted patina, and reddish-brown, white, and black paint
Height 115 cm (45 ? in.), diameter 45 cm (17 ? in.)
Inv. 1011-62

Bibliography: Fagg, 1982, p. 73, no. 10

138 Helmet crest

Yoruba, Nigeria
Bottle-gourd, wood, red clay, seeds, painted in black and white, fibers
Height 27.5 cm (10 7/8 in.)
Inv. 1015-57

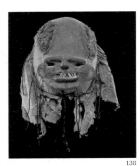

138

Acquired by Josef Mueller before 1942

This mask type remains uninvestigated. Inside this example is a label inscribed "Yoruba" in Mueller's handwriting. John Picton, in an unpublished file-card note, remarks that the western branch of the Yoruba possess a great number of masquerade costumes and masks of the most diverse form. These are usually known as *egigun*, evidently a garbling of the Oyo term *egungun*. As Picton adds, *egungun* masks served to commemorate the ancestors, though among the eastern Yoruba they primarily recalled the institutions created by them. According to Picton, similar masks were observed in the vicinity of Owo.

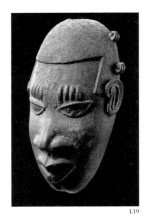

139

139 Pendant in mask form
Plate 44

Benin, Nigeria
Brass with encrusted patina, iron inlays

Height 17.9 cm (7 in.)
Inv. 1011-104
Formerly collection of Baudouin de Grunne

Bibliography: Musée Barbier-Mueller, 1987, p. 157; Muensterberger, 1979, p. 57; Fagg, 1980, p. 68; Ben Amos, 1988, p. 137, no. 74; *Art tribal* (Benin), 1992, p. 43, nos. 29, 44 and 30; Meyer, 1994, p. 187; Newton, 1995, p. 103

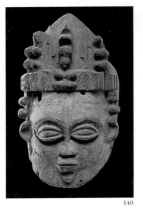

140

140 Face mask of the Ekpo society

Bini, Nigeria
Soft wood, encrusted gray and brown patina, cracks restored
Height 35 cm (13 ? in.)
Inv. 1011-40
Acquired by Josef Mueller before 1952

The Bini live in villages around the city of Benin. Like the Ishan and Urhobo, they speak Edo. Their Ekpo masks represent chiefs or persons of high social rank. In an unpublished file-card note, Alexander Lopasic views this mask as an example of the style of the village of Ugboko, a key center of sculpture in the Iyekhoriomo region. Typical traits of this style are elongates eyes, small mouth, and protruding ears.

141 Face mask

Yoruba (?), Edo (?), Nigeria
Soft wood, dark patina
Height 24 cm (9 ? in.)

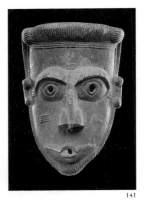

141

Inv. 1011-155
Acquired by Josef Mueller before 1942

This is another mask which has eluded specialists' attempts to determine its origin and function. A label in Josef Mueller's hand bears the note "Nigeria." Possibly this is one of the many masks used to invoke ancestors in eastern Yoruba country, or alternately, a mask of the Edo people who maintained contact with the Yoruba. The publication of sculptures whose geographical attribution is unsure is generally avoided. We consider it necessary in order to give experts on opportunity to study such objects and draw comparisons.

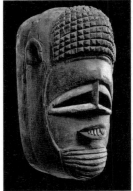

142

142 Face mask *(Elu)*
Plate 45

Owo, Nigeria
Wood with blackish-brown patina

and remnants of white and brown paint
Height 27 cm (10 5/8 in.)
Inv. 1012-24)

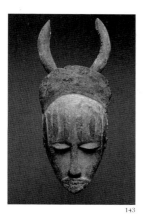

143 Face mask
Plate 46

Urhobo, Nigeria
Wood with encrusted patina and traces of white and black paint
Height 46 cm (18 1/8 in.)
Inv. 1012-2
Formerly collection of Philippe Guimiot

Bibliography: Fagg, 1980, p. 75; Foss, 1988, p. 150, no. 83; Newton, 1995, p. 110

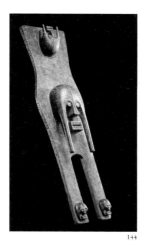

144 Forehead mask
Plate 47

Western or central Ijo, Nigeria
Wood

Length 118 cm (46 ? in.)
Inv. 1012-39

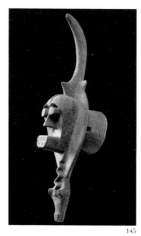

145 Forehead mask
Plate 48

Western or central Ijo, Nigeria
Wood with red pigments (redwood)
Length 67.8 cm (26 ? in.)
Inv. 1012-35

146 Helmet crest or headdress (Uguberi)

Ijo (?), Nigeria
Hardwood, black lacquer, white paint, rattan
Height 60.5 cm (23 7/8 in.)
Inv. 1012-19

This type of fish-shaped headdress is found not only among the Ijo but among related groups of the Niger delta, and among the Apoi, a Yoruba group of the western delta who have retained the original names for their ijo masks. (The information concerning this mask comes from an unpublished study by Martha Anderson, based on field research).

In the group of fish masks, the hammerhead (known as *uguberi* or, with the Apoi, *oguberiberi*) plays the role of a social outcast. The athletic antics of its wearer accompany joyous festivities.

According to Anderson, a masquerade figure of the same name was observed in Ikebiri, a

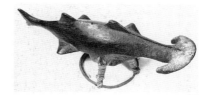

small market hamlet in the southern Ijo country. Serving the purpose of arbitrating disputes, it was considered to embody a powerful spirit.

Uguberi fish helmets from Ikebiri always appear in groups of seven, which represent father, mother and children. The numbers three and seven are sacred to the Ijo, notes Anderson. In addition to the purposes mentioned, masks of this type are thought capable of predicting death, containing epidemics, and furthering community welfare.

147 Helmet crest or headdress (Ugbo-ofurumo)

Ijo, Nigeria
Wood, red patina, white accents, rattan
Height 69 cm (27 1/8 in.)
Inv. 1012-26

The peoples inhabiting the Niger delta are fishermen who use a great variety of methods. According to Martha Anderson's unpublished communications, most of their fish masks embody water spirits.

In the central Ijo region the fish on the helmets are smaller than those of the Abua, Ekpeya, or other Ijo groups to the east, where they can take on enormous proportions.

An informant of Anderson's said the fish depicted here was a tiger shark (*ugbo-ofurumo*).

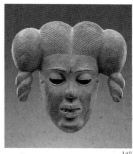

148 Female face mask (Mfon)
Plate 49

Anang, Nigeria
Wood with matte, dark patina
Height 23 cm (9 in.)
Inv. 1013-2

Bibliography: Fagg, 1980, no. 86; Nicklin, 1988, p. 172, no. 98; Newton, 1995, p. 115

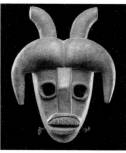

149 Face mask of the Ekpo society

Ogoni, Nigeria
Hardwood, black soot patina, damaged horns, mouth area restored

Height 33 cm (13 in.)
Inv. 1014-106

This mask represents a goat of the *karikpo* variety. According to Keith Nicklin, it probably originates from the vicinity of Boue (unpublished file-card note, 1995). It was in the possession of the Ekpo men's association, which honoured male ancestors.

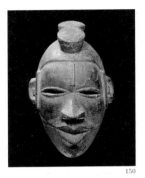

150 Female face mask with movable lower jaw (Elu)
Plate 50

Ogoni, Nigeria
Wood with smoked black patina, partly restored in mouth area
Height 19.3 cm (7 5/8 in.)
Inv. 1013-8

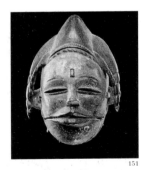

151 Face mask (Elu)

Ogoni, Nigeria
Wood, encrusted black soot patina with traces of white paint, fibers, nails
Height 22 cm (8 5/8 in.)
Inv. 1014-122

This mask has the movable lower jaw that characterizes Ogoni and some Ibibio masks.

G.I. Jones views their styles as entirely different, whereas Keith Nicklin finds them similar (Nicklin, 1988, p. 169). In an unpublished note Nicklin describes the present mask as a typical *elu*, adding that the coiffure with dangling braids is worn by young Ogoni girls at traditional festivities.

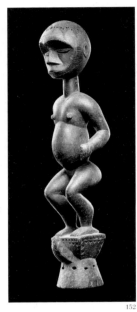

152 Headdress mask with female figure, used in *ogbom* dances
Plate 51

Ibibio (Eket), Nigeria
Wood, painted black; right arm missing
Height 66 cm (26 in.)
Inv. 1014-99

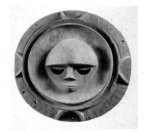

153 Face mask
Plate 52

Ibibio, Nigeria
Wood with dark patina
Diameter 28 cm (11 in.)
Inv. 1014-66
Formerly collection of J. Blanckaert, Brussels

Bibliography: *Arts premieres d'Afrique*, 1977, p. 87, no. 52; Nicklin, 1988, p. 174, no. 100; Newton, 1995, p. 113

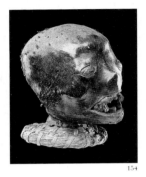

154 Headdress mask

Ejagham (?), Nigeria
Human skull, animal skin (?), rattan
Height 21 cm (8 ? in.)
Inv. 1015-90

Headdress masks covered with skin are found in the entire region of the Cross River. They are used by various groups, including the Ejagham (Ekoi), the Boki, Mbembe, Keaka, and even the Bangwa of Cameroon. Those human heads carved of wood and covered with animal skin (cf. plate 53) recall masks of the present type, which is based on a real human skull. Ekpo Eyo writes (Eyo, 1988, p. 159) that this headdress "had various purposes to fulfil among the secret societies along the Cross River."
 Suzanne Preston Blier divides the stylistic tendencies of Cross River art into three main categories. Along the lower reaches of the river, she says, on finds a "rounded and fleshly naturalism," along its middle reaches an "emphasized naturalism," and along the upper reaches "a skeletal abstraction." (cf. cat. 156)

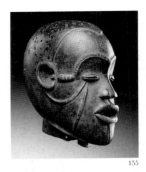

155 Headdress masks
Plate 53

Boki, Nigeria
Wood with reddish-brown primer and traces of blackish-brown paint, metal teeth
Height 20.5 cm (8 1/8 in.)
Inv. 1015-54

Bibliography: *Hier, aujourd'hui, demain*, 1987, p. 97, no. 10; Vion, 1988, p. 162, no. 89; Newton, 1995, p. 119

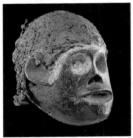

156 Helmet mask

Boki, Nigeria
Wood, painted in black, red, and white, resin (?), fibers
Height 55 cm (21 5/8 in.)
Inv. 1015-77

The sculptor has given this mask the form of a human skull, with deep eye cavities and gaping nostrils. In an unpublished note of 1995 Keith Nicklin associates the piece with headhunting, which was reported to have been practiced by the Igbo and other ethnic groups east of the Cross River.
 Nicklin mentions a similar mask in the possession of a warriors' society, which was dis-

played in 1977 in Adadama Beach.

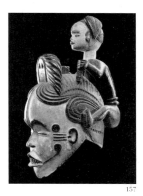

157

157 Female helmet crest, used in *okperegede* dances
Plate 54

Igbo (Izzi group), Nigeria
Wood painted in black and white
Height 49 cm (19 ? in.)
Inv. 1014-101

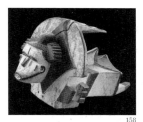

158

158

158 Helmet crest *(Ogbodo enyi)*
Plate 55

Igbo (northeastern Igbo), Nigeria
Wood, painted in black and white
with red accents
Length 59 cm (23 ? in.)
Inv. 1014-15
Formerly collection of Dr.
W. Muensterberger

Bibliography: Muensterberger, 1979,
pp. 60, 61; Fagg, 1980, p. 78; Cole,
1988, p. 170, no. 96

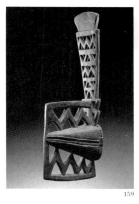

159

159 Face mask
Plate 56

Igbo (Uzouwani and southwestern
Nsukka region), Nigeria
Wood with traces of white and red
paint
Height 68.2 cm (26 7/8 in.)
Inv. 1014-92

Bibliography: Newton, 1995, p. 124

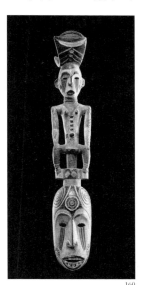

160

160 Face mask *(Opa nwa, agbogho okumkpa, agbogho mma)*
Plate 57

Igbo (Ada group), igeria
Wood painted in white, black, red,
and yellow
Height 60.5 cm (23 7/8 in.)
Inv. 1014-85

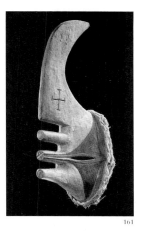

161

161 Face mask *(Mma ji)*

Igbo (Ada group), Nigeria
Hardwood, painted in black, red,
and white, woven fibers
Height 38.3 cm (15 1/8 in.)
Inv. 1014-79

This mask bears the name of *mma ji*, or "yam knife." It is also known as *mma ubi*, or "farmer's knife." The meaning of the three projections (some masks have four) is not known. According to an unpublished note by Simon Ottenberg, they might be intended to suggest a nose. This mask type never has a mouth or ears. The forehead projection, which recalls a boat's prow, actually represents a machete, a tool used in field-work and earlier as a weapon.

Ottenberg reports that this style of mask is danced in the village of Okpoha during the *okonkwo* ceremony, in which the dancers form a circle around two xylophone players.

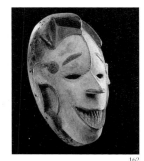

162

162 Face mask

Igbo, Nigeria
Wood, painted in black, red, and
white
Height 24.3 cm (9 5/8 in.)
Inv. 1014-124

This type of mask is worn and danced at *okoroshi* ceremonies, which involve religious rites for spirits or divinities of water (*owu*). These rites are widespread in the southwestern and northern Igbo region. *Okoroshi* masquerades were observed by Herbert Cole and Chike Aniakor (Cole and Aniakor, 1984, p. 186 ff.) in nine villages around Agwa. The authors were able to document several similar masks in photographs.

During the rainy season all daily activities are interrupted for a month in order to celebrate the advent of the water spirits. Two groups of dancers face each other, one in white masks and costumes ambodying the good spirits (*okoroshioma*, or "beautiful spirits"), the other with black faces representing the evil spirits (*okoroshiojo*, or "malicious, dark spirits"). Each group consists of various characters who dance in succession.

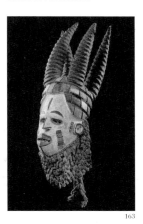

163

163 Large face mask

Igbo, Nigeria
Hardwood, shells, painted in black,
red, and white, fibers, traces of blue
paint
Height 87 cm (34 ? in.)
Inv. 1014-2

Despite its white face, Herbert Cole considers this mask an incarnation of a potent male spirit, due to its size and four horns. The color white might be associated with the "spirits of death," and, when used in connection with female figures, might embody "reincarnated ancestors."

In terms of style, William Fagg and Cole attribute the mask to the northern Igbo.

Bibliography: *Art africaine dans les collections genevoises*, 1973, p. 60, no. 37; Fagg, 1980, p. 83; Cole and Aniakor, 1984

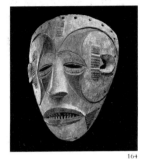

164

164 Face mask *(Agbogho mmuo)*

Igbo, Nigeria
Wood, painted in black, ocher, and white
Height 16.5 cm (6 ? in.)
Inv. 1014-70 B

This is one of the most familiar types of mask produced by the prolific Igbo artists. Representing the "spirit of a young girl" *(agbogho mmuo)*, it originated from the heart of Igbo country (according to Herbert Cole, from the Nri-Awka region, west of Onitsha).

Such masks are worn by young men during harvest celebrations and the ceremonies held annually in honor of the earth spirit, or *ane* (cf. Cole and Aniakor, 1984, p. 124 ff.). The "young girls" are accompanied by a "mother" whose mask is adorned with a great crest or hood. The dancers wear colorful, closefitting costumes with false breasts.

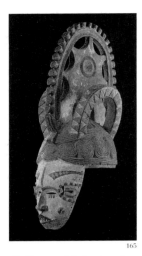

165

165 Face mask/helmet crest *(Ikorodo)*

Igbo, Nigeria
Soft wood, painted in black, white, and yellow
Height 56 cm (22 in.)
Inv. 1014-81

In an unpublished note Herbert Cole dates this mask to after 1940. Like the previous example, it represents the "spirit of a young girl," and possible comes from the area of Nsukka, where it is called *ikorodo*.

The triple-crested coiffure is a naturalistic representation of hairstyles actually worn by young girls of the region. The form of the central crest, recalling a cogwheel, presumably derived from the former custom of attaching brass coins to the hair.

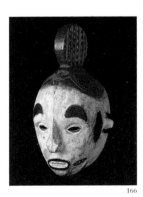

166

166 Face mask

Igbo, Nigeria
Hardwood, painted in black and white
Height 39 cm (15 3/8 in.)
Inv. 1014-16
Acquired by Josef Mueller before 1952

William Fagg illustrated a field photography by Kenneth Murray that shows a child wearing this mask near Onitsha. The author did not recognize it as being this mask, since at the time it still had small braids tacked to the sides, where the holes are still visible. The mask was probably danced for entertainment.

Herbert Cole, incognizant of this recent chance discovery, nevertheless made a prescient attribution in an unpublished note, saying that the mask surely represented a female figure, more precisely a child, and that its style implied a northern rather than a southern origin.

Bibliography: Fagg, 1980, p. 80

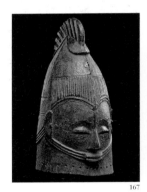

167

167 Helmet mask

Igbo, Nigeria
Hardwood, encrusted glossy black patina
Height 40.8 cm (16 1/8 in.)
Inv. 1014-83

This evidently very old conical mask bears a strong similarity to the helmet masks of the Igala. This group lives in the neighborhood of Nsukka in the northern Igbo region, where Herbert Cole

found a similar mask, called *ekpe* or *ojukwu*. It served to accompany through the crowd a larger, indeed enormous mask by the name of *ekwe*.

Cole views the relief pattern on the forehead as representing the scarification, or *ichi*, characteristic of person of rank.

Bibliography: Cole land Aniakor, 1984

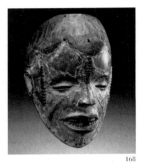

168

168 Face mask *(Ikpobi)*
Plate 58

Idoma (Akweya group), Nigeria
Wood with remnants of yellow ochre and black paint over white ground
Height 24 cm (9 ? in.)
Inv. 1014-87

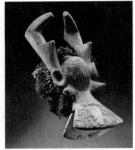

169

169 Helmet crest *(Augum or iki)*

Yukuben or Kutep, Nigeria
Hardwood, grayish-brown patina, traces of wild liquorice (*Abrus precatorius*) seeds around mouth, fibers
Length 63 cm (24 ? in.)
Inv. 1015-22

The Yukuben and the Kutep, both of whom speak a Jukun-

related language, live in the vicinity of the market town of Takum, in a heavily forested area south of the Benue and the Chamba and Jukun region (Marla Berns, unpublished note). According to Arnold Rubin, while zoomorphic mask variants are found among neighboring groups, this form originated among the Chamba.

The masks of the Yukuben are almost indistinguishable from those of the Kutep. The red seed (*Abrus precatorius*) decoration, the rilled, bulging forehead, and the flat snout, feature in the art of both groups.

In an unpublished manuscript Berns, a student of Rubin, recalls that he attributed the mask to the Yukuben rather than to the Kutep (Rubin, 1988, no. 105). For both, the type embodies a "bush spirit." According to Berns, the Yukuben call it *augum*, while the Kutep call it *iki*. Among the Kutep such masks are danced annually to celebrate the community's successful hunting. Among the Yukuben, in contrast, they serve to protect against destructive forces, and are danced in rites associated with farming.

Bibliography: Fagg, 1980, p. 101; Rubin, 1988, p. 180, no. 105

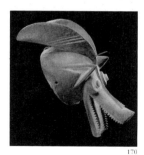

170 Helmet crest (Suaga)
Plate 60

Mambila, Cameroon/Nigeria
Wood, painted black and accented in white and red, nails
Height 38 cm (15 in.)
Inv. 1018-77

Bibliography: Perrois, 1994, p. 18, fig. 9

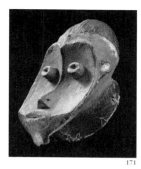

171 Forehead mask (Kiavia)
Plate 59

Mambila, Cameroon/Nigeria
Wood, painted in red, white, and blackish-brown, cord of plant fibers
Height 30 cm (11 ? in.)
Inv. 1018-76

Bibliography: Gillon, 1979, p. 81, no. 88; Northern, 1988, p. 185, no. 109; Newton, 1995, p. 133

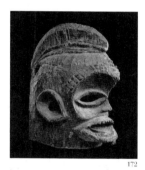

172 Helmet mask
Plate 61

Mambila, Cameroon/Nigeria
Wood, with encrusted patina and remnants of blackish-brown paint
Height 40 cm (15 ? in.)
Inv. 1018-85
Formerly collections of Charles Ratton and Arman

173 Helmet crest (Ngoin)
Plate 62

Western Grasslands, Cameroon, Babanki style
Wood painted blackish-brown with traces of white
Height 50 cm (19 5/8 in.)
Inv. 1018-43
Formerly collection of Josef Mueller;

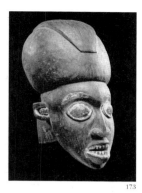

acquired before 1939
Bibliography: Northern, 1988, p. 190, no. 116; Perrois, 1994, p. 50, no. 6

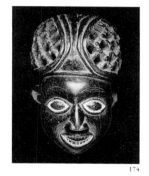

174 Helmet crest

Babanki-Tungo, Cameroon
Hardwood, glossy black patina, kaolin traces around eyes and mouth
Height 53.5 cm (21 1/8 in.)
Inv. 1018-23

Louis Perrois writes that the *juju nkoh* masks of the northwestern kingdom of Bamileke belong to the "society of princes" who are related to the ruling *fon*. They appear at coronations, funerals, and farming festivals. In the past century Babanki-Tungo was an important center of sculpture. Many rulers had their masks or thrones fabricated there.

The pierced pattern on the cowl of this mask recalls a tarantula, and represents the wool cap worn by princes or hight-ranking personages who were responsible for naming a ruler's successor.

Bibliography: Fagg, 1980, p. 104; *Westafrikanische Tage*, 1982, no. 43; Perrois, 1994, p. 50, no. 5

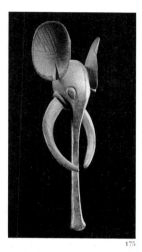

175 Helmet crest
Plate 63

Western Grasslands, Cameroon, Babanki style
Wood patinated by wear
Length 112.3 cm (44 ? in.)
Inv. 1018-82

Bibliography: Utotombo, 1988, p. 197, no. 146; Perrois, 1994, p. 50, no. 8

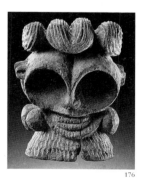

176 Dual-faced mask of the Troh night society
Plate 64

Bangwa, Cameroon
Wood with traces of kaolin
Height 41.5 cm (16 3/8 in.)
Inv. 1018-65

Bibliography: Hier, *aujourd'hui, demain*, 1987, p. 184, no. 112;

Northern, 1988, p. 188, no. 112; Meyer, 1991, p. 96, no. 80; Perrois, 1994, p. 40, no. 7; Newton, 1995, p. 134

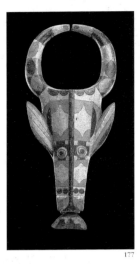

177

177 Forehead mask (Nyatti)
Plate 65

Duala, Cameroon
Wood, painted in black, white, and red, iron tongue
Height 76 cm (29 7/8 in.)
Inv. 1018-2
Formerly collection of Josef Mueller; acquired before 1939

Bibliography: *Die Kunst von Schwarzafrika*, 1971, p. 217, no. 011; Fagg, 1980, p. 106; Perrois, 1988, p. 199, no. 118; Perrois, 1994, p. 19, no. 14; Newton, 1995, p. 140; *Historia del Arte*, 1996, p. 2626

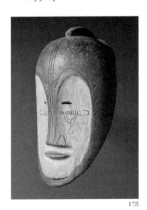

178

178 Face mask (Ngil)
Plate 66

Fang, Gabon or Equatorial Guinea
Wood, painted in white, yellow ochre, and gray-green
Height 44 cm
Inv. 1019-14
Formerly collection of Josef Mueller; acquired from Mme. Charles Vignier before 1939

Bibliography: Fragg, 1980, p. 111; Perrois, 1985, p. 224, no. 82; Perrois, 1988, p. 207, no. 124; *Hier, aujourd'hui, demain*, 1987, p. 70, 2; Meyer, 1991, p. 99, no. 81

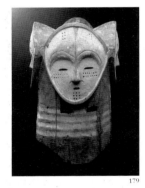

179

179 Helmet mask with four faces (Ngontang)
Plate 67

Fang, Gabon or Equatorial Guinea
Wood, painted in white and dark brown
Height 39 cm (15 3/8 in.)
Inv. 1019-23
Formerly collection of Josef Mueller; acquired from Mme. Charles Vignier around 1935

Bibliography: Perrois, 1979, no. 94; Perrois, 1985, p. 222, no. 77; Fagg, 1980, p. 108; Newton, 1995, p. 144

180 Helmet mask

Fang, Gabon
Soft wood, painted in black, red, and white, brass nails, fibers
Height 85 cm (33 ? in.) (including horns)
Inv. 1019-24
Acquired by Josef Mueller from the collection of Charles Ratton in 1939

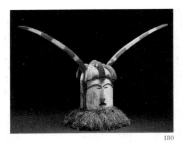

180

An old label on the mask indicates that it was collected by the friars of St. Peter's Mission in Libreville. Louis Perrois was able to identify the symbols employed in this large mask. They relate to Okukwé and Mwiri, two men's associations which had judicial functions in the southern Fang region.

Bibliography: Perrois, 1985, p. 223, no. 79

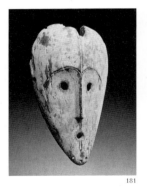

181

181 Face mask (Ngontang)

Fang, Gabon
Soft wood, white kaolin finish
Height 32 cm (12 5/8 in.)
Inv. 1019-76

According to Louis Perrois this mask is the work of a sculptor of the Betsi group, from the vicinity of Mitzic, north of the Ogowe Riverbend. It belongs to the group of *ngontang* masks, and is called *nlo ngon ntân*, "head of the white girl" or "dead young girl" (Perrois, 1988, p. 149). Without possessing a special sacred significance, the mask was probably danced only by an initiated man. Masks embodying a deceased person had two

purposes: to keep destructive forces away from the village and render evil doers ineffective.

Bibliography: Perrois, 1985, p. 224, no. 81; Perrois, 1988, p. 209, no. 126

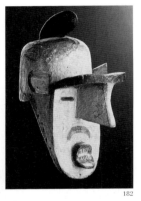

182

182 Face mask (Bikeghe or bikeuru)

Fang, Gabon
Soft wood, white kaolin finish, accented in black, ears and mouth red
Height 53 cm (20 7/8 in.)
Inv. 1019-20
Acquired by Josef Mueller from the collection of Charles Ratton in 1939

Louis Perrois described this large mask in 1985 and 1988. Known as *bikeghe* or *bikereu*, it was worn in joyous entertainment dances. According to Perrois the mask type derived directly from *ngil* and "recalls the terrifying head of this gorilla."

Bibliography: Fagg, 1980, p. 117; Perrois, 1979, no. 290; Perrois, 1985, p. 221, no. 75; Perrois, 1988, p. 208, no. 125

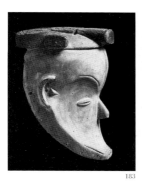

183

183 Face mask *(Ngontang)*

Fang, Gabon
Soft wood, white kaolin finish, black
and red accents
Height 26 cm (10 ? in.)
Inv. 1019-27
Acquired by Josef Mueller prior to
1939

This mask belongs to a group
known as *ngontang*, or "young
white girl." Despite its name it
is worn by men (cf. cat. 181).

Bibliography: Fagg, 1980, p. 112;
Perrois, 1985, p. 221, no. 76

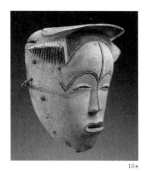

184

184 Face mask
Plate 68

Fang, Gabon or Equatorial Guinea
Wood, painted in white and
brownish tones, brass nails
Height 24 cm (9 ? in.)
Inv. 1019-16
Formerly collection of Josef Mueller;
acquired before 1939

Bibliography: Fagg, 1980, p. 113;
Perrois, 1979, no. 14; Perrois, 1985,
p. 222, no. 78; Perrois, 1988, p. 206,
no. 123

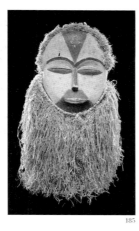

185

185 Face mask

Galoa, Gabon
Soft wood, painted in black, red,
white, and ochre; fibers
Height 26 cm (10 ? in.) (not
including fibers)
Inv. 1019-63
Collected by Philippe Guimiot near
Lambarene in 1963

The Galoa live along the lower
Ogowe River between the coast
and Lambarene. According to
Louis Perrois, their masks give
rhythm to life in the village, sanc-
tioning key events such as the
mourning of important person-
ages, the birth of twins, initia-
tions, etc. (Perrois, 1985, no. 40).
Being the works of a very
small ethnic group, these masks
are very rare. For a long time they
were confused with masks of the
Fang, who inhabit the area north
of the Ogowe. The first examples
found were illustrated by Leo
Frobenius (Halle, 1898, LXXIV,
no. 1, fig. 50).

Bibliography: Perrois, 1985, p. 206,
no. 40

186 Face mask with curved horns
Plate 69

Kwele, Gabon
Wood, painted in white and black
Height 42 cm (16 ? in.), width 62.5 cm
(24 5/8 in.)
Inv. 1019-15
Formerly collection of Josef Mueller;
acquired from Mme. Charles Vignier

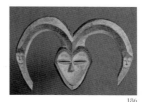

186

before 1939; collected by Aristide
Courtois, a government official,
before 1930

Bibliography: Fagg, 1980, p. 115;
Perrois, 1985, p. 195, no. 18; Perrois,
1988,m p. 211, no. 128; *Hier,
aujourd'hui, demain,* 1987, p. 70,
no. 1; Meyer, 1991, cover

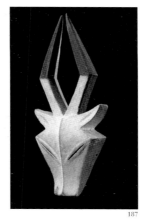

187

187 Mask
Plate 70

Kwele, Gabon
Wood, painted in white and black
Height 38 cm (15 in.)
Inv. 1019-49

Bibliography: *Die Kunst von Schwarz-
Africa,* 1971, p. 117, no. G16; Fagg,
1980, p. 114; Perrois, 1985, p. 196,
no. 20; Perrois, 1988, p. 210, no.
127; Newton, 1995, p. 146

188 Face mask *(Pibibuze)*
Plate 71

Kwele, Gabon
Wood, painted in white and black,
patinated by wear
Height 25.4 cm (10 in.)
Inv. 1019-80
Formerly collection of Tristan Tzara;
collected before 1930

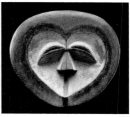

188

Bibliography: Gallerie Pigalle, 1930,
no. 205; Ratton, 1931, no. 17; *African
Negro Art,* 1935, no. 414; Buraud,
1948, fig. II; Schmalenbach, 1953,
p. 106, no. 97; *Arts d'Afrique et
d'Océanie,* Cannes, 1957, p. 190;
Fagg and Elisofon, 1958, p. 178,
no. 218; Leuzinger, 1962, p. 146,
no. 173 (drawing); *Afrique, cent tribus,
cent chefs-d'oeuvre,* 1964, no. 62;
Fagg, 1966, cover; Sweeney, 1970,
no. 21; Duerden, 1974, p. 88, no. 90;
Newton, 1995, p. 147; *Historia del
Arte,* 1996, p. 2624

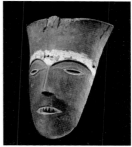

189

189 Face mask
Plate 72

Pomo, Republic of Congo
Wood, painted in reddish-brown,
blackish-brown, and white
Height 23.8 cm (9 3/8 in.)
Inv. 1021-41
Formerly collection of Max
Itzikowitz, Paris

Bibliography: Duponchel, 1981

190 Face mask
Plate 73

Mahongwe or Ngare, Republik of
Congo
Wood, painted in black, white, and
red
Height 35.5 cm (14 in.)
Inv. 1021-33

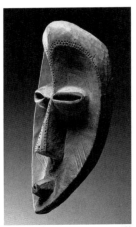

Formerly collections of Aristide [190]
Courtois (before 1930), Charles
Ratton, and The Museum of Modern
Art, New York (1939)

Bibliography: Siroto, 1954, p. 151;
Fagg, 1970, p. 139, no. 173; Kan,
1970, p. 58; Rubin, 1984, p. 263;
"Picasso," in The Great Artists, 1986,
vol. 4, part 71, p. 2250; Hier,
aujourd'hui, demain, 1987, p. 145;
Perrois, 1988, p. 218, no. 133;
Newton, 1995, p. 156; Historia del
Arte, 1996, p. 2501

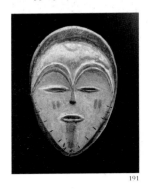

191 Face mask
Plate 74

Vuvi, Gabon
Wood, with black, white, and blue
painting
Height 34 cm (13 3/8 in.)
Inv. 1019-32
Formerly collection of Josef Mueller;
acquired before 1939

Bibliography: Perrois, 1985, p. 208,
no. 45

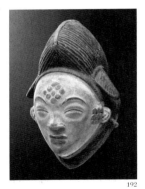

192 Face mask (Okuyi)
Plate 75

Punu/Lumbo, Gabon
Wood, painted in white and
blackish-brown
Height 28 cm (11 in.)
Inv. 1019-31
Formerly collection of Josef Mueller;
acquired before 1939

Bibliography: Allerlei Schönes aus
Afrika, Amerika und der Südsee, 1957,
no. 142; Fagg, 1980, p. 121; Perrois,
1985, p. 206, no. 41; Perrois, 1988,
p. 225, no. 138; Newton, 1995, p. 155

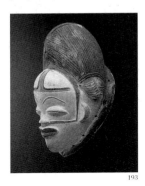

193 Face mask

Tsangui, Gabon
Soft wood, kaolin, black and red
paint
Height 28 cm (11 in.)
Inv. 1019-30
Acquired by Josef Mueller before
1939

This is another version of the
okuyi mask type of the Punu-
Lumbo. Hightly emphasized
scarification marks divide the
face at forehead and cheeks into
three areas, which is typical of
the Tsangui (Batsangui) who
live either side of the Gabon-
Republik of Congo border. Very
little is known about the func-
tion of "white masks" among
the peoples of the hinterland –
Tsangui, Ndjabi, and related
Douma-language groups.

Bibliography: Perrois, 1979, no. 268;
Fagg, 1980, p. 120; Westafrikanische
Tage, 1982, p. 54; Perrois, 1985, no.
43

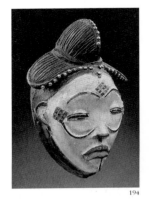

194 Face mask

Tsangui (?), Gabon
Soft wood, kaolin, painted on ochre
and black, brass tacks
Height 30 cm (11 ? in.)
Inv. 1019-66

A comparison of this mask with
the previous one would suggest
an origin in the Tsangui region,
even though the lozenge-shaped
scarification patterns on the
forehead are similar to those
seen in Puno and Lumbo works.
The tacks probably represent a
more recent adornment.

Bibliography: Bastin, 1984, p. 263,
no. 275; Perrois, 1985, p. 207, no.
42; Perrois, 1988, p. 223, no. 136;
Meyer, 1991, p. 104, no. 86

195 Face mask (Ndunga)
Plate 76

Vili (?), Republic of Congo, Kabinda,
Democratic Republic of Congo
Wood, painted in blackish-brown
and white

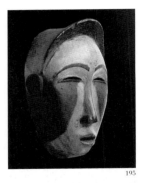

Height 30 cm (11 ? in.)
Inv. 1021-23
Formerly collection of Josef Mueller;
acquired before 1939

Bibliography: Fagg, 1980, p. 118;
Perrois, 1985, p. 205, no. 39

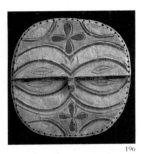

196 Face mask
Plate 77

Teke-Tsaayi, Republic of Congo
Wood, painted in white, red, and
black
Height 34 cm (13 3/8 in.)
Inv. 1021-20
Formerly collections of André
Derain, Charles Ratton, and Josef
Mueller (1939)

Bibliography: Galerie Pigalle, 1930,
no. 244; Ratton, 1931, no. 20; African
Negro Art, 1935; Schmalenbach,
1953, p. 106, no. 97; Leiris and
Delange, 1967, p. 333; Willett, 1971,
p. 198, no. 192; Dupré, 1979; Fagg,
1980, p. 123; Rubin, 1984, p. 49;
Hier, aujourd'hui, demain, 1987,
p. 43; Musée Dapper, 1993, p. 164;
Dupré, 1988, p. 229, no. 140;
Newton, 1995, p. 157; Lehuard,
1996, p. 121; Historia del Arte, 1996,
p. 2631

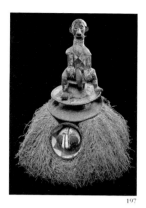

197 Helmet crest *(Kholuka)*
Plate 78

Northern Yaka, Democratic Republic of Congo
Wood, painted in blackish-brown, blue, ochre, and white, raffia fabric and fibers, rattan
Height 70 cm (27 5/8 in.)
Inv. 1026-99
Formerly collection of Josef Mueller; acquired before 1942

Bibliography: Fagg, 1980, p. 124; Bourgeois, 1988, p. 245, no. 150

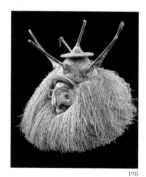

198 Helmet crest

Yaka, Democratic Republic of Congo
Soft wood, kaolin, raffia painted black, ochre, and blue, bast fringe collar
Height 56 cm (22 in.)
Inv. 1026-97
Acquired by Josef Mueller before 1942

It is almost impossible to distinguish the many variants of this mask type from one another. Even Arthur Bourgeois, in his standard work (Bourgeois, 1984), obviously faced this difficulty. One mask is described in the text as a *ndeemba* (p. 142), but in the annotation to the plate as a *kholuka* (p. 171). The author considers the masks with the largest protuberances or extensions to be the highest ranking.

These masks, characterized by a small face with a turned-up nose (an allusion to the male sex) and fringe of beard were danced in initiation rites (*mukhanda*) for young males.

Bibliography: Bourgeois, 1984, p. 135, no. 126

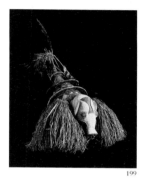

199 Helmet crest

Yaka, Democratic Republic of Congo
Soft wood, painted in black, ochre, blue, and white, hairpiece of painted raffia, bast fibers, feathers
Height 70 cm (27 ? in.)
Inv. 1026-98
Acquired by Josef Mueller before 1942

Another initiation mask of the northern Yaka, this one in the form of a pig's head.

Bibliography: Fagg, 1980, p. 124

200 Helmet crest

Yaka, Democratic Republic of Congo
Soft wood, painted in black, red, and white, raffia, hairpiece, bast collar
Height 72 cm (28 3/8 in.)
Inv. 1026-145
Acquired by Josef Mueller before 1942

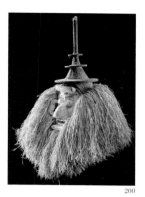

Another northern Yaka initiation mask. In this case the figure's nose is not turned up. Who or what he represents is not known.

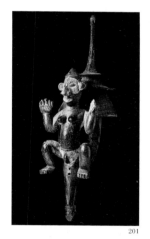

201 Helmet crest

Yaka, Democratic Republic of Congo
Wood, traces of black, ochre, white and blue paint, raffia hairpiece, bast collar (lost)
Height 63.5 cm (25 in.)
Inv. 1026-43
Acquired by Josef Mueller before 1942

This mask adorned with a female figure, and, like the previous one, has a face with a broad nose that is not upturned. The question arises whether only male faces were carved with an upturned nose.

Bibliography: Fagg, 1980, p. 125

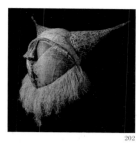

202 Helmet mask *(M-bawa)*
Plate 79

Yaka, Democratic Republic of Congo
Cane framework, woven bast with traces of light red, black, and white paint, metal, raffia fibers
Width 146 cm (57 ? in.)
Inv. 1026-42

Bibliography: Fagg, 1980, p. 127

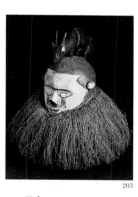

203 Helmet crest

Suku, Democratic Republic of Congo
Hardwood, face painted white, coiffure painted black, traces of blue pigment, fibers
Height 40 cm (15 ? in.)
(not including collar)
Inv. 1026-45
Acquired by Josef Mueller before 1942

This type of mask, used in boys' initiations and known by the name of *hemba*, is disseminated throughout the Suku area. Based on characteristic stylistic details. Arthur Bourgeois was able to distinguish four regional styles. The present mask comes from the northern Suku, and shows traits of two regional

styles. The design of the coiffure with straight hairline and angles above the ears pointed toward the eyes, and the open, tooth-studded mouth, are features of Regional Style A, which Bourgeois locates between the Lukula and Inzia rivers. The wide eye slits and marked eyebrow line, on the other hand, point to Regional Style B, which has been observed somewhat farther south, between Kwenge and Bakali.

Bibliography: Fagg, 1980, p. 129; Vion, 1988, p. 244, fig. 3

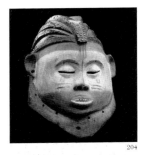

204

204 Bell-shaped helmet crest
Plate 80

Kwese (?), Democratic Republic of Congo
Wood, painted in white, red, and black, upholstery tacks
Height 37.5 cm (14 ? in.)
Inv. 1026-233

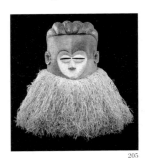

205

205 Helmet crest

Kwese, Democratic Republic of Congo
Hardwood, painted in black, red, and white, fiber collar
Height 54 cm (21 ? in.)
(not including collar)
Inv. 1026-173

This type of dance mask is used in initiation rites for young males.

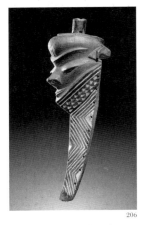

206

206 Forehead mask *(Mbuya* type: *giwoyo, muyombo,* or *ginjinga)*
Plate 81

Western (Kwilu) Pende, Democratic Republic of Congo
Wood, with white, rust-brown, and blackish-brown paint
Height 53.4 cm (21 in.)
Inv. 1026-216

Bibliography: Newton, 1995, p. 165; *Historia del Arte,* 1996, p. 2633

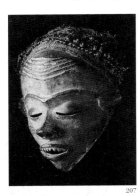

207

207 Face mask *(Mbuya* type: *gabundula)*

Pende, Democratic Republic of Congo
Wood, ochre-colored, hairpiece of black fibers
Height 23 cm (9 in.)
Inv. 1026-26

Influenced by Louis de Sousberghe, William Fagg erroneously believed this mask to be a *kijing,* from eastern Pende country (or by the Pende of Kasai). Malutshi Mudiji-Selenge corrected this error in 1988. He determined that "this *gabundula* mask ('executioner' mask) belongs to the *mbuya* group. It represents the executioner of a magicians' society, the *kodi dia ngang,*" which is known to the western Pende from the area of Kwilu.

The author interprets the *mifunyi,* the furrows on the mask's forehead, as a sign of the terrifying character of the depiction.
Herbert Cole (Cole, 1985, p. 83) distinguishes "village masks," or *mbuya,* which represent ancestors, from "power masks," or *minganji,* which represent living persons. The *mbuya* are used during boys' initiations.

Bibliography: Fagg, 1980, p. 130; Mudiji-Selenge, 1988, no. 154

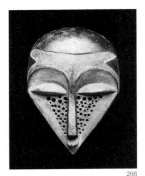

208

208 Small face mask

Pende, Democratic Republic of Congo
Wood, painted in black and red
Height 23 cm (9 in.)
Inv. 1026-25

The Pende inhabit the left bank of the Kasai River. They are better known for their large masks, *pumbu* and *gipogo (kipogo)* as for their small, triangular masks. An example very similar to the present one, in the Antwerp Museum of Tehnology, was published by Frank Herreman and

Constantijn Petridis (Herreman and Petridis, 1993, p. 75, no. 31).

According to these authors the present *mbuya* mask (described differently by Louis de Sousberghe) embodies a "troublemaker," and is allied with *tundu,* a *mbuya* mask used by the western Pende. If this interpretation is correct, the holes would represent pockmarks.

Bibliography: Fagg, 1980, p. 131

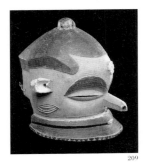

209

209 Helmet mask *(Gipogo)*

Pende, Democratic Republic of Congo
Wood, painted in black, ochre, and white
Height 33 cm (13 in.)
Inv. 1026-222
Acquired by Josef Mueller before 1952

This *gipogo* or *kipoko* mask of the eastern Pende (or the Pende of Kasai) embodies a chief. *Pogo, phogo,* or *phoko* are terms describing an executioner's knife.

The mask was stored at a site consecrated to the ancestors and was among the objects that formed the chief's treasure, or *kifumu.* Charged with potent magical powers, it was danced to ward off illnesses or other threats to the community.

Gipogo masks are also worn after the initiation of male adolescents, in particular after circumcision rites (Mudiji-Selenge, 1981, p. 229).

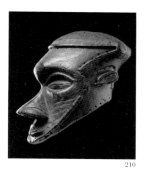

210

210 Helmet crest (Bwoom)
Plate 83

Kuba, Democratic Republic of Congo
Wood, with traces of black, red, and white paint
Height 40 cm (15 ? in.)
Inv. 1026-61

Bibliography: Fagg, 1980, p. 141; Vansina, 1988, p. 259, no. 162; Newton, 1995, p. 174

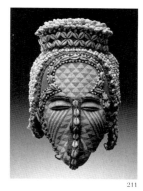

211

211 Face mask (Ngaady a Mwaash)
Plate 82

Kuba, Democratic Republic of Congo
Wood, with white and ochre paint, red textile, bark cloth, cord, cowrie shells, colored glass beads
Height 32.4 cm (12 ? in.)
Inv. 1026-189

Bibliography: Newton, 1995, p. 174; *Historia del Arte*, 1996, p. 2609

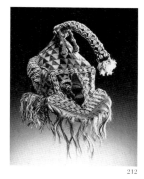

212

212 Helmet mask (Mukyeem)

Kuba, Democratic Republic of Congo
Woven plant fibers, glass beads, cowrie shells, nose and mouth of wood, fibers, black, red, and white paint
Height 43 cm (16 7/8 in.)
Inv. 1026-102

William Fagg mistakenly classified this mask as a *mwaash amboy* (or *moshambooy*). Joseph Cornet maintains that all "Mwash a Mbooy" masks are intended for kings (1978, no. 113). Colette Noll illustrates an identical mask from the Musée Royal de l'Afrique Central in Tervuren (1980, p. 72, no. 73), and considers it to be a "masculine attribute of king's sons, who wore it in coronation rituals or during the installation of chiefs. It embodies the mythical ancestor Woot." This interpretation is contradicted by Emil Torday. Anne-Marie Vion, finally, correctly calls the mask *mukyeem*, but without taking account of the data provided by Bope Mabintch Belepe. Belepe in 1981 advanced the hypothesis that *mukyeem* masks, with their protuberance resembling an elephant's trunk, originated not from the Bushoong but from two other Kuba groups, the Ngwoong and the Ngyeen.

Bibliography: Fagg, 1980, p. 140; Vion, 1988, p. 258, no. 161; Meyer, 1991, p. 96, no. 78

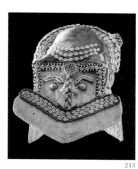

213

213 Helmet mask (Mwaash amboy)

Kuba, Democratic Republic of Congo
Bluish woven plant fiber on head, braided fibers, glass beads, cowrie shells, red pigment on wood
Height 40 cm (15 ? in.)
Inv. 1026-101
Acquired by Josef Mueller before 1942

A stylistically very similar *mwaash amboy* mask that differs only slightly from the present example is illustrated in Joseph Cornet (Cornet, 1978, no. 113). Cornet calls the mask *mikobi ngom*, and states that is goes back to a ruler of the Kuba who endeavoured to decorate a wooden drum (*ngom*). This recalls the kings of the Bushong, who were known as inventors of innovative masks and cultic objects.

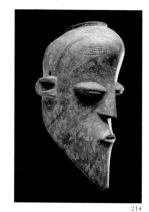

214

214 Forehead mask
Plate 84

Luluwa, Democratic Republic of Congo
Wood, with traces of white, black, and ocher paint
Height 43 cm (16 7/8 in.)
Inv. 1026-30
Formerly collections of André Lhote (before 1930) and Olivier Le Corneur

Bibliography: Galerie Pigalle, 1930, no. 206; Ratton, 1931, fig. 19; Fagg, 1980, p. 137; Muensterberger, 1979, p. 67; Musée Barbier-Mueller, 1987, p. 40, no. 1; Cornet, 1988, p. 263, no. 164; Newton, 1995, p. 176

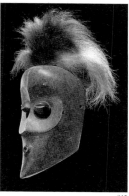

215

215 Forehead mask

Luluwa, Democratic Republic of Congo
Hardwood, with glossy black patina, fur
Height 32 cm (12 5/8 in.)
Inv. 1026-63

Very little is known about the few still extant masks of the Luluwa. They were evidently worn during circumcision ceremonies (*mukhanda*). Certain traits of these masks recall works of the Kete or Mbagani, who are related to the Luluwa. According to Joseph Cornet (Cornet, 1972, p. 147 ff.), the Luluwa, who in the last century were known as Bashilange ("dog-eaters"), differed from their neighbors, the Kuba and Luba, in never having developed a state structure. In about 1870 a chief united all of the villages

on the banks of the Lulua, a tributary of the Kasai. But the development came to an end with his death, and the people of the Bena Luluwa, today called Luluwa, remained a looseknit alliance of independent groups.

Bibliography: Fagg, 1980, p. 136

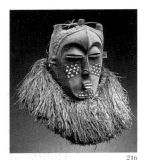

216 Helmet crest

Bena Biombo, Democratic Republic of Congo
Wood, painted in black, red, and white, fibers
Height 33 cm (13 in.) (not including fibers)
Inv. 1026-35
Collected by Hans Himmelheber in the village of Ngandu; acquired by Josef Mueller from the collection of Charles Ratton in 1939

The Biombo are related to the Kete. The overall configuration of the present mask recalls some Kuba helmet masks. Joseph Cornet, however, sees an influence of the eastern Pende in the pattern of black and white triangles. Such masks were worn in circumcision rites.

Bibliography: Fagg, 1980, p. 140; Cornet, 1988, p. 264, no. 167

217 Face mask *(Mfondo)*
Plate 85

Lwalwa (Lwalu), Democratic Republic of Congo
Wood, with blackish-brown stain and traces of white paint
Height 31.8 cm (12 ? in.)
Inv. 1026-218
Formerly Vrancken Collection, Brussels

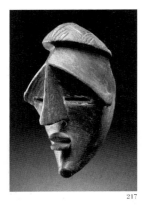

Bibliography: Meyer, 1991, p. 89, no. 70; Newton, 1995, p. 167

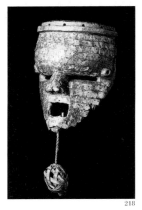

218 Face mask

Salampasu, Democratic Republic of Congo
Wood, copper plates, nails, and fibers
Height 23 cm (9 in.) (face)
Inv. 1026-31

Unlike the Luluwa, the Salampasu are a homogeneous people. Their settlements lie east of the Kasai and west of the upper Lulua. The Lwalwa are their northern neighbors and the Lunda their southern ones (Cornet, 1972, p. 170). Such masks, regardless of their material composition (cf. cat. 219), are worn in the initiation rites of men's associations. Those adorned with copper plates were formerly worn in ceremonies celebrating brave warriors. Salampasu masquerades were

held in wooden enclosures decorated with anthropomorphic figures carved in relief.

Bibliography: Muensterberger, 1979, p. 65; Fagg, 1980, p. 135; *Historia del Arte*, 1996, p. 2692

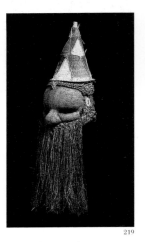

219 Helmet mask

Salampasu, Democratic Republic of Congo
Braided fibers, soaked in resin, black, red, and white pigments, fiber beard
Height 88 cm (34 5/8 in.) (face)
Inv. 1026-50
Formerly collection of Pierre Loeb, Paris

The bulging forehead of this mask conforms to the Salampasu style. The exact purpose of such imposing fiber masks is not known (Cornet, 1978, p. 188). Its beard would indicate that it represents a male figure (cf. cat. 218).

Bibliography: Fagg, 1980, p. 134

220 Forehead mask

Chokwe, Angola or Democratic Republic of Congo
Hardwood, painted in black and ocher (faded), hair of braides fibers
Height 55 cm (21 5/8 in.)
Inv. 1028-6
Acquired by Josef Mueller before 1952

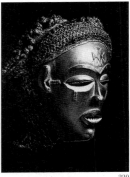

According to Marie-Louise Bastin, the Chokwe use three types of mask (Bastin, 1984, p. 315). These are the sacred mask, or *cihongo*; initiation masks (especially the *cikunza*, made of fibers and wearing a pointed cap); and finally, dance masks. The last group includes a female figure, or *pwo*, and her male counterpart, or *cihongo*, who symbolizes power. The male mask differs from the female in terms of its broad mouth and horizontally protruding beard. The Chokwe, who spread from their homeland of Angola throughout the southern region of the Democratic Republic of Congo, have influenced the art of many neightboring peoples, including the Lunda, Mbunda, Lovale, and Mbangani.

Bibliography: Fagg, 1980, p. 138

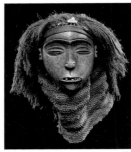

221 Forehead mask *(Mwana phwevo)*
Plate 86

Lwena, Angola
Wood, disk of shell, colored glass beads, bone, raffia fibers, and weave

Height 19 cm (7 ? in.)
Inv. 1028-32

Bibliography: Newton, 1995, p. 171

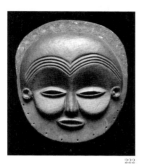

222 Face mask (Sachihongo)
Plate 87

Mbunda, Zambia
Wood, with blackish-brown paint
and traces of white pigment
Width 42.5 cm (16 ? in.)
Inv. 1028-34

Bibliography: Vrydagh, 1993, p. 37,
no. 1; Newton, 1995, p. 173

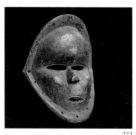

223 Mask

Mbunda, Angola or Zambia
Blackened wood
Height 17 cm (6 ? in.)
Inv. 1028-41
Formerly collection of Pierre
Dartevelle, Brussels

The function of this mask is not
known. It was mounted on a
large rattan basket covered with
fibers and worn on the head, not
in front of the face.
 Similar mask faces are found
in smaller versions on minia-
ture stools which even more
clearly reflect the Mbunda style,
especially as regards the wide
"rings" around the eyes.

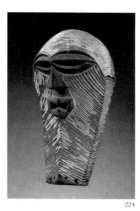

**224 Face mask, female Kifwebe
type,** *kikashi*
Plate 88

Eastern Songye, Democratic
Republic of Congo
Wood, with remnants of white and
red paint
Height 34 cm (13 3/8 in.)
Inv. 1026-110

Bibliography: Fagg, 1980, p. 142;
Cornet, 1988b; Newton, 1995, p. 178

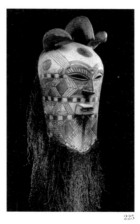

225 Face mask
Plate 89

Tempa songye, Democratic Republic
of Congo
Wood, with ocher, brown, black,
white, and red paint, remnants of a
net costume of raffia bast, raffia
fiber
Height 69 cm (27 1/8 in.)
Inv. 1026-44
Formerly collection of Berthe
Hartert

Bibliography: Fagg, 1980, p. 143;
Cornet, 1988, p. 265, no. 168; Neyt,
1995, cover, p. 3, no. 1

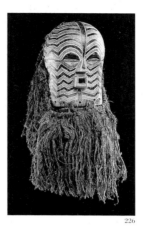

**226 Face mask, female Kifwebe
type,** *kikashi*

Songye, Democratic Republic of
Congo
Hardwood, traces of black, red,
white and ocher paint, fibers
Height 26.5 cm (10 3/8 in.) (not
including fibers), overall height 63
cm (24 ? in.)
Inv. 1026-135
Acquired by Gertrud Dubi-Mueller
from the collection of Charles Rattan
before 1939

This mask of the Kifwebe type
(cf. plate 88) embodies a female
spirit. The zigzag pattern of
broad stripes in contrasting col-
ors may provide a hint a to the
region of origin – perhaps that
of the eastern Songye?

Bibliography: Fagg, 1980, p. 142;
Neyt, 1992, cover, p. 8, no. 2

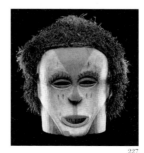

227 Face mask
Plate 91

Songye (?), Democratic Republic of
Congo
Wood, painted in white, red, and
blue, leather, bast fibers
Height 30 cm (11 ? in.)
Inv. 1026-286
Formerly collection of Berthe
Hartert

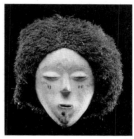

228 Face mask
Plate 90

Acquired from the Songye,
Democratic Republic of Congo
Wood, with white paint and traces of
blue and brown décor, upholstery
tack, metal teeth, bast fibers, bast
weave
Height 30 cm (11 ? in.)
Inv. 1026-291
Formerly collection of Berthe
Hartert

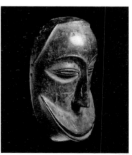

**229 Face mask
(*Mwisi gwa so'o*)**
Plate 92

Hemba, Democratic Republic of
Congo
Wood, with black paint
Height 23 cm (9 in.)
Inv. 1025-7

Bibliography: Fagg, 1980, p. 145; Bassani, 1981, p. 105, no. 6

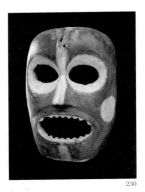

230 Face mask *(Nsembu)*
Plate 93

Kumu (Komo), Democratic Republic of Congo
Wood, painted in red, black, and white
Height 27.3 cm (10 ? in.)
Inv. 1026-226

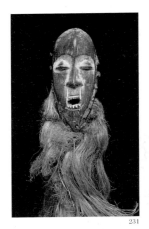

231 Mask *(Lukwakongo)*
Plate 94

Lega (Rega), Democratic Republic of Congo
Wood, with traces of blackish-brown and white paint, raffia fibers
Height 18 cm (7 1/8 in.) (not including beard)
Inv. 1026-3

Bibliography: Fagg, 1980, p. 151; Biebuyck, 1988, p. 284, no. 186; Newton, 1995, p. 187

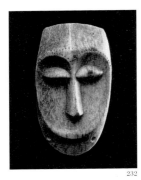

232 Miniature mask *(Lukungu)*
Plate 95

Lega (Rega), Democratic Republic of Congo
Bone, patinated by wear
Height 8 cm (3 1/8 in.)
Inv. 1026-1
Formerly collection of Dr. med. van den Bergh; collected during the Second World War

Bibliography: Vion, 1994, p. 82

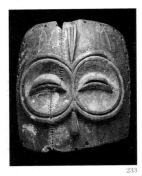

233 Face mask *(Eluba or emangungu)*

Bembe, Democratic Republic of Congo
Soft wood, encrusted black patina, traces of white paint; repaired with metal staples at place of origin
Height 24 cm (9 ? in.)
Inv. 1026-39
Acquired by Josef Mueller before 1939

The lower face of this mask was cut off at a much earlier period, probably because of damage. To permit the attachment of a cord, two new holes, one square, were drilled in the mask at that time.

Daniel Biebuyck points out that this "plank mask" type was used in puberty rites, or *butende*. Known as *eluba* or *emangungu*, it was worn with voluminous costumes made of banana leaves. This style of mask is just as popular for commercial replicas as the Kifwebe masks of the Songye.

The Bembe of the eastern region of the Democratic Republic of Congo, who speak a related language to the Lega, should not be confused with the Bembe who live near the mouth of the Zaire River.

Bibliography: Fagg, 1980, p. 149; Biebuyck, 1988, p. 281, no. 183

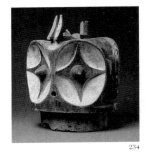

234 Dual-faced helmet mask *(Ibulu lya alunga)*
Plate 96

Bembe, Democratic Republic of Congo
Wood, painted in black, red, and white
Height 47 cm (18 ? in.)
Inv. 1026-38

Bibliography: Fagg, 1980, p. 147

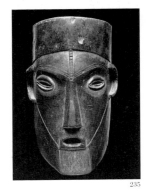

235 Face mask
Plate 97

Tabwa (?), Democratic Republic of Congo
Wood with glossy patina and traces of white and black paint
Height 32 cm (12 5/8 in.)
Inv. 1027-5

Bibliography: Muensterberger, 1979, p. 71; Maurer, 1988, p. 278, no. 179

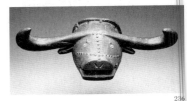

236 Pseudo-helmet mask *(Kiyunde)*
Plate 98

Tabwa, Democratic Republic of Congo
Wood with glossy patina, cowrie shells, upholstery tacks
Width 73 cm (28 ? in.)
Inv. 1026-58

Bibliography: Fagg, 1980, p. 153; Robert and Maurer, 1986, p. 64, fig. 14; Maurer, 1988, p. 279, no. 180; Newton, 1995, pp. 188, 189

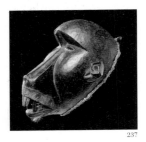

237 Face mask *(Lingwele)*
Plate 100

Makonde, Andonde (?), Mozambique
Wood with glossy black patina, remnants of animal hide, plant fibers; left ear restored
Height 24.8 cm (9 ? in.)
Inv. 1027-42

Bibliography: Castelli, 1988, p. 301, no. 198

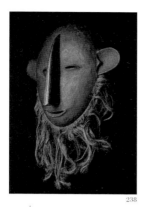

238 Face mask
Plate 99

Makonde, Tanzania
Wood with red paint, plant fibers,
glass, wax
Height 21.5 cm (8 ? in.) (not
including beard)
Inv. 1027-2
Formerly collection of the Linden-
Museum, Stuttgart; collected by
Seyfried in 1906

Bibliography: Muensterberger, 1979,
p. 69; Fagg, 1980, p. 155; Castelli,
1988, p. 299, no. 196; Newton,
1995, p. 199

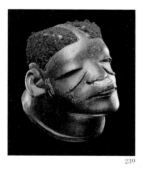

239 Helmet crest *(Lipiko)*

Makonde, Mawia, Tanzania
Soft wood, homogeneous black
stain, wax (scarification marks),
human hair
Height 26.5 cm (10 3/8 in.)
Inv. 1027-68

The helmet crests of the
Makonde, known as *lipiko*, are
characterized by three-dimen-
sional plastic design. They have
highly realistic traits, a seen

here in the carving of eyes,
nose, and mouth. Other striking
features are a great variety of
coiffures and elaborate scarifica-
tion patterns, which are fre-
quently rendered in spots and
strips of beeswax. In an unpub-
lished note, Enrico Castelli
ascribes this *lipiko* mask to the
Mawia, who derive from the
Makonde and live north of the
Rovuma River. The mask's scar-
ifications and lip plug are attrib-
utes of femininity.

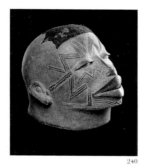

240 Helmet crest *(Lipiko)*

Makonde, Mawia, Tanzania
Wood, homogeneously colored in
light ocher
Height 27 cm (10 5/8 in.)
Inv. 1027-87

Like the previous one, this *lipiko*
mask is ascribed by Enrico
Castelli in an unpublished note
to the Mawia. Castelli interprets
the welts as representing scarifi-
cation patterns of a kind typi-
cally worn by the inhabitants of
the area around Mueda.

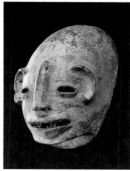

242 Belly mask *(Njorowe)*

Makonde, Tanzania
Soft wood, homogeneous ocher
finish, traces of black paint
Height 68 cm (26 ? in.)
Inv. 1027-94

241 Face mask

Makonde, Mozambique or
Tanzania (?)
Terracotta, homogeneous ocher
coloring, metal teeth
Height 26 cm (10 ? in.)
Inv. 1027-116
Formerly collection of Pierre
Dartevelle, Brussels

Though the terracotta masks of
the Makonde have long been
known, it was not until the
1980s that they were given
scholarly attention, by J.A.R.
Wembah-Rashid (n.d., vol. 1,
no. 3). He reports having discov-
ered, in 1986, two masks of clay,
and adds that the men who sold
them to him explained that they
were used in female initiation
rites in the suburbs of Dar es
Salaam. According to the
author's informants, the two
terracotta masks were worn as
face or head masks, but not in
the same manner as male
masks. Rather, they were held in
front of the face or covered the
head of the performer, who was
completely hidden in a black
cloak known as *kaniki* or *khanga*.

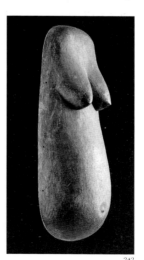

In an unpublished note, Enrico
Castelli dates this *njorowe* belly
mask to the pre-1930 period.
Such masks were worn in
dances that accompanied the
return of boys from bush camp.
The mask represents a pregnant
young woman (*amwali ndembo*).

In contrast to the *lipiko* mask,
this type is no longer made or
worn today.

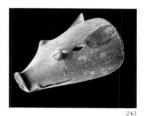

243 Helmet crest

Makonde, Mawia, Tanzania
Soft wood, homogeneous ocher
finish, black paint traces; repairs in
metal made at place of origin
Height 50.8 cm (20 in.)
Inv. 1027-77

In an unpublished note, Enrico
Castelli describes this mask as
representing a warthog, an
African wild pig (*mbengwa*) to
which the people have an
ambivalent relationship. On the
one hand, warthogs are feared
on account of their voracious-
ness and the crop hazard they
represent; on the other, they
figure as bringers of luck when
met with in the bush.

The purpose of this mask
is not known. Castelli knows
of only on eother example of
the type, in the National
Museum of Tanzania at Dar es
Salaam. Evidently the dancer
had to stoop in order to display
the mask in a horizontal posi-
tion.

Castelli ascribes the mask
to first groups of Mawia who
migrated into Tanzania in the
1930s and 1940s.

2

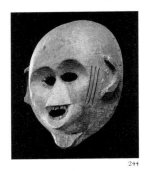

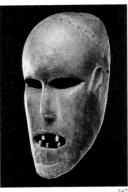

244 Face mask

Chewa (?), Lomwe (?), Marawi (?);
Mozambique, Tanzania, Malawi (?)
Hardwood, homogeneous light
ocher finish, traces of blue paint,
teeth of mussel shells
Height 31 cm (12 ? in.)
Inv. 1027-3

This mask was collected by a
German traveller at the begin-
ning of the century, surely
before 1920. William Fagg was
uncertain whether to ascribe it
to the Makonde or to a neigh-
boring group. Enrico Castelli, in
an unpublished note, has sug-
gested three possible ethnic
groups (see above).

Bibliography: Fagg, 1980, p. 154

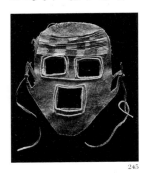

245 Face mask

Iraqw (?), Tanzania
Leather, homogeneous ocher finish,
decorated with glass beads held by
fibers and leather thongs
Height 28.1 cm (11 1/8 in.)
Inv. 1027-75

As Enrico Castelli's investiga-
tions in the land of the Iraqw
indicated, such masks are no

longer worn for ritual purposes.
However, contemporary masks
still have the strings of beads on
the forehead (unpublished
note). The masks once had the
function of protecting young
girls after their initiation, when,
having become adult women
(*qatsewar deena*), they returned
from seclusion.

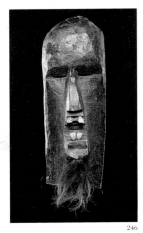

246 Face mask

Ziba, Tanzania
Hardwood, stained black, animal
hair and teeth
Height 43.6 cm (17 1/8 in.)

Masks of this type are in the
collections of the Musée de
l'Homme, Paris, and the
Linden-Museum, Stuttgart.
Though their origin is pre-
cisely known, their function
remains obscure.
 The Ziba inhabit the north-
western part of Tanzania, an
area bordering on Rwanda.

247 Face mask

Sukuma, Tanzania
Hardwood, homogeneous light
finish, teeth and bones, traces of
black paint
Height 28 cm (11 in.)
Inv. 1027-115

According to Pierre Dartevelle
(oral communication), this
mask, which once had leather
patches affixed to forehead and
chin, was used in harvest rites.

As we know from Georges Meu-
rant's investigations (1994), the
masqueraders at these cere-
monies also carried carved
wooden figures, possibly articu-
lated dolls. Meurant supposes
the masks were not originally
used in the context of harvest
rites but belonged to music and
dance groups that were popular
among the Sukuma from the
colonial period to the 1950s, and
who vied for the audience's
favor with entertaining perfor-
mances.

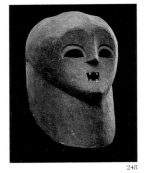

248 Helmet mask

Luguru, Kwere, Tanzania
Hardwood, homogeneous black
finish, encrusted patina, wooden
teeth; restored in area of left eye
Height 43 cm (16 7/8 in.)
Inv. 1027-89

This mask may be of Kwere ori-
gin. Charles Meur (Meur, 1994,
p. 428) illustrates a Kwere mask
with a "neck." He describes the
characteristics of Kwere masks
as follows: "The skull is volumi-

nous and hemispherical in
shape; sometimes it almost
entirely covers the wearer's
head and ends at the lower edge
of the back of the head…. The
forehead is bulging and round,
the eyebrow arches lead to the
bridge of the nose in raised
semi-ellipses. The closespaced
eyes are square or lentil-shaped,
the cheeks round" (Meur, 1994,
p. 383 f.). However, Meur also
notes that the Luguru style
bears similarities to that of the
Kwere.

BIBLIOGRAPHY

ADAMS, Monni
1995 "Composite Horizontal Headdress," in Tom Phillips (ed.), *Africa: The Art of a Continent*, Munich/New York, p. 362

ANDERSON, Martha
n.d. *Arts of Nigeria*, n.p. MS, Musée Barbier-Mueller, Geneva

ANDREE, Richard
1891 "Die Masken in Afrika," in *Globus* 60, pp. 212-215

ARNOLDI, Mary Jo
n.d. *Bamana and Bozo Puppetry of the Segou Region Youth Societies*, Bloomington, Indiana

BAEKE, Viviane
1995 "Hunga (?) Helmet Mask," in Gustaaf Verswijver et al. (eds.), *Treasures from the Africa-Museum Tervuren*, Musée royal de l'Afrique centrale, Tervuren, pp. 314-316

BALANDIER, Georges, and Jacques J. MAQUET
1974 *Dictionary of Black African Civilization*, New York

BARBIER, Jean Paul (ed.)
1993 *Art of Côte d'Ivoire from the Collections of the Barbier-Mueller Museum*, 2 vols., Geneva

BARLEY, Nigel
1996 "Sculpture in the Form of a Stylised Serpent (bansonyi)," in Tom Phillips (ed.), *Africa: The Art of a Continent*, Munich/New York, p. 476

BASCOM, William
1969 "Creativity and Style in African Art," in Daniel B. Biebuyck (ed.), *Tradition and Creativity in Tribal Art*, Berkeley/Los Angeles, pp. 98-119

1973 "A Yoruba Master Carver: Duga of Meko," in Warren L. d'Azevedo (ed.), *The Traditional Artist in African Societies*, Bloomington, pp. 62-78

BASSANI, Ezio
1981 "Recensioni, Reviews, Comptes-rendus," in *Critica D'Arte Africana*, Carlo L. Ragghianti (ed.), XLVI, n.s., 178, Florence

1982 "Un Cimier Bambara," in *Connaissance des Arts Tribaux*, Bulletin 15, Geneva

BASTIN, Marie-Louise
1969 "L'Art d'un peuple d'Angola. Arts of the Angolan Peoples. II: Lwena," in *African Arts* 2, 2, pp. 46-53, 77-80

1982 *La Sculpture Tshokwe*, Meudon

1984 *Introduction aux Arts de l'Afrique Noire*, Arnouville

1988 "Weibliche Maske," in Werner Schmalenbach (ed.), *Afrikanische Kunst aus der Sammlung Barbier-Mueller, Genf*, Munich, p. 256

BAY, Edna G.
1975 "The Heart-Shaped Face in African Art," in Daniel F. McCall and Edna G. Bay (eds.), *African Images — Essays in African Iconology*, New York, pp. 252-267

BEIER, Ulli
1991 *Yoruba. Das Überleben einer westafrikanischen Kultur*, Schriften des Historischen Museums Bamberg, Lothar Hennig (ed.), Bamberg

BELEPE, Bope Mabintch
1981 *Les Œuvres plastiques africaines comme documents d'histoire: Le cas des statues royales ndop des Kuba du Zaïre*, Tervuren

BEN-AMOS, Paula
1980 "Patron Artist Interactions in Africa," in *African Arts* 13, 3, pp. 56-57, 92

1988 "Anhänger in Maskenform," in Werner Schmalenbach (ed.), *Afrikanische Kunst aus der Sammlung Barbier-Mueller, Genf*, Munich, p. 141

BERNATZIK, Hugo
1944 *Im Reiche der Bidyogo*, Innsbruck

BERNS, Marla C.
n.d. *Arts of Nigeria*, n.p. MS, Musée Barbier-Mueller, Geneva

BIEBUYCK, Daniel B.
1969 *Tradition and Creativity in Tribal Art*, Berkeley/Los Angeles

1972 "Bembe Art," in *African Arts* 5, 3, pp. 12-19, 75-84

1973 *Lega Culture*, Berkeley/Los Angeles

1985 *The Arts of Zaire*. vol. I: *Southwestern Zaire*, Berkeley/Los Angeles/London

1986 *The Arts of Zaire*. vol. II: *Eastern Zaire*, Berkeley/Los Angeles/London

1988 Several commentaries in Werner Schmalenbach (ed.), *Afrikanische Kunst aus der Sammlung Barbier-Mueller, Genf*, Munich

1993 "Masks and Initiation among the Lega Cluster of Peoples," in Frank Herreman und Constantijn Petridis (eds.), *Face of the Spirits, Masks from the Zaire Basin*, Ethnographic Museum, Antwerp, pp. 183-196

1995 Several commentaries in Gustaaf Verswijver et al. (eds.), *Treasures from the Africa-Museum, Tervuren*, Musée royal de l'Afrique centrale, Tervuren

BINET, J.
1972 *Sociétés de danse chez les Fang*, Paris

BLADES, Richard
1985 "Yaka," in Herbert Cole (ed.), *I am not myself. The Art of African Masquerade*, Museum of Cultural History, UCLA, Los Angeles, pp. 78-82

BLAKELEY, Pamela A. R., and Thomas D.
1987 "So'o Masks and Hemba Funerary Festival," in *African Arts* 21, 1, pp. 30-37, 84-86

BLESSE, Giselher
1994 "Der Südosten Tanzanias — die Kunst der Makonde und der benachbarten Völker," in Jens Jahn (ed.), *Tanzania. Meisterwerke afrikanischer Skulptur. Sanaa za mabingwa wa kiafrika*, Haus der Kulturen der Welt Berlin und Städtische Galerie im Lenbachhaus München, Munich, pp. 432-444

BLIER, Suzanne Preston
1991 "Visages de fer: matière et sens au Danhomé," in *Art tribal*, Bulletin du Musée Barbier-Mueller, Geneva

BOAS, Franz
1955 *Primitive Art*, New York, first ed. 1927

BOCHET, Gilbert
1988 "Waniugo-Janusmaske," in Werner Schmalenbach (ed.), *Afrikanische Kunst aus der Sammlung Barbier-Mueller, Genf*, Munich, p. 87

1993 Several commentaries in Jean Paul Barbier (ed.), *Art of Côte d'Ivoire from the Collections of the Barbier-Mueller Museum*, 2 vols., Geneva

BOLZ, Ingeborg
1966 "Zur Kunst in Gabun," in *Ethnologica* 3, Cologne, pp. 85-221, plates XXXVIII-LXII

BOONE, Sylvia Ardyn
1986 *Radiance from the Waters. Ideals of Feminine Beauty in Mende Art*, New Haven/London

BOSTON, John S.
1960 "Some Northern Ibo Masquerades," in *Journal of the Royal Anthropological Institute* 90, pp. 54-65

n.d. *The Arts of Nigeria*, n.p. MS, Musée Barbier-Mueller, Geneva

BOURGEOIS, Arthur P.
1981 "Masques Suku," in *Arts d'Afrique Noire* 39, pp. 26-41

1984 *Art of the Yaka and Suku*, Paris

1988 "Maske," in Werner Schmalenbach (ed.), *Afrikanische Kunst aus der Sammlung Barbier-Mueller, Genf*, Munich, p. 245

1993 "Masks and Masking among the Yaka, Suku, and Related Peoples," in Frank Herreman and Constantijn Petridis (eds.), *Face of the Spirits, Masks from the Zaire Basin*, Ethnographic Museum, Antwerp, pp. 49-56

BOYER, Alain-Michel
n.d.a *Masque Lomane (ou Loman) du Gye*, n.p. MS, Musée Barbier-Mueller, Geneva

n.d.b *Masque Tu Bodu du Gye*, n.p. MS, Musée Barbier-Mueller, Geneva

1993 Several commentaries in Jean Paul Barbier (ed.), *Art of Côte d'Ivoire from the Collections of the Barbier-Mueller Museum*, 2 vols., Geneva

BRAIN, Robert, and Adam POLLOCK
1971 *Bangwa Funerary Sculpture*, London

BRAVMANN, René A.
1973 *Open Frontiers: The Mobility of Art in Black Africa*, Seattle/London

1974 *Islam and Tribal Art in West Africa*, Cambridge

1979 "Gur and Manding Masquerades in Ghana," in *African Arts* 13, 1, pp. 44-51, 98

1988 Several commentaries in Werner Schmalenbach (ed.), *Afrikanische Kunst aus der Sammlung Barbier-Mueller, Genf*, Munich

1993 Several commentaries in Jean Paul Barbier (Hrsg.), *Art of Côte d'Ivoire from the Collections of the Barbier-Mueller Museum*, 2 vols., Geneva

1995 "Mask (sakrobundi)," in Tom Phillips (ed.), *Africa: The Art of a Continent*, Munich/New York, pp. 452-453

BRETT-SMITH, Sarah
1988 Several commentaries in Werner Schmalenbach (ed.), *Afrikanische Kunst aus der Sammlung Barbier-Mueller, Genf*, Munich

n.d. *Korè Society Mask*, n.p. MS, Musée Barbier-Mueller, Geneva

BRUYNINX, Elze
1993 Several commentaries in Jean Paul Barbier (ed.), *Art of Côte d'Ivoire from the Collections of the Barbier-Mueller Museum*, 2 vols., Geneva

BURAUD
1948 *Les Masques*, Paris

BURSSENS, H.
1995 "Bwoom mask," in Gustaaf Verswijver et al. (eds.), *Treasures from the Africa-Museum Tervuren*, Musée royal de l'Afrique centrale, Tervuren, pp. 337-338

CARROLL, Kevin
1967 *Yoruba Religious Carving*, London

CASTELLI, Enrico
1988 Several commentaries in Werner Schmalenbach (ed.), *Afrikanische Kunst aus der Sammlung Barbier-Mueller, Genf*, Munich

1993 n.p. MS, Musée Barbier-Mueller, Geneva

CEYSSENS, R.
1995 "Mfondo face mask," in Gustaaf Verswijver et al. (eds.), *Treasures from the Africa-Museum Tervuren*, Musée royal de l'Afrique centrale, Tervuren, pp. 327-328

COLE, Herbert M.
1985 *I am not myself. The Art of African Masquerade*, Museum of Cultural History, UCLA, Los Angeles

1988 "Helmmaske," in Werner Schmalenbach (ed.), *Afrikanische Kunst aus der Sammlung Barbier-Mueller, Genf*, Munich, p. 170

n.d. n.p. MS, Musée Barbier-Mueller, Geneva

COLE, Herbert M., and Chike C. ANIAKOR
1984 *Igbo Arts. Community and Cosmos*, Museum of Cultural History, University of California, Los Angeles

CORNET, Joseph
1972 *Art de l'Afrique Noire au pays du Fleuve Zaïre*, Brussels

1973 *Afrikanische Kunst. Schätze vom Zaïre*, Geneva

1978 *A Survey of Zaïrian Art*, The Bronson Collection, North Carolina

1988 Several commentaries in Werner Schmalenbach (ed.), *Afrikanische Kunst aus der Sammlung Barbier-Mueller, Genf*, Munich

D'AZEVEDO, Warren L. (ed.)
1973 *The Traditional Artist in African Society*, Bloomington/London

DEFREMERY, C., and B.R. SANGUINETTI (eds.)
1853-1858 *Voyages d'Ibn Batoutah*, I-IV, Paris

DE HEUSCH, Luc
1995 "Mask," in Tom Phillips (ed.), *Africa: The Art of a Continent*, Munich/New York, p. 281

n.d. (1995) "Beauty is Else-where: Returning a Verdict on Tetela Masks. Historical and Ethnological Notes on the Nkutshu," in Luc de Heusch (ed.), *Objects, Signs of Africa*, Musée royal de l'Afrique centrale, Tervuren, pp. 175-206

DELACOUR, A.
1947 "Sociétés secrètes chez les Tenda," in *Etudes Guineennes* 2, pp. 37-52

DELANGE, Jacqueline
1958 *L'Art de l'Afrique noire*, Besançon

1967 *Arts et peuples de l'Afrique oire. Introduction à l'analyse des créations plastiques*, Paris

DELUZ, Ariane
1988 Several commentaries in Werner Schmalenbach (ed.), *Afrikanische Kunst aus der Sammlung Barbier-Mueller, Genf*, Munich

1993 Several commentaries in Jean Paul Barbier (ed.), *Art of Côte d'Ivoire from the Collections of the Barbier-Mueller Museum*, 2 vols., Geneva

DE SOUSBERGHE, Louis
1959 *L'Art Pende*, Académie Royale de Belgique, Classe des Beaux-Arts, Mémoires, Collection in 4°, 2nd s., IX, 2, Brussels

DEVISCH, R.
1995 "Ndeemba mask, Tsekedye mask," in Gustaaf Verswijver et al. (eds.), *Treasures from the Africa-Museum Tervuren*, Musée royal de l'Afrique centrale, Tervuren, pp. 306-307

DIETERLEN, Germaine
1951 *Essai sur la religion Bambara*, Paris

1988 "Walu-Maske," in Werner Schmalenbach (ed.), *Afrikanische Kunst aus der Sammlung Barbier-Mueller, Genf*, Munich, p. 66

1989 "Masks and Mythology of the Dogon," in *African Arts* 22, 3, pp. 34-43

DONNER, Etta
1940 "Kunst und Handwerk in NO-Liberia," in *Baessler Archiv* 23, pp. 45-110

DORSINVILLE, Roger, and Mario MENEGHINI
1973 "The Bassa Mask — A Stranger in the House," in *Ethnologische Zeitschrift Zürich* 1, pp. 5-53

DREWAL, Henry John
1989 "Art and Ethos of the Ijebu," in Allen Wardwell (ed.), *Yoruba. Nine Centuries of African Art and Thought*, Center for African Art, New York, pp. 117-145

1990 "African Art Studies Today," in *The State of the Discipline. African Art Studies*, Washington, pp. 29-62

n.d. *Arts of Nigeria*, n.p. MS, Musée Barbier-Mueller, Geneva

DREWAL, Henry John, John PEMBERTON III and Rowland ABIODUN
1989 *Yoruba — Nine Centuries of African Art and Thought*, New York

DREWAL-THOMPSON, Margaret
1977 "Projections from the Top in Yoruba Art," in *African Arts* 11, 1, pp. 43-91

DREWAL-THOMPSON, Margaret, and Henry John DREWAL
1983 *Gelede: A Study of Art and Female Power among the Yoruba*, Bloomington

DUERDEN, Dennis
1974 *African Art, an Introduction*, London/New York/Sydney

DUPONCHEEL, C.
1981 *Masterpieces of the Peoples Republic of Congo*, The African-American Institute, New York

DUPRÉ, Marie-Claude
1968 "A propos d'un masque des Téké de l'ouest (Congo-Brazzaville)," in *Objets et Mondes. La Revue du Musée de l'Homme* 8, 4, Paris, pp. 295-310

1979 "A propos du masque Téké de la Collection Barbier-Müller," in *Connaissance des Arts Tribaux*, Bulletin 2, Geneva

1988 "Maske," in Werner Schmalenbach (ed.), *Afrikanische Kunst aus der Sammlung Barbier-Mueller, Genf*, Munich, p. 229

EISENHOFER, Stefan
1993 *Höfische Elfenbeinschnitzerei im Reich Benin. Kontinuität oder Kontinuitätspostulat?*, Munich

ELISOFON, Eliot, and William FAGG
1978 *The Sculpture of Africa*, New York

ELSAS, Ellen, and Robin POYNOR
1984 *Nigerian Sculpture. Bridges to Power*, Birmingham Museum of Art

EYO, Ekpo
1977 *Two Thousand Years Nigerian Art*, Federal Department of Antiquities, Lagos

1988 "Aufsatzmaske," in Werner Schmalenbach (ed.), *Afrikanische Kunst aus der Sammlung Barbier-Mueller, Genf*, Munich, p. 163

EZRA, Kate
1988 *Art of the Dogon*, Metropolitan Museum of Art, New York

FAGG, William
1961 *Nigeria. 2000 Jahre Plastik*, Städtische Galerie München, Munich

1965 *Sculptures africaines. Les univers artistiques des tribus*, Paris

1966 *African Tribal Sculptures: The Congo Basin Tribes*, New York

1968 *African Tribal Images*, Cleveland Museum of Art, Cleveland, Ohio

1970 *African Sculpture*, Brooklyn Museum, New York

1980 *Masques d'Afrique dans les collections du Musée Barbier-Müller*, Geneva

FAGG, William, and Eliot ELISOFON
1978 *The Sculpture of Africa*, New York

FAGG, William, and John PEMBERTON
1982 *Yoruba. Sculpture of Western Africa*, Bryce Holcombe (ed.), New York

FALGAYRETTES-LEVEAU, Christiane (ed.)
1996 *Masques*, Paris

FALGAYRETTES-LEVEAU, Christiane, and Lucien STEPAN
1993 *Formes et Couleurs, Sculptures de l'Afrique noire*, Paris

FASEL, Françoise
1993 Several commentaries in Jean Paul Barbier (ed.), *Art of Côte d'Ivoire from the Collections of the Barbier-Mueller Museum*, 2 vols., Geneva

FELDMEIER, Jana
1992 *Darstellung und Funktion des Weiblichen im Maskenwesen des Westsudan am Beispiel der Dogon und Nioniose*, Master's thesis, Munich

FELIX, Marc Leo
1989 *Maniema: An Essay on the Distribution of the Symbols and Myths as Depicted in the Masks of Greater Maniema*, Galerie Fred Jahn, Munich

1993 "The Animal in us: The Ubiquitous Zoomorphic Masking Phenomenon of Eastern Zaire," in Frank Herreman and Constantijn Petridis (eds.), *Face of the Spirits, Masks from the Zaire Basin*, Ethnographic Museum, Antwerp, pp. 199-214

1995 *Art & Kongos. Les peuples Kongophones et leur Sculpture. vol. I: Les Kongo du Nord*, Brussels

FISCHER, Eberhard
1962 "Die Künstler der Dan," in *Baessler Archiv* 10, pp. 161-263

1970 "Selbstbildnerisches, Porträt und Kopie bei den Masken-schnitzern der Dan in Liberia," in *Baessler Archiv* 18, pp. 15-41

1978 "Dan Forest Spirits. Masks in Dan Villages," in *African Arts* 11, 2, pp. 16-23, 94

FISCHER, Eberhard, and Hans HIMMELHEBER
1976 *Die Kunst der Dan*, Museum Rietberg, Zurich

FISCHER, Eberhard, and Lorenz HOMBERGER
1985 *Die Kunst der Guro, Elfenbein-küste*, Museum Rietberg, Zurich

FÖRSTER, Till
1987 *Glänzend wie Gold*, Berlin

1988a *Die Kunst der Senufo*, Museum Rietberg, Zurich

1988b *Kunst in Afrika*, Cologne

FORDE, Daryll, and G.I. JONES
1950 *The Ibo and Ibibio-Speaking Peoples of South-Eastern Nigeria*, Ethnographic Survey of Africa, Western Africa, III, International African Institute, London, 1967

FOSS, Perkins
1988 "Mädchenmaske," in Werner Schmalenbach (ed.), *Afrikanische Kunst aus der Sammlung Barbier-Mueller, Genf*, Munich, p. 150

FRANZ, L.
1967 "Das Zeichen des sakralen Rindes," in *Archaeologica Austriaca* 40, pp. 99-112

FRASER, Douglas (ed.)
1974 *African Art as Philosophy*, New York

FREYER, Bryna
1974 "Positive/Negative," in Douglas Fraser (ed.), *African Art as Philosophy*, New York, pp. 30-35

FROBENIUS, Leo
1897 *Der Kameruner Schiffsschnabel und seine Motive*, Halle

1898 *Die Masken und Geheimbünde Afrikas*, Halle

GALLOIS-DUQUETTE, Danielle
1976 "Informations de l'art plastique de Bidjogo," in *Arts d'Afrique Noire* 18, pp. 26-43

1981 "Les Masques bovins des îles Bissagos (Guinée-Bissau)," in *Connaissance des Arts Tribaux*, Bulletin 12, Geneva

GARDI, Bernhard
1986 *Zaïre. Masken, Figuren*, Museum für Völkerkunde und Schweizerisches Museum für Volkskunde, Basel

1994 *Kunst in Kamerun*, Museum für Völkerkunde und Schweizerisches Museum für Volkskunde, Basel

GARRARD, Timothy F.
1993 Several commentaries in Jean Paul Barbier (ed.), *Art of Côte d'Ivoire from the Collections of the Barbier-Mueller Museum*, 2 vols., Geneva

1995 "Pair of helmet mask crests," in Tom Phillips (ed.), *Africa: The Art of a Continent*, Munich/New York, p. 454

GEBAUER, Paul
1968 *A Guide to Cameroon Art from the Collection of Paul and Clara Gebauer*, Portland Art Museum, Portland

1979 *Art of Cameroon*, Portland Art Museum and Metropolitan Museum of Art, New York

GERBRANDS, Adrian A.
1957 *Art as an Element of Culture, especially in Negro Africa*, Leiden

GILLON, Werner
1979 *Collecting African Art*, Chatham

GLAZE, Anita
1988 Several commentaries in Werner Schmalenbach (ed.), *Afrika-nische Kunst aus der Sammlung Barbier-Mueller, Genf*, Munich, p. 84

1993 Several commentaries in Jean Paul Barbier (ed.), *Art of Côte d'Ivoire from the Collections of the Barbier-Mueller Museum*, 2 vols., Geneva

GLÜCK, Julius F.
1956 *Afrikanische Masken*, Baden Baden

GOLDWATER, Robert
1960 *Bambara Sculpture from the Western Sudan*, Museum of Primitive Art, New York

1964 *Senufo Sculpture from West Africa*, Museum of Primitive Art, New York

1969 "Judgement of Primitive Art, 1905-1965," in Daniel B. Biebuyck (ed.), *Tradition and Creativity in Tribal Art*, Berkeley/Los Angeles, pp. 24-41

GRIAULE, Marcel
1938 *Masques Dogons*, Travaux et Mémoires de l'Institut d'Ethnologie, 33, Paris

GROSSE, Ernst
1894 *Die Anfänge der Kunst*, Freiburg/Leipzig

HABI BUGANZA MULINDA
1995 "Ndunga mask," in Gustaaf Verswijver et al. (eds.), *Treasures from the Africa-Museum, Tervuren*, Musée royal de l'Afrique centrale, Tervuren, pp. 283-285

n.d. (1995) "Masks as Proverbial Language. Woyo, Zaire," in Luc de Heusch (ed.), *Objects, Signs of Africa*, Musée royal de l'Afrique centrale, Tervuren, pp. 147-159

HALEY, Jennifer
1985 "Bamana," in Herbert Cole (ed.), *I am not myself. The Art of African Masquerade*, Museum of Cultural History, UCLA, Los Angeles, pp. 28-33

HARLEY, George W.
1950 "Masks as Agents of Social Control in Northeast Liberia," in *The Papers of the Peabody Museum* 32, 2, pp. I-XIV, 1-45

HART, William A.
1986 "Aron Arabai: The Temne Mask of Chieftaincy," in *African Arts* 19, 2, pp. 41-45, 91

1987 "Masks with Metal-Strip Ornaments from Sierra Leone," in *African Arts* 20, 3, pp. 68-74, 90

1988 "Limba Funeral Masks," in *African Arts* 22, 1, pp. 60-67, 99

1990 "Le Masque d'une dynastie Temné — The Mask of a Temne Dynasty," in *Art tribal*, Bulletin du Musée Barbier-Mueller, Geneva, pp. 3-15

HARTER, Pierre
1986 *Arts anciens du Cameroun*, Arts d'Afrique Noire, Arnouville

1991 "Les Bambara," in *Primitifs. Art Tribal — Art Moderne* 4, pp. 30-48

1993 Several commentaries in Jean Paul Barbier (ed.), *Art of Côte d'Ivoire from the Collections of the Barbier-Mueller Museum*, 2 vols., Geneva

HASELBERGER, Herta
1969 "Bemerkungen zum Kunsthandwerk in der Republik Haute-Volta: Gurunsi und Alt-völker des äußersten Südwestens," in *Zeitschrift für Ethnologie* 94, 2, pp. 171-246

HÉBERT, Jean
1961 "Du Marriage toussian," in *Bulletin de l'IFAN* 23, 3-4, pp. 697-731

HEINTZE, Beatrix
1995 *Alfred Schachtzabels Reise nach Angola 1913-1914*, Afrika Archiv 1, Cologne

HEROLD, Erich
1967 *Ritualmasken Afrikas aus den Sammlungen des Naprstek-Museums*, Prague

HERREMAN, Frank
1993 "Vili," in Frank Herreman and Constantijn Petridis (eds.), *Face of the Spirits, Masks from the Zaire Basin*, Ethnographic Museum, Antwerp, p. 30

HERREMAN, Frank, and Constantijn PETRIDIS (eds.)
1993 *Face of the Spirits, Masks from the Zaire Basin*, Ethnographic Museum, Antwerp

HERSAK, Dunja
1986 *Songye Masks and Figure Sculpture*, London

1993 "The Kifwebe Masking Phenomenon," in Frank Herreman and Constantijn Petridis (eds.), *Face of the Spirits, Masks from the Zaire Basin*, Ethnographic Museum, Antwerp, pp. 145-158

281

1995 Several commentaries in Gustaaf Verswijver et al. (eds.), *Treasures from the Africa-Museum, Tervuren*, Musée royal de l'Afrique centrale, Tervuren

n.d. (1995) "Colours, Stripes and Projection: Revelations on Fieldwork Findings and Museum Enigmas," in Luc de Heusch (ed.), *Objects, Signs of Africa*, Musée royal de l'Afrique centrale, Tervuren, pp. 161-173

HIMMELHEBER, Hans
1935 *Negerkünstler*, Stuttgart

1960 *Negerkunst und Negerkünstler*, Braunschweig

1964 "Die Geister und ihre irdischen Verkörperungen als Grundvorstellung in der Religion der Dan," in *Baessler-Archiv* 12, pp. 1-88

1972 "Das Portrait in der Neger-kunst," in *Baessler-Archiv* 20, pp. 261-311

1979 *Masken und Beschneidung*, Zurich

1993 *Zaire 1938/39. Photographic Documents on the Arts of the Yaka, Pende, Tshokwe and Kuba*, Museum Rietberg, Zurich

HIRSCHBERG, Walter (ed.)
1962 *Monumenta Ethnographica. Bd.I. Schwarzafrika — frühe völker-kundliche Bilddokumente*, Graz

HOLY, Ladislav
1967 *La Sculpture africaine. Afrique orientale et meridionale*, Paris

HOMBERGER, Lorenz
1994 *Afrikanische Masken aus dem Museum Rietberg*, Museum Rietberg, Zurich

1996 *Afrikanische Masken*, Zurich

HORTON, Robin
1960 *The Gods as Guests*, Lagos

1965 *Kalabari Sculpture*, Department of Antiquities, Lagos

HUG, Alfons, and Haus der Kulturen der Welt (eds.)
1996 *Neue Kunst aus Afrika*, Berlin

HUNN, Judith
1985 "Lega," in Herbert Cole (ed.), *I am not myself. The Art of African Masquerade*, Museum of Cultural History, UCLA, Los Angeles, pp. 88-93

IMPERATO, Pascal James
1970 "The Dance of the Tyi Wara," in *African Arts* 4, 1, pp. 8-13, 71-80

1971 "Contemporary Adapted Dances of the Dogon," in *African Arts* 5, 1, pp. 28-33, 68-72, 84

1981 "Sogoni koun," in *African Arts* 14, 2, pp. 38-47, 72, 88

JAHN, Jens (ed.)
1994 *Tanzania. Meisterwerke afrikanischer Skulptur. Sanaa za mabingwa wa kiafrika*, Haus der Kulturen der Welt Berlin und Städtische Galerie im Lenbachhaus München, Munich

JENSEN, Adolf Ellegard
1950 "Über das Töten als kultur-geschichtliche Erscheinung," in *Paideuma* 4, pp. 23-28

1960 *Mythos und Kult bei Natur-völkern*, Wiesbaden

JESPERS, Philippe
n.d. (1995) "Mask and Utterance: The Analysis of an 'Auditory' Mask in the Initiatory Society of the Komo Minyanka, Mali," in Luc de Heusch (ed.), *Objects, Signs of Africa*, Musée royal de l'Afrique centrale, Tervuren, pp. 37-56

JONES, G.I.
1973 "Sculpture from the Umuahia Area of Nigeria," in *African Arts* 6, 4, pp. 58-63, 96

1984 *The Art of Eastern Nigeria*, Cambridge

KAMER, Hélène
1976 *Les "Duen-Fubara"*, Paris

KAMER, Henri
1973 *Haute-Volta*, Paris

KAN, Michael
1995 in *African Sculpture (3) Masterpieces*, The Detroit Institute of Arts, Washington/London

KARUTZ, Richard
1901 *Die afrikanischen Hörner-masken*, Mitteilungen der Geogra-phischen Gesellschaft Lübeck, 15, Lübeck

KASFIR, Sidney L.
n.d. n.p. MS, Musée Barbier-Mueller, Geneva

KECSKÉSI, Maria
1982 *Kunst aus dem Alten Afrika*, Sammlungen aus dem Staatlichen Museum für Völkerkunde München, vol. 2, Innsbruck/Frankfurt a.M.

KINGDON, Zachary
1995 Text to cat. nos. 4.71a-4.71f in Tom Phillips (ed.), *Africa: The Art of a Continent*, Munich/New York, pp. 300-301

KLIEMAN, Kairn
1985 "Pende," in Herbert Cole (ed.), *I am not myself. The Art of African Masquerade*, Museum of Cultural History, UCLA, Los Angeles, pp. 83-87

KOLOSS, Hans-Joachim
1980 *Kamerun. Könige — Masken — Feste*, Stuttgart/Cologne

1990 "Traditionen afrikanischer Kunst," in *Paideuma* 36, pp. 79-104

KOLOSS, Hans-Joachim, and Till FÖRSTER
1990 *Die Kunst der Senufo, Elfenbeinküste*, Staatliche Museen Preußischer Kulturbesitz, Berlin

KRIEG, Karl-Heinz, and Wulf LOHSE
1981 *Kunst und Religion bei den Gbato-Senufo, Elfenbeinküste*, Hamburgisches Museum für Völkerkunde, Hamburg

KRIEGER, Kurt
1990 *Ostafrikanische Plastik*, Museum für Völkerkunde, Berlin

KRIEGER, Kurt, and Gerdt KUTSCHER
1960 *Westafrikanische Masken*, Museum für Völkerkunde, Berlin

KUBIK, Gerhard
1987 *Nyau. Maskenbünde im süd-lichen Malawi*, Vienna

1993 *Makisi Nyau Mapiko. Maskentraditionen im bantu-sprachigen Afrika*, Munich

1995 "Mwan'phwó mask," in Gustaaf Verswijver et al. (eds.), *Treasures from the Africa-Museum, Tervuren*, Musée royal de l'Afrique centrale, Tervuren, pp. 319

LAMP, Frederick
1986 "The Art of the Baga: A Preliminary Inquiry," in *African Arts* 19, 2, pp. 64-67, 92

1996 *The Art of the Baga*, Museum of African Art, New York

LAUDE, Jean
1966 *Les Arts de l'Afrique noire*, Paris

1973 *African Art of the Dogon*, Brooklyn Museum, New York

LAYOUX, J.D.
1962 *Merveilles du Tassili N'Ajjer*, Paris

LEHUARD, Raoul
1977 "De l'Origine du masque tsaye'," in *Arts d'Afrique Noire* 23, pp. 10-15

1993 "Masks among the Kongo Peoples," in Frank Herreman and Constantijn Petridis (eds.), *Face of the Spirits, Masks from the Zaire Basin*, Ethnographic Museum, Antwerp, pp. 25-37

1996 *Les Arts bateke*, Arnouville

LEIRIS, Michel
1977 *Die eigene und die fremde Kultur*, Frankfurt a.M.

LEIRIS, Michel, and Jacqueline DELANGE
1968 *Afrika. Die Kunst des Schwarzen Erdteils*, Munich

LEM, F.-H.
1949 *Sudanese Sculpture*, Paris

LE MOAL, Guy
1980 *Les Bobo — Nature et Fonction des Masques*, Ostrom/Paris

LEUZINGER, Elsy
1962 "Afrique, l'art des peuples noirs," in *L'Art dans le Monde*, Paris

1977 *The Art of Black Africa*, New York

1985 *Kunst der Naturvölker*, Frankfurt a.M./Berlin/Vienna

LINDBLOM, K. Gerhard
1927 *The Use of Stilts especially in Africa and America*, Stockholm

1928 *Further Notes on the Use of Stilts*, Stockholm

LINTIG, Bettina von
1994 *Die bildende Kunst der Bang-wa. Werkstatt-Traditionen und Künstlerhandschriften*, Munich

LOMMEL, Andreas
1970 *Masken, Gesichter der Mensch-heit*, Zurich

LOPASIC, Alexander
1996 n.p. MS, Musée Barbier-Mueller, Geneva

MACK, John
1994 *Masks. The Art of Expression*, London

1995 "Mask," in Tom Phillips (ed.), *Africa: The Art of a Continent*, Munich/New York, p. 278

MAES, J.
1924 *Aniota-Kifwebe*, Antwerp

MANSFELD, Alfred
1908 *Urwald-Dokumente*, Berlin

MAQUET, Jacques J.
1962 *Afrique. Les civilisations noires*, n.p.

MARK, Peter
1983 "Diola Masking Traditions and the History of the Casamance (Senegal)," in *Paideuma* 29, pp. 3-22

1988 "L'Ejumba du Musée Barbier-Mueller: symbolisme et fonction — The Ejumba of the Barbier-Mueller Museum: Symbolism and Function," in *Art tribal II*, Bulletin du Musée Barbier-Mueller, Geneva, pp. 17-22

1992 *The White Bull and the Sacred Forest. Form, Meaning, and Change in Senegambian Initiation Masks*, Cambridge

MAURER, Evan M.
1988 Several commentaries in Werner Schmalenbach (ed.), *Afrikanische Kunst aus der Sammlung Barbier-Mueller, Genf*, Munich

McCALL, D.F.
1975 "The Hornbill and Analogous Forms in West African Sculpture," in D.F. McCall and E.G. Bay (eds.), *African Images — Essays in African Iconology*, New York, pp. 269-324

McLUHAN, Elizabeth
1974 "Earth/Man," in Douglas Fraser (ed.), *African Art as Philosophy*, New York, pp. 22-28

McNAUGHTON, Patrick R.
1988 *The Mande Blacksmiths. Knowledge, Power and Art in West Africa.* Bloomington/Indianapolis

1991 "Is There History in Horizontal Masks? A Preliminary Response to the Dilemma of Form," in *African Arts* 24, 2, pp. 40-53, 88-89

MENEGHINI, Mario
1974 "The Grebo Mask," in *African Arts* 8, 1, pp. 36-39, 87

MERRIAM, A.P.
1978 "Kifwebe and Other Masked and Unmasked Societies among the Basongye," in *Africa-Tervuren* 24, 3, pp. 57-73, 89-101

MESSENGER, John C.
1973 "The Carver in Anang Society," in Warren L. d'Azevedo (ed.), *The Traditional Artist in African Societies*, Bloomington, pp. 101-127

MESTACH, J.W.
1985 *Etudes Songye. Formes et symbolique. Essai d'analyse. Songye Studien. Formen und Symbolik. Analytischer Essay*, Galerie Jahn, Munich

MEAUZE, Pierre
1967 "L'Art nègre, sculpture," in *Formes et Couleurs*, Paris

MEUR, Charles
1994 "Annäherung an die Maskenschnitzerei Tanzanias," in Jens Jahn (ed.), *Tanzania. Meisterwerke afrikanischer Skulptur. Sanaa za mabingwa wa kiafrika*, Haus der Kulturen der Welt Berlin und Städtische Galerie im Lenbachhaus München, Munich, pp. 371-387

MEURANT, Georges
1994 "Die Bildhauerkunst der Nyamwezi," in Jens Jahn (ed.), *Tanzania. Meisterwerke afrikanischer Skulptur. Sanaa za mabingwa wa kiafrika*, Haus der Kulturen der Welt Berlin und Städtische Galerie im Lenbachhaus München, Munich, pp. 217-235

MEYER, Laure
1991 *Afriques noire, masques, sculptures, bijoux*, Paris

MUDIJI-SELENGE, Malutshi
n.d. *Masque Giwoyo*, n.p. MS, Musée Barbier-Mueller, Geneva

MUENSTERBERGER, Werner
1979 *Universalité de l'art tribal/ Universality of Tribal Art*, Geneva

MUSÉE BARBIER-MUELLER (ed.)
1987 *Hier, aujourd'hui, demain, dix ans d'activité du Musée Barbier-Mueller*, Geneva

N'DIAYE, Francine
1994 *Secrets d'initiés. Masques d'Afrique Noire dans les collections du Musée de l'Homme*, Boulogne-Billancourt

NEWTON, Douglas, and Hermione WATERFIELD
1995 *Tribal Sculpture. Masterpieces from Africa, South Asia and the Pacific in the Barbier-Mueller Museum*, New York

NEYT, François
1979a *L'Art Eket*, n.p.

1979b "Masque-Eléphant et Statuaire Igbo," in *Arts d'Afrique Noire* 32, pp. 29-45

1981 *Traditional Arts and History of Zaire*, Société d'Arts Primitifs, Institut Supérieur d'Archéologie et d'Histoire de l'Art, Université catholique de Louvain, Brussels

1992 "Les Masques Tetela existent-ils? Do Tetela Masks exist?," in *Art tribal*, Bulletin du Musée Barbier-Mueller, Geneva, pp. 3-14

1993 "South-East Zaire. Masks of the Luba, Hemba and Tabwa," in Frank Herreman and Constantijn Petridis (eds.), *Face of the Spirits, Masks from the Zaire Basin*, Ethnographic Museum, Antwerp, pp. 163-181

NEYT, François, and André DÉSIRANT
1985 *The Arts of the Benue to the Roots of Tradition*, Ottignies

NICKLIN, Keith
1974 "Nigerian Skin-Covered Masks," in *African Arts* 7, 3, pp. 7-15, 67-68, 92

1988 Several commentaries in Werner Schmalenbach (ed.), *Afrikanische Kunst aus der Sammlung Barbier-Mueller, Genf*, Munich

n.d. n.p. MS, Musée Barbier-Mueller, Geneva

NICKLIN, Keith, and Jill SALMONS
1984 "Cross River Art Styles," in *African Arts* 18, 1, pp. 28-43, 93-94

n.d.a *Annang Face Mask*, n.p. MS, Musée Barbier-Mueller, Geneva

n.d.b *Ogoni Face Mask*, n.p. MS, Musée Barbier-Mueller, Geneva

n.d.c *Ogoni*, n.p. MS, Musée Barbier-Mueller, Geneva

n.d.d *Eket Dance Headdress*, n.p. MS, Musée Barbier-Mueller, Geneva

n.d.e *Eket Face Mask*, n.p. MS, Musée Barbier-Mueller, Geneva

n.d.f *Bokyi Dance Headdress*, n.p. MS, Musée Barbier-Mueller, Geneva

NOLL, Colette
1980 *Esprits et dieux d'Afrique*, Exh. cat., Musée Chagall, Paris

NORTHERN, Tamara
1973 *Royal Art of Cameroon*, Hopkins Center Art Galleries, Dartmouth College, Hanover, New Hampshire

1984 *Art of Cameroon*, Smithsonian Institution, Washington

1988 Several commentaries in Werner Schmalenbach (ed.), *Afrikanische Kunst aus der Sammlung Barbier-Mueller, Genf*, Munich

NUNLEY, John
1981 "The Fancy and the Fierce," in *African Arts* 14, 2, pp. 52-58, 87

OLBRECHTS, F.M.
1959 *Les Arts Plastiques du Congo Belge*, Brussels/Antwerp

OTTENBERG, Simon
1975 *Masked Rituals of the Afikpo. The Context of an African Art*, Seattle

n.d. *Maske, Igbo, Ada-Gruppe*, n.p. MS, Musée Barbier-Mueller, Geneva

PAGER, Harald
1975 *Stone Age Myth and Magic as Documented in the Rock Paintings of South Africa*, Graz

PAULME, Denise
1956 "Structures sociales en pays baga," in *Bulletin de l'I.F.A.N.* XVIII, series B, 1-2, pp. 98-116

1988 Several commentaries in Werner Schmalenbach (ed.), *Afrikanische Kunst aus der Sammlung Barbier-Mueller, Genf*, Munich

PEMBERTON III, John
1989 "The Carvers of the Northeast," in Allen Wardwell (ed.), *Yoruba. Nine Centuries of African Art and Thought*, Center for African Art, New York, pp. 189-211

PERROIS, Louis
1979 *Arts du Gabon*, Paris

1985 *Ancestral Art of Gabun from the Collection of the Barbier-Mueller Museum*, Geneva

1988 Several commentaries in Werner Schmalenbach (ed.), *Afrikanische Kunst aus der Sammlung Barbier-Mueller, Genf*, Munich

1988b *Gabon. L'ordre du sacré*, Paris

1994 *Arts royaux du Cameroun*, Geneva

1996 "Mask," in Tom Phillips (ed.), *Africa: The Art of a Continent*, Munich/New York, pp. 324-325

PERROIS, Louis, and Marta SIERRA DELAGE
1990 *The Art of Equatorial Guinea. The Fang Tribes*, New York

PETRIDIS, C.
1993 Several commentaries in Frank Herreman and Constantijn Petridis (eds.), *Face of the Spirits, Masks from the Zaire Basin*, Ethnographic Museum, Antwerp

1995 "Face Mask. Helmet Mask," in Gustaaf Verswijver et al. (eds.), *Treasures from the Africa-Museum, Tervuren*, Musée royal de l'Afrique centrale, Tervuren, pp. 329-330

PHILLIPS, Ruth B.
1978 "Masking in Mende Sande Society Initiation Rituals," in *Africa* 48, 3, pp. 265-279

1980 "The Iconography of the Mende Sowei Mask," in *Ethnologische Zeitschrift Zürich* I, pp. 113-132

PHILLIPS, Tom (ed.)
1995 *Africa: The Art of a Continent*, Munich/New York

PICTON, John
1988 Several commentaries in Werner Schmalenbach (ed.), *Afrikanische Kunst aus der Sammlung Barbier-Mueller, Genf*, Munich

PLANCQUAERT, M.
1930 *Les Sociétés secrètes des Bayaka*, Louvain

POYNOR, Robin
1987 "Naturalism and Abstraction in Owo masks," in *African Arts* 20, 4, pp. 56-61, 91

n.d. n.p. MS, Musée Barbier-Mueller, Geneva

RAABE, Eva Ch. (ed.)
1992 *Mythos Maske*, Frankfurt a.M.

RATTON, Charles
1931 *Masques africains*, Paris

RICHARDS, Olufei J.V.
1974 "The Sande Mask," in *African Arts* 7, 2, pp. 48-51

RIGAULT, Patricia
1995 "Double face mask," in Tom Phillips (ed.), *Africa: The Art of a Continent*, Munich/New York, p. 451

ROBERTS, Allen F.
1995a *Animals in African Art. From the Familiar to the Marvelous*, Museum for African Art, New York

1995b "Buffalo mask," in Gustaaf Verswijver et al. (eds.), *Treasures from the Africa-Museum, Tervuren*, Musée royal de l'Afrique centrale, Tervuren, pp. 371-372

ROBERTS, Allen F., and Evan M. MAURER (eds.)
1986 *The Rising of a New Moon: A Century of Tabwa Art*, The University of Michigan Museum of Art, Ann Arbor

ROGERS, Donna Coates
1979 *Royal Art of the Kuba*, University of Texas, Austin

ROOD, Armistead P.
1969 "Bété Masked Dance. A View from Within," in *African Arts* 2, 3, pp. 36-43, 76

ROSS, Doran, and Herbert M. COLE
1977 *The Arts of Ghana*, Los Angeles

ROY, Christopher
1980 "Mossi Zazaido," in *African Arts* 13, 3, pp. 42-47

1981 "Mossi Masks in the Barbier-Mueller Collection," in *Connaissance des Arts Tribaux*, Bulletin 12, Geneva

1983 "Forme et Signification des Masques Mossi — Form and Meaning of Mossi Masks," in *Arts d'Afrique Noire* 48, pp. 9-23

1984 "Forme et Signification des Masques Mossi — Form and Meaning of Mossi Masks," in *Arts d'Afrique Noire* 49, pp. 11-22

1987 *Art of the Upper Volta Rivers*, Paris

1988 Several commentaries in Werner Schmalenbach (ed.), *Afrikanische Kunst aus der Sammlung Barbier-Mueller, Genf*, Munich

1991 "Créativité et évolution chez les Bwa: un masque-poisson en bois — Creativity and Change among the Bwa: A Wooden Fish Mask," in *Art tribal*, Bulletin du Musée Barbier-Mueller, Geneva, pp. 43-56

1992 *Art and Life in Africa. Selections from the Stanley Collection*, University of Iowa Museum of Art

RUBIN, Arnold
1988 "Maske," in Werner Schmalenbach (ed.), *Afrikanische Kunst aus der Sammlung Barbier-Mueller, Genf*, Munich, p. 180

RUBIN, William (ed.)
1984 *"Primitivism" in 20th Century Art*, 2 vols., New York

SAGER, Peter
1992 *Die Besessenen — Begegnungen mit Kunstsammlern zwischen Aachen und Tokio*, Cologne

SAVARY, Claude
1977 *Sculptures d'Afrique*, Geneva

SCHÄFER, Rita
1990 *Die Sande-Frauengeheimgesellschaft der Mende in Sierra Leone*, Bonn

SCHMALENBACH, Werner
1953 *Die Kunst Afrikas*, Basel

1988 *Afrikanische Kunst aus der Sammlung Barbier-Mueller, Genf*, Munich

SCHWARTZ, Nancy Beth A.
1972 *Mambilla – Art and Material Culture*, Publications in Primitive Art 4, Milwaukee Public Museum

SCHWEEGER-HEFEL, Annemarie
1980 *Masken und Mythen*, Vienna

SEGY, Ladislas
1976 *Masks of Black Africa*, New York

SIEBER, Roy
1961 *Sculpture of Northern Nigeria*, Museum of Primitive Art, New York

1988 "Aufsatzmaske," in Werner Schmalenbach (ed.), *Afrikanische Kunst aus der Sammlung Barbier-Mueller, Genf*, Munich, p. 166

SIEBER, Roy, and Roslyn Adele WALKER
1987 *African Art in the Cycle of Life*, National Museum of African Art, Washington

SIEGMANN, William
1988 Several commentaries in Werner Schmalenbach (ed.), *Afrikanische Kunst aus der Sammlung Barbier-Mueller, Genf*, Munich

SIROTO, Leon
1954 "A Mask Style from the French Congo," in *Man* 54, pp. 148-150

1979 "Witchcraft Belief and the Explanation of Traditional African Iconology," in Justine Cordwell (ed.), *The Visual Arts: Plastic and Graphic*, New York

SKOUGSTAD, Norman
1978 *Traditional Sculpture from Upper Volta*, African-American Institute, New York

SMITH, Marion W. (ed.)
1961 *The Artist in Tribal Society*, London

SOTHEBY'S
1983 "A Gola Wood Helmet Mask," in *Auction Catalogue*, May 22, London, p. 66

STEGER, Friedrich
1867 *Mungo Park's Reisen in Afrika. Von der Westküste zum Niger*, Leipzig

STRAUBE, Helmut
1955 *Die Tierverkleidungen der afrikanischen Naturvölker*, Wiesbaden

SWEENEY, James Johnson
1970 *African Sculpture*, Princeton, 1st ed. 1952, 2nd ed. 1964

SZALAY, Miklós
1986 *Die Kunst Schwarzafrikas*, Zurich

1995 *Afrikanische Kunst aus der Sammlung Han Coray, 1916-1928*, Völkerkundemuseum der Universität Zürich, Munich/New York

TESSMANN, Günter
1913 *Die Pangwe*, 2 vols., Berlin

THOMAS, L.-V.
1965 "Bukut chez les Diola-Niomoun," in *Notes Africaines* 108, pp. 97-118

THOMPSON, Robert Farris
1974 *African Art in Motion*, Los Angeles

1976 *Black Gods and Kings. Yoruba Art at the UCLA*, Bloomington

TORDAY, E., and T.-A. JOYCE
1911 *Notes ethnographiques sur les peuples communément appelés Bakuba, ainsi que sur les peuplades apparentées. Les Bushongo*, Brussels

TURNER, Victor
1982 *From Ritual to Theatre*, New York

UNDERWOOD, Leon
1952 *Masks of West Africa*, London

UTOTOMBO
1988 *L'Art de l'Afrique noire dans les collections privées belges*, Brussels

VANDENHOUTE, Jan P.L.
1948 *Classification stylistique du masques Dan et Guere de la Côte d'Ivoire occidentale*, Leiden

VAN GEERTRUYEN, Godelieve
1979 "Le Style Nimba," in *Arts d'Afrique Noire* 31, pp. 20-37

VANSINA, Jan
1955 "Initiation Rituals of the Bushong," in *Africa* 25, pp. 138-153

1988 "Bwoom-Maske," in Werner Schmalenbach (ed.), *Afrikanische Kunst aus der Sammlung Barbier-Mueller, Genf*, Munich, p. 259

VERGER-FÈVRE, Marie-Noël
1985 "Etude des masques faciaux de l'ouest de la Côte d'Ivoire conservés dans les collections publiques françaises," in *Arts d'Afrique Noire* 53, pp. 17-29, 54, 19-33

1988 Several commentaries in Werner Schmalenbach (ed.), *Afrikanische Kunst aus der Sammlung Barbier-Mueller, Genf*, Munich

1993 Several commentaries in Jean Paul Barbier (ed.), *Art of Côte d'Ivoire from the Collections of the Barbier-Mueller Museum*, 2 vols., Geneva

VERSWIJVER, Gustaaf, Els DE PALMENAER, Viviane BAEKE und Anne-Marie BOUTTIAUX-NDIAYE (eds.)
1995 *Treasures from the Africa-Museum, Tervuren*, Musée royal de l'Afrique centrale, Tervuren

VION, Anne-Marie
1988 Several commentaries in Werner Schmalenbach (eds.), *Afrikanische Kunst aus der Sammlung Barbier-Mueller, Genf*, Munich

1994 *Parure*, Paris

VOGEL, Susan
1988 Several commentaries in Werner Schmalenbach (ed.), *Afrikanische Kunst aus der Sammlung Barbier-Mueller, Genf*, Munich

1991 *Africa Explores. 20th Century African Art*, New York

1993 Several commentaries in Jean Paul Barbier (ed.), *Art of Côte d'Ivoire from the Collections of the Barbier-Mueller Museum*, 2 vols., Geneva

VOLAVKA, Zdenka
1976 "Le ndunga," in *Arts d'Afrique Noire* 17, pp. 28-43

VRYDAGH, André P.
1993 "Un Masque Mbunda," in *Art tribal*, Bulletin du Musée Barbier-Mueller, Geneva, pp. 37-45

WALLACE, Gail
1985 "Makonde," in Herbert Cole (ed.), *I am not myself. The Art of African Masquerade*, Museum of Cultural History, UCLA, Los Angeles, pp. 94-97

WEMBAH-RASHID, J.A.R.
n.d. "Masks and Masked Dancing in Jambo," in *The Inflight Magazine of Air Tanzania Corporation* 1, 3, Dar es Salaam

WESTON, Bonnie E.
1985 "A Kuba Mask," in Herbert Cole (ed.), *I am not myself. The Art of African Masquerade*, Museum of Cultural History, UCLA, Los Angeles, pp. 103-105

WILLETT, Frank
1971 *African Art, an Introduction*, London

1977 *Bambles, Bangles and Beads. Trade Contacts of Medieval Ife*, Edinburgh

1978 "An African Sculptor at Work," in *African Arts* 11, 2, pp. 28-33, 96

WITTMER, Marcilene K.
1991 *Visual Diplomacy. The Art of the Cameroon Grassfields*, Hurst Gallery, Cambridge, Massachusetts

WITTMER, Marcilene K., and William ARNETT
1978 *Three Rivers of Nigeria*, Arnett Collection, High Museum, Atlanta

YOSHIDA, Kenji
1993 "Masks and Secrecy among the Chewa," in *African Arts* 26, 2, pp. 34-45, 92

1995 "Mask (samahongo)," in Tom Phillips (ed.), *Africa: The Art of a Continent*, Munich/New York, p. 166

ZAHAN, Dominique
1974 *The Bambara*, Institute of Religious Iconography, State University Groningen, Leiden

1980 *Antilopes du Soleil*, Vienna

ZEITLYN, David
1994 "Mambila Figurines and Masquerades. Problems of Interpretation," in *African Arts* 27, 4, pp. 38-47, 94

n.d. n.p. MS, Musée Barbier-Mueller, Geneva

ZWERNEMANN, Jürgen
1978 "Masken der Bobo-Ule und Nuna im Hamburgischen Museum für Völkerkunde," in *Mitteilungen aus dem Museum für Völkerkunde Hamburg* 8, pp. 45-83

ZWERNEMANN, Jürgen, and Wulf LOHSE
1985 *Aus Afrika. Ahnen — Geister — Götter*, Hamburgisches Museum für Völkerkunde, Hamburg

EXHIBITION CATALOGUES

(LISTED ALPHABETICALLY) AND REFERENCE WORKS

African Negro Art, New York, 1935

African Sculpture Lent by New York Collectors, The Museum of Primitive Art, New York, 1958

Afrique, cent tribus, cent chefs-d'œuvre, Pavillon de Marsan, Paris, 1964

Allerlei Schönes aus Afrika, Amerika und der Südsee, Museum der Stadt Solothurn, 1957

Art Africain dans les collections genevoises, Musée d'Ethnographie, Geneva, 1973

Arts d'Afrique et d'Oceanie, Cannes, 1957

Arts premiers d'Afrique Noire, Exposition au centre culturel Crédit Communal de Belgique, Brussels, 1977

Art Tribal, Spécial Bénin / Tribal Art, special edition, Geneva, 1992

Die Kunst von Schwarz-Afrika, Kunsthaus Zürich, 1971

Exposition d'art africain et d'art oceanien, Galerie Pigalle, Paris, 1930

Hier, aujourd'hui, demain, Musée Barbier-Mueller, Geneva, 1987

Historia del arte, Encyclopedia in 16 vols., vol. 14: *Amerika, Afrika und Ozeanien*, Barcelona, 1996

Kunst der Neger, Kunsthalle, Bern, 1953

Sculptures de l'Afrique noire, Musée des Beaux Arts, La Chaux-de-Fonds, 1955

The Great Artists, Pablo Picasso, 71, vol. 4, *The 20th Century*, 1986

Westafrikanische Tage, Ingelheim am Rhein, 1982

INDEX OF ETHNIC GROUPS

Included in this index are the groups/regions represented by masks in this volume

PHOTOGRAPHIC ACKNOWLEDGEMENTS

The publisher, authors, and the Musée Barbier-Mueller would like to thank the following anthropologists, photographers, museums, and archives for their cooperation and loan of photographic materials:

Chike C. Aniakor illus. 10 / p. 18

Roger Asselberghs plates 12, 22, 24, 49, 55, 65, 68, 88; photo to plate 23

Barbier-Mueller Archive, Geneva illus. 13 / p. 19; illus. 15 / p. 15; illus. 24 / p. 32 (C. M. Firmin); photos to plates 1, 6, 12 (Jean Paul Barbier); 24, 26, 29, 30, 33 (J.Campé); 34, 35, 36, (top), 38 (A. M. Boyer); frontispiece, 7, 39 (Monique Barbier-Mueller); 42 (Jean Paul Barbier); 50 (Keith Nicklin and Jill Salmons); 74 (P. Amrouche); 80, 82, 88, 91, 97

Documentation Barbier-Mueller, Geneva photos to plates 5 (Courtesy Archives nationales d'outre-mer à Aix en Provence); 10 (Courtesy Ministère de la France d'outre-mer)

A. de Barros Machado, Copyright Musée Royal de l'Afrique centrale, Tervuren photo to plate 85

Basler Missionsarchiv photo to plate 65

Hugo B. Bernatzik illus. 12 / p. 18

Daniel P. Biebuyck photos to plates 94, 85

Thomas D. and Pamela A. R. Blakely photo to plate 92

G. Bochet photo to plate 15

Green Bonny, Courtesy Keith Nicklin and Jill Salmons (Documentation Barbier-Mueller) photo to plate 51

A.-M. Boyer, Kouassi-Périta (Documentation Barbier-Mueller) photo to plate 36 (bottom)

Robert Brain photo to plate 64

René Bravmann photo to plate 19

Courtesy René Bravmann photos to plates 17, 18

Herbert Cole photo to plate 55

Dominique Darbois photo to plate 13

Patrick Darlot photos to plates 8, 9

M. C. Dupré photo to plate 77

Eliot Elisofon illus. 28 / p. 35

William Fagg photo to plate 98

Pierre-Alain Ferrazzini cover; plates 1-5, 7-11, 13-21, 23, 25-27, 29-48, 50-54, 56-64, 66, 67, 69-87, 89-100

D. Gallois-Duquette photo to plate 21

Courtesy Paul Gebauer photo to plate 61

W. Hart (Documentation Barbier-Mueller) photo to plate 27

Pierre Harter illus. 11 / p. 18

C. Hénault photo to plate 93

Hoa-Qui, Paris illus. 4 / p. 14; photo to plate 41

Robin Horton photo to plate 48

Courtesy Robin Horton photo to plate 47

M. Huet, Hoa-Qui, Paris photos to plates 37, 75

Institut d'Ethnologie, Paris photo to plate 6

Dany Keller Galerie, Munich illus. 29 / p. 35

Hans-Joachim Koloß photo to plate 62

Gerhard Kubik (Courtesy Helmut Hillegeist) photo to plate 100

Jean-Dominique Lajoux illus. 2 / p. 12

Frederick Lamp photo to plate 25

Jacek Lapott illus. 8 / p. 17

Hugo Lemp, Paris photo to plate 40

Magnum/George Roger illus. 21 / p. 28

R. P. Marchal (Musée Royal de l'Afrique centrale, Tervuren) illus. 19 / p. 27

Courtesy Peter Mark photo to plate 20

Collection G.Mols photo to plate 22

Musée Royal de l'Afrique centrale, Tervuren photos to plates 79, 81, 83, 96

Courtesy Musée des Arts d'Afrique et d'Océanie, Paris photo to plate 60

Keith Nicklin and Jill Salmons (Documentation Barbier-Mueller) photos to plates 52, 53

Tamara Northern photo to plate 63

Simon Ottenberg photos to plates 56, 57

John Pemberton III photo to plate 43

H. Pepper photo to plate 67

Père Convers (Documentation Barbier-Mueller) photo to plate 14

Père Nadal (Documentation Barbier-Mueller) photo to plate 11

M. Plancquaert photo to plate 78

Jeffrey Ploskonka illus. 16 / p. 20

Robin Poynor photo to plate 45

Courtesy Robin Poynor photo to plate 49

Prestel-Verlag illus. 5 / p. 15, 6 / p. 16, 22 / pp. 22 f.; photos to plates 3, 14, 69-73, 76, 89, 90, 99

Fulvio Roiter illus. 7 / p. 16

Courtesy Hans and Betty Schaal illus. 27 / p. 34

Alfred Schachtzabel illus. 9 / p. 17

Heini Schneebeli illus. 28

Courtesy Nancy Beth A. Schwartz photo to plate 59

Turstan Shaw photo to plate 44

Courtesy Roy Sieber photo to plate 58

Günther Spannaus photo to plate 28

R. Steffen illus. 6

S. Touré illus. p. 10: photo to plate 16

M. N. Verger-Fèvre photo to plate 32

A. Vrydagh (Documentation Barbier-Mueller) photo to plate 87

Boris Wastiau photo to plate 86

Dominique Zahan photos to plates 2, 4

The pictures in the Catalogue section (pp. 239-278) are courtesy of Pierre-Alain Ferrazzini, with the exception of the following catalogue numbers: 15 (R. Steffen); 42, 51, 65, 67, 148, 158, 177, 184, 194, 207, 224 (Roger Asselberghs); 75 (Heini Schnebeli); 146 (François Martin)